# Christo and Jeanne-Claude

All items are lent by the artists.
*Alle Ausstellungsstücke wurden von
den Künstlern entliehen.*

Unless otherwise indicated, all photographs are by
Wolfgang Volz.
*Wenn nicht anders angegeben, stammen die Fotografien
von Wolfgang Volz.*

© 2001 TASCHEN GmbH
Hohenzollernring 53, D–50672 Köln
**www.taschen.com**
© 2001 Christo, New York
© 2001 for the photographs by Wolfgang Volz, Düsseldorf

Edited by Simone Philippi, Cologne
Designed by Claudia Frey, Cologne
English translations by Ingrid Taylor, Munich
German translations by Yvonne Havertz, Cologne and
Wolfgang Volz, Düsseldorf
Reproductions of the original works: Eeva-Inkeri, New York;
André Grossmann, New York; Wolfgang Volz, Düsseldorf
Production: Horst Neuzner, Cologne

Printed in Germany
ISBN 3–8228–5504–9

The artists do not derive income from the sale of this book.

# Christo and Jeanne-Claude
# Wrapped Reichstag
# Berlin 1971-95

A documentation exhibition
*Eine Dokumentationsausstellung*

**Photographs: Wolfgang Volz**

**Picture Notes: David Bourdon**
**History of the Reichstag building: Michael Cullen**

**TASCHEN**

KÖLN LONDON MADRID NEW YORK PARIS TOKYO

## Significant Dates

**1894** Designed by architect Paul Wallot, the German Reichstag is inaugurated on December 5.

**1933** The Reichstag is set on fire, February 27.

**1945** After the battle for Berlin, the Reichstag is in ruins. It is restored between 1957 and 1971, under the supervision of architect Paul Baumgarten.

**1961** The Berlin Wall is built. Although the Reichstag is located in West Berlin, in the British military sector, 39 meters (128 feet) of the east façade are in the Soviet military sector (East Berlin).
Christo creates a collage with photographs and a text, titled: *Project for a Wrapped Public Building.*

**1971** Michael S. Cullen sends Christo and Jeanne-Claude a postcard of the Reichstag.

**1972** *Valley Curtain, Rifle, Colorado, 1970–1972* is completed. Christo makes the first collage for *Wrapped Reichstag, Project for Berlin.* The Christos ask Michael S. Cullen to "please get the permit".

**1974** *The Wall – Wrapped Roman Wall, Rome* and *Ocean Front, Newport, Rhode Island* are completed.

**From 1976 to June 1995, the Christos visit Germany 54 times.**

**1976** Visits to Germany: Nos. 1 and 2
Christo goes to see the Reichstag while Jeanne-Claude is working in California.
Meeting with Bundestag President Annemarie Renger.
*Running Fence, Sonoma and Marin Counties, California, 1972–1976* is completed in September.

**1977** Visit to Germany: No. 3
Meetings with politicians, members of parliament, and the new Bundestag President, Karl Carstens.
May: Karl Carstens gives the project its **first refusal**.

**1978** Visit to Germany: No. 4
April: first meeting of the Kuratorium for the *Wrapped Reichstag* project in Hamburg.
*Wrapped Walk Ways, Loose Park, Kansas City, Missouri, 1977–1978* is completed in October

**1979** Visits to Germany: Nos. 5, 6 and 7

**1980** Visits to Germany: Nos. 8 and 9
During a Kuratorium meeting at the home of Otto and Winnie Wolff von Amerongen, Walter Scheel, former President of the Federal Republic of Germany, promises to talk to Richard Stücklen, President of the Bundestag.

**1981** Visit to Germany: No. 10
Richard Stücklen gives the project its **second refusal**.
October 4: Willy Brandt pays a visit to Christo and Jeanne-Claude at home in New York.

**1982** Visits to Germany: Nos. 11, 12 and 13

**1983** *Surrounded Islands, Biscayne Bay, Greater Miami, Florida, 1980–1983* is completed in May.

**1984** Visits to Germany: Nos. 14, 15 and 16
Rainer Barzel, President of the Bundestag, is not opposed to the project. However, he is forced to resign.

**1985** Visit to Germany: No. 17
*The Pont Neuf Wrapped, Paris, 1975–1985* is completed in September.

**1986** Visits to Germany: Nos. 18 and 19
Roland Specker founds the "Berliner für den Reichstag" association and begins to collect signatures in support of the project.
Eberhard Diepgen, lord mayor of West Berlin, pays a visit to Christo and Jeanne-Claude at home in New York .

**1987** 750th anniversary of the founding of the city of Berlin. Shortly after Roland Specker shows Philipp Jenninger, president of the Bundestag, a notarized statement containing 70,000 signatures in favor of the project, Jenninger gives the project its **third refusal**.

**1988** Visits to Germany: Nos. 20 and 21
Rita Süssmuth becomes president of the Bundestag.

**1989** September 6: Marianne Kewenig and Roland Specker meet with Rita Süssmuth at the Bundestag. November 9: fall of the Berlin Wall.

**1990** March 18: free elections to the East German Chamber of Deputies.
October 3: Germany is reunified.

**1991** June 20: Berlin is voted the seat of government and parliament following a twelve-hour debate in the Bundestag.
*The Umbrellas, Japan – USA, 1984–1991* is completed in October.
December: letter to Christo and Jeanne-Claude from Rita Süssmuth, inviting them to visit her in Bonn and offering her help with the *Wrapped Reichstag* project.

**1992** Visits to Germany: Nos. 22, 23, 24 and 25
February 9: first meeting with Rita Süssmuth, at a working lunch to discuss the project.
October 8: Willy Brandt dies. He had been a strong supporter of the *Wrapped Reichstag.*

**1993** Visits to Germany: Nos. 26, 27, 28, 29, 30, 31, 32, 33, 34 and 35
A scale model of the *Wrapped Reichstag* is exhibited in the Reichstag and later in the lobby of the Bundestag in Bonn. A long and arduous lobbying campaign is organized by Wolfgang and Sylvia Volz and Michael S. Cullen, setting up individual meetings for Christo and Jeanne-Claude with hundreds of members of Parliament, one by one, in their offices. Sometimes the artists are joined by Roland Specker.

**1994** Visits to Germany: Nos. 36, 37, 38, 39, 40, 41, 42, 43 and 44
February 25: the Bundestag debates the *Wrapped Reichstag* project and votes to grant **permission** – the first time in history that the future existence of a work of art is debated and voted on in a parliament.
October 1: Wolfgang and Sylvia Volz move from their Düsseldorf home to Berlin. Together with Roland Specker they open the office of "Verhüllter Reichstag GmbH" a few meters away from the Reichstag.

**1995** Visits to Germany: Nos. 45, 46, 47, 48, 49, 50, 51, 52, 53 and 54
From October 1994 to June 1995, project directors Roland Specker, Wolfgang and Sylvia Volz are at work finalizing all the contracts for the permits in Bonn and Berlin. They organize the work of the engineers, and select and hire German manufacturers for the fabric, the ropes, the inflatable elements, and the steel structures.
On June 24 the wrapping of the Reichstag is completed, by a work force of 90 professional climbers and 120 installation workers. The Reichstag remains wrapped for 14 days. The removal starts on July 7, and all materials are recycled.

## Fact Sheet

### The Building: The German Reichstag

Height at roof: *105.5 ft/32.2 m*
Height of towers: *139.4 ft/42.5 m*
Length, east and west façade: *445.2 ft/135.7 m*
Width, north and south façade: *314.9 ft/96 m*
Total perimeter: *1,520.3 ft/463.4 m*
Number of towers: *4*
Number of inner courtyards: *2*

### The Materials

Length of yarn used for weaving: *43,836 miles/70,546 km*
manufactured by Bremer Woll-Kämmerei, Bremen, Germany
Silver polypropylene fabric (fire-retardant B1):
*119,603 yd²/100,000 m²*
woven by Schilgen, Emsdetten, Germany
Width of the original woven fabric: *5 ft/1.55 m*
Tensile strength of fabric: *4000 Newtons per 5 cm*
Total weight of fabric: *135,583 lbs/61,500 kg*
Weight of aluminum for metallization for 100,000 m²:
*8.82 lbs/4 kg*
metallized by Rowo-Coating, Herbolzheim, Germany
Fabric panels: *70*
sewn by Spreewald Planen, Vetschau, Germany, and Zeltaplan, Taucha,
Germany, and Canobbio, Castelnuovo, Italy
Average size of panel: *121.4 x 131.2 ft/37 x 40 m*
Sewing-thread: *807.8 miles/1,300 km*
Total length of all seams: *1,706,640 ft/520,000 m*
Blue polypropylene rope with a diameter of 32 mm:
*17,060 yd/15,600 m*
manufactured by Gleistein, Bremen, Germany
Window anchors: *110*
Roof anchors: *270*
Weight of steel for roof: *440,920 lbs/200,000 kg*
Weight of steel for window anchors: *77,160 lbs/35,000 kg*
Cages for ornamental sandstone vases: *24*
average size of vase cages: *4.7 x 5.9 x 32.8 ft/4.5 x 1.8 x 10 m*
Cages for statues: *16*
Size of statue cages: *31.2 x 16.4 x 14.7 ft/9.5 x 5 x 4.5 m*
all steel manufactured by Stahlbau Zwickau, Zwickau, Germany
Air-cushions (necessary during installation): *32*
manufactured by Heba, Emsdetten, Germany
Number of weights on ground, attached to fabric: *477*
*(1.5 tons/m)*
manufactured by EKO Stahl, Eisenhüttenstadt, Germany
Sum of weights on ground: *2,205,000 lbs/1,000,000 kg*

### The Work Force

Chief executive officers: Roland Specker (administration) and
Wolfgang Volz (technical affairs and construction)
Engineering planning: IPL Ingenieurplanung Leichtbau
GmbH, Radolfzell, Germany: Harald Mühlberger, Wolfgang
Renner, Roland Gerster, Hartmut Ayrle, Michael Kiefer, Birgit
Klopfer, Udo Rutsche, Gerd Schmid, Bernd Stimpfle, Jürgen
Trenkle, Jörg Tritthardt, Hans-Jürgen Weißer
Engineering advisors: Vince Davenport, John Thomson,
Dimiter Zagoroff
Crew to install the fabric and the ropes:
RVM, Reichstagsverhüllungsmontage GmbH, Berlin: Frank
Seltenheim, Jens Fellmuth, Peter Gutmann, Ralf Haeger,
Robert Jatkowski, Henrik Modes, Bodo Senkel
Exclusive photographers: Wolfgang and Sylvia Volz, with the
assistance of Aleks Perković, Roland Bauer, Rainer Drexel,
André Gelpke, André Grossmann, Heinrich Hecht
Monitor organization: Roland Specker under the guidance
of Simon Chaput
Number of monitors: *1200 total in two ten-day periods, 600
daily in four shifts of 150 each*
Number of professional climbers: *90 in two shifts of 45 each*
Number of installation helpers: *120 in two shifts of 60 each*
Office staff in Berlin: Werner Braunschädel, Pamela Groos,
Katrin Specker, Annette van Straelen, Julia Wirtz, Martina
Witzel, Renate Wolff
Security staff: Kötter Holding International, Stefan Bisanz,
Detlev Brachmann, Heinz Dickmeis, Birgit Gerhard, Uwe
Gerstenberg, Claudia Herrmann, Torben Meyer, Bernhard
Neumann, Gerd Raue, Peter Wöhrmann, Bruno Zahner
Office staff in New York: Calixte Stamp and Vladimir
Yavachev

### Legal Background

The project was constructed by "Verhüllter Reichstag GmbH",
a subsidiary of C.V.J. Corporation, Jeanne-Claude Christo-
Javacheff, President and Treasurer, Scott Hodes, Secretary and
Legal Counsel, Christo V. Javacheff, Assistant Secretary. Legal
counsel was provided by attorney Prof. Peter Raue.
Architectural advice was provided by Prof. Jürgen Sawade.
Historical advice was provided by Michael S. Cullen. Permits
were required and received from the German Parliament, the
Bundestag, the local administration in Berlin and the city dis-
trict department of Tiergarten.

Members of parliament visited before the debate and vote
in the Bundestag: *352*
Number of presidents of the Bundestag involved
(1976–1995): *6*

As with Christo and Jeanne-Claude's previous art projects,
*The Wrapped Reichstag, Berlin,* 1971–1995, was entirely
financed by the artists, through the sale, by their C.V.J.
Corporation, of Christo's preparatory drawings, collages, scale
models, original lithographs, and early works. The artists do
not accept sponsorship of any kind.

## Bedeutende Daten

**1894** Am 5. Dezember wird das von dem Architekten Paul Wallot entworfene Reichstagsgebäude eingeweiht.

**1933** Der Reichstag wird am 27. Februar in Brand gesteckt.

**1945** Nach der Schlacht um Berlin liegt der Reichstag in Trümmern. Unter der Leitung des Architekten Paul Baumgarten wird er zwischen 1957 und 1971 wieder aufgebaut.

**1961** Die Berliner Mauer wird gebaut. Der Reichstag liegt zwar in Westberlin (im britischen Sektor), doch 39 Meter der Ostfassade befinden sich auf Ostberliner Gebiet (also im sowjetischen Sektor). Christo entwirft eine Collage mit Fotografien und einem Text *Projekt für ein verhülltes öffentliches Gebäude.*

**1971** Michael S. Cullen schickt Christo und Jeanne-Claude eine Ansichtskarte des Reichstagsgebäudes.

**1972** *Valley Curtain, Rifle, Colorado, 1970–1972* wird realisiert. Christo fertigt die erste Collage *Verhüllter Reichstag, Projekt für Berlin* an. Die Christos schreiben an Michael S. Cullen: »Bitte holen Sie die Genehmigung ein.«

**1974** *Die Mauer – Verhüllte römische Stadtmauer, Rom* und *Ocean Front, Newport, Rhode Island* werden realisiert.

**Von 1976 bis Juni 1995 besuchen die Christos Deutschland 54mal.**

**1976** Deutschlandbesuche Nr. 1 und 2
Christo nimmt den Reichstag zum ersten Mal in Augenschein, während Jeanne-Claude in Kalifornien arbeitet.
Treffen mit Bundestagspräsidentin Annemarie Renger.
*Running Fence, Sonoma und Marin Counties, Kalifornien, 1972–1976* wird im September realisiert.

**1977** Deutschlandbesuch Nr. 3
Begegnungen mit Politikern, Parlamentsmitgliedern und dem neuen Bundestagspräsidenten Karl Carstens.
Mai: Von Karl Carstens wird das Projekt zum **ersten Mal** abgelehnt.

**1978** Deutschlandbesuch Nr. 4
April: Erstes Treffen des Kuratoriums für das Reichstagsprojekt in Hamburg.
*Wrapped Walk Ways, Loose Park, Kansas City, Missouri, 1977–1978* wird im Oktober realisiert.

**1979** Deutschlandbesuche Nr. 5, 6 und 7

**1980** Deutschlandbesuche Nr. 8 und 9
Während einer Kuratoriumssitzung bei Otto und Winnie Wolff von Amerongen verspricht der frühere Bundespräsident Walter Scheel, mit Bundestagspräsident Richard Stücklen zu sprechen.

**1981** Deutschlandbesuch Nr. 10
Durch Richard Stücklen wird das Projekt zum **zweiten Mal** abgelehnt.

4. Oktober: Willy Brandt besucht Christo und Jeanne-Claude in New York.

**1982** Deutschlandbesuche Nr. 11, 12 und 13

**1983** *Surrounded Islands, Biscayne Bay, Greater Miami, Florida, 1980–1983* wird im Mai realisiert.

**1984** Deutschlandbesuche Nr. 14, 15 und 16
Bundestagspräsident Rainer Barzel, der nicht gegen das Projekt ist, muß zurücktreten.

**1985** Deutschlandbesuch Nr. 17
*Der verhüllte Pont Neuf, Paris, 1975–1985* wird im September realisiert.

**1986** Deutschlandbesuche Nr. 18 und 19
Roland Specker gründet den Verein »Berliner für den Reichstag«, der eine Unterschriftensammlung zugunsten des Projekts in Gang setzt.
Eberhard Diepgen, der Regierende Bürgermeister von Berlin, besucht Christo und Jeanne-Claude in New York.

**1987** Berlin feiert sein 750jähriges Stadtjubiläum.
Kurz nachdem Roland Specker Bundestagspräsident Philipp Jenninger eine notariell beglaubigte Bestätigung darüber übergeben hat, daß 70 000 Unterschriften für das Projekt gesammelt wurden, wird das Projekt von Philipp Jenninger zum **dritten Mal** abgelehnt.

**1988** Deutschlandbesuche Nr. 20 und 21
Rita Süssmuth wird Bundestagspräsidentin.

**1989** 6. September: Marianne Kewenig und Roland Specker werden im Bundestag von Rita Süssmuth empfangen.
9. November: Fall der Berliner Mauer

**1990** 18. März: Freie Wahlen zur Volkskammer der DDR.
3. Oktober: Deutschland wird wiedervereint.

**1991** 20. Juni: Nach einer zwölfstündigen Debatte votiert der Bundestag für Berlin als Regierungs- und Parlamentssitz.
*The Umbrellas, Japan – USA, 1984–1991* wird im Oktober realisiert.
Dezember: Christo und Jeanne-Claude erhalten einen Brief von Rita Süssmuth, worin diese sie nach Bonn einlädt und ihre Unterstützung für das Projekt *Verhüllter Reichstag* anbietet.

**1992** Deutschlandbesuche Nr. 22, 23, 24 und 25
9. Februar: Erstes Zusammentreffen mit Rita Süssmuth, um bei einem Arbeitsessen das Projekt zu erörtern.
8. Oktober: Willy Brandt stirbt. Er hatte das Projekt nach Kräften unterstützt.

**1993** Deutschlandbesuche Nr. 26, 27, 28, 29, 30, 31, 32, 33, 34 und 35
Ein maßstabgerechtes Modell des *Verhüllten Reichstags* wird im Reichstag und später in der Lobby des Bundestags in Bonn ausgestellt. Ein langes und mühsames Lobbying beginnt.

Wolfgang und Sylvia Volz sowie Michael S. Cullen arrangieren für Christo und Jeanne-Claude Gesprächstermine mit Hunderten von Abgeordneten, die alle einzeln in ihren Büros aufgesucht werden. Manchmal werden die Künstler von Roland Specker begleitet.

**1994** Deutschlandbesuche Nr. 36, 37, 38, 39, 40, 41, 42, 43 und 44
25. Februar: Nach einer leidenschaftlich geführten Debatte gibt der Bundestag seine **Zustimmung** zum Projekt *Verhüllter Reichstag.* Es ist das erste Mal in der Geschichte, daß in einem Parlament über die künftige Existenz eines Kunstwerks debattiert und abgestimmt wird.
1. Oktober: Wolfgang und Sylvia Volz ziehen nach Berlin. Zusammen mit Roland Specker eröffnen sie in unmittelbarer Nähe des Reichstags das Büro der »Verhüllter Reichstag GmbH«.

**1995** Deutschlandbesuche Nr. 45, 46, 47, 48, 49, 50, 51, 52, 53 und 54
Oktober 1994 bis Juni 1995: Die Projektleiter Roland Specker sowie Wolfgang und Sylvia Volz arbeiten am Abschluß sämtlicher Verträge für die Genehmigungen in Bonn und Berlin. Sie organisieren die Arbeit der Ingenieure und beauftragen deutsche Unternehmen für das Gewebe, die Seile, die aufblasbaren Elemente und die Stahlkonstruktionen.
Am 24. Juni 1995 wird die Verhüllung des Reichstagsgebäudes von einer Mannschaft, bestehend aus 90 Gewerbekletterern und 120 Montagearbeitern, vollendet. Der Reichstag bleibt für 14 Tage verhüllt. Der Abbau beginnt am 7. Juli, und alle Materialien werden recycelt.

## Info-Blatt

### Das Gebäude: Der Deutsche Reichstag

Dachhöhe: *32,2 m*

Turmhöhe: *42,5 m*

Länge Ost- bzw. Westfront: *135,7 m*

Breite Nord- bzw. Südseite: *96 m*

Gebäudeumfang: *463,4 m*

Türme: *4*

Innenhöfe: *2*

### Die Materialien

Länge des Webgarns: *70 546 km*

erstellt von der Bremer Woll-Kämmerei GmbH, Bremen

Polypropylengewebe, silbrig glänzend: *100 000 m²*

(schwer entflammbar, entsprechend B1)

gewebt von Schilgen GmbH & Co., Emsdetten, Nordrhein-Westfalen

Breite der originalen Stoffbahnen: *1,55 m*

Reißfestigkeit: *4000 Newton/5 cm*

Gesamtgewicht des Gewebes: *61 500 kg*

Gesamtgewicht des Aluminiums für die Metallisierung: *4 kg*

beschichtet von Rowo-Coating GmbH, Herbolzheim, Baden-Württemberg

Gewebepaneele: *70*

vernäht von Spreewald Planen GmbH, Vetschau, Brandenburg, und Zeltaplan GmbH, Taucha, Sachsen und Canobbio, Castelnuovo, Italien

Durchschnittsgröße der Paneele: *37 x 40 m*

Länge des Nähgarns: *1300 km*

Gesamtnahtlänge: *520 000 m*

Polypropylenseil, blau (32 mm Durchmesser): *15 600 m*

erstellt von Gleistein GmbH, Bremen

Fensterhalterungen: *110*

Dachhalterungen: *270*

Gewicht aller Stahlkonstruktionen auf dem Dach: *200 000 kg*

Gewicht aller Stahlkonstruktionen in den Fenstern: *35 000 kg*

Metallkäfige für die Vasen (ca. 4,5  x 1,8  x 10 m): *24*

Metallkäfige für die Statuen (ca. 9,5  x 5  x 4,5 m): *16*

Alle Stahlkonstruktionen wurden hergestellt von Stahlbau Zwickau GmbH, Zwickau, Sachsen

Luftkissen für die Installation: *32*

hergestellt von Heba GmbH, Emsdetten, Nordrhein-Westfalen

Bodengewichte zur Befestigung des Stoffes (1500 kg/lfm): *477*

hergestellt von EKO Stahl GmbH, Eisenhüttenstadt, Brandenburg

Summe der Bodengewichte: *1 000 000 kg*

### Die Mitarbeiter

Geschäftsführer:  Roland Specker (Finanzen) und Wolfgang Volz (Technik und Konstruktion)

Ingenieurplanung:  IPL Ingenieurplanung Leichtbau, Radolfzell, Baden-Württemberg: Harald Mühlberger, Wolfgang Renner, Roland Gerster, Hartmut Ayrle, Michael Kiefer, Birgit Klopfer, Udo Rutsche, Gerd Schmid, Bernd Stimpfle, Jürgen Trenkle, Jörg Tritthardt, Hans-Jürgen Weißer

Technische Beratung: Vince Davenport, John Thomson, Dimiter Zagoroff

Montage von Gewebe und Seil:

Reichstagsverhüllungsmontage GmbH, Berlin: Frank Seltenheim, Jens Fellmuth, Peter Gutmann, Ralf Haeger, Robert Jatkowski, Henrik Modes, Bodo Senkel

Exklusiv autorisierte Projektfotografen: Wolfgang und Sylvia Volz mit Hilfe von Aleks Perković, Roland Bauer, Rainer Drexel, André Gelpke, André Grossmann, Heinrich Hecht

Monitororganisation:  Roland Specker unter der Leitung von Simon Chaput

Anzahl der Monitore:  insg. 1200 in zwei Perioden von jeweils 10 Tagen, täglich 600 in vier Tagesschichten von je 150 Personen

Gewerbekletterer: *90 (in zwei Schichten von je 45)*

Installationsmitarbeiter: *120 (in zwei Schichten von je 60)*

Büroangestellte in Berlin:  Werner Braunschädel, Pamela Groos, Katrin Specker, Annette van Straelen, Julia Wirtz, Martina Witzel, Renate Wolff

Sicherheit:  Kötter Holding International, Stefan Bisanz, Detlev Brachmann, Heinz Dickmeis, Birgit Gerhard, Uwe Gerstenberg, Claudia Herrmann, Torben Meyer, Bernhard Neumann, Gerd Raue, Peter Wöhrmann, Bruno Zahner

Büroangestellte in New York:  Calixte Stamp und Vladimir Yavachev

### Der juristische Hintergrund

Das Projekt wurde von der »Verhüllter Reichstag GmbH« durchgeführt.

Sie ist eine Tochtergesellschaft der C.V.J. Corporation, Jeanne-Claude Christo-Javacheff, Vorsitzende und Leiterin der Finanzabteilung, Scott Hodes, Vorstand und juristischer Berater, Christo V. Javacheff, Assistent des Vorstandes.

Juristischer Berater in Berlin war Rechtsanwalt Prof. Dr. Peter Raue. Bei architektonischen Fragen beriet Prof. Dr. Jürgen Sawade. Michael S. Cullen war der Projekthistoriker. Für die Realisation des Projektes brauchten Christo und Jeanne-Claude die Zustimmung vom Deutschen Bundestag und die Baugenehmigung vom Bezirksamt Tiergarten, Berlin.

Einzelgespräche mit Bundestagsmitgliedern: *352*

Zahl der beteiligten Bundestagspräsidenten (1976–1995): *6*

Das Projekt *Verhüllter Reichstag, Berlin,* 1971–1995 wurde, wie alle anderen Projekte der Künstler, ausschließlich aus eigenen Mitteln finanziert, also durch den Verkauf von Vorstudien, Zeichnungen, Collagen und maßstabgerechten Modellen sowie früheren Arbeiten und Originallithographien. Christo und Jeanne-Claude verlangen und akzeptieren keinerlei Fördermittel aus öffentlicher oder privater Hand.

## Early Proposals

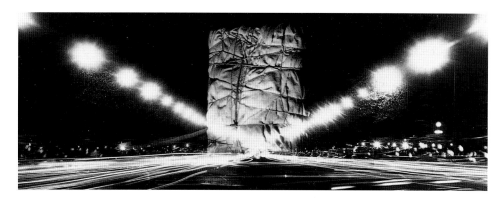

Christo first came up with the idea of wrapping public buildings in fabric in 1961. His earliest two proposals were for buildings in Paris. The Bulgarian-born artist had been living there since 1958, creating artworks that consisted of ordinary objects wrapped in fabric or plastic. At first satisfied to package small objects (paint cans, chairs, bicycles and a car), he began to contemplate the possibility of much larger, enigmatically transformed objects. In October 1961, he conceived a monumental package – suggesting a massive horizontal building, equivalent to an eight-story structure (opposite) – bundled in cloth and polyethylene and tied with rope and steel cable; he gave it visual form by collaging a photograph of one of his actual, if considerably smaller, packages on a photograph of a Paris setting. In a text below the picture, he explained his proposed procedure for wrapping a public building in rubberized tarpaulins and reinforced plastic, secured with steel cables and rope.

He suggested several types of buildings that he deemed suitable for wrapping: stadiums, concert halls, museums, prisons and parliaments.

Christo's second unrealized proposal for Paris (right, top) involved a giant vertical package (taller than the Arc de Triomphe); this image of a wrapped bundle as the focal point of the Avenue des Champs-Élysées was achieved in a darkroom with the aid of a photographer friend who superimposed two negatives.

When the Galleria Nazionale d'Arte Moderna in Rome offered Christo a solo exhibition in 1967, he proposed wrapping the museum as well, and he submitted a scale model (right, center) to show what he had in mind. Curiously, the exhibition was canceled.

In 1968 Christo proposed wrapping the Museum of Modern Art in New York (right, bottom) in conjunction with an exhibition, "Dada, Surrealism, and Their Heritage". The museum's insurance company, as well as the city's fire and police departments, were apprehensive about the consequences, so permission was denied.

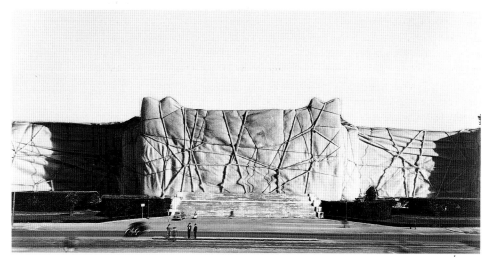

**Packaged Building, Project**
Photo-collage 1963
13 x 36 cm
*Photo: Harry Shunk*

**Wrapped Museum, Project for Galleria Nazionale d'Arte Moderna, Rome**
Photo-collage 1967, detail
55.8 x 76.2 cm
*Menil Foundation, Houston, Texas*
*Photo: Ferdinand Boesch*

**The Museum of Modern Art Wrapped, Project for New York**
Collaged photographs 1968, detail
38 x 25.4 cm
*The Museum of Modern Art, New York*
*Photo: Ferdinand Boesch*

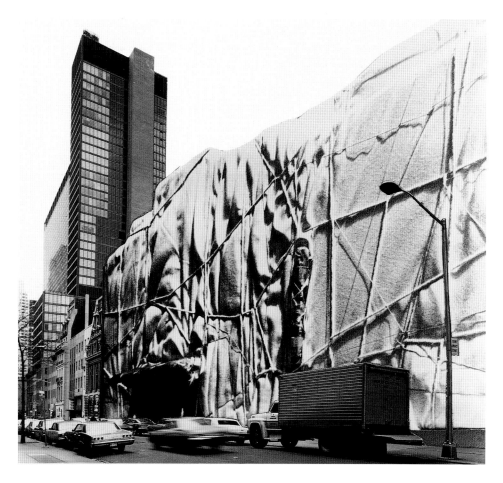

## Frühe Pläne

1961 kam Christo zum ersten Mal der Gedanke, öffentliche Gebäude zu verhüllen. Bei seinen ersten beiden Plänen ging es um Gebäude in Paris, wohin der aus Bulgarien stammende Künstler 1958 umgesiedelt war. Bei den in diesen frühen Pariser Jahren entstandenen Kunstwerken handelte es sich um mit Stoff oder Plastikfolie verhüllte Alltagsgegenstände. Nachdem er sich zunächst damit begnügt hatte, eher kleine Dinge (Farbdosen, Stühle, Fahrräder und ein Auto) zu verhüllen, begann er die Möglichkeit ins Auge zu fassen, sehr viel größere Objekte zu verhüllen, um sie rätselhaft zu transformieren. Im Oktober 1961 konzipierte er ein in Stoff und Polyäthylenfolie eingehülltes und mit Stahl- und gewöhnlichen Seilen zusammengebundenes monumentales Paket, das an ein massives, horizontal ausgerichtetes, achtstöckiges Gebäude denken ließ (rechts). Diesem Projekt gab er eine visuelle Form, indem er eine Fotografie eines seiner verwirklichten – wenn auch sehr viel kleineren – Pakete mit einer in den Straßen von Paris aufgenommenen Fotografie collagierte. In einem Begleittext zu dieser Collage erläuterte er sein Projekt für ein in gummierte Leinwand- und verstärkte Kunststoffplanen gehülltes und mit Seilen und Stahlseilen verschnürtes öffentliches Gebäude. Er führte mehrere Gebäudetypen an, die er als für eine Verhüllung geeignet erachtete: Sportstadien, Konzerthallen, Museen, Gefängnisse und Parlamentsgebäude.

Bei Christos zweitem nicht realisierten Projekt für Paris (Abb. S. 8 oben) ging es um ein gigantisches vertikales Paket (größer als der Triumphbogen); diese Darstellung eines verhüllten Pakets als Brennpunkt der Champs-Élysées wurde mit Hilfe eines befreundeten Fotografen geschaffen, der in der Dunkelkammer das eine Negativ in das andere einblendete.

Als die Galleria Nazionale d'Arte Moderna in Rom Christo 1967 eine Einzelausstellung anbot, machte er den Vorschlag, auch das Museum selbst zu verhüllen, und er reichte ein maßstabgetreues Modell ein (Abb. S. 8 Mitte), um seine Vorstellungen zu verdeutlichen. Erstaunlicherweise wurde die Ausstellung abgesagt.

1968 schlug Christo anläßlich der Ausstellung »Dada, Surrealism, and Their Heritage« die Verhüllung des Museum of Modern Art in New York vor (Abb. S. 8 unten). Da die Versicherung des Museums wie auch die Polizei und die Feuerwehr Sicherheitsbedenken äußerten, wurde die Genehmigung verweigert.

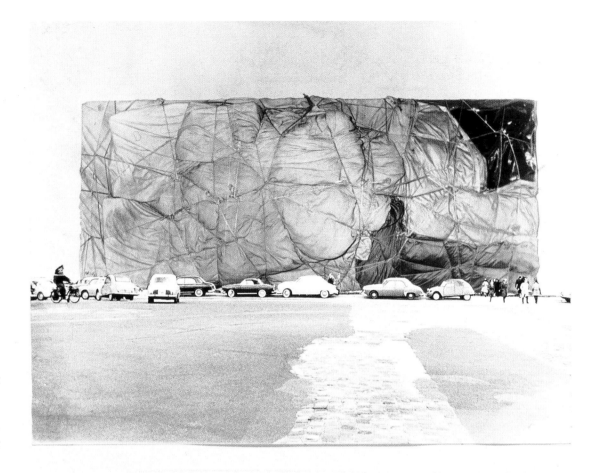

**Projet d'un Edifice Public Empaqueté**
Collage 1961
41.5 x 25 cm
Photographs by Harry Shunk
and a text by Christo

PROJET D'UN EDIFICE PUBLIC EMPAQUETE

I. Notes générales:
Il s'agit d'un immeuble situé dans un emplacement vaste et régulier.
Un bâtiment ayant une base rectangulaire, sans aucune façade. Le bâtiment sera complètement fermé-c'est à dire empaqueté de tous les côtés. Les entrées seront souterraines, placées environ à 15 ou 20 metres de cet edifice. L'empaquetage de cet immeuble sera éxécuté avec des bâches des toiles gommées et des toiles de matiere plastique renforcée d'un largeur mouenne de 10 à 20 metres, des cordes métalliques et ordinaires. Avec les cordes de métal nous pouvons obtenir les points, qui peuvent servir en suite à l'empaquetage de bâtiment. Les cordes métalliques évitent la construction d'un échafaudage. Pour obtenir le resultat nécessaire il faut environ 10000 metres de bâches, 20000 metres de cordes métalliques, 80000 metres de cordes ordinaires.
Le present projet pour un edifice public empaqueté est utilisable:
I. Comme salle sportive-avec des piscines, le stade de football, le stade des disciplines olimpiques, ou soit comme patinoire à glace ou à hockey.
II. Comme salle de concert, planetarium, salle de conférence et essais expérimentaux.
III. Comme un musée historique, d'art anciéne et d'art moderne.
IV. Comme salle parlementaire ou un prison.

CHRISTO
octobre 1961, Paris

The Reichstag, west facade, around 1896
The view is from a building on the north central side of the
Königsplatz. (The inscription "Dem Deutschen Volke" is not
visible, it was applied only in 1916).

Der Reichstag, Westfassade, um 1896
Diese Fotografie wurde von einem in der Mitte der Nordseite des
Königsplatzes gelegenen Gebäude aus aufgenommen.
(Die Inschrift »Dem Deutschen Volke« wurde erst 1916
angebracht.)

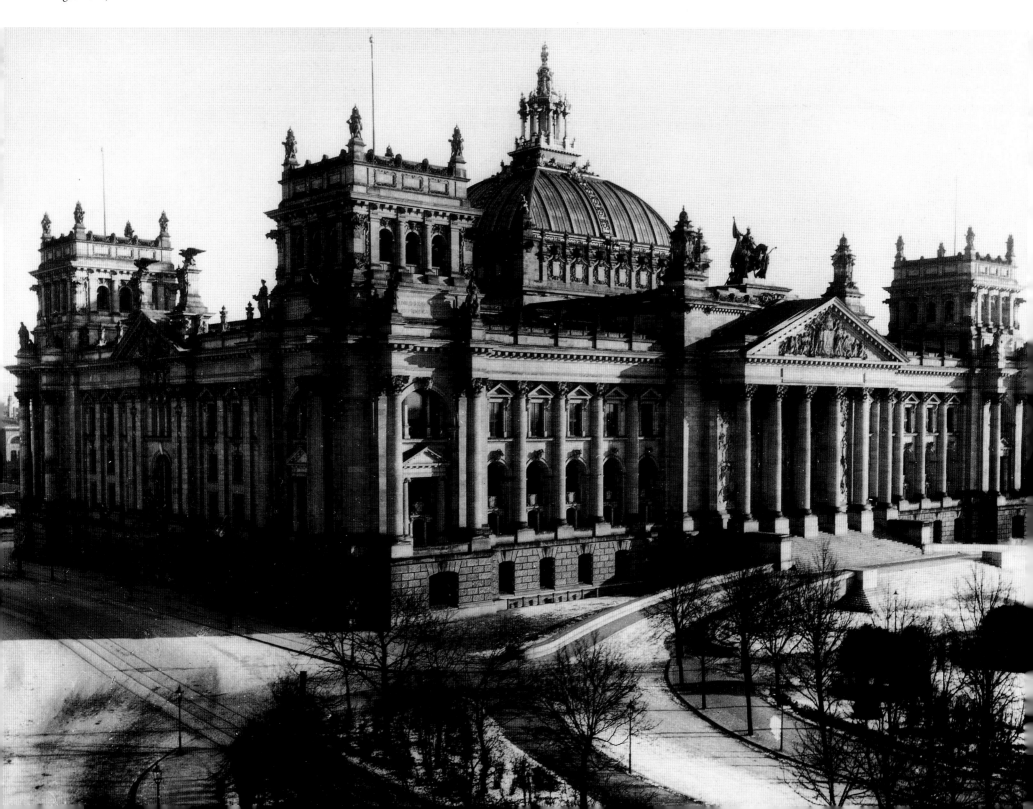

# The Reichstag: Its turbulent history

*by Michael S. Cullen*

The once and future parliament of Germany has had a very checkered history of which only a tiny fragment can be described in this short account.

For almost 1000 years, the German nation was organized as a very loose confederation of states, known as the Holy Roman Empire of the German Nation, ruled by an emperor. In contrast to the rulers of many other budding states – France, England – the office of Emperor was not heriditary, but elective. The elections were held in large assemblies known as "Reichstag"; "Reich", among other things, means empire; "Tag" is an old Germanic word meaning not only "day" but also "gathering,"assembly," "council."The Reichstag – the word came into use only after 1500 – had many other functions. It advised the emperor on matters of money and administration, voted on making war and peace and ratified treaties with foreign powers. Entitled to vote were princes and clerics, but they themselves were not elected, only appointed. Neither were the assemblies periodic nor did they have the right to convene or adjourn on their own. Until 1663, Reichstage – the plural – were held in different places, in Speyer, Worms, Augsburg, Nuremberg, Frankfurt, even south of the alps near Piacenza, Italy. Commencing in 1663, the Reichstag was held in one city, Regensburg, north Bavaria. Napoleon dissolved it in 1806.

When Bismarck re-created the German Empire in 1871, he had put in the constitution a new Reichstag, this time to be elected by universal suffrage. It needed a new building, somewhere in Berlin.

In April 1871, just after the Reichstag had convened, a commission was appointed to find a suitable spot and create specifications for a competition. The commission certainly had in mind what it knew of Washington because the building was not only to be practical but also a monument to German unification, for which it would have to be freestanding. The commission chose a plot at the Königsplatz (Place Royal), upon which the palace of the collector and diplomat Raczynski stood. Although Raczynski refused to part from his building, the competition was announced just around Christmas 1871 and included the site.

Curiously enough for Europe of that time, the competition was international, and so was the jury; its most distinguished member was Gottfried Semper, once from Hamburg, but at the time a citizen of Switzerland. Of the 102 entries, 15 came from the United Kingdom and about 10 from Austria-Hungary. The names of the winners were announced in June 1872; the winner with a design in neo-Ranaissance style was a German architect, Ludwig Bohnstedt, who had designed many buildings in St. Petersburg; a fourth prize went to Sir George Gilbert Scott, perhaps the most famous and successful neo-Gothic architect in England at that time. Yet, Bohnstedt could not really enjoy

# Der Reichstag: Seine turbulente Geschichte

*von Michael S. Cullen*

Der einstige und künftige Sitz des deutschen Parlaments hat eine sehr wechselvolle Geschichte, von der hier nur ein Ausschnitt behandelt werden kann.

Fast 1000 Jahre lang war die deutsche Nation als ein sehr lockerer Staatenbund – das Heilige Römische Reich Deutscher Nation – unter der Oberherrschaft eines Kaisers organisiert. Im Gegensatz zu den Herrschern vieler anderer europäischer Staaten wie Frankreich oder England wurden die deutschen Kaiser nicht durch Erbfolge bestimmt, sondern auf großen Versammlungen – den ›Reichstagen‹ – von Kurfürsten in ihr Amt gewählt. Darüber hinaus hatte der Reichstag – das Wort kam erst nach 1500 in Gebrauch – viele andere Funktionen. Er beriet den Kaiser in Finanz- und Verwaltungsfragen, stimmte über Krieg und Frieden ab und ratifizierte Verträge mit fremden Mächten. Die Mitglieder – weltliche wie geistliche Würdenträger – wurden nicht gewählt, sondern ernannt. Die Versammlungen fanden nicht regelmäßig statt und konnten nur vom Kaiser einberufen werden. Bis 1663 tagte der Reichstag in verschiedenen Städten – in Speyer, Worms, Augsburg, Nürnberg, Frankfurt am Main und selbst südlich der Alpen bei Piacenza in Italien. Seit 1663 war Regensburg der Tagungsort des ›immerwährenden‹ Reichstags. 1806 wurde der Reichstag von Napoleon aufgelöst.

Als Bismarck 1871 das (zweite) deutsche Kaiserreich schuf, fügte er in die Verfassung einen neuen, vom Volk gewählten Reichstag ein. Für diesen Reichstag wurde ein Sitzungsgebäude in Berlin benötigt.

Im April 1871, unmittelbar nach der konstituierenden Sitzung des neugewählten Reichstags, wurde eine Kommission ernannt, die einen geeigneten Standort finden und das Bauprogramm und die Wettbewerbsbedingungen formulieren sollte. Der Kommission stand zweifellos das Beispiel des Kapitols in Washington vor Augen: Das Gebäude sollte nicht nur seinen praktischen Zweck erfüllen, sondern – als freistehendes Gebäude – auch ein Symbol für die deutsche Einheit sein. Als Standort wählte die Kommission den Königsplatz aus, wo das Palais des Kunstsammlers und Diplomaten Graf Raczynski stand. Obwohl Raczynski sich nicht von seinem Gebäude trennen wollte, wurde der Wettbewerb im November 1871 für diesen Standort ausgeschrieben.

Der Wettbewerb wurde international ausgeschrieben, was für die damalige Zeit alles andere als selbstverständlich war, und auch die Jury war international besetzt; das berühmteste Mitglied war der aus Hamburg stammende Gottfried Semper, der in der Schweiz lebte. Von den 102 Wettbewerbsbeiträgen kamen 15 aus Großbritannien und etwa 10 aus Österreich-Ungarn. Die Namen der Gewinner wurden im Juni 1872 bekanntgegeben; Den ersten Preis erhielt der deutsche Architekt Ludwig Bohnstedt, der viele Gebäude in St. Petersburg entworfen hatte; er hatte einen Entwurf im Stil der Neorenaissance vorgelegt. Ein vierter Preis ging an Sir George Gilbert Scott, den vielleicht bekanntesten und

his prize; the site was still not available, and all efforts to get it and get the building going had to be shelved.

For the next decade, the commission and several sub-commissions looked into other sites, always coming up with either the old one or one across the way, upon which the Kroll Opera House stood. This was rejected by the representatives as being too far away from the city or center of government. Even the emperor, Wilhelm I, could not persuade the representatives to accept the Kroll site.

By a lucky accident, the Empire found out that the heir of Raczynski (he had died in 1874) was not opposed to parting with his property, and, once a contract had been drawn up, it took only two more years of arm-twisting in parliament before the contract could be ratified. The way was open for a new competition. This was announced in February 1882 and won by a young architect from Frankfurt/Main, Paul Wallot on June 26, 1882, his 41st birthday.

Wallot spent the better part of two years revising his design, and, after approval by the emperor in late 1883, the cornerstone was laid on June 9, 1884; in keeping with tradition, there were more members of the general staff on hand than Reichstag deputies.

The Reichstag building covers an area of about 135,000 square feet. The structure consists largely of more than 32 million brick, covered by over 30,000 cubic meters of sandstone from more than 20 quarries from all over the German Empire. Until 1894, the costs were held at around 24 million marks. By World War I, art, furniture and other technical innovations had raised the cost to over 31 million marks. Since the building had been designed for a parliament in which office work was not anticipated, there were only a few offices, for high-ranking members; in 1912 this was changed, and nearly 100 very small offices, more like cubicles, were created in the attic area.

The inscription „Dem Deutschen Volke" (To the German People) was only put up around Christmas 1916, a ploy by the emperor to win the support of his people for the cruel and costly war which he had helped precipitate. Wallot did not live to see the inscription; he died in August 1912.

After the emperor's abdication in November 1918, the Reichstag became the parliament of the new Weimar Republic, so named because due to Berlin's unruly crowds the constitutional convention had to conduct its deliberations on the new constitution in Weimar where it was finally adopted in August 1919. The Reichstag became the national parliament again. For a short period the building was occupied by soldiers, and when the Reichstag wanted to move back in, the building was so infested by lice and vermin that it had to be fumigated.

The Reichstag as an institution was under incessant attack by the radical right, of whom the most vocal were the Nazis. Over 100 Nazis were voted into the Reichstag in 1930. The same year, Hitler, who was not a member of the Reichstag until 1933, said that he only wanted to be elected to the Reichstag to destroy it from within.

During the night of February 27, 1933, four weeks after Hitler had assumed power and one week before general elections, the Reichstag

erfolgreichsten englischen Architekten dieser Zeit, der einen neugotischen Entwurf eingereicht hatte. Bohnstedt konnte sich seines Preises jedoch nicht wirklich freuen; das Gelände wurde immer noch nicht freigegeben, und alle Bemühungen, es zu bekommen und mit den Bauarbeiten zu beginnen, mußten aufgeschoben werden.

Zehn Jahre lang suchten die Kommission und mehrere Unterkommissionen nach anderen Standorten, doch immer wieder kam man entweder auf den alten oder auf den ihm gegenüberliegenden zurück, auf dem sich die Kroll-Oper befand. Dieser Standort wurde jedoch von den Abgeordneten mit der Begründung abgelehnt, er sei zu weit vom Stadtzentrum entfernt. Selbst Kaiser Wilhelm I. konnte die Abgeordneten nicht zu einer Zustimmung zu diesem Standort bewegen.

Raczynski starb 1874, und durch einen glücklichen Zufall stellte sich heraus, daß sein Sohn bereit war, das Grundstück an das Reich abzutreten. Nachdem ein Vertrag angefertigt worden war, brauchte das Parlament noch zwei Jahre, bevor er ratifiziert werden konnte. Damit war der Weg für einen neuen Wettbewerb frei. Er wurde im Februar 1882 ausgeschrieben und von Paul Wallot, einem jungen Architekten aus Frankfurt am Main, gewonnen. Die Entscheidung wurde am 26. Juni 1882, seinem 41. Geburtstag, bekanntgegeben.

Wallots Bearbeitung seines Entwurfs, an der er fast zwei Jahre lang gearbeitet hatte, wurde Ende 1883 vom Kaiser gebilligt, und am 9. Juni 1884 wurde der Grundstein gelegt. Wie es sich für eine preußische Zeremonie gehörte, nahmen daran mehr Militärangehörige als Reichstagsabgeordnete teil.

Das Reichstagsgebäude bedeckt eine Fläche von knapp 13.000 Quadratmetern. Mehr als 32 Millionen Ziegelsteine wurden verbaut, und die mehr als 30.000 Kubikmeter Sandstein für die Fassaden wurden aus mehr als 20 verschiedenen Steinbrüchen im In- und Ausland herbeigeschafft. Bis 1894 waren die Kosten auf 24 Millionen Reichsmark aufgelaufen, und bis zu Beginn des Ersten Weltkriegs hatten sie sich – durch die künstlerische Ausschmückung, Inneneinrichtung und technische Innovationen – auf 31 Millionen erhöht. Da das Gebäude als reines Versammlungsgebäude konzipiert war, waren ursprünglich nur wenige Büros für hochrangige Mitglieder vorgesehen gewesen. 1912 wurde diese Konzeption geändert, und im Dachbodenbereich wurden fast 100 – sehr kleine – kabinenartige Büros eingerichtet.

Die von Wallot geplante Inschrift »Dem Deutschen Volke« wurde erst kurz vor Weihnachten 1916 angebracht – eine Konzession des Kaisers, der sich lange gegen die Inschrift gesträubt hatte, um die Unterstützung seines Volkes für den grausamen und kostspieligen Krieg zu gewinnen, den er mit angezettelt hatte.

Nach der Abdankung des Kaisers im November 1918 rief Philipp Scheidemann aus einem Fenster des Reichstagsgebäudes die Republik aus.

Nachdem am 11. August 1919 in Weimar die neue Verfassung verabschiedet worden war, wurde der Reichstag zum Parlamentssitz der neuen Weimarer Republik. Zuvor jedoch mußte das Gebäude, das für kurze Zeit von Soldaten besetzt worden war, erst einmal entlaust werden.

The Reichstag viewed from a Zeppelin about 1929

Der Reichstag von einem Zeppelin aus gesehen, um 1929

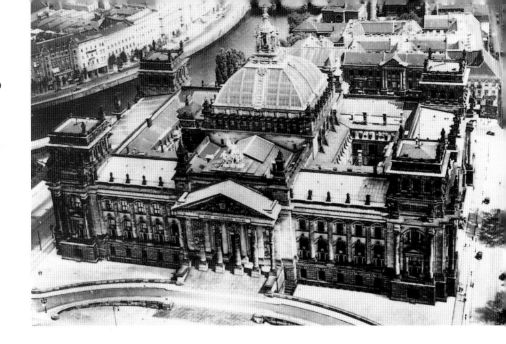

Passers-by watch the smoldering Reichstag on Tuesday morning, February 28th, 1933; the main part of the building had been gutted by fire the previous night.

Passanten am Morgen des 28. Februar 1933 vor dem schwelenden Reichstag, der in der Nacht zuvor in Brand gesetzt worden war.

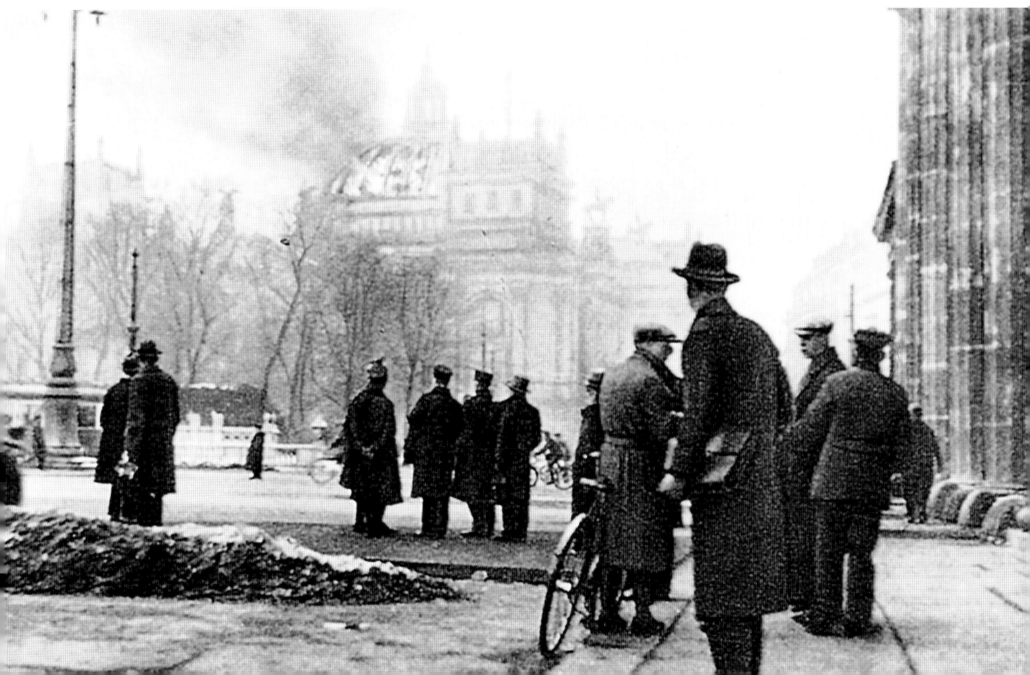

was set on fire. A young Dutchman, Marinus van der Lubbe, was found on the scene and accused of arson which he did not deny. The Nazis used the fire; they accused the communists of being behind it and caused the party's activities, but also those of the social democrats, to be suspended, banned their newspapers and incarcerated thousands of their supporters. Several other persons were arrested and accused, the deputy Ernst Torgler and four Bulgarian communists, among whom was Georgi Dimitroff. Reichstag sessions were moved to the Kroll Opera House across the square; it was in that building that the enabling act was passed in March 1933, giving Hitler widespread powers.

The Reichstag fire trial was held in Leipzig at the Supreme Court and in a budget-committee meeting room of the Reichstag which had escaped the fire, and it was attended by scores of foreign journalists. The trial resulted in the acquittal of all the accused except Lubbe who was beheaded in January 1934 in the courtyard of the Leipzig police headquarters. While Torgler was released, the Bulgarians had to wait until Stalin had made them Soviet citizens before they could be flown to Moscow in February 1934.

Although the damage to the Reichstag was so extensive that debates, if they can be called that at all, could no longer be held there, the library and archives escaped damage. Parliamentary activity was moved, ironically, to the Kroll Opera House, the very site once-upon-a-time thought suitable for the Reichstag, which had been converted quickly into a make-shift parliament. The Reichstag itself was repaired and used for propaganda exhibitions such as "Bolshevism Unmasked", "The Eternal Jew", etc. In the basement there was an infirmary and several beds were used by a large nearby hospital for purposes of maternity ward.

The area around the Reichstag was chosen by Hitler as the center of his projected capital city, to be known as "Germania;" for a large domed "Hall of the People", the buildings near the Reichstag were razed and tunnels were commenced. (It is the remnants of these monstrous tunnels – some walls are 11 meters thick – that were slowly being removed from the ground over the summer of 1995). The Reichstag itself was spared; Albert Speer, Hitler's minister in charge of building Berlin, claims that Hitler liked it, but it is more likely that Hitler wanted to show the scale of his new buildings – the "Hall of the People" would have been four times the height of the Reichstag!

A building as prominent as the Reichstag was almost a natural target for bombs, but the building suffered only minimal damage throughout the war. The real damage to the building was caused by Red Army artillery during the Battle of Berlin in April 1945. It is said that the Red Army fired about 1,000,000 shells into the Reichstag, which was the symbol for ending the war; on April 30th, Red Army soldiers planted the Red Flag on the battered Reichstag dome; the photographs we know today were posed for and taken on May 2nd: Berlin capitulated and the shooting stopped. Hitler never made a speech in the Reichstag building nor did the Nazi-controlled Reichstag as an institution ever pass one law within its walls.

Der Reichstag als Institution stand unter ständigem Angriff der radikalen Rechten. 1930 waren über 100 Nationalsozialisten in den Reichstag gewählt worden, die ihre Stimme besonders laut erhoben. Hitler, der erst 1933 Mitglied des Reichstags wurde, verkündete noch, daß er nur in den Reichstag gewählt werden wolle, um ihn von innen zu zerstören.

In der Nacht zum 27. Februar 1933, vier Wochen nach Hitlers Machtergreifung und eine Woche vor den Reichstagswahlen, wurde der Reichstag in Brand gesetzt. Der junge Holländer Marinus van der Lubbe wurde am Tatort verhaftet und der Brandstiftung beschuldigt, was er nicht leugnete. Die Nazis wußten den Reichstagsbrand für ihre Sache zu nutzen; sie beschuldigten die Kommunisten, van der Lubbe angestiftet zu haben, und verboten die KPD, aber auch die SPD und andere Parteien. Die Zeitungen dieser Parteien wurden eingestellt und Tausende ihrer Anhänger verhaftet. Zu den als Hintermänner beschuldigten gehörten der KPD-Abgeordnete Ernst Torgler und vier bulgarische Kommunisten. Einer davon war Georgi Dimitroff, der spätere bulgarische Ministerpräsident. Die Reichstagssitzungen wurden in die gegenüberliegende Kroll-Oper verlegt, und in diesem Gebäude wurde im März 1933 das ›Ermächtigungsgesetz‹ erlassen, mit dem sich Hitler umfassende Vollmachten sicherte.

Der Reichstagsbrandprozeß wurde im Leipziger Reichsgerichtshof und im unbeschädigt gebliebenen Saal des Haushaltsausschusses im Reichstagsgebäude abgehalten. Er wurde von einer großen Zahl ausländischer Journalisten verfolgt. Bis auf van der Lubbe, der im Januar 1934 im Hof des Leipziger Polizeipräsidiums enthauptet wurde, mußten alle Beschuldigten freigesprochen werden. Die vier Bulgaren wurden von Stalin zu sowjetischen Staatsbürgern erklärt und im Februar 1934 nach Moskau ausgeflogen.

Der Reichstag war zwar so schwer in Mitleidenschaft gezogen, daß die Debatten – wenn sie denn noch so genannt werden konnten – dort nicht mehr abgehalten werden konnten, doch die Bibliothek und die Archive waren unbeschädigt geblieben. Für das Parlament selbst wurde die Kroll-Oper in kurzer Zeit provisorisch umgerüstet – das Gebäude, das Jahre zuvor beinahe anstelle des Raczynski-Palais dem Reichstag hätte weichen müssen. Der Reichstag selbst wurde notdürftig instand gesetzt und für Propagandaausstellungen wie »Bolschewismus ohne Maske«, »Der ewige Jude« usw. genutzt. Im Krieg wurde hier ein Lazarett eingerichtet, und der Keller wurde von der nahe gelegenen Charité als Entbindungsstation genutzt.

Die Umgebung des Reichstags hatte Hitler als Zentrum seiner geplanten gigantomanen Welthauptstadt »Germania« vorgesehen. Für eine »Große Halle des Volkes« – die Kuppelhöhe sollte 290 Meter betragen – wurden die Gebäude in der Nähe des Reichstags abgerissen. Auch mit dem Bau gigantischer Tunnel wurde begonnen. (Es waren die Überreste dieser monströsen Tunnel – einige Wände sind 11 Meter dick –, die im Sommer 1995 nach und nach entfernt wurden.) Der Reichstag selbst wurde verschont; Albert Speer, Hitlers Generalbauinspektor für die Umgestaltung Berlins, behauptete, Hitler habe das Gebäude gemocht. Wahrscheinlicher ist jedoch, daß Hitler es als Vergleichsmaßstab

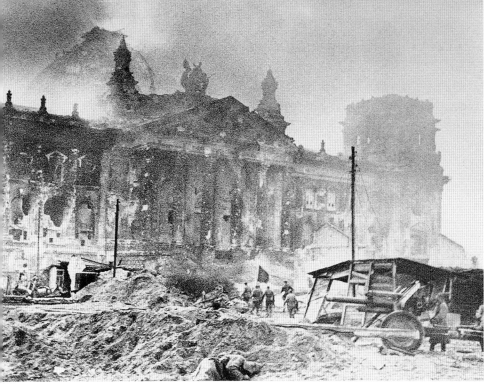

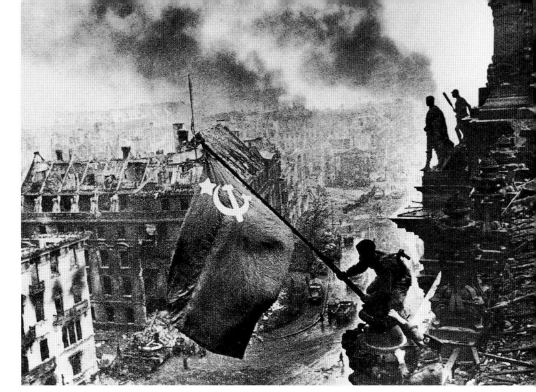

Ivan Shagin

The Battle of the Reichstag, April 30, 1945

Die Schlacht um den Reichstag, 30. April 1945

The "Red Flag" of the Soviet Army being displayed from one of the large urns on the east cornice of the Reichstag; this famous photograph, made by Yevgeni Khaldei, was actually taken on May 2, 1945, as no photographer was available when the real flag was put up during the late evening of April 30, 1945.

Die »Rote Fahne« der Roten Armee wird auf einer der großen Urnen am Ostgesims des Reichstagsdaches gehißt. Diese berühmte Fotografie von Jewgenij Chaldej wurde erst am 2. Mai 1945 aufgenommen, da bei der eigentlichen Hissung der Fahne am späten Abend des 30. April 1945 kein Fotograf anwesend war.

The desolate Reichstag in the early days of May, 1945
The greatly damaged dome was removed in November 1954.

Der zerstörte Reichstag in den ersten Maitagen 1945.
Die weitgehend zerstörte Kuppel wurde im November 1954 entfernt.

The Reichstag during the summer of 1945          Der Reichstag im Sommer 1945

Yevgeni Khaldei

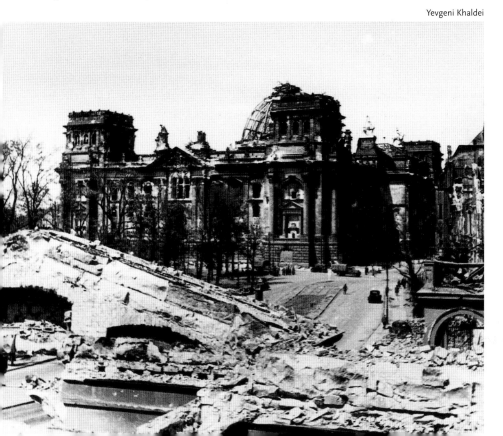

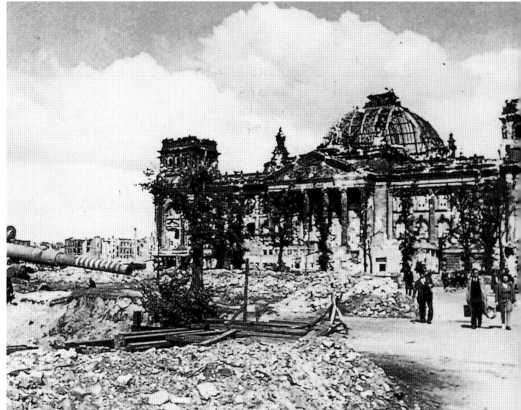

The Reichstag was a ruin, and between 1945 and 1954 there was heated debate on whether or not it should be torn down or rebuilt; in November 1954, the dome, supposedly a hazard, was melted down and dismantled.

During the Cold War, East and West Berlin started to compete in building affairs, and, after two competitions for Berlin as capital, West Berlin staged a competition for all of Berlin, while East Berlin staged a competition for only East Berlin, it was decided to rebuild the Reichstag. A competition was held in 1960 and won by the architect Paul Baumgarten. His work on the building- it was thoroughly modernized-lasted until 1971, when the building was inaugurated on the 100th anniversary of Bismarck's Reichstag's first session, March 21, 1871; that was the day on which the exhibition "Questions on German History" was inaugurated. (Due to reconstruction, the exhibition has since been dismantled and will be reassembled later at another place).

Between 1971 and 1989, the Reichstag led a quiet life; although it was operated under the auspices of the Bundestag in Bonn, it could not, by allied order, be used for plenary sessions of the Bundestag nor for meetings of the committees on defense and foreign affairs. Many people thought it might be possible to use it for a museum of German history, or as a building to house the municipal assembly; still others tried to have the dome replaced.

Berlin's wall fell on November 9, 1989, and Germany was reunited on October 3, 1990. One clause of the unification agreement between East and West Germany stated that although Berlin was the capital, it would be decided at a later date as to the site of the government and the legislature (Bundestag). Germany became once again divided, not by a wall, but by a heated debate between those who favored leaving the Bundestag in Bonn and those who favored moving it to Berlin, as stated in the preamble to the German constitution.

On June 20, the debate about Berlin was held in the Bundestag in Bonn. By a narrow vote, Berlin won; the government and parliament were to move to Berlin no later than June 20, 1995. Since I realized that there was little time, and since the Christos were busy preparing for *The Umbrellas*, I obtained an appointment to see Mrs. Rita Süssmuth, President of the German Bundestag (Speaker of the House) on July 1. She spoke about the need to have a competition for the building's reconstruction, but also in very warm words about her wanting to see the Christos succceed in wrapping the Reichstag. When I told Christo and Jeanne-Claude, who were completely preoccupied with *The Umbrellas* , they did not believe me.

It was only on October 30 1991, that the steering committee of the Bundestag decided that it would view the Reichstag building as the future parliament/legislature. According to the timetable, that meant that the Reichstag would have to be wrapped, unwrapped and reconstructed within less than four years. There was no time to lose. Mrs. Süssmuth, aware of the time constraints, invited the Christos to visit her in February 1992 in Bonn.

für seine neu geplanten Gebäude stehen lassen wollte – die »Große Halle des Volkes« sollte viermal so hoch wie der Reichstag werden!

Obwohl ein so hervorstechendes Gebäude wie der Reichstag fast ein natürliches Ziel für Bomben war, trug er während des Krieges nur geringfügige Schäden davon. Die eigentliche Zerstörung des Gebäudes erfolgte erst durch die Artillerie der Roten Armee während der Eroberung Berlins im April 1945.

Es heißt, daß die Rote Armee den Reichstag mit etwa 1.000.000 Granaten beschoß. Um ihren Sieg zu symbolisieren, hißten ein paar Soldaten der Roten Armee auf der zertrümmerten Reichstagskuppel die Rote Fahne. Die Fotos, die wir heute kennen, wurden nachgestellt und am 2. Mai aufgenommen: Berlin hatte kapituliert, und der Krieg war zu Ende. Hitler hielt übrigens weder eine Rede im Reichstagsgebäude, noch wurde innerhalb dieser Mauern auch nur ein einziges Gesetz vom nationalsozialistischen Scheinparlament verabschiedet.

Der Reichstag war eine Ruine, und zwischen 1945 und 1954 wurde heftig darüber debattiert, ob er abgerissen oder wieder aufgebaut werden sollte. Im November 1954 wurde die Kuppel, die angeblich einsturzgefährdet war, gesprengt.

Während des Kalten Krieges suchten Ost- und Westberlin einander im Baubereich zu übertreffen. Im Westen wurde ein die ganze Stadt umfassender Wettbewerb »Hauptstadt Berlin« ausgeschrieben, während der Ostberliner »Ideenwettbewerb zur sozialistischen Umgestaltung des Zentrums der Hauptstadt der DDR, Berlin« sich auf den Ostteil der Stadt beschränkte. 1960 wurde ein Wettbewerb zur Umgestaltung des Reichstagsgebäudes ausgeschrieben, den der Architekt Paul Baumgarten gewann. Unter seiner Leitung wurde das Gebäude in jahrelanger Arbeit gründlich modernisiert. Am 21. März 1971, dem 100. Jahrestag der ersten Sitzung eines gewählten Reichstags, wurde der umgebaute Reichstag mit der Eröffnung der Dauerausstellung »Fragen an die deutsche Geschichte« der Öffentlichkeit übergeben.

Zwischen 1971 und 1989 führte der Reichstag ein ruhiges Leben; er stand zwar unter der Verwaltung des Bundestags in Bonn, durfte jedoch auf Anordnung der Alliierten nicht für Plenarsitzungen des Bundestags oder etwa für Sitzungen des Verteidigungsausschusses genutzt werden. Regelmäßig tauchten neue Nutzungsvorschläge auf – als Museum für deutsche Geschichte, als Sitz des Berliner Stadtparlaments, usw. –, und auch die Erneuerung der Kuppel wurde immer wieder diskutiert.

Am 9. November 1989 fiel die Berliner Mauer, und am 3. Oktober 1990 wurde Deutschland wiedervereint. Im Vereinigungsvertrag zwischen der Bundesrepublik und der DDR war Berlin zwar als Hauptstadt festgeschrieben worden, die Frage des Regierungs- und Parlamentssitzes jedoch offengelassen worden. Erneut wurde Deutschland geteilt, diesmal nicht durch eine Mauer, sondern durch eine heftig geführte Debatte zwischen denen, die den Bundestag in Bonn belassen wollten, und denen, die ihn – wie in der Präambel zum Grundgesetz des vereinten Deutschlands ausgesagt – nach Berlin verlegen wollten.

After getting the parameters for future parliamentary use settled, several large discussions were held about the architectural scheme. Many suggestions were made, among others to do away with the building entirely, or else modernize it beyond recognition, but in the end, Sir Winston Churchill's dictum "First we form our buildings, then they form us" was roughly adhered to, to modernize it mostly on the inside and leave the exterior untouched. In June 1992, a competition was announced. The jury, which deliberated in January 1993, picked three first-prize winners, the Dutchman Pi de Bruijn, the Spaniard Santiago Calatrava, and the Englishman Sir Norman Foster. The jury also added a recommendation for wrapping the Reichstag. After all three were asked to revise their designs and compete with one another, Foster's design was chosen by a majority of the building committee on June 21, 1993, and scheduled for detailed planning on July 1, 1993.

Am 20. Juni 1991 fand im Bundestag in Bonn die Berlin-Debatte statt. Mit einer knappen Mehrheit fiel die Entscheidung für Berlin aus. Bis spätestens zum 20. Juni 1995 sollten die Regierung und das Parlament nach Berlin verlegt werden.

Erst am 30. Oktober 1991 beschloß der Ältestenrat des Bundestags, daß das deutsche Parlament künftig im Reichstag tagen wird. Da der Umzug bis 1995 abgeschlossen sein sollte, standen für die Verhüllung, die Enthüllung und den Umbau des Reichstags nur knapp vier Jahre zur Verfügung. Es war also keine Zeit zu verlieren. Das war natürlich auch Frau Süssmuth klar, und sie lud die Christos ein, sie im Februar 1992 in Bonn zu besuchen.

Nachdem die politischen Entscheidungen getroffen waren, setzten die Diskussionen über die architektonischen Fragen ein. Unter anderem wurde auch vorgeschlagen, das Gebäude ganz abzureißen oder bis zur Unkenntlichkeit zu modernisieren. Doch schon Sir Winston Churchill hatte festgestellt: »Zuerst gestalten wir unsere Gebäude, und dann gestalten sie uns.« So kam man nach langen Debatten schließlich zu der Entscheidung, das Gebäude im Innern zu modernisieren und das Äußere unberührt zu belassen. Im Juni 1992 wurde ein Wettbewerb ausgeschrieben. Die Jury, die im Januar 1993 tagte, vergab drei erste Preise: an den Niederländer Pi de Bruijn, den Spanier Santiago Calatrava und an den Engländer Sir Norman Foster. Die Jury sprach sich auch für die Verhüllung des Reichstags aus. Nachdem alle drei Architekten gebeten worden waren, ihre Entwürfe zu überarbeiten und in einem beschränkten Wettbewerb gegeneinander anzutreten, beschloß die Baukommission des Bundestags am 21. Juni 1993, Fosters Entwurf dem Ältestenrat zu empfehlen, und am 1. Juli 1993 nahm der Ältestenrat diese Empfehlung an.

To protest the division of Berlin an immense crowd of Berliners gathered in front of the Reichstag on September 9, 1948.

Eine gewaltige Menschenmenge versammelte sich am 9. September 1948 vor dem Reichstag, um gegen die Teilung Berlins zu protestieren.

The south facade of the Reichstag, about 1985; the Berlin wall and the Brandenburg Gate are clearly visible.

Der Reichstag von Südwesten aus gesehen, wahrscheinlich um 1985; die Mauer und das Brandenburger Tor sind deutlich zu erkennen.

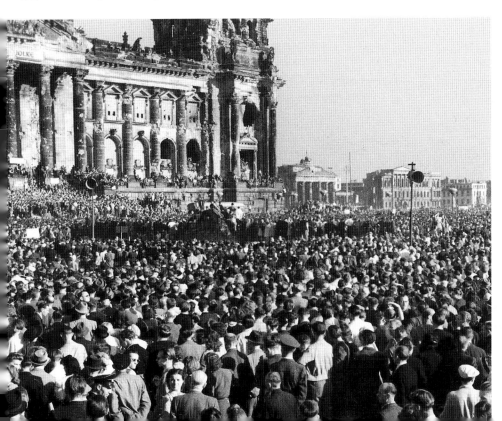

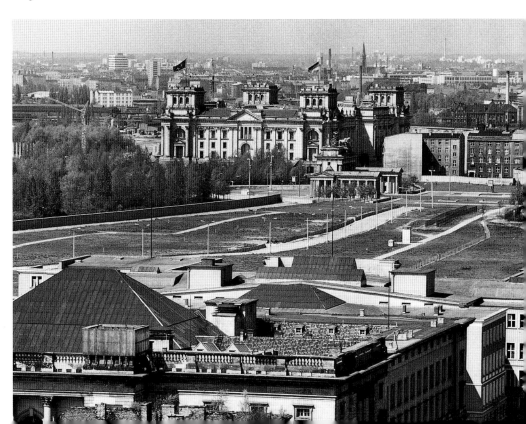

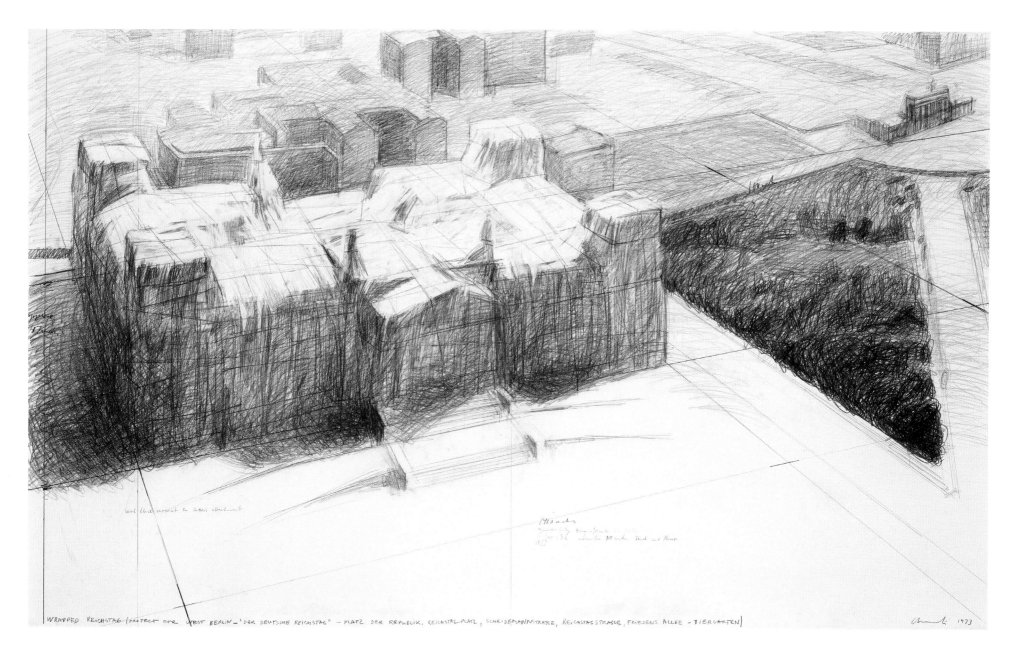

WRAPPED REICHSTAG (PROJECT FOR WEST BERLIN - "DER DEUTSCHE REICHSTAG" - PLATZ DER REPUBLIK, REICHSTAG-PLATZ, SCHEIDEMANNSTRASSE, REICHSTAGSTRASSE, FRIEDENS ALLEE - TIERGARTEN)

**Wrapped Reichstag,**
**Project for Berlin**
Drawing 1973
91.5 x 152.4 cm
Pencil and charcoal

## Seeing Berlin for the First Time

Christo visited West Berlin for the first time in February 1976. Accompanied by his American contact Michael Cullen and photographer Wolfgang Volz (who would later become co-director of the Reichstag project), Christo personally inspected the Reichstag building, except for the towers and the roof. He met with party members of the Christian Democratic Union (CDU) and the Social Democratic Party (SPD). He also met with Hans-Jürgen Hess, the Reichstag's administrative director, who promised to set up an appointment with Annemarie Renger, the President of the Bundestag, based in Bonn. (The Bundestag is the lower house of the parliament of the Federal Republic of Germany. It is an elected body of representatives that elects the chancellor and votes on all national legislation.)

In June 1976, Christo revisited West Berlin. This time he met with cultural spokespeople from the CDU, SPD, and the Free Democratic Party (F.D.P.). He also met with Bundestag President Annemarie Renger (SPD), who explained that she could not make any decision alone; the Allies would have to take part, and she would have to await the results of the federal election in October. With President Renger's permission, Christo was shown all parts of the Reichstag. As a result, his drawings and collages became more specifically detailed.

Following spread: A map (left page) and an aerial photograph (right page) show the location of the rectangular Reichstag, facing the Platz der Republik just south of a bend in the Spree River. The orange line on the map represents the Berlin Wall.

## Zum ersten Mal in Berlin

Im Februar 1976 kam Christo zum ersten Mal nach Westberlin. Begleitet von seinem amerikanischen Kontaktmann Michael Cullen und dem Fotografen Wolfgang Volz (der später Kodirektor des Reichstagsprojekts werden sollte), inspizierte Christo persönlich das Reichstagsgebäude, bis auf die Türme und das Dach. Er traf sich mit Parteimitgliedern der CDU und der SPD. Er traf sich auch mit Hans-Jürgen Heß, dem Verwaltungsdirektor des Reichstags, der versprach, ein Treffen mit Bundestagspräsidentin Annemarie Renger zu vereinbaren.

Im Juni 1976 kam Christo erneut nach Westberlin. Diesmal traf er sich mit kulturpolitischen Sprechern der CDU, SPD und F.D.P., wie auch mit Bundestagspräsidentin Annemarie Renger (SPD), die erklärte, daß sie die Entscheidung nicht allein treffen könne; auch die Alliierten hätten mitzureden, und außerdem müsse das Ergebnis der Bundestagswahlen im November abgewartet werden. Mit Frau Rengers Genehmigung wird Christo durch alle Teile des Reichstagsgebäudes geführt. Die dabei gewonnenen Detailkenntnisse gehen von nun an in seine Zeichnungen und Collagen ein.

Folgende Doppelseite: Eine Karte (linke Seite) und eine Luftaufnahme (rechte Seite) zeigen die Lage des rechteckigen Reichstagsgebäudes unmittelbar südlich eines Spreebogens am Platz der Republik. Die orangefarbene Linie auf der Karte bezeichnet die Berliner Mauer.

**Wrapped Reichstag,
Project for Berlin**
Collage 1975
71 x 56 cm
Pencil, fabric, twine, crayon, charcoal, photostat from photograph by Wolfgang Volz and historical photographs

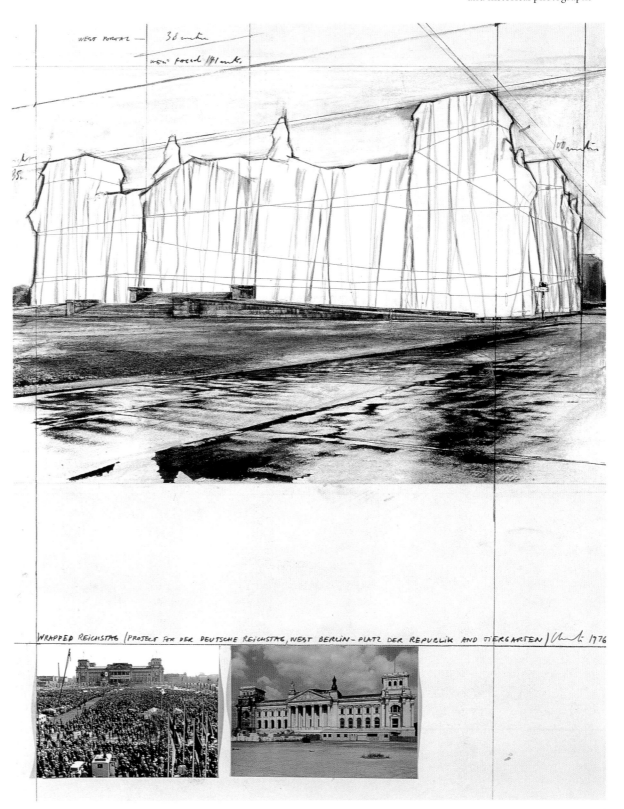

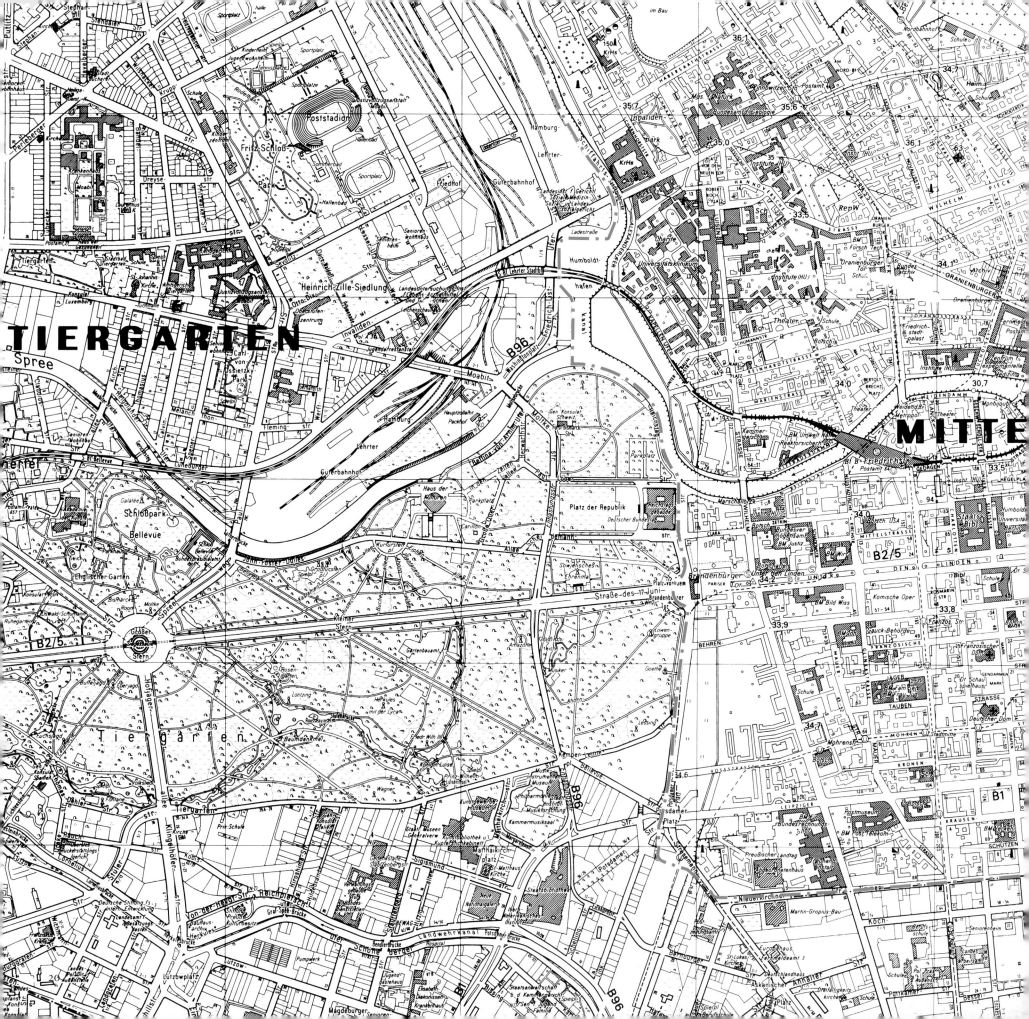

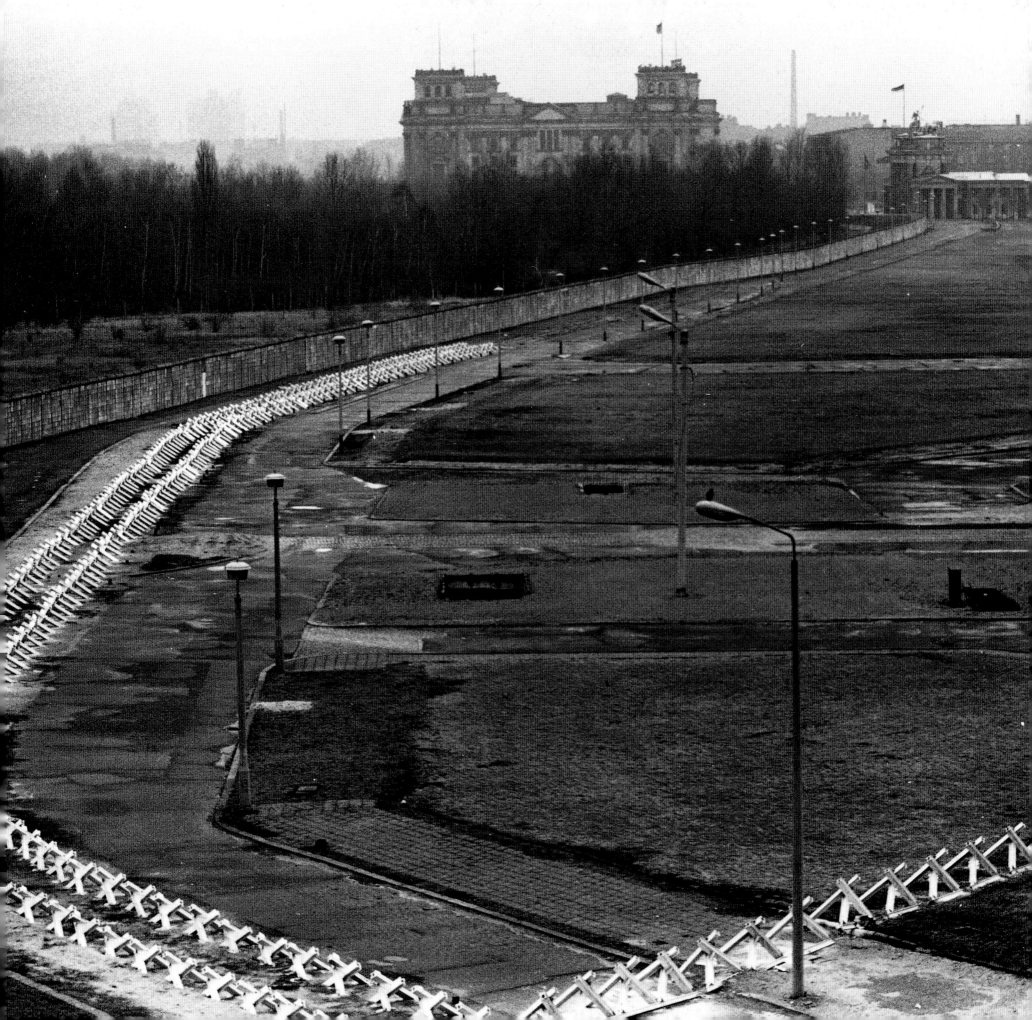

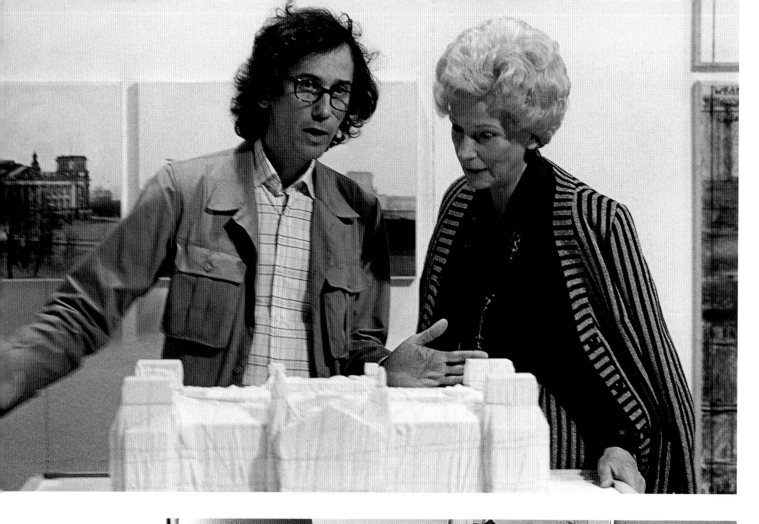

Christo with Bundestag Vice-President Annemarie Renger, September 12, 1977. In 1976, Renger (SPD), then President of the Bundestag, had been in favor of the project. Unfortunately, a few weeks later, the Social Democrats lost the election, and Karl Carstens (CDU) became the new president of the Bundestag.

Christo mit der Bundestagsvizepräsidentin Annemarie Renger, 12. September 1977. Annemarie Renger (SPD) hatte 1976 als Bundestagspräsidentin das Projekt befürwortet, doch verloren die Sozialdemokraten wenige Wochen später die Wahlen, und Karl Carstens (CDU) wurde an ihrer Stelle Bundestagspräsident.

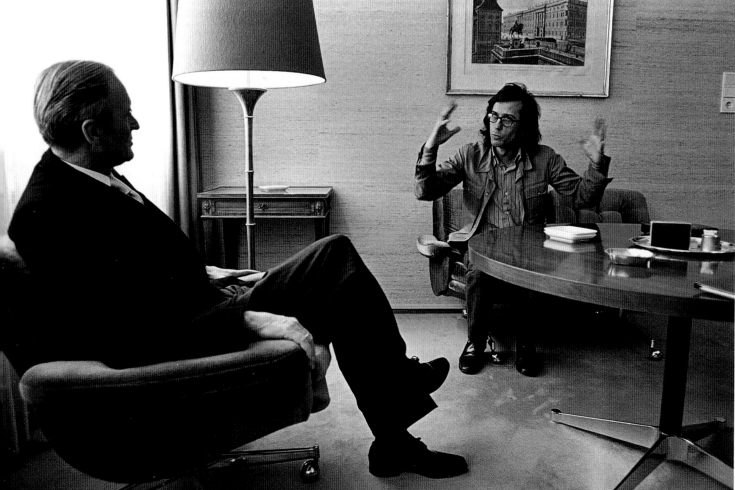

Dr. Karl Carstens (CDU), while President of the Bundestag, listened to Christo's explanations during his January 1977 meeting; he then took a few months to reflect and announced that he was opposed to the project. Later, at a time, when he was President of the Federal Republic, Carstens declared that he no longer opposed the project. By then, however, the decision was no longer in his hands.

Dr. Karl Carstens (CDU) hörte sich während des Treffens am 20. Januar 1977 Christos Erläuterungen an, um sich einen Eindruck von dem vorgeschlagenen Projekt zu verschaffen. Nach mehrmonatiger Überlegung gab er seine Ablehnung des Projekts bekannt. Später, als Carstens Bundestagspräsident geworden war, erklärte er, daß er nichts mehr gegen das Projekt einzuwenden habe, doch da lag die Entscheidung nicht mehr in seiner Hand.

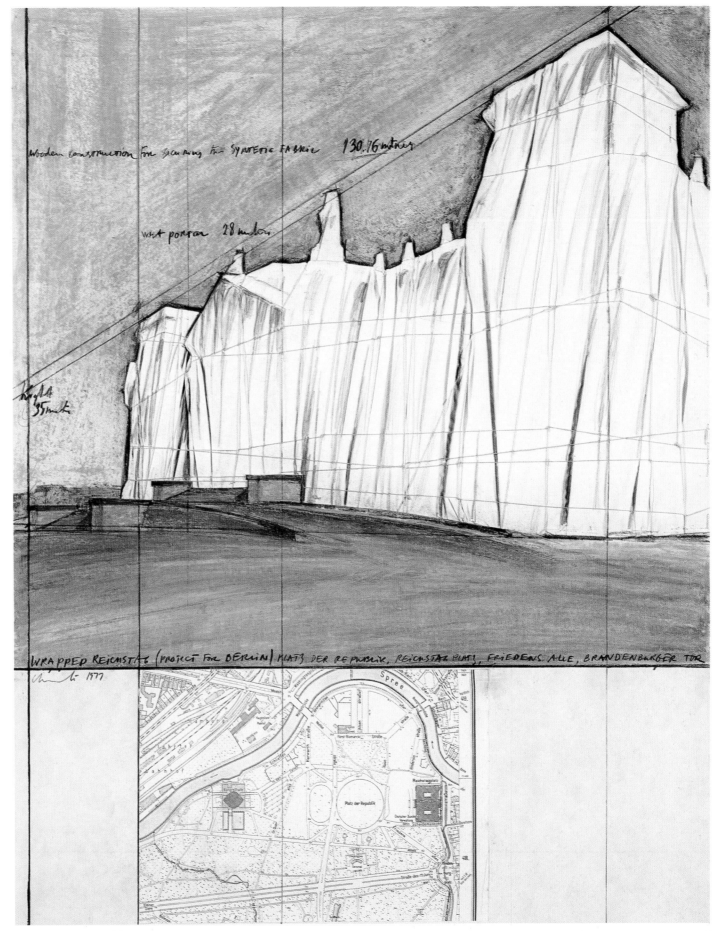

**Wrapped Reichstag,**
**Project for Berlin**
Collage 1977
71 x 56 cm
Pencil, fabric, twine, photostat
from a photograph by Wolfgang
Volz, crayon, charcoal, pastel
and map

**Wrapped Reichstag, Project for Berlin**

Drawing 1978, in two parts: 38 x 165 cm and 106.6 x 165 cm. Pencil, charcoal, pastel, crayon and map

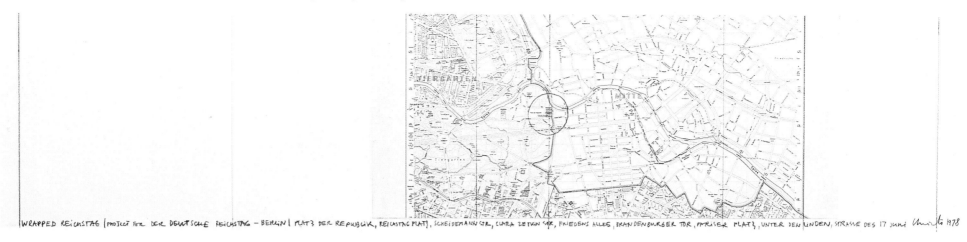

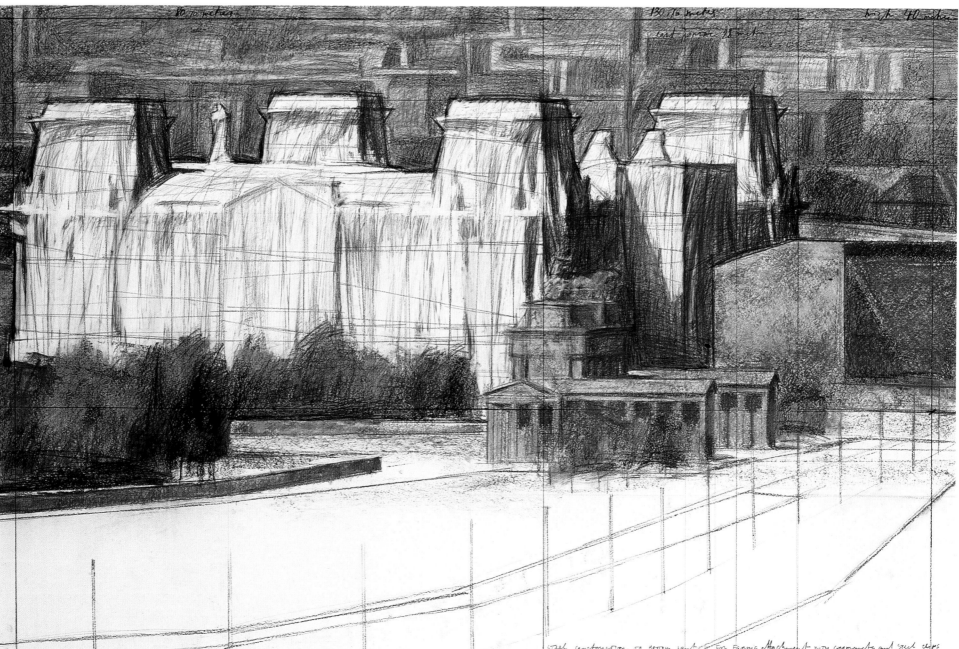

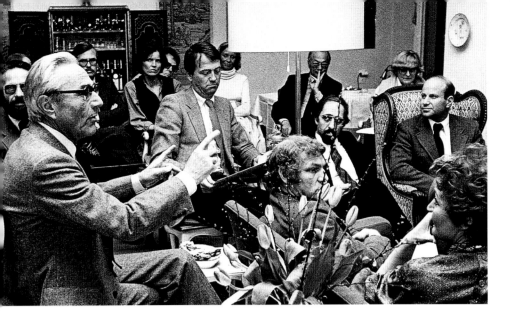
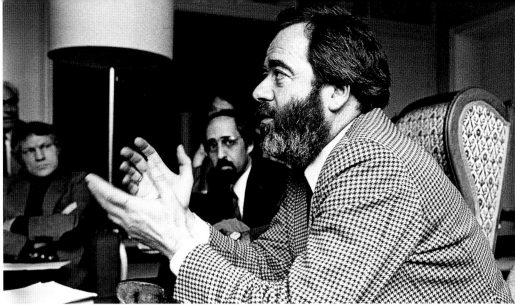

## A "Kuratorium" with Clout

Christo and Jeanne-Claude took the unusual step of convening a "Kuratorium" of a dozen or so notable people from various fields (artistic, scientific, business and legal) to generate interest in the Berlin project throughout Germany. (The Kuratorium had no legal status and none of its members were paid.) In April 1978, the artists went to Hamburg for the Kuratorium's first meeting at the home of Gerd Bucerius (above, left, with hands in the air), publisher of the weekly newspaper *Die Zeit*. Art and architecture historian Tilmann Buddensieg (above, right) addressed some of the issues. Those present included (below, from the left): Christo, Karl Ruhrberg, Heinrich Senfft, Wieland Schmied, Jeanne-Claude, Petra Kipphoff, Ernst Hauswedell, and Marie Christine von Wolff-Metternich. Other members of the Kuratorium included Reimar Lüst, Arend Oetker, Michael and Christl Otto, Elfriede Ruhrberg, Carl Vogel, Otto and Winnie Wolff von Amerongen, and Peter von Wolff-Metternich.

## Ein schlagkräftiges Kuratorium

Christo und Jeanne-Claude entschlossen sich zu dem außergewöhnlichen Schritt, ein Kuratorium zu gründen, um das Interesse am Berliner Projekt in ganz Deutschland zu schüren. Das Kuratorium setzte sich aus etwa einem Dutzend namhafter Repräsentanten verschiedener Professionen – Kunsthistorikern, Wissenschaftlern, Geschäftsleuten und Juristen – zusammen. Es hatte keinen juristischen Status, und alle Mitglieder waren ehrenamtlich tätig. Im April 1978 reisten die Künstler nach Hamburg, um im Haus des Verlegers der Wochenzeitung »Die Zeit«, Gerd Bucerius (oben links, mit erhobenen Händen), an der konstituierenden Sitzung des Kuratoriums teilzunehmen. Der Kunst- und Architekturhistoriker Tilmann Buddensieg (oben rechts) brachte einige der anstehenden Fragen zur Sprache. Zu den Anwesenden zählten (unten, von links nach rechts): Christo, Karl Ruhrberg, Heinrich Senfft, Wieland Schmied, Jeanne-Claude, Petra Kipphoff, Ernst Hauswedell und Marie Christine von Wolff-Metternich. Zu den weiteren Mitgliedern des Kuratoriums gehörten Reimar Lüst, Arend Oetker, Michael und Christl Otto, Elfriede Ruhrberg, Carl Vogel, Otto und Winnie Wolff von Amerongen sowie Peter von Wolff-Metternich.

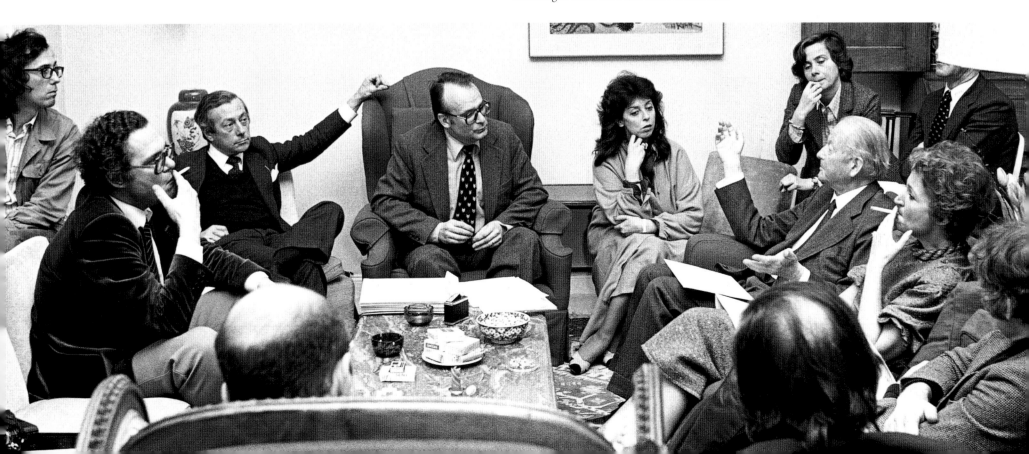

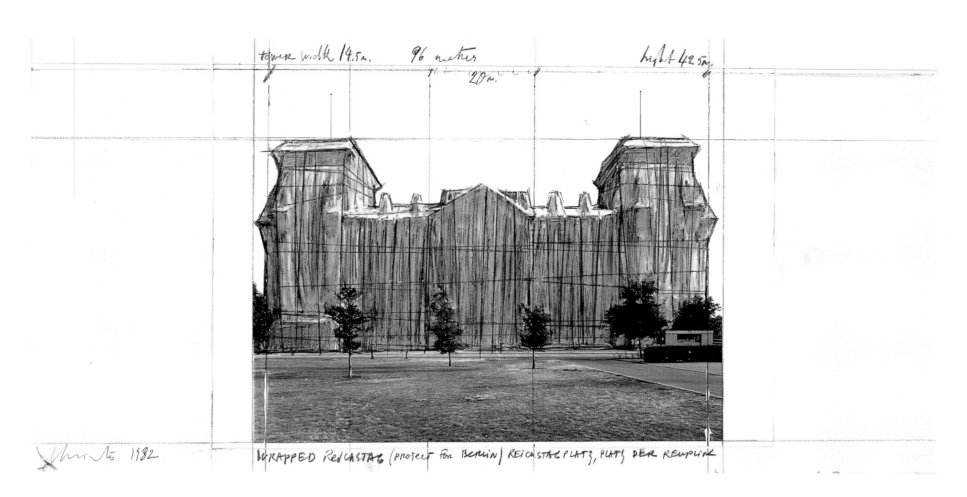

tower width 14.5m.    96 meters    height 42.5m.

20m.

Christo 1982    WRAPPED REICHSTAG (project for Berlin) REICHSTAGPLATZ, PLATZ DER REPUBLIK

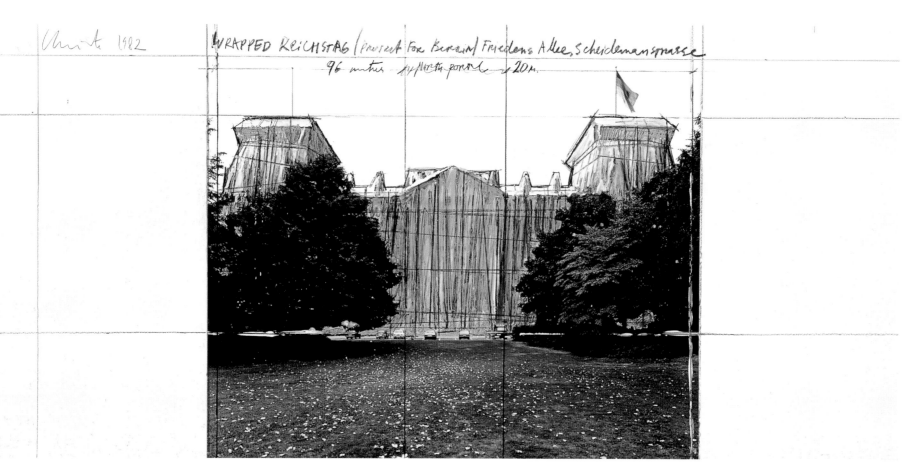

Christo 1982    WRAPPED REICHSTAG (project for Berlin) Friedens Allee, Scheidemansprasse

96 meters    by North portal    20m.

**Wrapped Reichstag,
Project for Berlin**
Collage 1982
31.7 x 65.5 cm
Pencil, enamel paint, photograph
by Wolfgang Volz, crayon and
charcoal

**Wrapped Reichstag,
Project for Berlin**
Drawing 1979, in two parts:
38 x 244 cm and 106.6 x 244 cm
Pencil, charcoal, pastel, crayon
and map

**Wrapped Reichstag,
Project for Berlin**
Collage 1982
31.7 x 65.5 cm
Pencil, enamel paint, photograph
by Wolfgang Volz, crayon and
charcoal

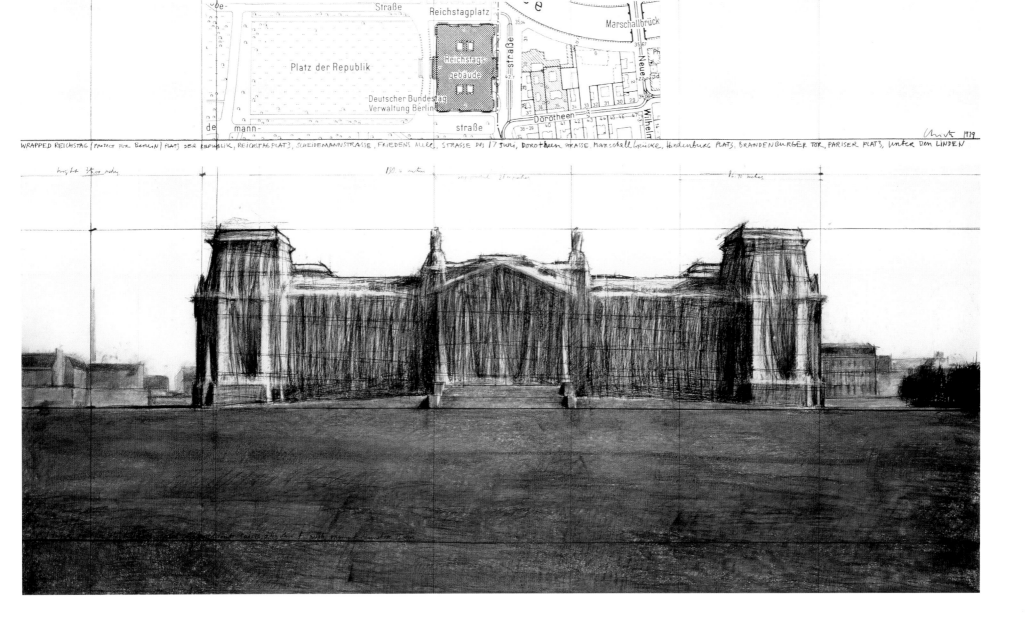

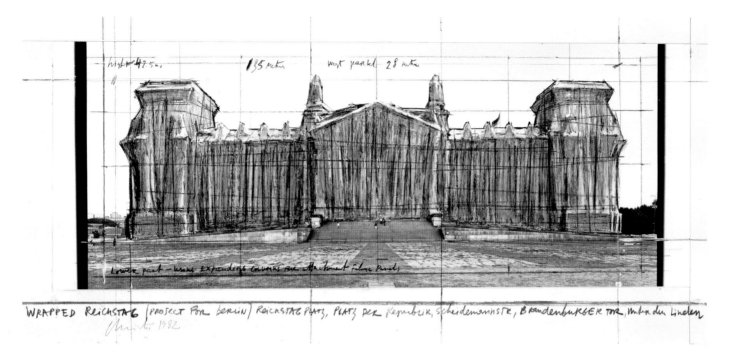

**Wrapped Reichstag,
Project for Berlin**
Collage 1982
32 x 65,5 cm
Pencil, enamel paint, photograph
by Wolfgang Volz, charcoal, pastel
and crayon

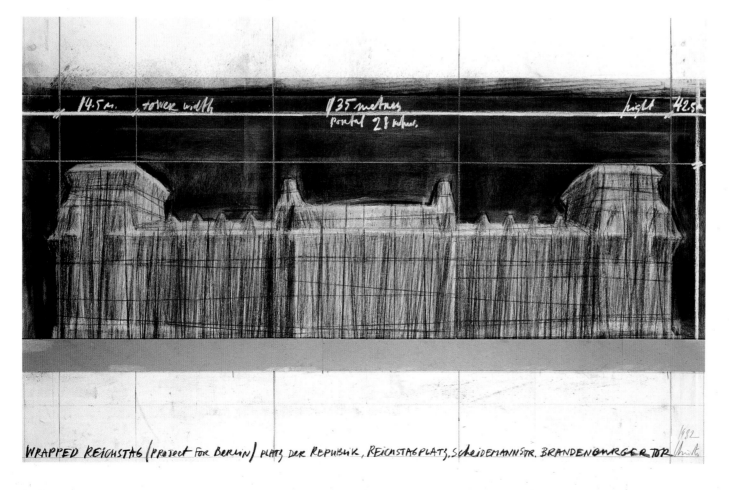

During an official visit to New York, former West
German Chancellor Willy Brandt took the time
to climb the steep stairs to Christo's studio in
Manhattan (fifth floor, no elevator!) and afterwards,
to the fourth-floor home of Jeanne-Claude and
Christo, to assure them of his continuing support.
He also scolded them mildly, saying: "You cannot
abandon the project now – too many Germans are
counting on you."

Während eines offiziellen Besuchs in New York
nahm sich der frühere Bundeskanzler Willy Brandt
die Zeit, die steilen Treppen zu Christos Atelier in
Manhattan hinaufzusteigen (vierter Stock, kein
Aufzug!). In der Wohnung von Christo und Jeanne-
Claude im dritten Stock sicherte er ihnen
anschließend seine weitere Unterstützung zu und
mahnte sie: »Sie dürfen das Projekt jetzt nicht
aufgeben, zu viele Deutsche zählen auf Sie.«

**Wrapped Reichstag,
Project for Berlin**
Drawing – Collage 1982
66 x 104 cm
Pencil, charcoal, crayon, pastel,
tape and brown cardboard

Following spread:
Folgende Doppelseite:
**Wrapped Reichstag,
Project for Berlin**
Scale model 1981
65 x 152.5 x 193 cm
Fabric, rope, paint and wood

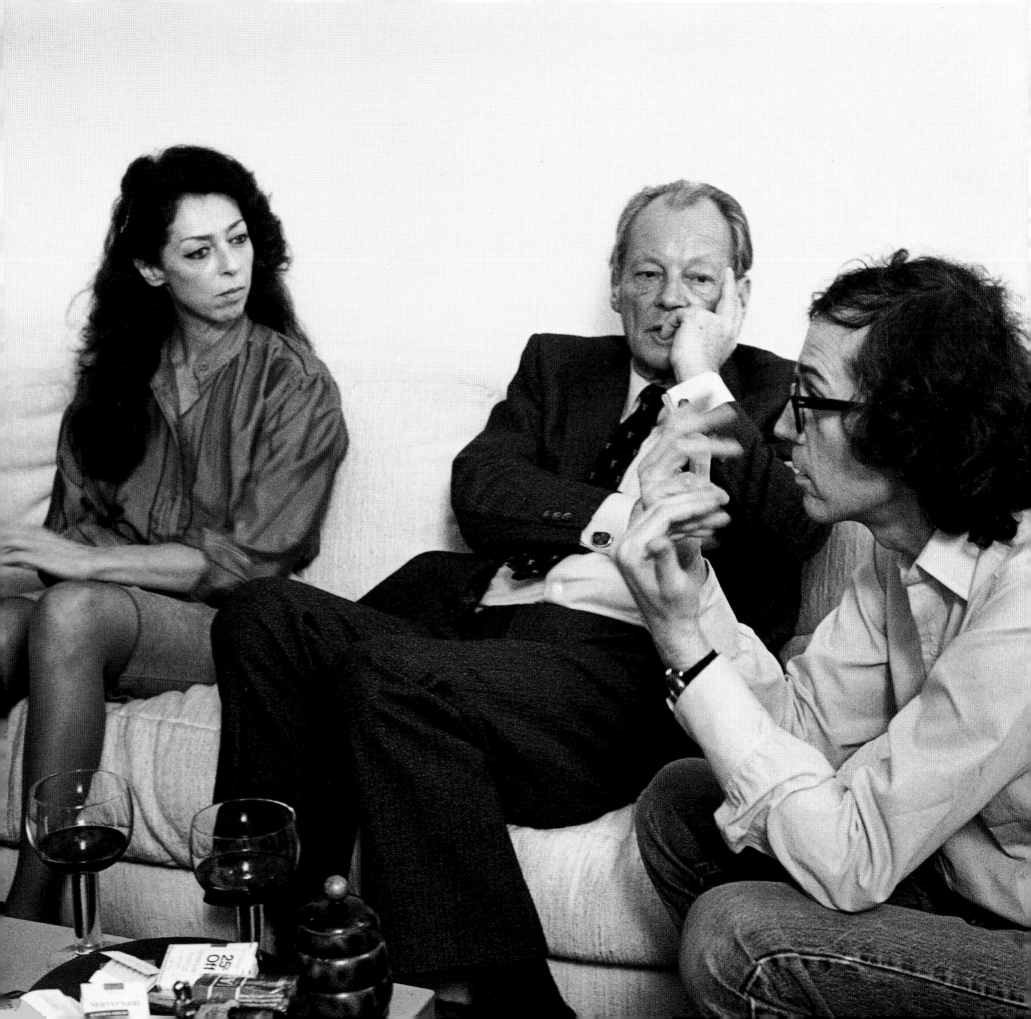

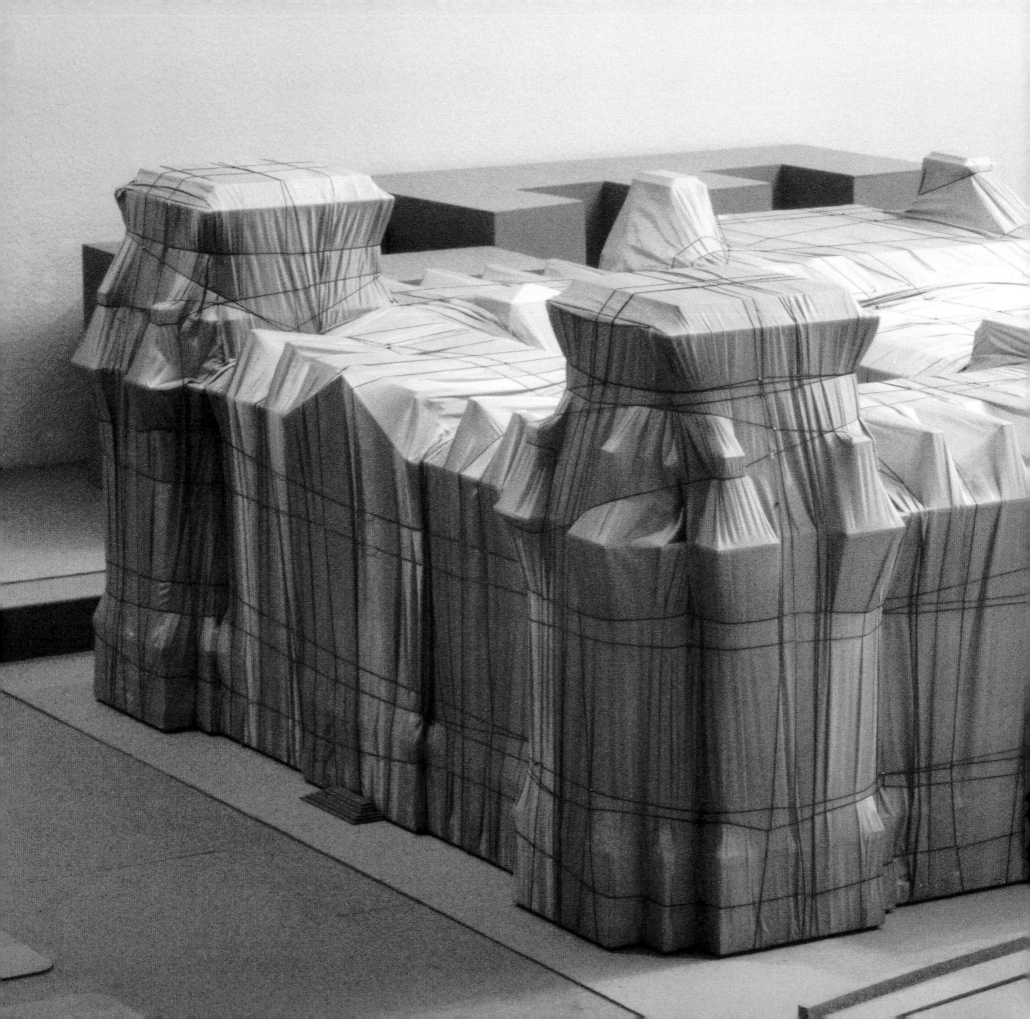

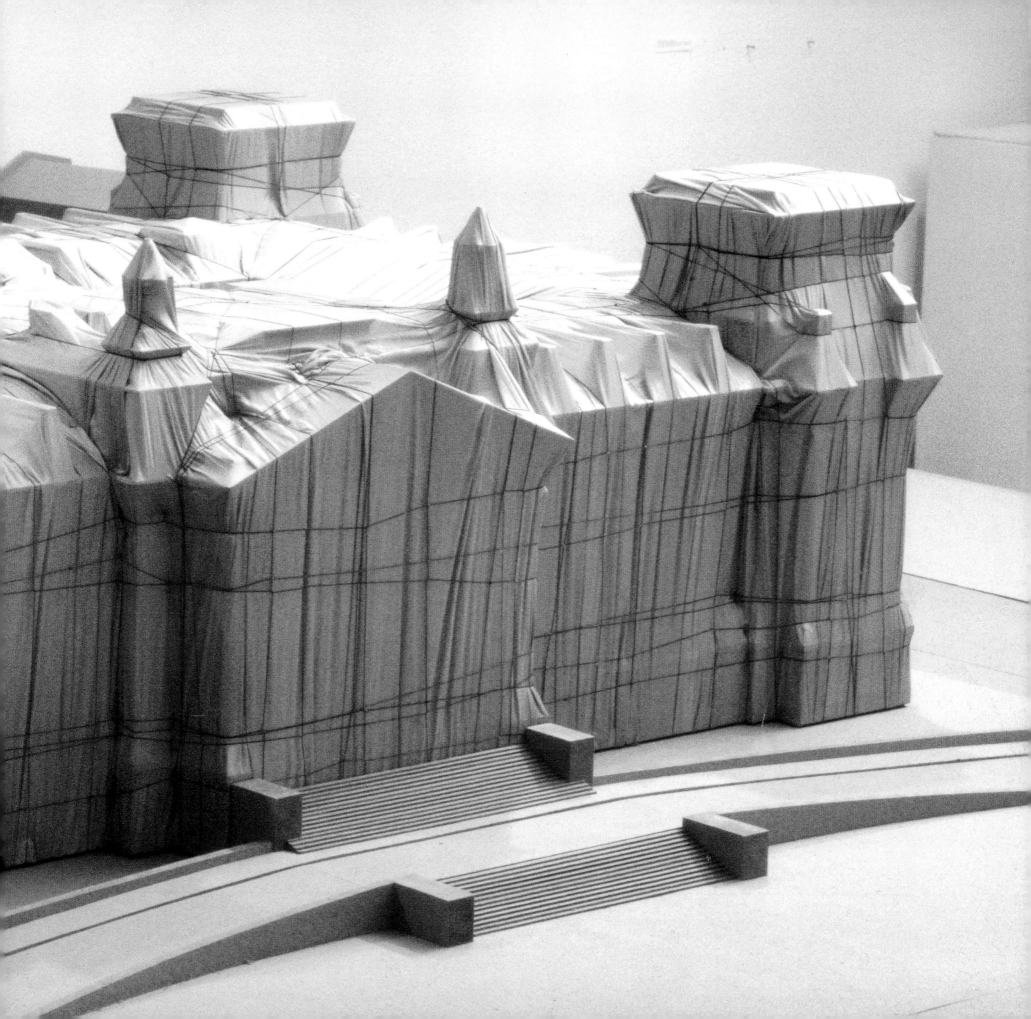

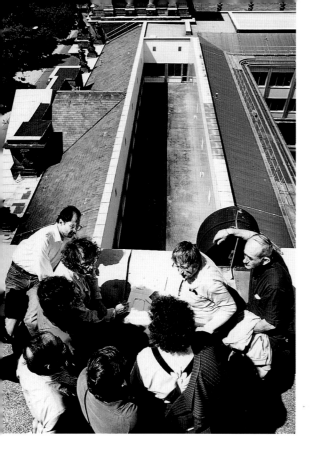
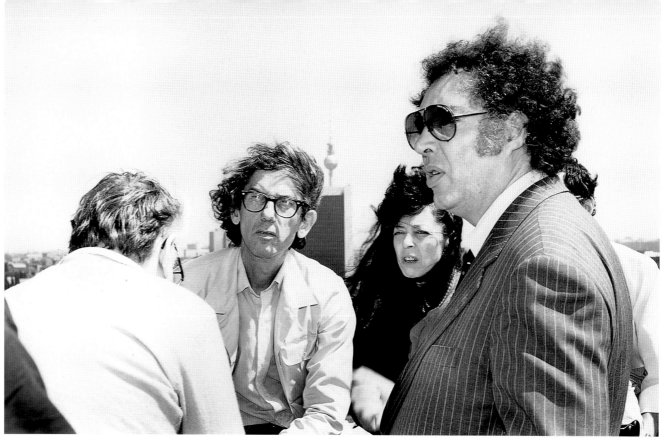
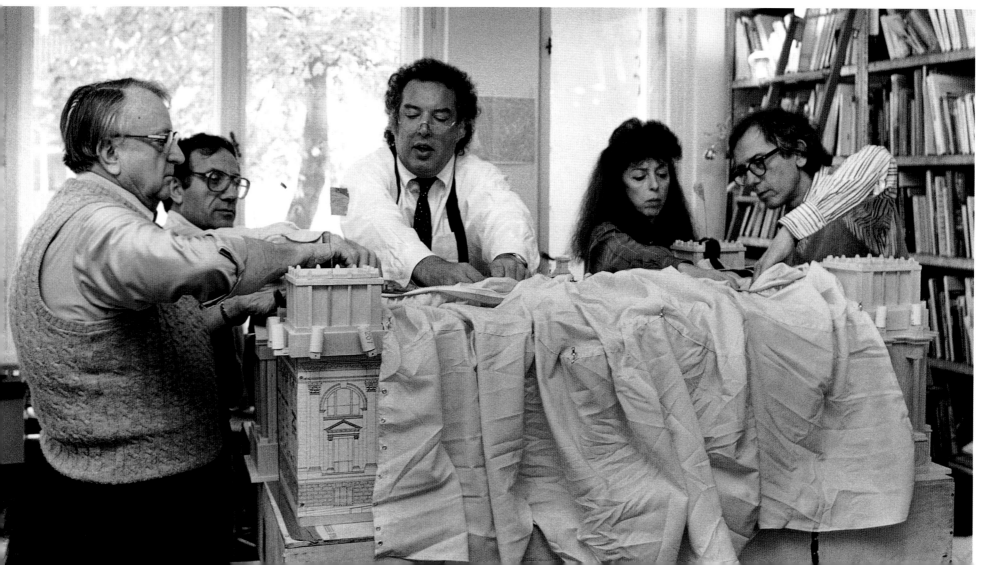

## Back in Berlin

Although the Christos had not yet secured even the hint of a government permit, they proceeded to develop the logistics of their planned wrapping anyway. Through Michael Cullen's persistence, the artists, West Berlin architect Jürgen Sawade (near left, top) and other key collaborators obtained permission to make an on-site inspection of the Reichstag's roof (far left, top) in July 1984.

A balcony (right) on the Reichstag's east facade, a restricted area because it was under the jurisdiction of East Germany, was visited by the artists and their entourage which included (from the left) August Huber (Kansas City building contractor), Josy Kraft (the Basel-based registrar/curator for all the Christos' exhibitions), Theodore Dougherty (Colorado engineer and building contractor), Michael Cullen, Thomas Golden (a *Surrounded Islands* team captain), Roseline de Lamotte (a French consultant) and Phyllis Dougherty (wife and associate of Ted Dougherty). From there, they could see the four-meter-high (13-feet-high) graffiti-covered Berlin Wall and the Brandenburg Gate.

Working with a scale model of the Reichstag (left, below) in Michael Cullen's home, Theodore Dougherty (who has worked on all the artists' projects since 1971), Des Moines engineer Vahé Aprahamian, Jürgen Sawade, Jeanne-Claude and Christo spent hours experimenting with a scale model that Dougherty had fabricated in his Colorado workshop, trying to determine whether the fabric should be lifted upward from the ground or unrolled downward from the roof. Ultimately, they agreed it should be unrolled downward, using the roof as a working platform. The decision was made on October 31, 1984 – and proved to be the exact procedure that would be followed in June 1995.

## Zurück in Berlin

Obwohl man in der Frage der Genehmigung noch keinen Schritt weitergekommen war, setzten die Christos ihre logistischen Vorbereitungen für die geplante Verhüllung fort. Michael Cullens Hartnäckigkeit war es zu verdanken, daß den Künstlern, dem Westberliner Architekten Jürgen Sawade (gegenüber, oben rechts) und anderen wichtigen Mitarbeitern im Juli 1984 eine Ortsbesichtigung des Reichstagsdaches genehmigt wurde (gegenüber, oben links).

Die Künstler durften auch einen Balkon an der auf Ostberliner Gebiet gelegenen Ostfassade des Reichstags betreten, der normalerweise unzugänglich war (rechts). Begleitet wurden sie (von links nach rechts) von August Huber (einem Bauunternehmer aus Kansas City), Josy Kraft (der von Basel aus alle Ausstellungen der Christos betreut), Theodore Dougherty (einem Ingenieur und Bauunternehmer aus Colorado), Michael Cullen, Thomas Golden (der an *Surrounded Islands* als Mannschaftsleiter beteiligt war), Roseline de Lamotte (einer französischen Beraterin) und Phyllis Dougherty (Ehefrau und Mitarbeiterin von Ted Dougherty). Von diesem Balkon aus konnten sie die vier Meter hohe, mit Graffiti bedeckte Berliner Mauer und das Brandenburger Tor sehen.

In Michael Cullens Wohnung experimentierten Theodore Dougherty (der seit 1971 an allen Projekten der Künstler mitgearbeitet hat), der Ingenieur Vahé Aprahamian aus Des Moines, Iowa, Jürgen Sawade, Jeanne-Claude und Christo stundenlang mit einem maßstabgerechten Modell des Reichstags, das Dougherty in seiner Werkstatt in Colorado gebaut hatte (gegenüber, unten), um herauszufinden, ob das Gewebe vom Boden aus hochgehievt oder vom Dach aus hinabgelassen werden solle. Sie einigten sich schließlich darauf, das Dach als Arbeitsplattform zu benutzen und das Gewebe von dort aus zu entrollen. Diese Entscheidung wurde am 31. Oktober 1984 getroffen – und genau dieses Verfahren wurde dann im Juni 1995 in die Tat umgesetzt.

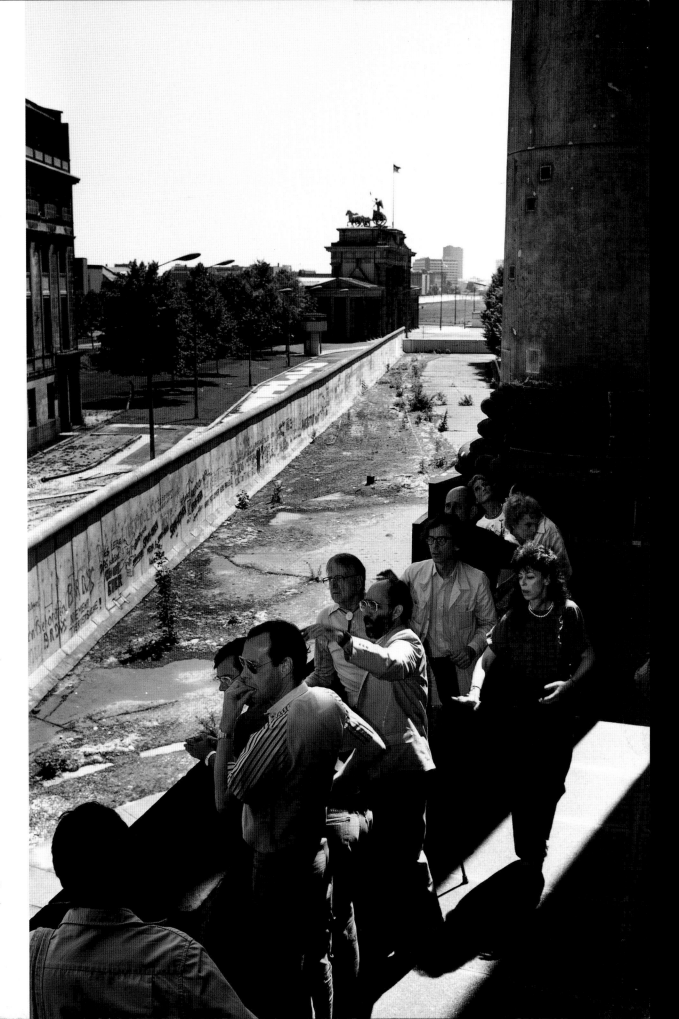

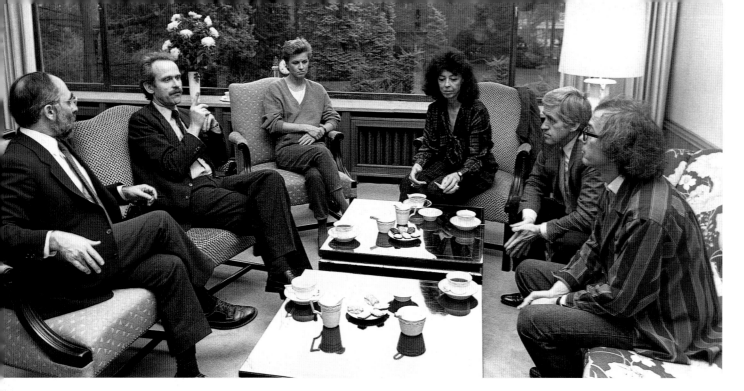

Following the success of their Pont Neuf project, Christo and Jeanne-Claude met with West Berlin Mayor Eberhard Diepgen on December 21, 1985. However, the meeting had somewhat clandestine overtones, as if the mayor did not wish to be publicly associated with the artists or their Reichstag project. The conference took place not in the mayor's office but, instead, in the Senatsgästehaus (the Berlin Senate's guest house), located in Grunewald, a suburb of the city. Moreover, the meeting was scheduled for Saturday, when no workers would be present. Furthermore, the mayor requested no photographs be taken of him attending the gathering. Those who did consent to be photographed at the guest house meeting included (top, from the left) Michael Cullen, Volker Hassemer, Sylvia Volz, Jeanne-Claude, interpreter Dieter Weber and Christo.

Later that day, at the Steigenberger Hotel in West Berlin, Volker Hassemer exchanged views with Roland Specker (below), a businessman who was establishing 'Berliners for the Reichstag' (Berliner für den Reichstag), an association to promote Berlin. Within the next couple of years, he would collect the signatures of 70,000 Germans

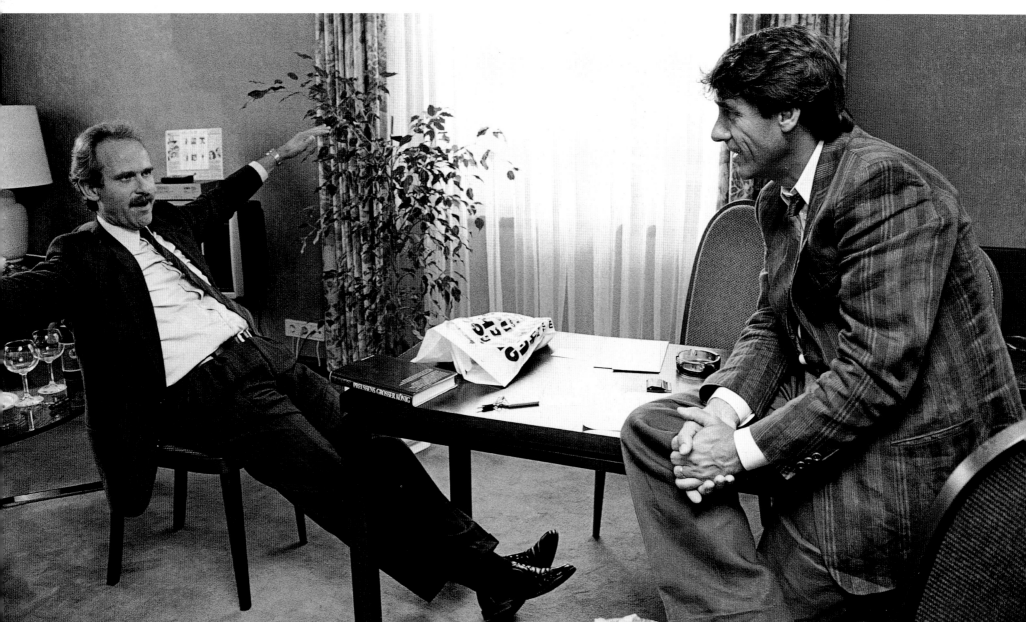

who favored the wrapping. (Several years later, in May 1994, he would become co-director – with photographer Wolfgang Volz – of the Reichstag project.) Elsewhere in the Steigenberger Hotel, Hassemer's assistant Bernhard Schneider (right, top), Jeanne-Claude, Christo and Marie Christine von Wolff-Metternich discussed the significance of the day's events (and non-events). At a December 19 luncheon meeting at the Deutsche Bank, Christo and Klaus-Rüdiger Landowski (right, center), the fraction leader of the CDU in Berlin, reflected on the intricacies of German politics. At the same event the Christo team enjoyed another meeting with Hans-Jürgen Heß (right, below), the Reichstag's administrative director, accompanied by his wife Erika.

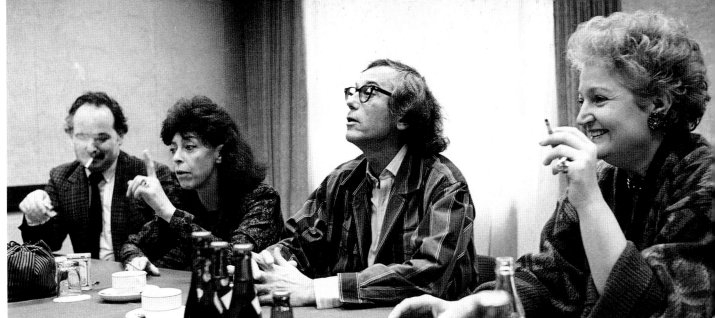

Nach dem überwältigenden Erfolg ihres *Verhüllten Pont Neuf* trafen sich Christo und Jeanne-Claude am 21. Dezember 1985 mit dem Berliner Regierenden Bürgermeister Eberhard Diepgen. Die Begegnung erinnerte allerdings ein wenig an ein konspiratives Treffen; es hatte den Anschein, als wolle Diepgen nicht in der Öffentlichkeit mit den Künstlern oder ihrem Reichstagsprojekt in Verbindung gebracht werden. Das Gespräch fand nicht in seinem Büro statt, sondern im Senatsgästehaus im Vorort Grunewald. Überdies wurde es an einem Samstag anberaumt, einem Tag, an dem kein Personal zugegen war. Und schließlich hatte er sich erbeten, während der Zusammenkunft nicht fotografiert zu werden. Zu den Gesprächsteilnehmern, die nichts dagegen hatten, sich fotografieren zu lassen, gehörten (Abb. S. 34 oben, von links nach rechts): Michael Cullen, Volker Hassemer, Sylvia Volz, Jeanne-Claude, der Dolmetscher Dieter Weber und Christo.

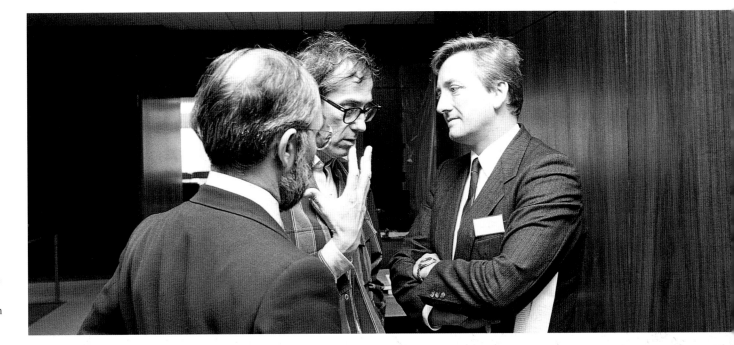

Einige Stunden später gab es im Steigenberger Hotel in Westberlin ein Gespräch zwischen Volker Hassemer und dem Geschäftsmann Roland Specker (S. 34 unten), der im Begriff war, den Verein »Berliner für den Reichstag« zu gründen. Innerhalb der nächsten Jahre sammelte er 70.000 Unterschriften zugunsten der Reichstagsverhüllung. (Einige Jahre später – im Mai 1994 – wurde er neben dem Fotografen Wolfgang Volz Kodirektor des Reichstagsprojekts.) In einem anderen Zimmer des Steigenberger Hotel erörterten Hassemers Mitarbeiter Bernhard Schneider (oben rechts), Jeanne-Claude, Christo und Marie Christine Gräfin von Wolff-Metternich die Tragweite dessen, was sich an diesem Tage ereignet (und nicht ereignet) hatte.

Während eines Mittagessens im Hause der Deutschen Bank am 19. Dezember unterhielten sich Christo und Klaus-Rüdiger Landowski (rechts, Mitte), der Fraktionsvorsitzende der CDU im Berliner Senat, über die Kniffligkeit der deutschen Politik. Bei dieser Gelegenheit konnten die Christos und ihre Mitarbeiter auch Hans-Jürgen Heß (unten rechts) wieder einmal begrüßen, den Verwaltungsdirektor des Reichstags, der von seiner Frau Erika begleitet wurde.

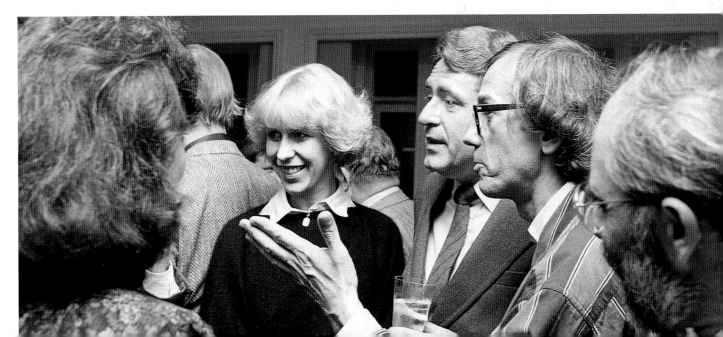

**Wrapped Reichstag,**
**Project for Berlin**
Collage 1986
56 x 71 cm
Pencil, fabric, twine, pastel, char-
coal and crayon

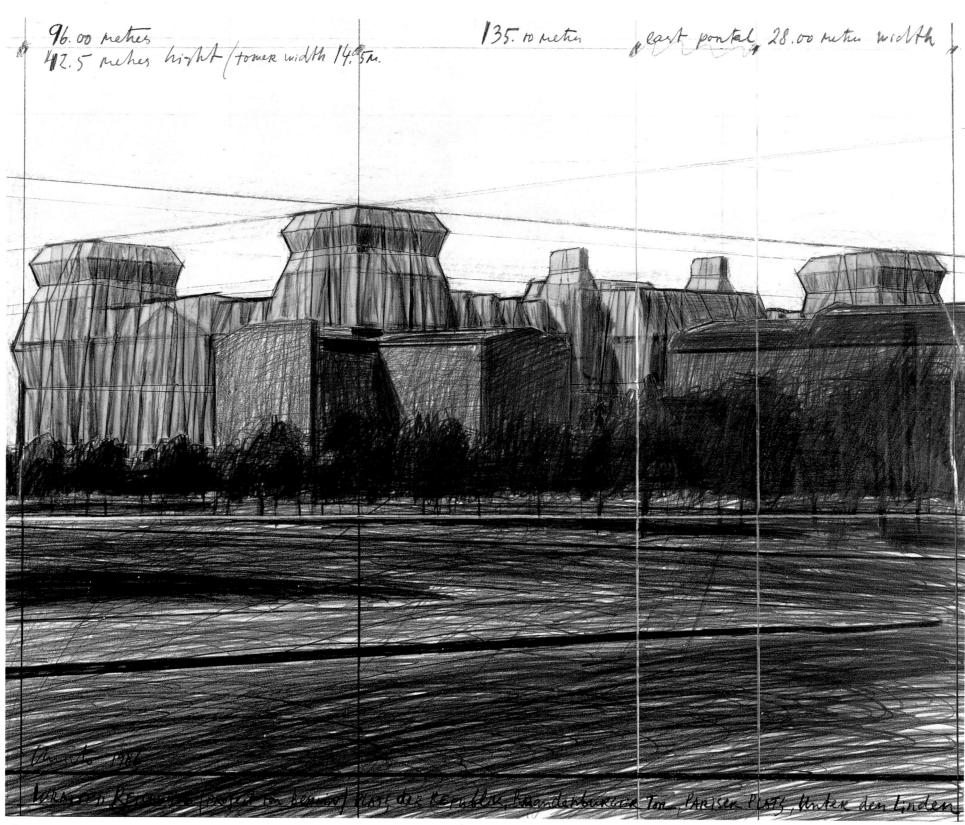

West Berlin Mayor Eberhard Diepgen and his large entourage (right, top) paid a late morning visit to the Christos at their home in Manhattan on September 21, 1986. Although known for his patience, Christo (below) warned Mayor Diepgen that, if the Germans did not make up their minds soon, he and Jeanne-Claude would be fully engaged on another of their projects.

Am späten Vormittag des 21. September 1986 besuchte der Berliner Regierende Bürgermeister Eberhard Diepgen mit großem Gefolge die Christos in ihrer Wohnung in Manhattan (oben rechts). Der für seine Geduld bekannte Christo (unten) ließ Diepgen bei dieser Gelegenheit wissen, daß er auf eine baldige Entscheidung dringen müsse, da er und Jeanne-Claude sich ansonsten gezwungen sähen, sich ganz auf ein anderes ihrer Projekte zu konzentrieren.

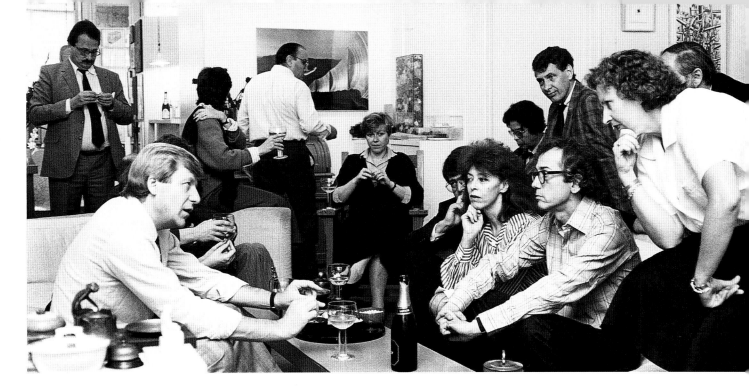

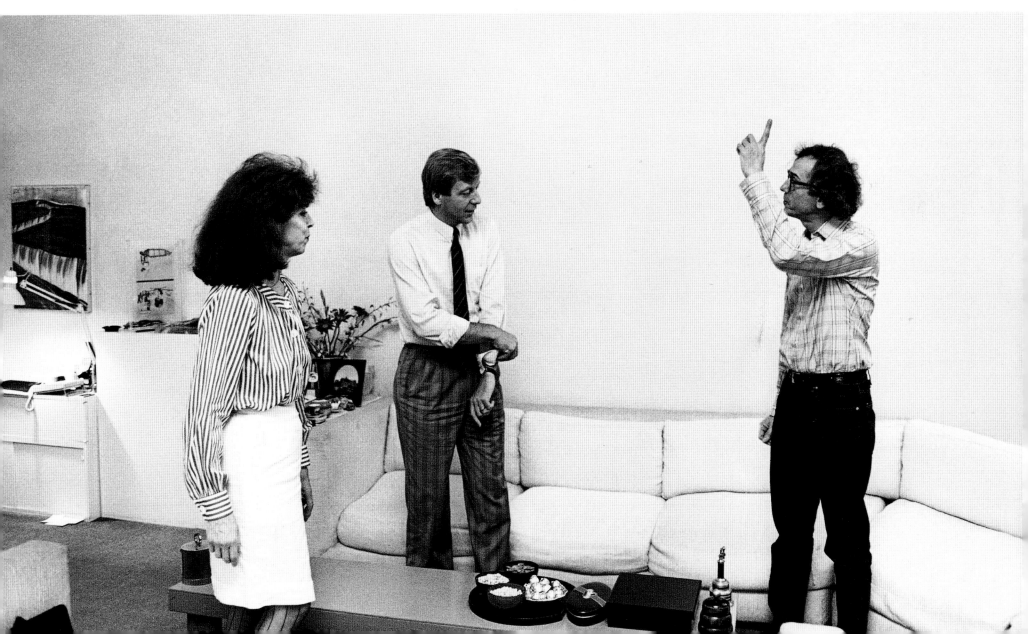

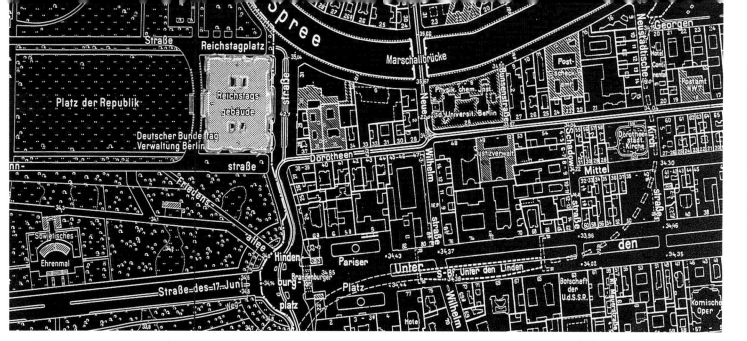

Jeanne-Claude and Christo tried to meet – unsuccessfully – with Philipp Jenninger (CDU) who became Bundestag president in February 1987 and held that office until his resignation in November 1988. However, it was known (from press accounts and his broadcast remarks) that he would never permit the wrapping of the Reichstag.

Ohne Erfolg bemühten sich Jeanne-Claude und Christo um eine Zusammenkunft mit Philipp Jenninger (CDU), der im Februar 1987 das Amt des Bundestagspräsidenten übernahm, das er bis zu seinem Rücktritt im November 1988 innehatte. Aus Presseberichten und seinen in Rundfunk und Fernsehen geäußerten Bemerkungen war jedoch unmißverständlich klar geworden, daß er einer Verhüllung des Reichstags niemals zustimmen werde.

**Wrapped Reichstag,**
**Project for Berlin**
Collage 1987, in two parts:
30.5 x 77.5 cm and 66.7 x 77.5 cm
Pencil, fabric, twine, pastel, charcoal, crayon and map

## The Berlin Wall Comes Down

Since August 1961 the Berlin Wall, erected by the East German government along the border between East and West Berlin, had physically and metaphorically divided the two Germanies. But on November 9, 1989, the failing Communist regime, unable to keep its citizenry from fleeing, lifted travel restrictions to the West. Within days the wall was being dismantled. Germany was on the road to reunification, and the Reichstag became an obvious focal point for public gatherings and a lot of flag-waving.

The whole political landscape was changing and a movement was afoot to move the Bundestag from Bonn and return it to Berlin, possibly to the Reichstag. The winds that brought political reversals also raised new and more urgent expectations concerning the wrapping of the monument which now had fresh symbolic significance.

## Die Berliner Mauer fällt

Seit August 1961 hatte die von der DDR-Regierung längs der Grenze zwischen Ost- und Westberlin errichtete Berliner Mauer die beiden deutschen Staaten geographisch und symbolisch voneinander getrennt. Am 9. November 1989 jedoch hob das schwankende kommunistische Regime, das die Flucht seiner Bürger nicht mehr aufhalten konnte, die Ausreisebeschränkungen in den Westen auf. Innerhalb weniger Tage wurde die Mauer eingerissen. Deutschland befand sich auf dem Wege zur Wiedervereinigung, und der Reichstag wurde zu einem Brennpunkt öffentlicher Kundgebungen, bei denen viele Flaggen geschwenkt wurden.

Die ganze politische Landschaft änderte sich, und immer lauter wurde die Forderung vorgebracht, den Regierungssitz von Bonn nach Berlin zu verlegen – und damit den Bundestag ins Reichstagsgebäude. Mit den politischen Umwälzungen erhielt der Reichstag eine neue symbolische Bedeutung, die auch der Frage der Verhüllung eine neue Relevanz und Dringlichkeit verlieh.

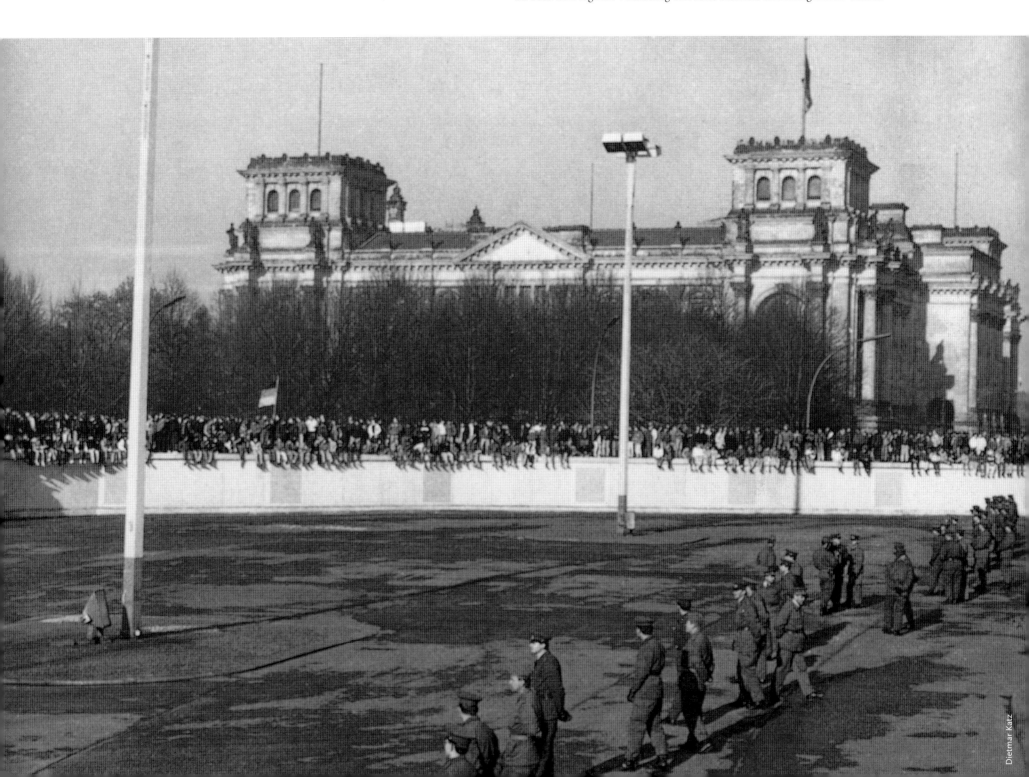

Dietmar Katz

**Wrapped Reichstag, Project for Berlin**
Drawing 1992, in two parts: 38 x 165 cm and 106.6 x 165 cm, Pencil, charcoal, pastel, crayon and technical data

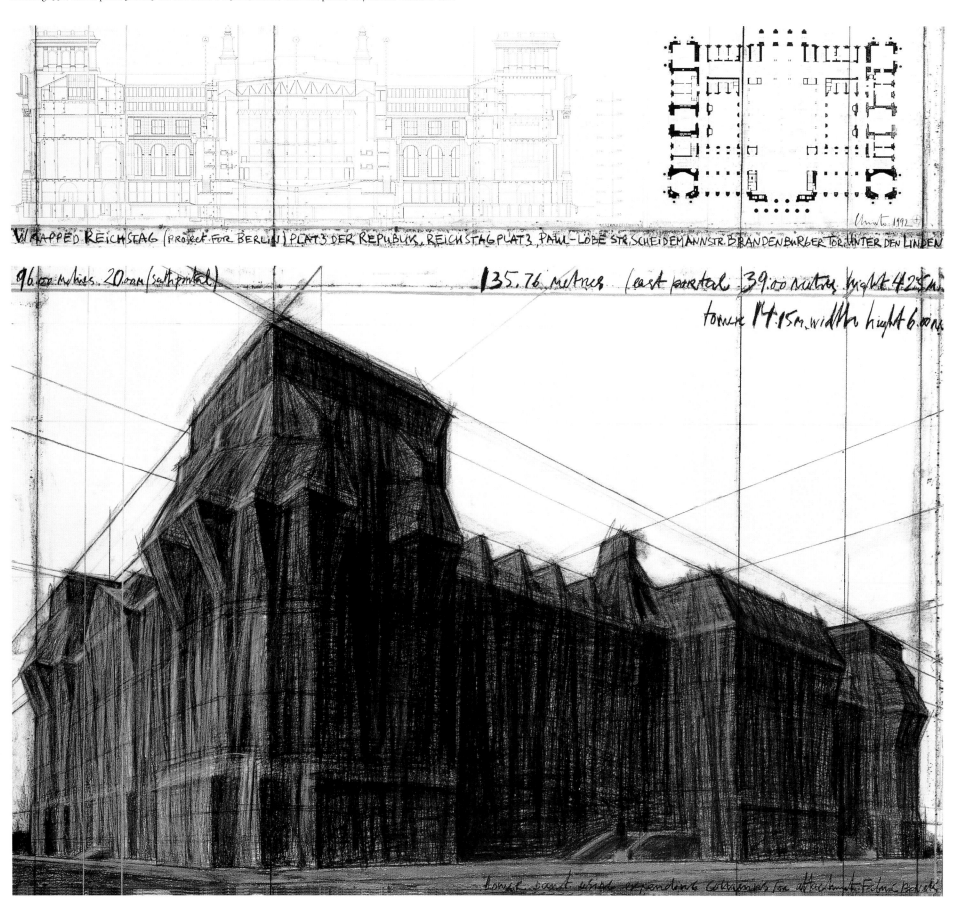

## Surprise! An Invitation From Germany

While rushing toward the completion of *The Umbrellas*, the Christos were confronted by a German journalist in California, who asked them, "What about the Reichstag?" After 20 years of frustrating involvement with German politicians, Christo impatiently snapped, "If the Germans want us to wrap the Reichstag, they should write us a letter." His derisive remark was published in the ensuing article. Amazingly enough, a couple of months later, Christo and Jeanne-Claude actually received a letter (below) from Rita Süssmuth (CDU), the new president of the Bundestag. She offered to help them realize their "dream" of wrapping the Reichstag. Noting that "the Reichstag has been chosen as the parliament building for the newly reunited Germany," she saw a window of opportunity in which the building could be wrapped before extensive restoration work was scheduled to begin. Needless to say, Christo and Jeanne-Claude were elated by Rita Süssmuth's interest.

## Eine Einladung aus Deutschland!

In der Endphase der Realisierung des Projekts *The Umbrellas* trat in Kalifornien ein deutscher Journalist auf die Christos zu und fragte sie, wie es denn mit dem Reichstagsprojekt stehe. Nach seinen zwanzigjährigen frustrierenden Erfahrungen mit deutschen Politikern gab Christo kurz angebunden zur Antwort: »Wenn die Deutschen wollen, daß wir den Reichstag verhüllen, sollen sie uns einen Brief schreiben.« Und diese Antwort war dann auch in den Zeitungen zu lesen.
Einige Monate später erhielten Christo und Jeanne-Claude tatsächlich einen Brief aus Deutschland (unten). Rita Süssmuth (CDU), die neue Bundestagspräsidentin, ließ die Künstler wissen, sie wolle »Ihnen helfen, Ihren Traum, das Reichstagsgebäude zu verhüllen, zu realisieren«.
Sie verwies darauf, daß »das Reichstagsgebäude zum Parlamentssitz für das wiedervereinigte Deutschland bestimmt worden« sei, und äußerte die Hoffnung, daß das Gebäude vor Beginn der umfangreichen Umbauarbeiten verhüllt werden könne.
Selbstverständlich versetzte dieser Brief Christo und Jeanne-Claude in Hochstimmung.

---

20. 12. 91    11:29        *BT-Verw. Praes. Buero    S01

PROF. DR. RITA SÜSSMUTH
PRÄSIDENTIN
DES DEUTSCHEN BUNDESTAGES

5300 BONN 1  20. Dezember 1991
BUNDESHAUS
TELEFON (0228) 16-2000

An
Christo und Jeanne-Claude
48 Howard Street
New York, N.Y. 10013

Fax: 001-212-966-2891

Dear Christo and Jeanne-Claude,

As you know from Mr. Cullen, I personally would like to help you realize your dream of wrapping the Reichstag building.

As you also know, the Reichstag has been chosen as the parliament building for the newly re-united Germany. Since it is much to small for current needs, its insides need alterations and the surrounding areas will be built up. There is a great urgency to start work as soon as possible.

I know from Mr. Cullen and also from some publications that you require one year preparation for the Reichstag project. If it is to be realized by later summer of 1993 you will need full authorization no later than this summer. Although I cannot promise that you now, I am hopeful that with your help this will be possible.

DEC-20-91 FRI   06:24                49 228 162945       P.01

20. 12. 91    11:29        *BT-Verw. Praes. Buero    S02

- 2 -

Unfortunately, I was not able to see your project in California and Japan, about which I have read much. I was greatly upset by the two fatal accidents, but they have not changed my mind about your Reichstag project.

Since I cannot come to New York to meet you, I would like to invite you to visit me in Berlin or Bonn in the second halfe of January or the beginning of February. I am sure, that our two schedules will permit us some time and look forward to receiving your appointment suggestions.

Sincerely yours

Prof. Dr. Rita Süssmuth

DEC-20-91 FRI   06:25                49 228 162945       P.02

The Christos met with Bundestag President Rita Süssmuth (CDU) in her residence in Bonn on February 9, 1992. The entire group sat down to a three-hour working lunch (below). The group included (from the left) Peter Conradi, President Rita Süssmuth, Jeanne-Claude, Peter Jung and Helmut Georg Müller (both assistants to the president), Michael Cullen, Christo, Roland Specker (co-director, with Wolfgang Volz, of the project) and Sylvia Volz. The Christos informed President Süssmuth that they would need about 18 months advance notice to prepare the work. She stated that the decision was not hers alone, that she would have to confer with the party whips. She also suggested that an exhibition of Christo's work in Bonn could be very helpful in generating public support.

Am 9. Februar 1992 trafen die Christos Bundestagspräsidentin Rita Süssmuth zu einem dreistündigen Arbeitsessen in ihrer Bonner Residenz (unten). Die Teilnehmer waren (von links nach rechts): Peter Conradi, Rita Süssmuth, Jeanne-Claude, Peter Jung und Helmut Georg Müller (zwei Mitarbeiter der Bundestagspräsidentin), Michael Cullen, Christo, Roland Specker (zusammen mit Wolfgang Volz Kodirektor des Projekts) und Sylvia Volz. Die Christos erklärten, daß sie etwa 18 Monate bräuchten, um die Verhüllung vorzubereiten. Frau Süssmuth gab zu verstehen, daß sie die Entscheidung nicht allein treffen könne; sie müsse sich mit den Fraktionsvorsitzenden der Parteien abstimmen. Sie schlug vor, eine Ausstellung von Christos Werken in Bonn zu veranstalten, um so auch die Öffentlichkeit für die Sache zu gewinnen.

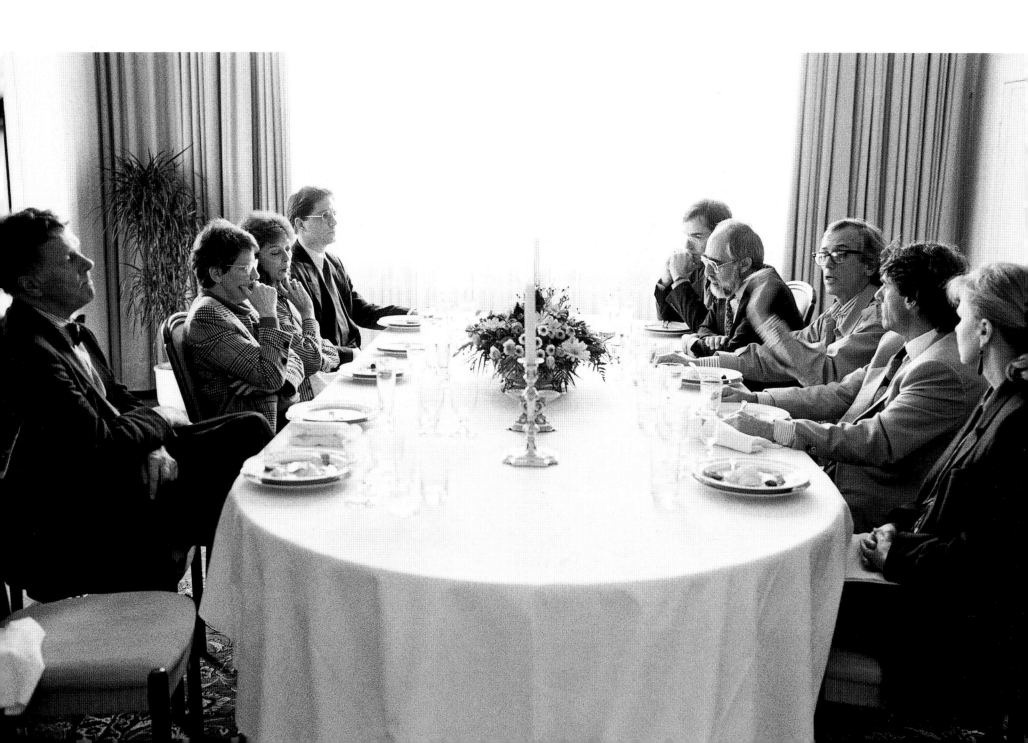

**Wrapped Reichstag,
Project for Berlin**
Collage 1992, in two parts:
77.5 x 66.7 cm
and 77.5 x 30.5 cm
Pencil, fabric, twine, photo-
graph by Wolfgang Volz,
pastel, charcoal, crayon and
map

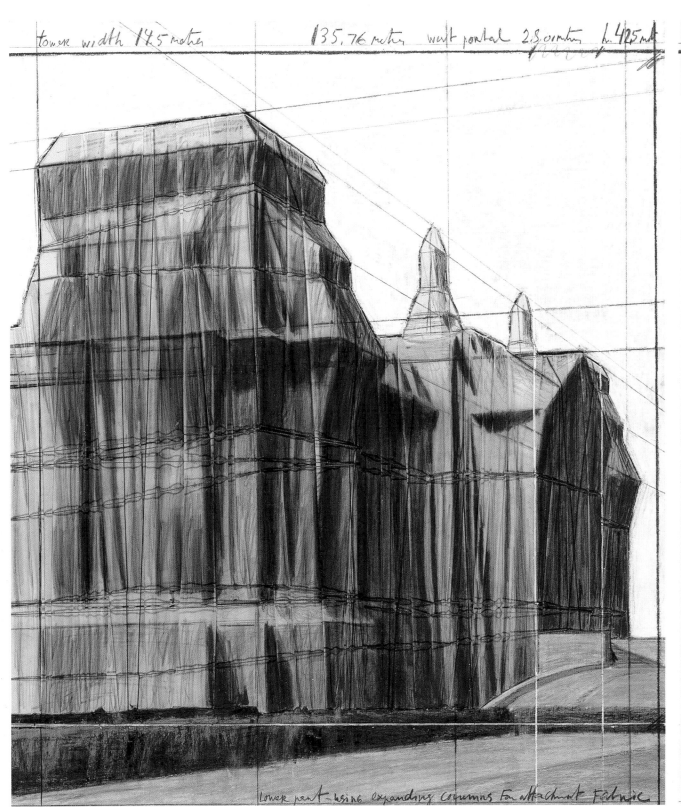

tower width 14.5 meter                135.76 meter   west portal 2.3 cm/m   h. 425 m

lower part - using expanding columns for attachment fabric

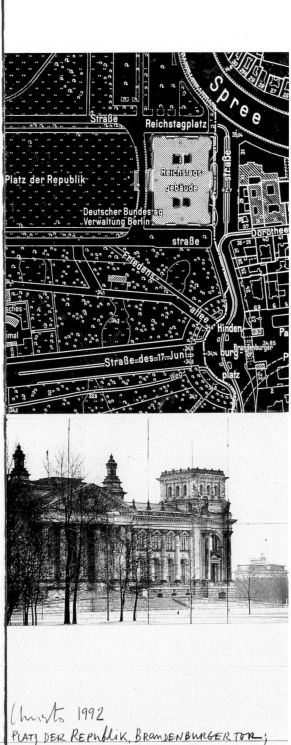

WRAPPED REICHSTAG (project for Berlin)

Christo 1992
PLATZ DER REPUBLIK, BRANDENBURGER TOR;

43

Bundestag President Rita Süssmuth welcomed Jeanne-Claude and Christo to her office in the Reichstag (left, center) on November 9, 1992. Although this was only their second encounter, the president expressed distress that the project was not advancing faster. As the group gathered around a breakfast table (below), President Süssmuth explained how she thought the matter could be resolved by the Ältestenrat. (This is a council of the "elders," or senior representatives in the Bundestag. Within the hierarchy of Germany's parliament, it ranks just below the president and the presidium of vice-presidents. The Ältestenrat meets once a week, when the Bundestag is in session, and decides on the agenda.) Once again, President Süssmuth advised the artists and their team (co-director Roland Specker is on the extreme right) that the project had to be presented to the public, possibly in the form of an exhibition or press conference, so that it could be widely discussed.

The artists met with Irmgard Schwaetzer (F.D.P.), the Minister of Construction, whose department was responsible for the reconstruction of the Reichstag, in her Bonn office (left, top) on November 13. She received them rather frostily, almost as if she expected to be asked for money. But she warmed to them when she realized they were not going to ask her ministry for any funds with which to wrap the Reichstag.

Am 9. November 1992 hieß Bundestagspräsidentin Rita Süssmuth Jeanne-Claude und Christo in ihrem Büro im Reichstag willkommen (links, Mitte). Obwohl es erst ihre zweite Begegnung war, äußerte Frau Süssmuth ihr Bedauern über den langsamen Fortschritt des Projekts. Am Frühstückstisch erklärt Frau Süssmuth den Gesprächsteilnehmern (unten), sie glaube, daß der Ältestenrat des Bundestags die Entscheidung über die Reichstagsverhüllung zu treffen habe. Erneut gab Frau Süssmuth den Künstlern und ihren Mitarbeitern (Kodirektor Roland Specker ist am rechten Rand zu sehen) den Rat, das Projekt – möglichst in Form einer Ausstellung oder einer Pressekonferenz – der Öffentlichkeit vorzustellen, um eine breite Diskussion in Gang zu setzen.

Am 13. November trafen die Künstler die für den Umbau des Reichstags verantwortliche Bundesbauministerin Irmgard Schwaetzer (F.D.P.) in ihrem Bonner Büro (oben links). Die Atmosphäre war zunächst etwas frostig, da Frau Schwaetzer den Argwohn hegte, ihr Ministerium werde um Zuschüsse für die Verhüllung gebeten. Sie taute jedoch spürbar auf, als man ihr diese Befürchtung nahm.

Heribert Scharrenbroich invited other members of the Bundestag to a presentation of the Christos' project in the parliament's restaurant (below) on May 12, 1993. Standing at the microphone, Scharrenbroich introduced the artists to the gathering. Brigitte Schulte (right, top) and Wolfgang Thierse (right, center), both members of the SPD, examined the Christos' books and posters and decided to support the project. Friedbert Pflüger (right, bottom), a member of the CDU, was also in favor of the Reichstag's wrapping.

One of the key politicians who was against the project was Hans Klein (bottom, left), a member of the Christian Social Union (CSU) and a vice-president of the Bundestag. He frankly confided that he could not support their proposed wrapping, because it would result in something tantamount to political suicide.

Heribert Scharrenbroich lud andere Bundestagsabgeordnete für den 12. Mai 1993 zu einer Präsentation des Reichstagsprojekts ins Bundestagsrestaurant ein (unten). Am Mikrophon stellte Scharrenbroich die Künstler den Gästen vor. Die SPD-Abgeordneten Brigitte Schulte (oben rechts) und Wolfgang Thierse (rechts, Mitte) musterten die Bücher und Plakate der Christos und beschlossen, das Projekt zu unterstützen. Auch Friedbert Pflüger von der CDU (unten rechts) befürwortete die Verhüllung des Reichstags.

Zu den wichtigen Politikern, die das Projekt ablehnten, gehörte der CSU-Abgeordnete und Bundestagsvize-präsident Hans Klein (unten links), der eine Zustimmung zur Reichstagsverhüllung mit »politischem Selbstmord« gleichsetzte.

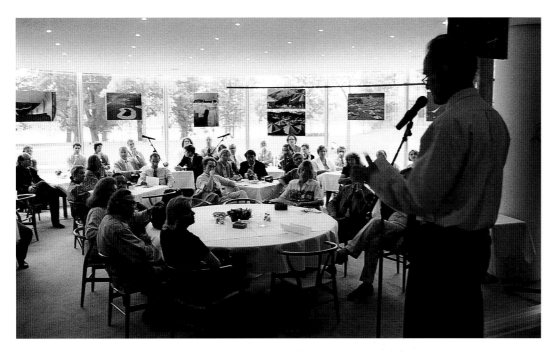

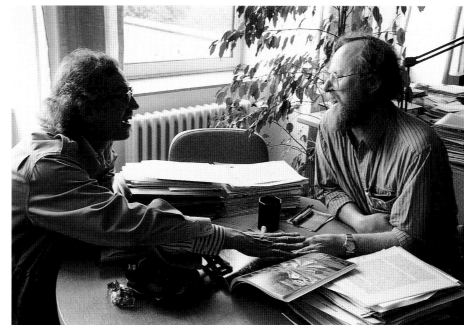

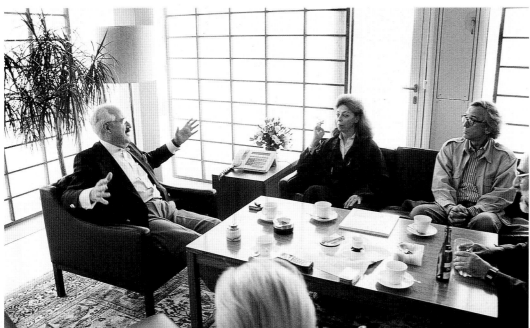

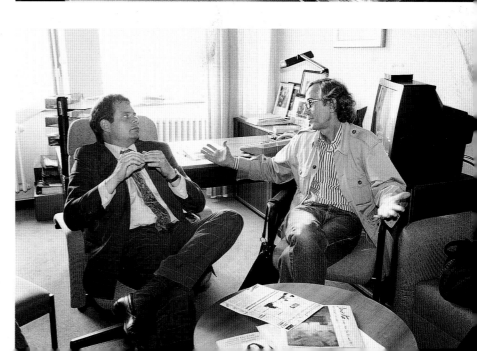

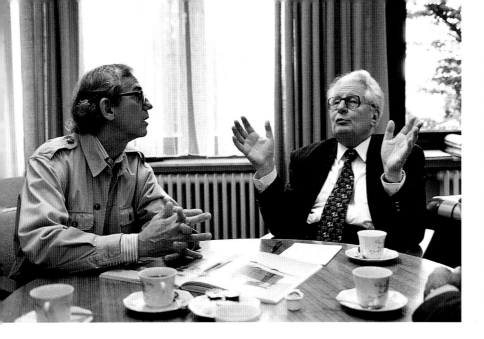

Christo and Jeanne-Claude returned to Bonn in September 1993 to continue their lobbying of individual politicians. They met with Hans-Jochen Vogel (left, top), a senior SPD member, and Peter Glotz (left, center), also a member of the SPD. Both supported the project.

Werner Hoyer (left, bottom), general secretary of the F.D.P. party, seemed surprisingly well informed about the Christos' work. As a student at the University of California, Berkeley, he had actually seen *Running Fence*.

Dankward Buwitt (below, flanked by the Christos and Michael Cullen), a representative in the CDU party, favored the proposed artwork. Torsten Wolfgramm (bottom), a senior leader in the F.D.P. party, was aggressively helpful.

Im September 1993 kehrten Christo und Jeanne-Claude nach Bonn zurück, um ihre Gespräche mit einzelnen Politikern fortzusetzen. Sie trafen die SPD-Politiker Hans-Jochen Vogel (oben links) und Peter Glotz (links, Mitte), die beide das Projekt unterstützten.

F.D.P.-Generalsekretär Werner Hoyer (unten links) schien erstaunlich gut über das Werk der Christos informiert zu sein. Als Student an der University of California in Berkeley hatte er 1976 das Projekt *Running Fence* aus der Nähe gesehen.

Dankward Buwitt von der CDU (rechts, Mitte, flankiert von den Christos und Michael Cullen) befürwortete das Reichstagsprojekt. Torsten Wolfgramm von der F.D.P. (unten rechts) setzte sich vehement für das Projekt ein.

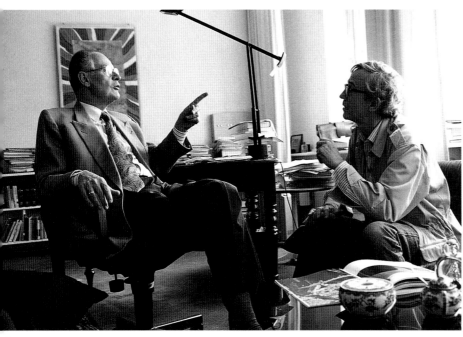

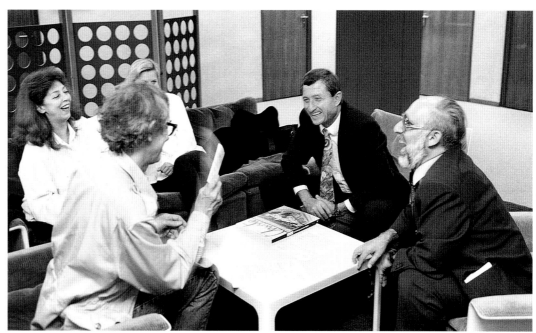

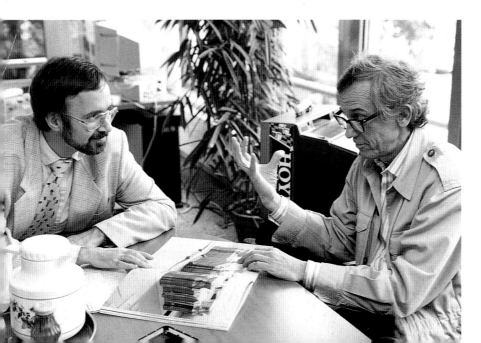

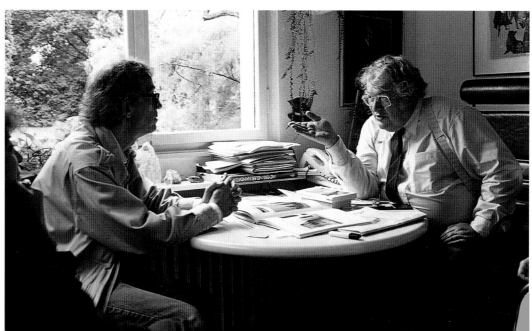

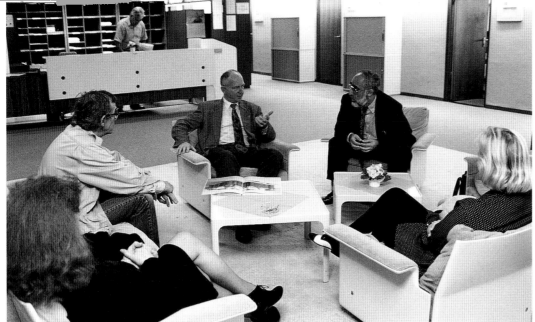

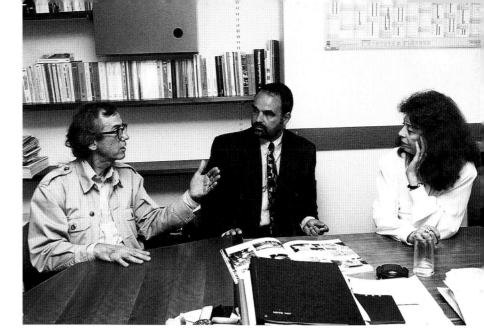

Christo and Jeanne-Claude presented their wrapping plan to Horst Gibtner (above, in the center), a member of the CDU. They also met with Peter Struck (below), an SPD member of the Ältestenrat who proved to be a key organizer of the campaign. Thomas Kossendey (right, top), a member of the CDU, favored the proposal. Franz Möller (right, center), however, was one CDU member of the Ältestenrat who was not won over by the Christos. He politely indicated that he opposed their project. But Konrad Elmer (right, bottom), a member of the SPD, seemed to like what he heard.

Christo und Jeanne-Claude konnten auch Horst Gibtner von der CDU (oben links, in der Mitte) für das Projekt gewinnen. Peter Struck (unten links), der für die SPD im Ältestenrat des Bundestags saß, sollte sich als einer der engagiertesten Förderer des Projekts erweisen. Auch der CDU-Abgeordnete Thomas Kossendey (oben rechts) setzte sich für das Projekt ein. Franz Möller (rechts, Mitte) gehörte allerdings zu den von der CDU gestellten Mitgliedern des Ältestenrats, den die Christos nicht überzeugen konnten. Höflich ließ er sie wissen, daß er ihr Projekt ablehne. Bei Konrad Elmer von der SPD (unten rechts) schienen sie jedoch auf offene Ohren zu stoßen.

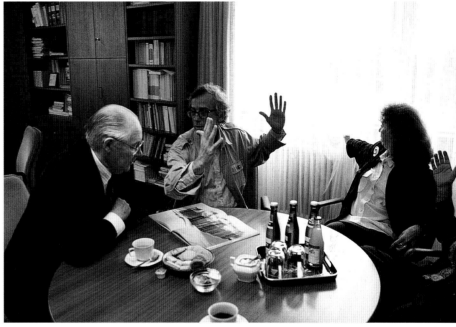

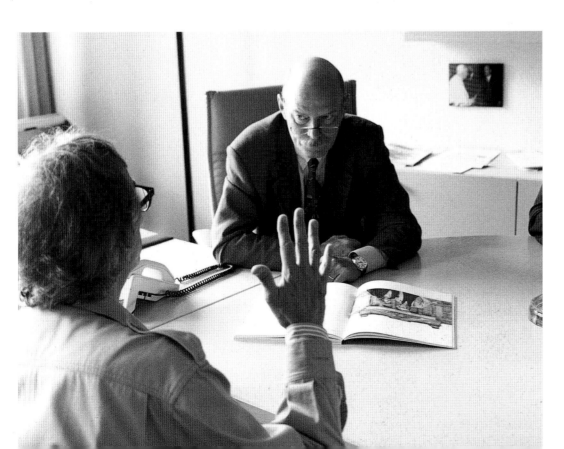

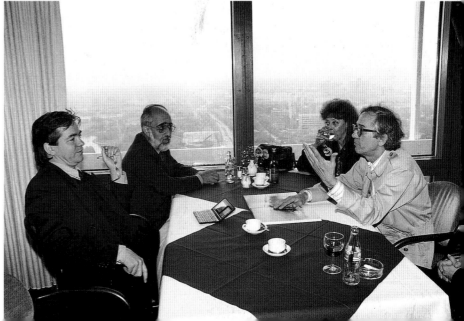

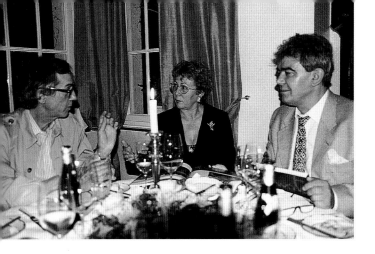

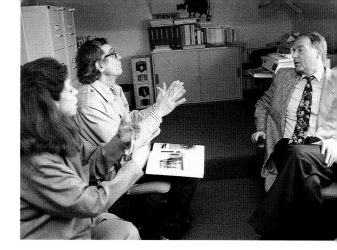

## The Lobbying Intensifies

The artists stepped up the pace of their campaign in October 1993, by which time they had refined their presentation. To each politician they emphasized three major points: 1) they sought to create a work of art by temporarily wrapping the Reichstag; 2) the project would be achieved at no cost to the German taxpayers, because they would use their own money; and 3) all the materials would be recycled in accordance with environmental regulations.

Making an unusually positive response, Otto Reschke (left, top), an SPD member of the Bundestag, accompanied by his aide Erika Wangemann, graciously invited Christo to dinner in the Halbedel's Gasthaus in Bad Godesberg.

The artists met with five members of the F.D.P. – Günther Bredehorn (left, second from top), Martin Grüner (left, third from top), Rainer Funk (left, bottom), a "Staatssekretär" in the Ministry of Justice, Dirk Hansen (right, top) and Norbert Eimer (right, bottom). All were for the project.

The CDU's Johannes Nitsch (right, second from top), was still another member of the Bundestag who endorsed the wrapping. But Joachim Hörster (right, third from top) of the CDU opposed the project, despite pressure from Heribert Scharrenbroich (with pipe).

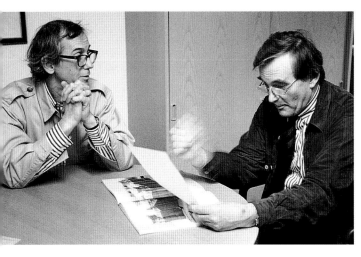

## Das Lobbying wird intensiviert

Im Oktober 1993 legten die Künstler eine noch schnellere Gangart ein. Inzwischen hatten sie ihre Strategie noch mehr verbessert, um die Abgeordneten für ihre Sache zu gewinnen. Bei jedem Gespräch wurden von jetzt an drei wichtige Punkte hervorgehoben: 1) mit der kurzzeitigen Verhüllung des Reichstags werde die Absicht verfolgt, ein Kunstwerk zu schaffen; 2) das Projekt werde den deutschen Steuerzahler keinen Pfennig kosten, weil die Künstler alle Kosten selbst tragen; und 3) alle verwendeten Materialien sollten den Umweltschutzbestimmungen gemäß recycelt werden.

Der SPD-Abgeordnete Otto Reschke (oben links) unterstützte nicht nur das Projekt, er war sogar so zuvorkommend, Christo in »Halbedels Gasthaus« in Bad Godesberg zum Essen einzuladen. Begleitet wurde er von seiner Mitarbeiterin Erika Wangemann. Die Künstler trafen sich mit fünf F.D.P.-Mitgliedern – Günther Bredehorn (links, zweite Abb. von oben), Martin Grüner (links, dritte Abb. von oben), Rainer Funk, Staatssekretär im Justizministerium (unten links), Dirk Hansen (oben rechts) und Norbert Eimer (unten rechts). Alle befürworteten das Projekt.

Auch Johannes Nitsch von der CDU (rechts, zweite Abb. von oben) gehörte zu den Bundestagsabgeordneten, die sich für das Projekt aussprachen. Sein Parteifreund Joachim Hörster (rechts, dritte Abb. von oben) ließ sich jedoch auch von Heribert Scharrenbroich (mit Pfeife) nicht umstimmen und blieb bei seiner ablehnenden Haltung.

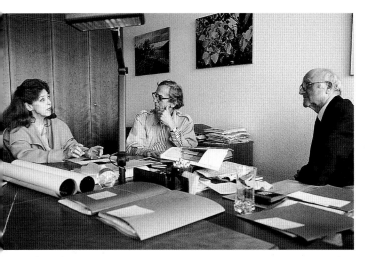

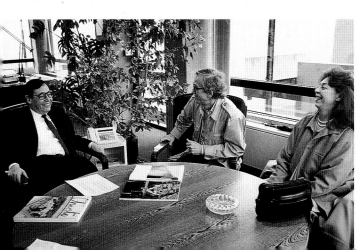

**Wrapped Reichstag,
Project for Berlin**
Drawing 1992, in two parts:
38 x 244 cm and 106.6 x 244 cm
Pencil, charcoal, crayon, pastel
and technical data
*Private Collection, Europe*

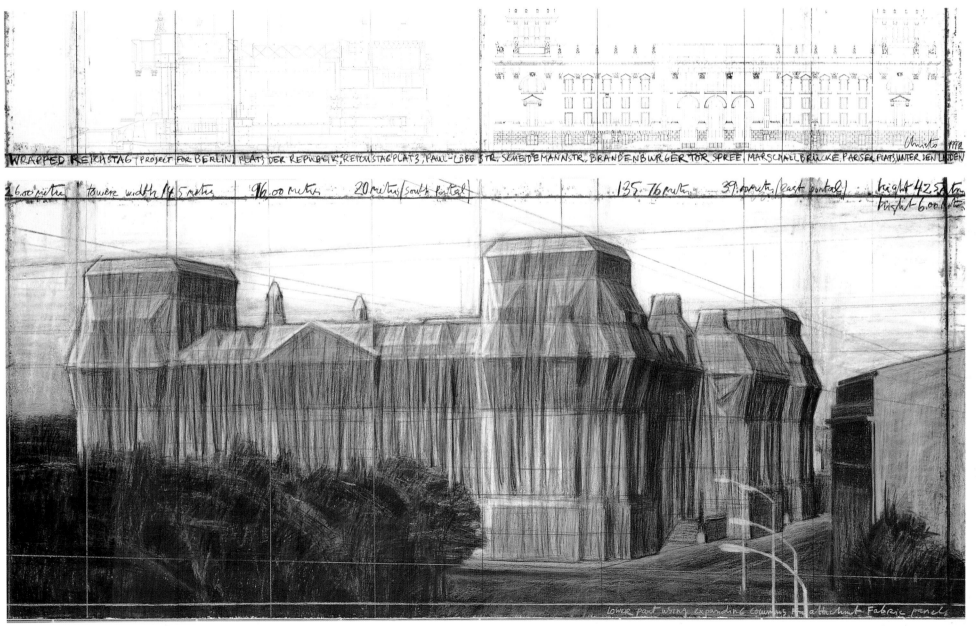

49

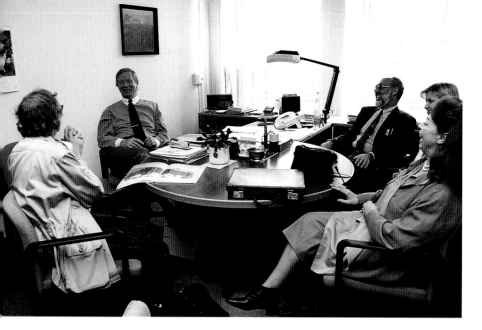

Klaus-Jürgen Hedrich (left, top) of the CDU welcomed the Christo team to his Bonn office in October 1993 and volunteered his support.

From a room in the Maritim-Hotel in Bonn-Bad Godesberg, where the team was staying, project co-director Wolfgang Volz (below) telephoned the offices of Bundestag members while Christo looked over a copy of *Kürschner*, a handbook of the German parliament. After every office presentation, the team asked the politician whether they could add his or her name to their list of supporters. They showed the current list, so the representative could see what other names were already there. Sometimes the member was ready to join immediately. At other times Volz made a follow-up call to ask about the decision. In this methodical way the list of supporters continued to grow.

Among politicians who refused to be listed, Joachim Schmidt (left, center) of the CDU informed the team in June 1993 that he opposed their project because he believed only permanent works could qualify as art. He played a tape of classical music to underscore his point. The Christos also encountered opposition from Foreign Minister Klaus Kinkel (left, bottom, holding a book), a member of the F.D.P., whom they met in October when all of them were guests on a television talk show. Kinkel let viewers know that he did not consider the wrapping a good idea.

Klaus-Jürgen Hedrich (oben links) von der CDU begrüßte das Christo-Team im Oktober 1993 in seinem Bonner Büro und bot seine Unterstützung an.

Von einem Zimmer im Hotel Maritim in Bonn-Bad Godesberg aus rief Wolfgang Volz (unten rechts), der Kodirektor des Projekts, weitere Abgeordnete an, während Christo im »Kürschner« blättert, dem Bundestagshandbuch, in dem alle Abgeordneten verzeichnet und abgebildet sind. Nach jedem Gespräch fragte das Team den jeweiligen Politiker, ob sein oder ihr Name auf die Liste der Befürworter gesetzt werden dürfe. Sie legten ihnen diese Liste vor, damit sie sehen konnten, wer schon darin verzeichnet war. Einige Abgeordnete erklärten sich sofort dazu bereit. In anderen Fällen fragte Volz telefonisch nach, wie die Entscheidung ausgefallen sei. Mittels dieser methodischen Vorgehensweise wurde die Liste immer länger.

Zu den Politikern, die sich nicht in die Liste aufnehmen lassen wollten, gehörte Joachim Schmidt (links, Mitte) von der CDU. Im Juni 1993 begründete er dem Team gegenüber seine ablehnende Haltung damit, daß er nur dauerhafte Werke als Kunst akzeptieren könne. Zur Bekräftigung seines Arguments spielte er ihnen klassische Musik vor. Auch bei Außenminister Klaus Kinkel von der F.D.P. (unten links) fanden die Christos kein Verständnis. Sie begegneten ihm im Oktober, als sie gemeinsam in einer Fernsehtalkshow zu Gast waren. Kinkel ließ das Publikum wissen, daß er die Verhüllung für keine gute Idee halte.

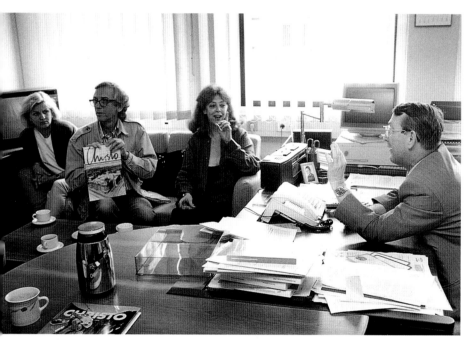

Sylvia Volz

**Wrapped Reichstag, Project for Berlin**
Collage 1992, in two parts:
66.7 x 77.5 cm and 66.7 x 30.5 cm
Pencil, fabric, twine, pastel, charcoal, crayon and map

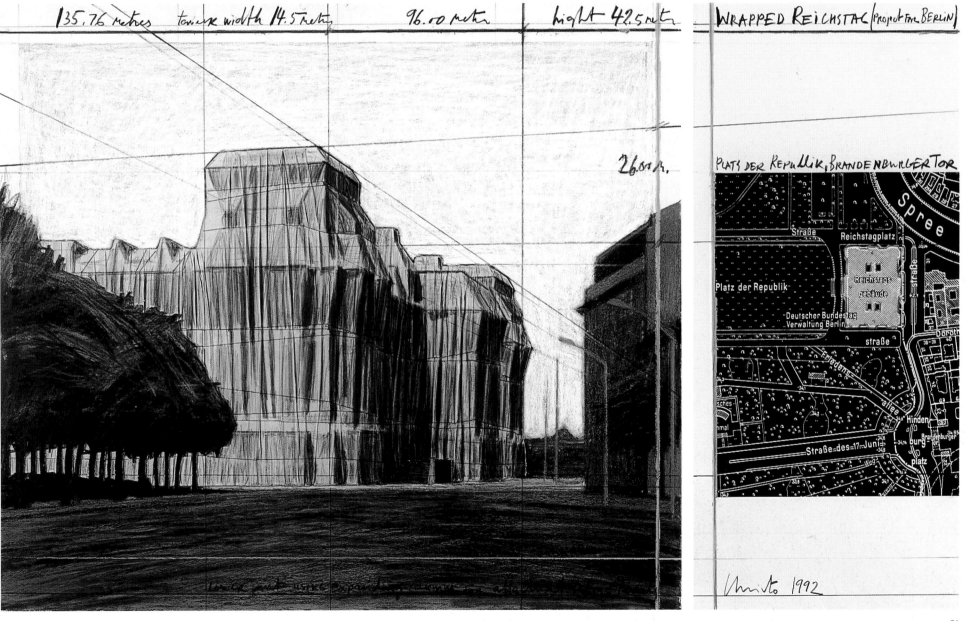

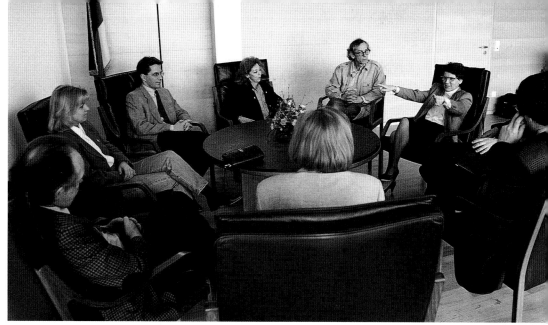

Gabriele Iwersen (left, top), an SPD member of the Bundestag, decided to support the project in September 1993. Earlier, in June, Rainer Eppelmann (left, center), an influential East German member of the CDU, helped round up the support of other East German members. Gerd Poppe (left, bottom) of the Green Party (Bündnis 90/Die Grünen) could not find office time to meet with the Christo team, so he invited them to his home in Berlin-Prenzlauer Berg.

Bundestag President Rita Süssmuth (above) tracked the artists' progress from her office in Bonn. In September, she was shown the fabric (below) that had been chosen in June. Christo incorporated a swatch of the fabric for the first time in one of his 1994 works (opposite).

Die SPD-Abgeordnete Gabriele Iwersen (oben links) entschloß sich im September 1993, das Projekt zu unterstützen. Schon im Juni hatte der einflußreiche CDU-Politiker Rainer Eppelmann (links, Mitte) den Christos zugesagt, auch bei anderen Parlamentariern aus der früheren DDR für das Projekt zu werben. Gerd Poppe (unten links) vom Bündnis 90/Die Grünen lud das Christo-Team in seine Wohnung am Prenzlauer Berg in Berlin ein. Von ihrem Bonner Büro aus verfolgte Bundestagspräsidentin Rita Süssmuth (oben rechts) die Fortschritte der Christos. Im September wurde ihr das Gewebe vorgestellt, für das sie sich im Juni entschieden hatten (unten rechts). In einer seiner Arbeiten von 1994 verwendete Christo zum ersten Mal ein Muster dieses Gewebes (gegenüberliegende Seite).

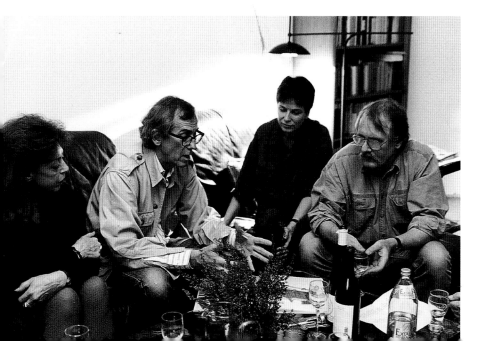

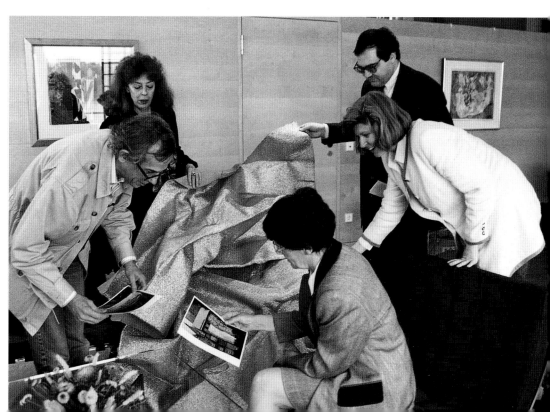

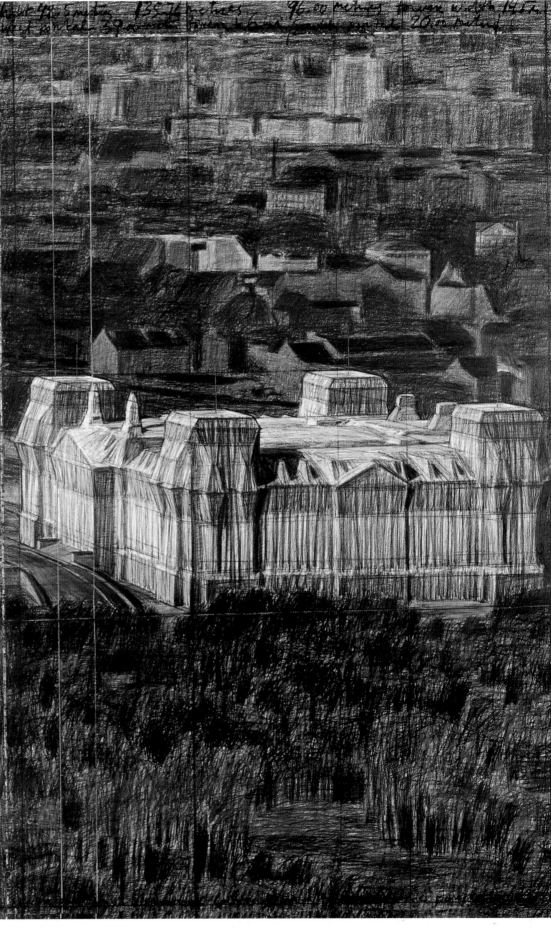

WRAPPED REICHSTAG (project for BERLIN) PLATS DER REPUBLIK, SPREE

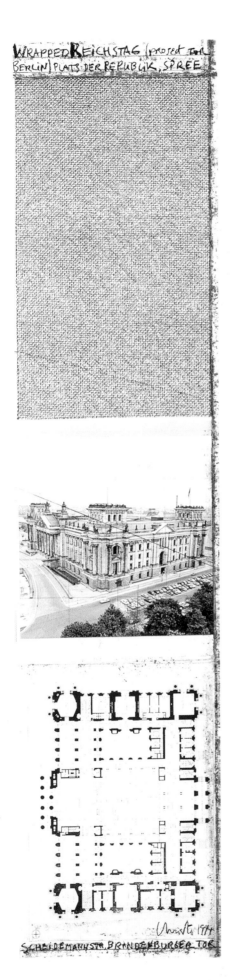

**Wrapped Reichstag,
Project for Berlin**

Drawing 1994, in two parts:
165 x 38 cm and 165 x 106.6 cm
Pencil, charcoal, pastel,
crayon, photograph by
Michael Cullen, architecture
plan, fabric sample and tape

SCHEIDEMANYSTR. BRANDENBURGER TOR

53

**Wrapped Reichstag,**
**Project for Berlin**
Drawing 1994, in two parts:
38 x 244 cm and 106.6 x 244 cm
Pencil, charcoal, photograph by
Wolfgang Volz, pastel, crayon,
aerial photograph, fabric sample
and tape

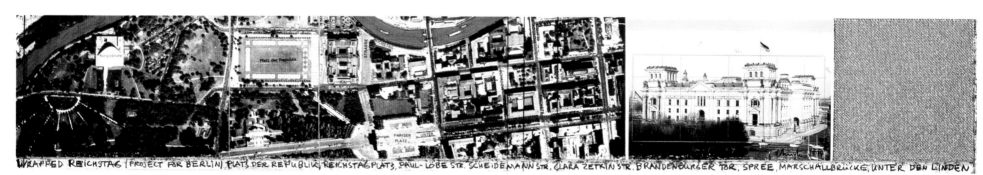

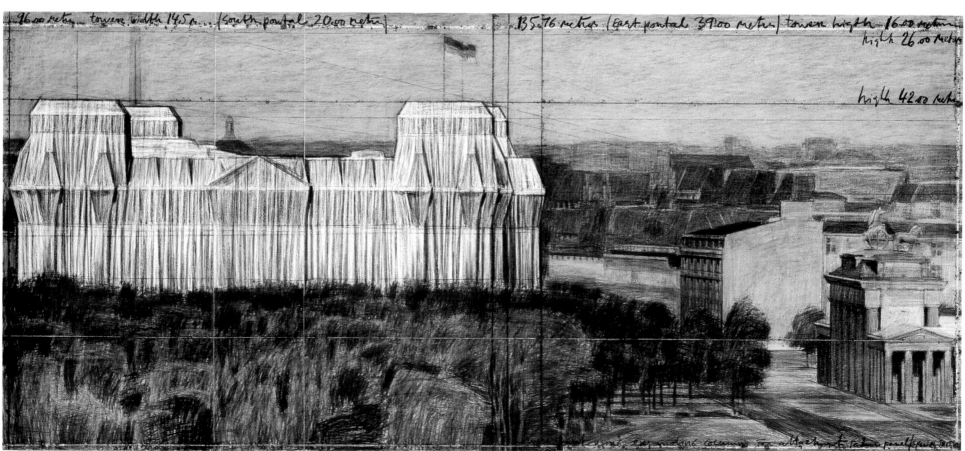

JEANNE-CLAUDE AND CHRISTO / 48 HOWARD STREET / NEW YORK CITY / NEW YORK / 10013 / U.S.A. / 212.966.44.37 AFTER 10:30A.M. / Fax: 1.212.966.2891

New York City, February 7th. 1994

The Aeltestenrat of the German Bundestag decided on February 3rd. that the
"WRAPPED REICHSTAG, PROJECT FOR BERLIN"
will be debated and voted upon in the Plaenum of the Bundestag on
FRIDAY, FEBRUARY 25th. 1994, at 9 in the morning, one hour session.

It will be the first time in the world that a work of art will be decided
by a vote in Parliament.

WE NEED YOUR HELP.

Please write a letter to your "Mitgleid des Deutschen Bundestages" in
your area, to firmly express your support of the project.

Also, please, ask all your friends around you to write to their "Mitgleid..."

If you do not know the name of your representative, and the address, you can
ask our friend Wolfgang Volz, he is the Project Manager and he has all those
informations.
His phone in Dusseldorf is: 0211- 666 331.
His Mobile phone: 0172- 215 15 10.
His Fax: 0211- 6790263

WE ARE COUNTING ON YOU TO HELP US. EACH VOTE IS CRUCIAL,
WE MUST GET A MAJORITY.

Jeanne-Claude                    Christo

---

DEAR ............,

THANKS TO YOUR WONDERFUL SUPPORT IN THE PAST MONTHS, WE ARE
VERY CLOSE TO RECEIVING PERMISSION FOR THE "WRAPPED REICHSTAG,
PROJECT FOR BERLIN."

ONCE MORE, WE ASK FOR YOUR SUPPORT BY BEING PRESENT AT THE
BUNDESTAG ON FRIDAY FEBRUARY 25TH , 1994 AT 9 O'CLOCK IN THE
MORNING BECAUSE YOUR VOTE IS CRUCIAL TO OBTAINING THE MAJORITY.

**WE ARE COUNTING ON YOUR PRESENCE AT THE PLAENUM**

WHATEVER DECISION IS TAKEN ABOUT THE " VERHÜLLTER REICHSTAG",
TOGETHER WE WILL HAVE ENLIGHTENED EUROPE AND THE WORLD ABOUT
TODAY'S GERMANY :

WE BELIEVE WE CAN WIN BUT WE CAN NOT DO IT WITHOUT YOUR VOTE

WITH MOST FRIENDLY THOUGHTS,

JEANNE-CLAUDE        AND        CHRISTO

---

# Deutscher Bundestag

## Stenographischer Bericht

## 211. Sitzung

### Bonn, Freitag, den 25. Februar 1994

### Inhalt:

**Tagesordnungspunkt 9:**

Beratung des Antrags der Abgeordneten Johannes Gerster (Mainz), Heribert Scharrenbroich, Peter Kittelmann, Dr. Peter Struck, Peter Conradi, Freimut Duve, Manfred Richter (Bremerhaven), Ina Albowitz, Uwe Lühr, Andrea Lederer, Werner Schulz (Berlin) und weiterer Abgeordneter
**Verhüllter Reichstag — Projekt für Berlin** (Drucksache 12/6767)

| | |
|---|---|
| Peter Conradi SPD | 18275 B |
| Dr. Burkhard Hirsch F.D.P. | 18278 A |
| Heribert Scharrenbroich CDU/CSU | 18278 D |
| Dr. Dietmar Keller PDS/Linke Liste | 18280 C |
| Konrad Weiß (Berlin) BÜNDNIS 90/DIE GRÜNEN | 18281 B |
| Manfred Richter (Bremerhaven) F.D.P. | 18282 A |
| Dr. Wolfgang Schäuble CDU/CSU | 18283 A |
| Eike Ebert SPD | 18286 A |
| Dr. Ulrich Briefs fraktionslos | 18287 B |
| Freimut Duve SPD | 18287 D |
| Namentliche Abstimmung | 18288 C |
| Ergebnis | 18294 A |

**Tagesordnungspunkt 10:**

Beratung der Unterrichtung durch die Bundesregierung: **Erster Altenbericht der Bundesregierung** (Drucksache 12/5897)

| | |
|---|---|
| Hannelore Rönsch, Bundesministerin BMFuS | 18289 A |
| Lieselott Blunck (Uetersen) SPD | 18290 D |
| Walter Link (Diepholz) CDU/CSU | 18291 B, 18305 D |
| Dr. Barbara Höll PDS/Linke Liste | 18291 C |
| Klaus Riegert CDU/CSU | 18292 C |
| Arne Fuhrmann SPD | 18296 A |
| Erika Reinhardt CDU/CSU | 18298 D |
| Hans A. Engelhard F.D.P. | 18300 D |
| Dr. Barbara Höll PDS/Linke Liste | 18302 C |
| Dr. Wolfgang Ullmann BÜNDNIS 90/DIE GRÜNEN | 18304 A |
| Lisa Seuster SPD | 18305 C |
| Walter Link (Diepholz) CDU/CSU | 18308 B |
| Winfried Fockenberg CDU/CSU | 18310 B |
| Dr. Rudolf Karl Krause (Bonese) fraktionslos | 18311 B |

**Tagesordnungspunkt 11:**

a) Erste Beratung des von der Bundesregierung eingebrachten Entwurfs eines Gesetzes über Sicherheit und Gesundheitsschutz bei der Arbeit **(Arbeitsschutzrahmengesetz)** (Drucksache 12/6752)

b) Beratung der Unterrichtung durch die Bundesregierung
Bericht der Bundesregierung über den Stand der Unfallverhütung und das Unfallgeschehen in der Bundesrepublik Deutschland: **Unfallverhütungsbericht 1992** (Drucksache 12/6429)

| | |
|---|---|
| Horst Günther, Parl. Staatssekretär BMA | 18312 B |
| Manfred Reimann SPD | 18313 B |

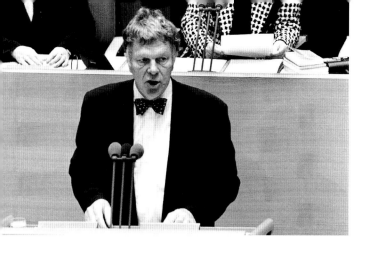

Peter Conradi (SPD) was the first speaker in the February 25, 1994 parliamentary session. He argued in favor of the project.

Peter Conradi (SPD) trat am 25. Februar 1994 als erster ans Rednerpult. Er sprach sich für das Projekt aus.

Konrad Weiss (Bündnis 90/Die Grünen) spoke eloquently in favor of the art project.

Konrad Weiß (Bündnis 90/Die Grünen) setzte sich eloquent für das Kunstprojekt ein.

All photos: Aleksander ▶

Burkhard Hirsch (F.D.P.) spoke against the project. He had been the most persistent opponent since the 1970s.

Burkhard Hirsch (F.D.P.) sprach sich gegen das Projekt aus. Er war seit den siebziger Jahren einer der hartnäckigsten Gegner der Reichstagsverhüllung gewesen.

Wolfgang Schäuble, speaking.

Wolfgang Schäuble bei seiner Rede.

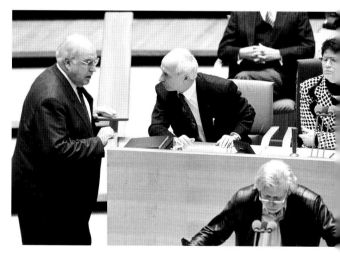

Heribert Scharrenbroich (CDU/CSU) violated house rules by displaying an exhibit – in this case, a sample of the fabric.

Heribert Scharrenbroich (CDU/CSU) verstieß gegen die parlamentarischen Gepflogenheiten, als er ein Gewebemuster zeigte.

During Ulrichs Briefs' speech chancellor Kohl approached the presidential dais to influence the sequence of speakers with Hermann Pohler (CDU). Although the "pro" and "anti" forces had vied to have the closing speech, the last two speeches were both "pro".

Während der Rede von Ulrich Briefs versuchte Bundeskanzler Kohl auf Hermann Pohler (CDU) einzureden, um eine andere Rednerfolge durchzusetzen. Die letzten beiden Reden wurden von Vertretern der »pro«-Seite gehalten, obwohl sowohl die »pro«- als auch die »kontra«-Kräfte um die abschließende Rede gewetteifert hatten.

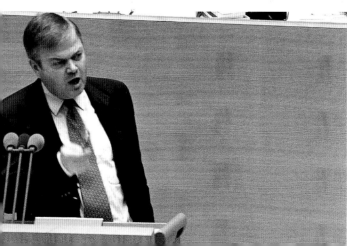

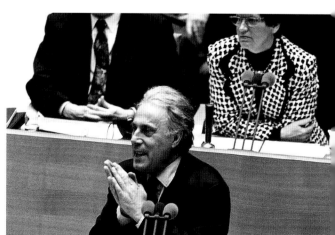

Eike Ebert (SPD) spoke out against the project.

Eike Ebert (SPD) sprach sich gegen das Projekt aus.

Freimut Duve (SPD), the last speaker, brought the debate to a rousing conclusion by urging his colleagues to vote "yes."

Freimut Duve (SPD), der letzte Redner, setzte der Debatte ein mitreißendes Ende und appellierte an seine Kollegen, mit »Ja« zu stimmen.

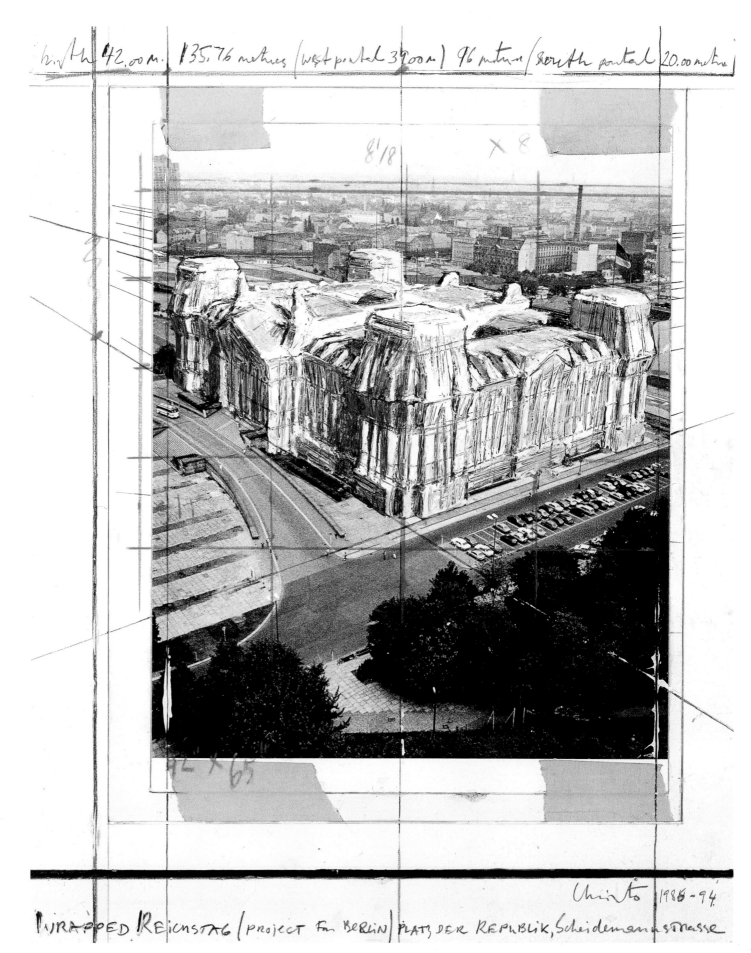

**Wrapped Reichstag,
Project for Berlin**
Collage 1986–94,
35.5 x 28 cm,
pencil, enamel paint, photograph
by Michael Cullen, charcoal,
crayon and tape

**Wrapped Reichstag, Project for Berlin**
Drawing 1994, in two parts: 38 x 165 cm and 106.6 x 165 cm, pencil, charcoal, pastel, crayon, fabric sample and map

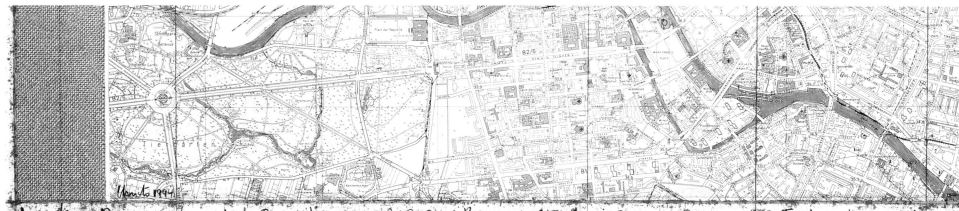

WRAPPED REICHSTAG (PROJECT FOR BERLIN) PLATЗ DER REPUBLIK, REICHSTAG PLATЗ, SCHEIDEMANNSTR, BRANDENBURGER TOR, SPREE, UNTER DEN LINDEN

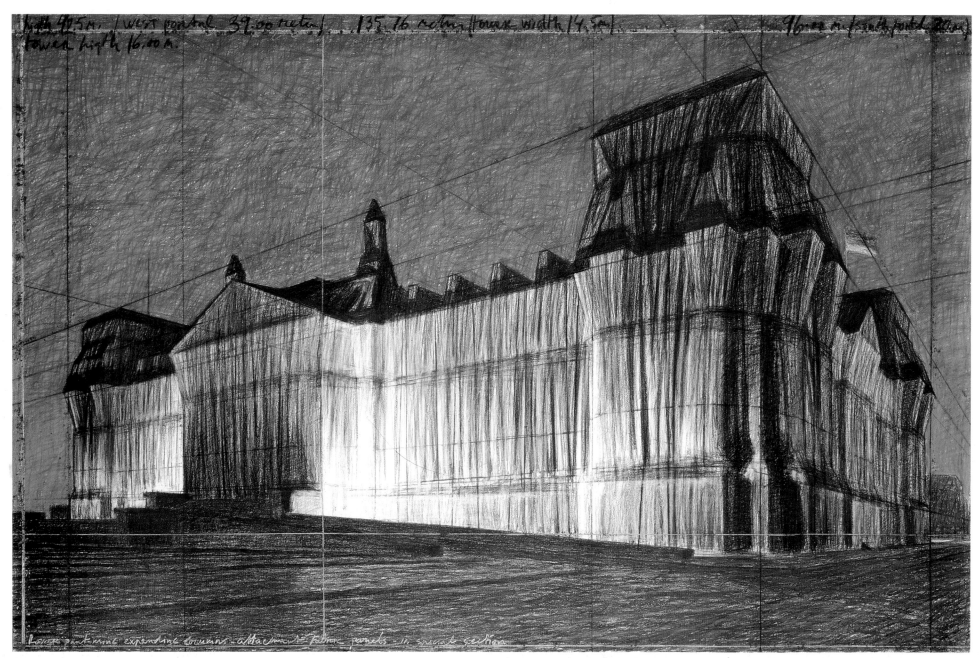

58

In its 211th full plenary session on February 25, 1994, the Bundestag debated the *Wrapped Reichstag* project for over an hour before the votes were cast: 292 in favor, 223 against, with 9 abstentions and 1 invalid vote. The high attendance (525 members) had been exceeded on only a very few occasions in the previous decade.

Das Plenum des Deutschen Bundestags debattierte am 25. Februar 1994 in seiner 211. Sitzung über eine Stunde das Projekt *Verhüllter Reichstag*, bevor die Stimmen abgegeben wurden: 292 Stimmen für das Projekt, 223 Gegenstimmen, 9 Enthaltungen, 1 ungültige Stimme. Die Sitzungsbeteiligung – 525 Abgeordnete waren anwesend – wurde in den letzten zehn Jahren nur selten übertroffen.

Aleksander Perković

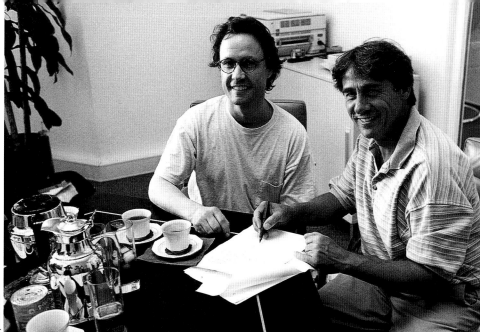

Sylvia Volz

Peter Raue (above, left), a Berlin-based lawyer, and Scott Hodes, a Chicago-based lawyer, went over the final details of the incorporation papers for the"Verhüllter Reichstag GmbH" in Roland Specker's Berlin office on May 8, 1994. The German company, a subsidiary of the C.V.J.Corporation in the U.S.A., was founded with the specific mission of wrapping the Reichstag. Hodes has represented C.V.J. – the artists' main firm – for more than 30 years.
Wolfgang Volz and Roland Specker (above, right), co-presidents of the newly formed company, signed the contract. Volz took charge of technical and construction matters, Specker handled the administrative end. Sylvia Volz, Bruno Zahner (a site assistant to Christo) and the artist (below) attended the contract signing.

Peter Raue (links oben), ein Anwalt aus Berlin, und Scott Hodes, Anwalt aus Chicago, besprachen am 8. Mai 1994 in Roland Speckers Berliner Büro die letzten Details der Registrierungspapiere der »Verhüllter Reichstag GmbH«, einer speziell zur Durchführung des Projekts gegründeten Tochtergesellschaft der amerikanischen C.V.J. Corporation. Hodes repräsentiert die C.V.J. Corporation – die juristische Dachgesellschaft für die Projekte der Künstler – seit mehr als dreißig Jahren.
Wolfgang Volz und Roland Specker (rechts oben), die Geschäftsführer der neu gegründeten Gesellschaft, unterzeichneten den Vertrag. Volz war für den technischen Bereich verantwortlich, Specker für die Verwaltung. Sylvia Volz, Bruno Zahner (ein technischer Assistent Christos) und der Künstler (unten) waren bei der Vertragsunterzeichnung zugegen.

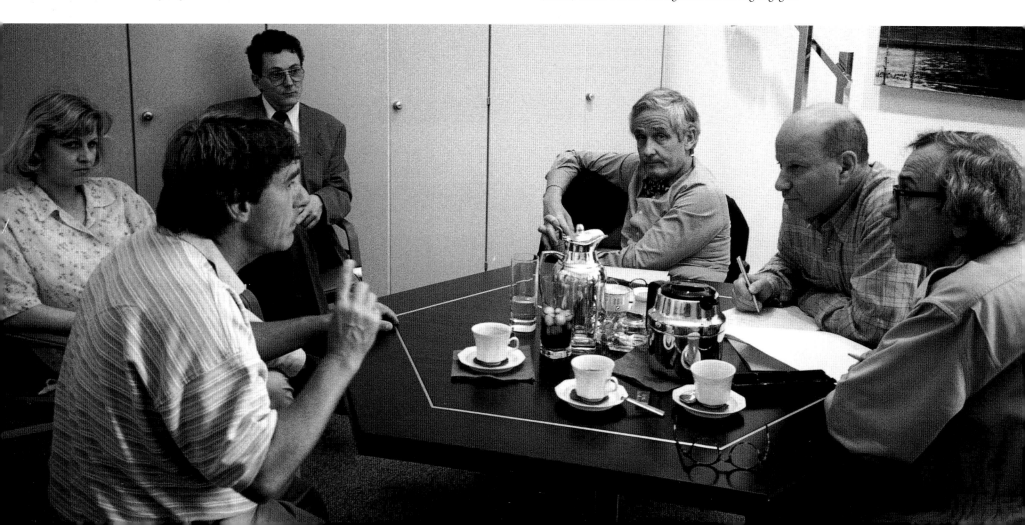

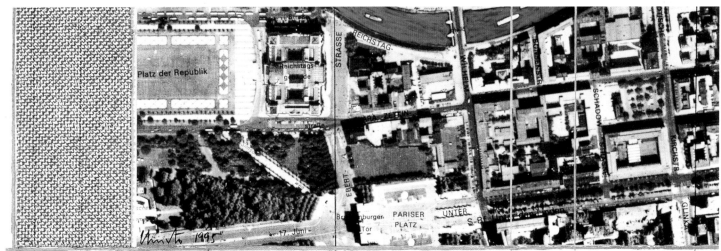

WRAPPED REICHSTAG (PROJECT FOR BERLIN) PLATS DER REPUBLIK, REICHSTAGPLATZ, SPRE, EBERTSTR. TIERGARTEN

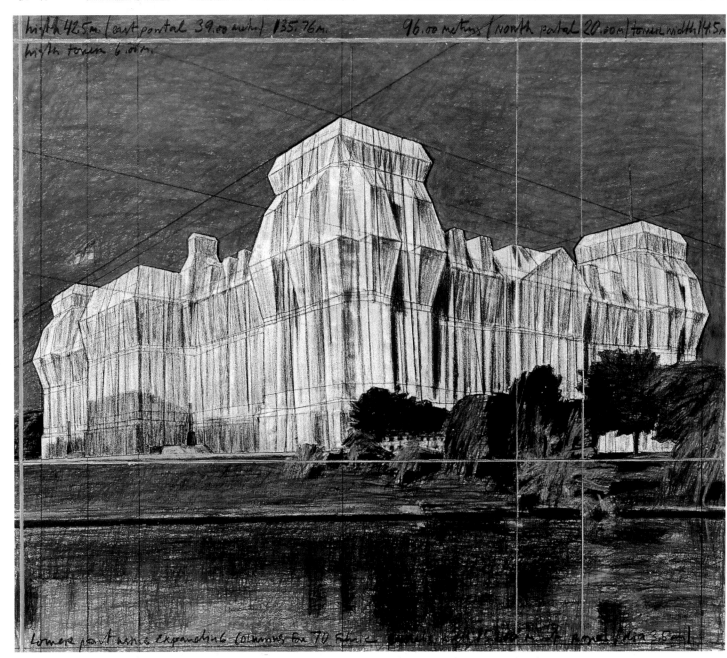

**Wrapped Reichstag,
Project for Berlin**

Collage 1995, in two parts:
30.5 x 77.5 cm and 66.7 x 77.5 cm
Pencil, fabric, twine, pastel, charcoal, crayon, aerial photograph
and fabric sample

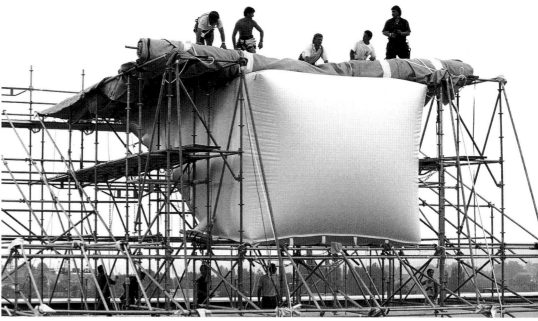

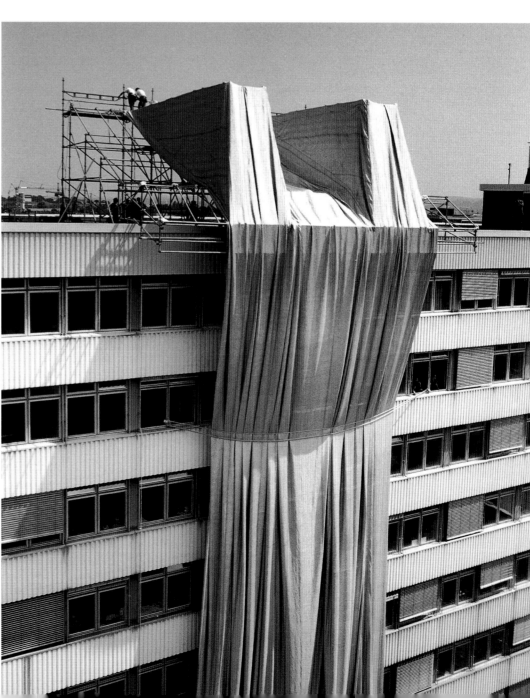

## Test Wrapping in Southern Germany

In July 1994 the Christos and members of their American team met with staff members of IPL in Radolfzell to discuss various design developments. Jeanne-Claude and Hartmut Ayrle (far left, top) discussed the folds she had sewn on the fabric section example. The orderly unfurling of the fabric was planned by nearly everyone involved (far left, center), including Christo, Hans-Jürgen Weisser, Hartmut Ayrle, Wolfgang Renner, Roland Gerster (who co-headed the company with Renner) and Jeanne-Claude. Hartmut Ayrle (far left, bottom) offered his advice on the unfurling procedure as Christo and his American consulting engineers, Vince Davenport and Dimiter Zagoroff, looked on. The IPL team conducted a test unfurling atop the roof of a building in Konstanz, about 20 kilometers southeast of Radolfzell. They first constructed a framework of steel pipes, creating a three-dimensional form that corresponded to the angular configuration of the Reichstag's roof. Then they inflated a large air cushion (near left, top), designed to fill out the space between the two "ears." With Christo's idea to use inflated air cushions to provide a flat top surface, the workers were finally able to unroll the fabric over the edge of the roof (near left, bottom). From the rooftop of a nearby building, the Christos and their associates (below) assessed the results of the test unfurling.

The test enabled the team to finalize the installation procedure, to choose the diameter of the rope and to estimate what kind and how many attachments were needed and what size was best for the overlapping folds.

## Testverhüllung in Süddeutschland

Im Juli 1994 trafen sich die Christos und Mitglieder ihres amerikanischen Teams mit Mitarbeitern von IPL in Radolfzell, um verschiedene Planungsentwicklungen zu erörtern. Jeanne-Claude und Hartmut Ayrle (links, oben) erörterten die Falten auf dem von ihr genähten Stoffmuster. Fast alle daran Beteiligten – darunter Christo, Hans-Jürgen Weisser, Hartmut Ayrle, Wolfgang Renner, Roland Gerster (der die Firma zusammen mit Renner leitete) und Jeanne-Claude – spielten die planmäßige Entrollung des Gewebes durch (links, Mitte). Unter den wachsamen Blicken Christos und seiner amerikanischen Ratgeber, der Ingenieure Vince Davenport und Dimiter Zagoroff, gab Hartmut Ayrle (links, unten) seine Ratschläge zum Entfaltungsprozeß.

Auf dem Dach eines Gebäudes in Konstanz führte das IPL-Team eine Testentfaltung durch. Zunächst konstruierten sie ein Stahlrohrgerüst, eine dreidimensionale Form, die dem Aufbau des Reichstagsdachs entsprach. Dann wurde ein großes Luftkissen aufgeblasen (oben rechts), das den Raum zwischen den beiden »Ohren« ausfüllte. Mit Hilfe der aufgeblasenen Luftkissen – einer Idee Christos – wurde eine ebene Dachoberfläche erreicht, so daß die Arbeiter das Gewebe über den Rand des Daches entrollen konnten (unten rechts). Vom Dach eines nahe gelegenen Gebäudes aus beurteilten die Christos und ihre Mitarbeiter die Ergebnisse der Testentfaltung (unten).

Anhand der Testergebnisse konnte das Team das Installationsverfahren festlegen, die Stärke der Seile bestimmen und die Art und Anzahl der benötigten Befestigungen sowie die optimale Größe für die einander überlappenden Falten einschätzen.

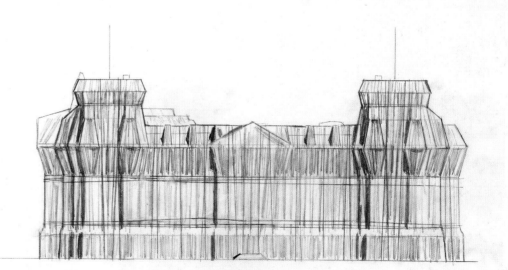

"WRAPPED REICHSTAG (PROJECT FOR BERLIN)     Christo 1994

SOUTH          1:250

**Wrapped Reichstag,**
**Project for Berlin**
Collaged drawing 1994
56 x 71 cm
Pencil, tracing paper and tape

Textile executive Stephan Schilgen and his colleague Ute Heimsoth, at the Düsseldorf studio of Wolfgang Volz, discussed the purchase order of the fabric in August 1994. Although none of the building permits had been obtained, the purchase order had to be placed in advance to allow sufficient manufacturing time. Between August and February, Schilgen wove 109,400 square meters of the fabric, two rolls at a time on a wide machine.

Im August 1994 besprachen der Textilunternehmer Stephan Schilgen und seine Kollegin Ute Heimsoth im Düsseldorfer Studio von Wolfgang Volz den Kaufauftrag für das Gewebe. Obwohl noch keine Baugenehmigungen vorlagen, mußte der Kaufauftrag im voraus erteilt werden, um mit der Fertigung nicht in Verzug zu kommen. Von August bis Februar wurden in der J. Schilgen GmbH & Co. 109.400 Quadratmeter des Verhüllungsgewebes hergestellt, jeweils zwei Rollen gleichzeitig auf einer breiten Maschine.

Sylvia Volz

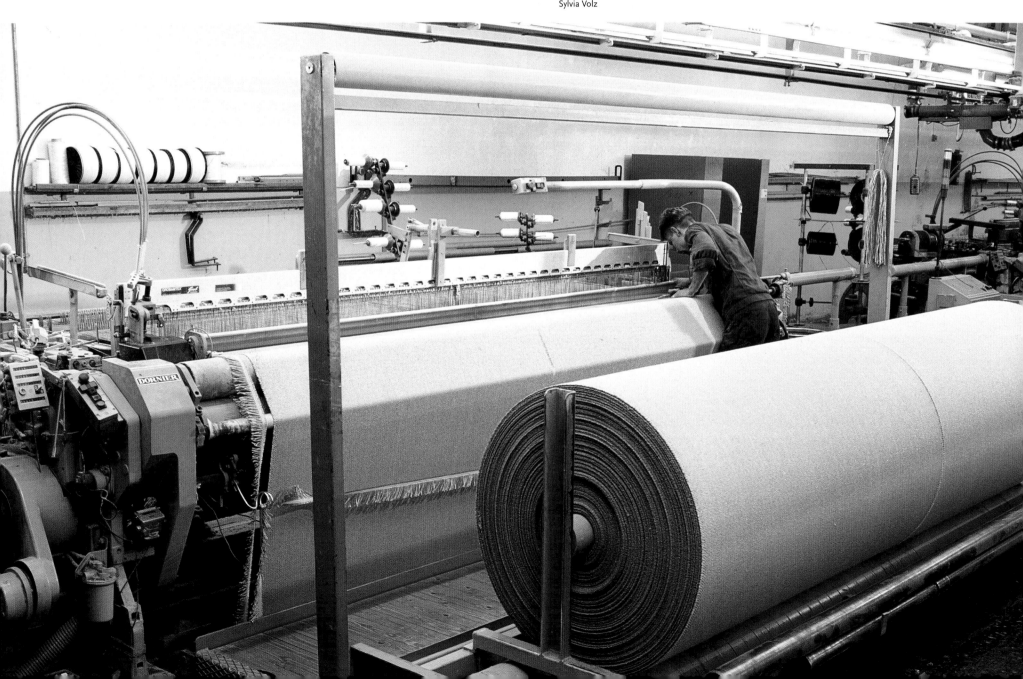

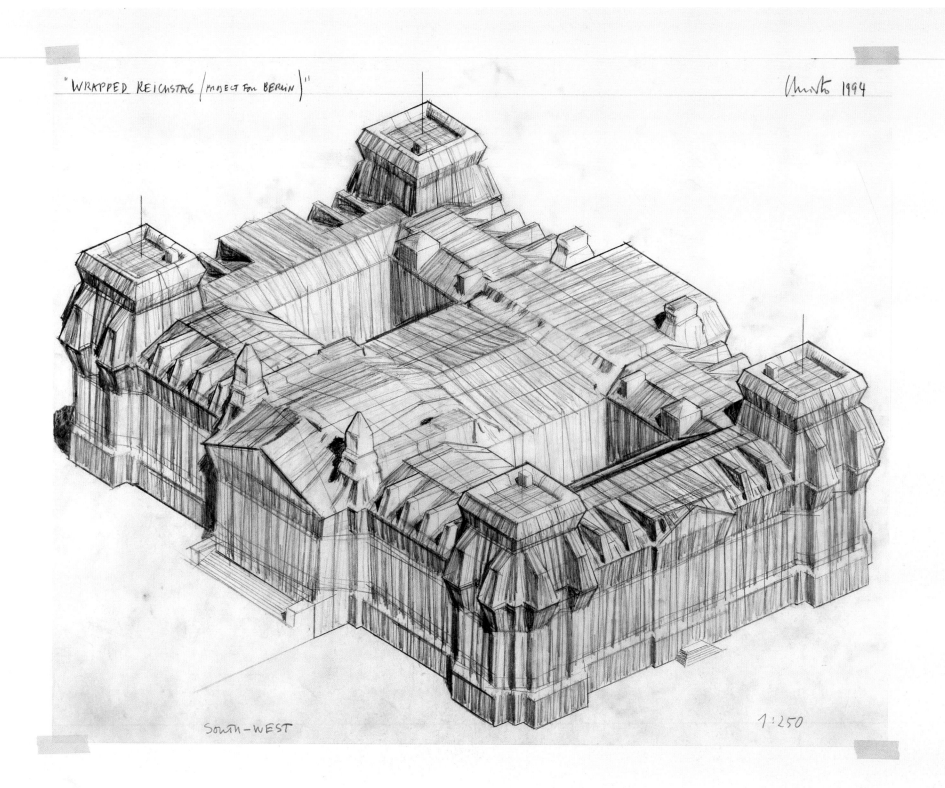

"WRAPPED REICHSTAG (PROJECT FOR BERLIN)"

Christo 1994

SOUTH-WEST

1:250

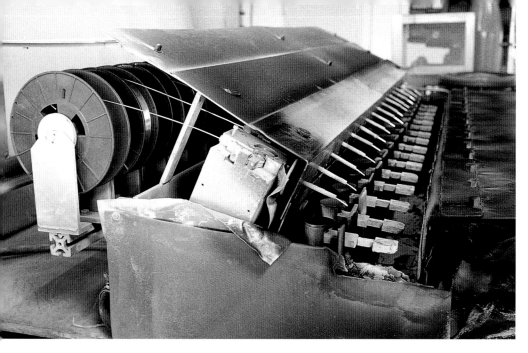

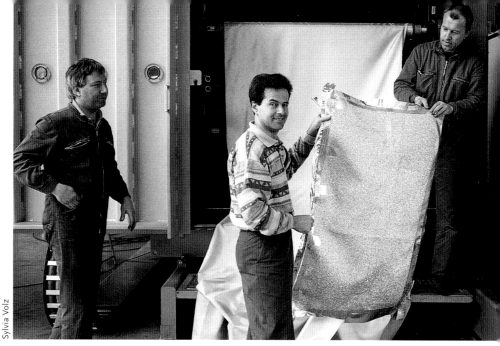

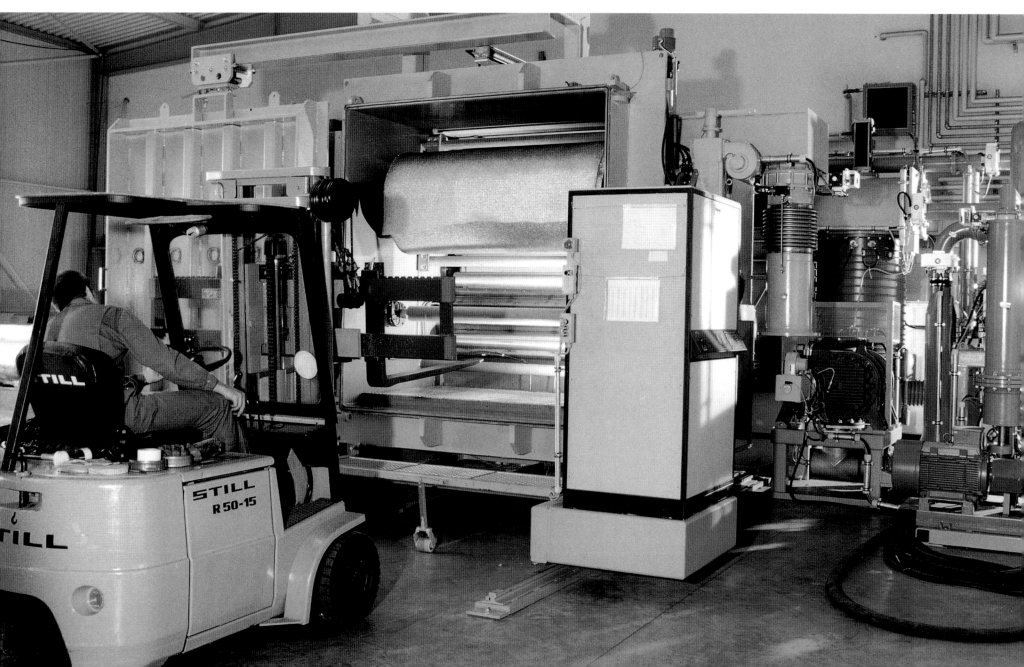

## Aluminizing the Fabric

Rowo-Coating Gesellschaft für Beschichtung mbH in Herbolzheim aluminized the woven gray fabric in a vacuum chamber, using a process called Anodic Arc Evaporation. Rolls of aluminum wire (far left, top) were vaporized, and their vapor was then evenly distributed on the surface of the fabric which passed through the vacuum chamber at a speed of 150 meters per minute. The deposited layer of aluminum was so thin that only four kilograms of the metal were needed to aluminize all 109,400 square meters of fabric. Rolf Schmidt, Wolfgang Siefert and Roland Müller (near left, top) ran a test piece before the first production roll of fabric was aluminized. A forklift (left, bottom) pulled the first production rolls out of the vacuum chamber.

## Das Gewebe wird aluminisiert

Nach dem anodischen Lichtbogenverdampfverfahren wurde das graue Gewebe bei der Rowo-Coating Gesellschaft für Beschichtung mbH in Herbolzheim in einer Vakuumkammer mit Aluminium beschichtet. Aluminiumdrahtrollen (ganz links, oben) wurden vaporisiert, und der Aluminiumdampf wurde dann gleichmäßig auf die Oberfläche des Gewebes verteilt, das mit einer Geschwindigkeit von 150 Metern pro Minute durch die Vakuumkammer geführt wurde. Die aufgedampfte Aluminiumschicht war so dünn, daß für die ganzen 109.400 Quadratmeter des Gewebes nur vier Kilogramm Aluminium benötigt wurden. Rolf Schmidt, Wolfgang Siefert und Roland Müller (links oben) führten einen Testdurchlauf durch, bevor die erste Geweberolle aluminisiert wurde. Ein Gabelstapler (unten links) holte die ersten beschichteten Rollen aus der Vakuumkammer.

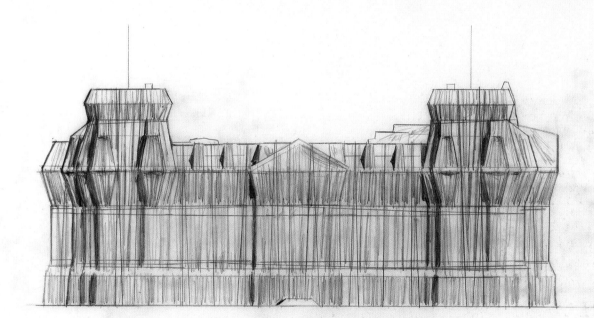

"WRAPPED REICHSTAG (Project for BERLIN)"

Christo 1994

NORTH          1:250

**Wrapped Reichstag,
Project for Berlin**
Collaged drawing 1994
56 x 71 cm
Pencil, tracing paper and tape

Wolfgang Volz made an initial presentation of the fabric (above, left) for the first time to officials of the Tiergarten district, in which the Reichstag is situated, on March 18, 1994. His audience included (to his right) Johann Schilcher (the appointed head of the Tiergarten's building department), Gabriele Müller and Guntolf Gehlhaar (both municipal employees) and Hans Schütz (in charge of the Tiergarten's permitting agency). Schilcher expedited the permitting process by organizing a series of meetings that coordinated matters concerning the fire and police departments, such as traffic management, safety and first aid. On May 17, Tiergarten officials convened with representatives from other agencies in the Reichstag's Assembly room (below) in the southwest tower after touring the roof of the building. They discussed fire-safety requirements and required that all glass areas on the roof would have to be covered with wooden planks. In September, Tiergarten officials agreed that no permits for commercial activities would be granted for the vicinity of the Reichstag during its wrapping.

Am 18. März 1994 präsentierte Wolfgang Volz zum ersten Mal den Beamten des Bezirks Tiergarten, in dem der Reichstag liegt, ein Gewebemuster (links oben). Zu den Anwesenden gehörten (zu seiner Rechten) Johann Schilcher (der neu ernannte Bauamtsleiter des Bezirks Tiergarten), die Kommunalbediensteten Gabriele Müller und Guntolf Gehlhaar sowie Hans Schütz (für die Genehmigungsbehörde des Bezirks). Schilcher beschleunigte das Genehmigungsverfahren, indem er eine Folge von Sitzungen mit Vertretern der Feuerwehr und der Polizei organisierte, in denen Fragen zur Verkehrsführung, sicherheitstechnische und rettungsdienstliche Fragen koordiniert besprochen wurden. Am 17. Mai trafen sich Vertreter des Bezirksamts Tiergarten mit Repräsentanten anderer Behörden im Versammlungssaal im Südwestturm des Reichstags (unten), nachdem sie das Dach des Gebäudes inspiziert hatten. Sie erörterten Brandschutzmaßnahmen und forderten, daß alle gläsernen Bereiche auf dem Dach mit Holzplanken bedeckt werden sollten. Im September stimmte das Bezirksamt Tiergarten der Forderung der Christos zu, daß während der Reichstagsverhüllung für die nähere Umgebung des Gebäudes keine Konzessionen für kommerzielle Aktivitäten erteilt werden sollten.

"WRAPPED REICHSTAG (PROJECT FOR BERLIN) Christo 1994

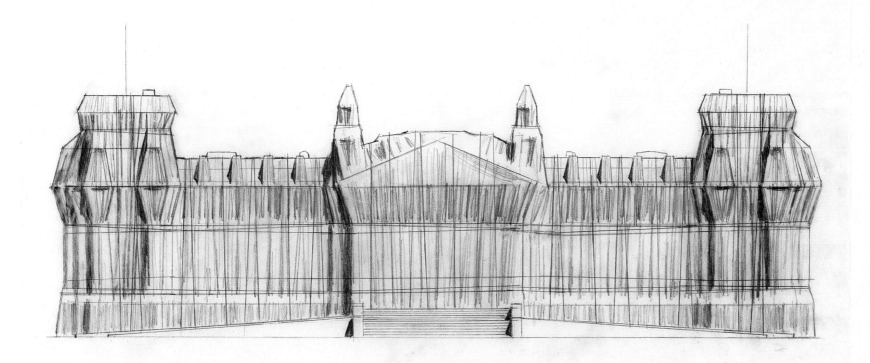

1:250

WEST

**Wrapped Reichstag,**
**Project for Berlin**
Drawing 1995, in two parts:
38 x 244 cm and 106.6 x 244 cm
Pencil, charcoal, pastel, crayon,
map, technical data and fabric
sample

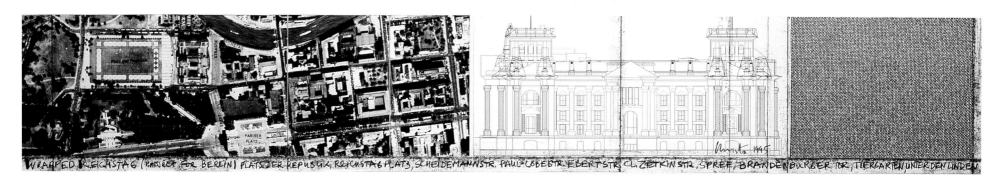

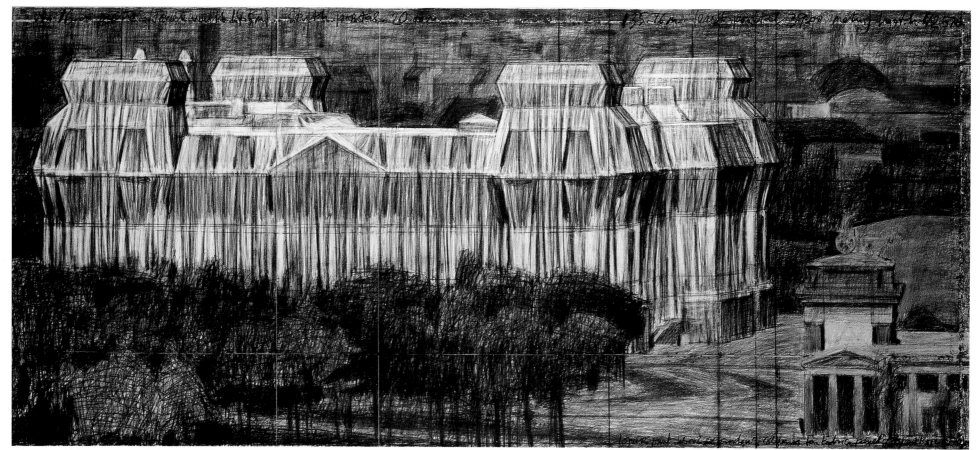

## Verhüllter Reichstag, Projekt für Berlin
### Weekly Report by Wolfi

**Monday, October 24th, 1994**

**8:00**
Quick visit to Spreewaldplanen in Vetschau, one of the potential sewing companies to ask them to quickly sew a piece of vertical connection for testing at BAM.

**13:00**
Meeting at the Bezirksamt Tiergarten about the safety of all the workers involved. There was special emphasis on the professional climbers, since there is an ongoing controversy between the organization, who represents the construction workers (members of them present) and the climbers about the education and proof of abilities. These climbers even though professional are a little more individualistic than the regular construction worker and therefor more difficult to fit into a organization. It was clarified, that all future procedures for the safety of the workers will be coordinated with those organizations and for the training they will also be consulted.

**14:30**
Visit to BAM with the material from Spreewald to convince them to test it as soon as they can.

**Tuesday, October 25th, 1994**

**10:00**
Mr. Müller-Nicholson, Mr. Knabben come to office to present their idea about a audio-visual production for museums.

**11:00**
Mr. Johanesson from NRW Werbung comes to office to talk about the realization of the photo of Christo and Jeanne-Claude, Stefan Schilgen with the model and fabric for the ad for the state of Northrhein Westfalia.

**12:00**
Mrs. Stampehl of Blueband Hotels comes to office to present their hotels and talk about an offer.

**13:00**
Frau Meier from BZ comes to the office to interview Wolfi and Sylvie for an article about the office.

**15:00**
Mr. Eilenberger and Mr. Winkler form the sewing company Zeltaplan come to the office to discuss their offer to us in the presence of Mr. Mann and Mr. Zaumseil. This is the last of the sewing-companies to visit us. They (5) will all now produce two types of samples for their sewing to prove their capabilities, which will also be tested at BAM at their cost. After that based on the results and all other information we will be ready for a decision.

**Wednesday, October 26th, 1994**

**13:00**
The materials are ready for testing at BAM and S.+W. are present at the test to find out how the two samples for the vertical connection act under the test for flame-retardancy. The first sample tested is a connection with only one vertical belt sewn out of the actual wrapping fabric attached. This sample performs very well and burns only 1/3. The temperature of the smoke and it's contents passes the test. The second sample with one additional belt of same kind does not pass the test. But we have one which works. Hurray.
The German Dome, just renovated and almost finished burns down inside. It was going to be the home of the exhibition which is now inside the Reichstag.

---

## Verhüllter Reichstag, Projekt für Berlin
### Weekly Report by Wolfi

**Week from October 30th - November 5th 1994**

**Tuesday, November 1st:**

The kestrel on the Reichstag comes back into our life through a fax from the Naturschutzbund, an environmental protection organization threatening to sue us for setting the date in June/July. This is the time when the young kestrels on the north/west tower are still in the nest and the parents will be driven away by the activities of the steelworks and the wrapping.

**Wednesday, November 2nd:**

10:00 Meeting with the people from Tiergarten in our office - their first visit here. Subject is the birds on the Reichstag. Also present is Mr. Braun head of the Foster-office explaining their activities, which clearly will drive the kestrel away sooner or later anyway.

11:30 Hartmut Ayrle, Sylvie and I visit the mason, who on this day starts the test for the sandstone of the building. He has installed a piece of our fabric hanging in folds in front of a real piece of sandstone from the Reichstag. A big blower sends wind to the assembly - beaufort force 6-8. We look, film and photograph.

15:30 Meeting at Tiergarten with Mr. Christian Muhs, Berlin's highest protector of the environment. The meeting is again about the birds with the kestrel especially. He wants to find out, whether the bird is not already forced out by the asbestos-removal. If not there is the possibility to issue a special permit to prevent the bird to nest in this spot. He explains that not only the bird but also the nest is protected by European law. Also he says, that whatever he does can be challenged by about 10 licensed organizations in Berlin. The can sue him at the European court.

**Thursday November 3rd:**

Jörg Tritthard calls and tells me that one of the sewing companies is concerned, whether handling and sewing of the fabric can be hazardous to the health. Frantic phonecalls back and forth with the result that as far as the research stands there is no reason for concern. Later again Jörg calls and indicates that there is a serious problem with the edges of the fabric. The way the seam is designed there is a possibility that it will be necessary to cut the edges again at the sewing factory by hand, which would be extremely costly and time-consuming. Schilgen is not able to cut the sides more precisely. The problem is solved at 15:00 by a little drawing I make and fax to Jörg indicating that we only have to fold the sides 0.5 centimeters more and still put the 3 seams in the middle.

**Friday, November 4th:**

11:00 Meeting with Mr. Fürneisen of the Bundesbaugesellschaft to show him the plans for the application for the building permit. The meeting starts with a long talk about the kestrel, a concern for them as well. There is total agreement that their activities will expel the bird for the next 5 years if not forever. He says that he will not let us stand in the rain, but support us. I explain all the plans to him and he is very happy with everything, purring like a pussycat. What a change.

15:00 Roland and I conclude, that if the environmentalists will sue the argument has to be that if the Wrapping will be stopped the Bundesbaugesellschaft will start their activities 2 months earlier and drive the bird away just the same.

---

## Verhüllter Reichstag, Projekt für Berlin
### Weekly Report by Wolfi

**13. November 1994**

**Monday, November 7th, 1994**

10:00 The test to show if there is any abrasion on the sandstone or on the fabric conducted by Mr. Engler is finished. The conclusion is that there is nothing to worry about what so ever.

13:00 Mr. Braun is at the office to offer his service to us to enter a hypertext-page about the project on internet. It does sound interesting, but further talks are necessary to confirm, whether he is capable to do this in a proper manner. This would open a completely new way to do research about the project worldwide on internet, where we could be sure, that the researcher gets correct information.

**Tuesday, November 8th, 1994**

10:00 Roland and I meet with Mr. Muhs, the top environmentalist officer in Berlin, about the kestrel. Roland insists that the asbestos-removal has to be considered as an important influence on the matter. That it cannot be, that Christo and Jeanne-Claude are the only ones taking the blame that the kestrel-nest (a crow's nest actually) has to be removed. All the activities will make it necessary and it is not going to be a feast for the press that we are the scapegoats. Mr. Muhs telephones the architect of the asbestos-removal, Mr. Peters, afterwards. The conclusion is that Mr. Peters either alone or together with us will put in the application for a permit to prevent the kestrel to nest.

Afternoon: Sir Norman Foster pays a 10 minute visit to the office.

**Wednesday, November 9th, 1994**

9:00 Visit to BAM to see how the upper connections sewn by all 5 sewing companies in the race are being tested. All perform very well so far. Some of the alternatives, which are done by the applicants, perform even better than the IPL design.

11:30 Mr. Schleper-Damrich of Europe Academy is at the office to discuss a date for a lecture. This is like a YPO of Germany. It is discussed to make a date around the opening in Oslo.

8:00 Dinner with Mr. Mark Braun of the Foster office as thanks for their cooperation and help with the contract with the German Republic.

**Friday, November 11th, 1994**

10:00 Hartmut Ayrle together with Roland, Sylvie and I hand in the papers for the application for the building permit. It is a total of about 20 + kilos of paper. Mr. Hans Schütz together with Mrs. Gabriele Müller are very pleased, that the application is almost complete and permittable. It is now going to be send out to all agencies involved. He only requests, that the fabric is marked on the plans in color and that he gets one set of plans mounted on linen. Hartmut will act accordingly.

**Saturday, November 12th, 1994**

4:00 PM Mr. Flis comes to the office with proof-prints for 5 new posters. Three of them are printed in heliogravure. They are better than what we have seen before but not yet perfect. Corrections are made.

Jürgen Sawade does not come - he is in bed with a flu.

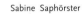

---

**Christo and Jeanne-Claude WRAPPED REICHSTAG, Project for BERLIN**

### Weekly Report by Wolfi

**Monday, November 14th 1994**

13:00 Sylvie and I witness further testing at BAM - Bundesanstalt für Materialprüfung - where it becomes very clear, that the performance of the 5 sewing companies is all very satisfactory.

17:00 Jürgen Sawade is still sick

**Tuesday, November 15th 1994**

14:00 Roland and Annette are at Bezirksamt Tiergarten for a further round-table with DER about the responsabilities outside the Bannmeile (aerea without commercial activities). A way is found, that VRT does not have to make a contract with Tiergarten at all, but DER can do it directly. It also becomes clear, that there is no way to prevent sellers carrying little trays from selling things inside the Bannmeile. The request from us is filed, that at least in the Wiese and around the building we can maintain the non-commercialism even with the ambulant sellers.
In that context the question arises, what those people with existing licenses behind the Reichstag will do. What if they temporarily rent that license to someone specialized in something we do not like at all? Are those licenses issued for something specific? The Bezirk Mitte will answer.

17:00 The Hissens come to office to film.

20:00 Celebration of Roland's birthday, which s one day later.

**Wednesday, November 16th 1994**

German Holyday

**Friday, November 18th 1994**

9:30 Meeting at Tiergarten with Mr. Schilcher, Mr. Schütz, Proofing engineer Dr. Stucke, Mr. Weiser of IPL and Roland. The calculations of the structural engineering, which is part of our application for the building permit is being evaluated and it is determined, what additional numbers Mr. Stucke still needs.

11:00 The fire department gives it's comments to our application for the building permit. This is the common procedure. They look whether all their demands concerning safety in the case of a fire especially inside the building are met. They are very happy and approve of the application.

---

Bundestag President Rita Süssmuth, seated between Roland Specker and Wolfgang Volz, the co-presidents of "Verhüllter Reichstag GmbH", signed the contract permitting the company to make temporary use of the Reichstag. The signing occurred on October 18, 1994, after seven and a half months of contractual negotiations. President Süssmuth's chief of staff, Thomas Läufer, witnessed the proceedings.

Bundestagspräsidentin Rita Süssmuth, zwischen Roland Specker und Wolfgang Volz, den beiden Geschäftsführern der »Verhüllter Reichstag GmbH«, unterzeichnete den Vertrag, der dieser Gesellschaft die kurzzeitige Nutzung des Reichstags genehmigte. Die Vertragsunterzeichnung fand am 18. Oktober 1994 statt. Die Vertragsverhandlungen hatten siebeneinhalb Monate in Anspruch genommen. Auch Thomas Läufer, der Büroleiter der Bundestagspräsidentin, war bei der Vertragsunterzeichnung zugegen.

Sabine Saphörster

## A Multitude of Permits

The permitting process continued through November 1994, when IPL architect Hartmut Ayrle (right, top) pointed out safety procedures to officials of the Tiergarten district, the fire and police departments and the Berlin Senate. The building permit was issued on February 23, 1995. Horst Porath (right, center), the head of the Tiergarten's building department, commemorated the occasion with the project directors Roland Specker and Wolfgang Volz. All shared a celebratory toast in Porath's office (right, bottom), where they were joined by Hans Schütz, Johann Schilcher and Guntolf Gehlhaar.

## Genehmigungen über Genehmigungen

Der Genehmigungsprozeß setzte sich auch im November 1994 fort, als der IPL-Architekt Hartmut Ayrle (oben rechts) den Vertretern des Bezirks Tiergarten, der Feuerwehr, der Polizei und des Berliner Senats Sicherheitsmaßnahmen erläuterte. Die Baugenehmigung wurde am 23. Februar 1995 erteilt. Horst Porath (rechts, Mitte), der Leiter des Bauamts des Bezirks Tiergarten, stieß mit den Projektleitern Roland Specker und Wolfgang Volz in seinem Büro auf dieses Ereignis an (unten rechts). Hans Schütz, Johann Schilcher und Guntolf Gehlhaar gesellten sich dazu.

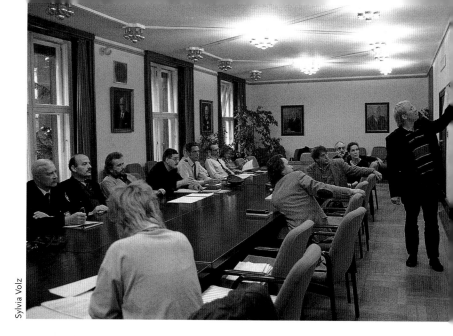

Sylvia Volz

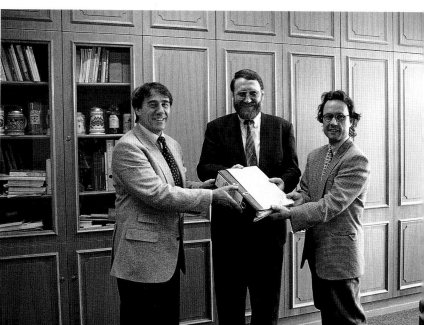

Sylvia Volz

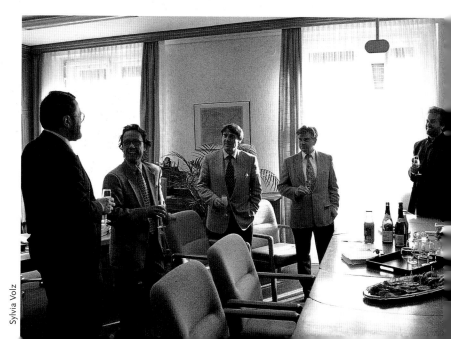

Sylvia Volz

Sylvia Volz

"WRAPPED REICHSTAG (PROJECT FOR BERLIN)

Christo 1994

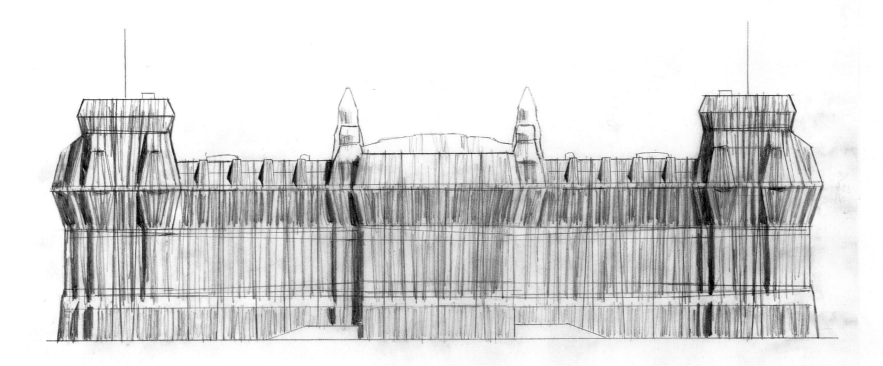

EAST          1:250

**Wrapped Reichstag,**
**Project for Berlin**
Collaged drawing 1995
56 x 71 cm
Pencil, charcoal, crayon, tracing
paper and tape on a photograph
by Wolfgang Volz

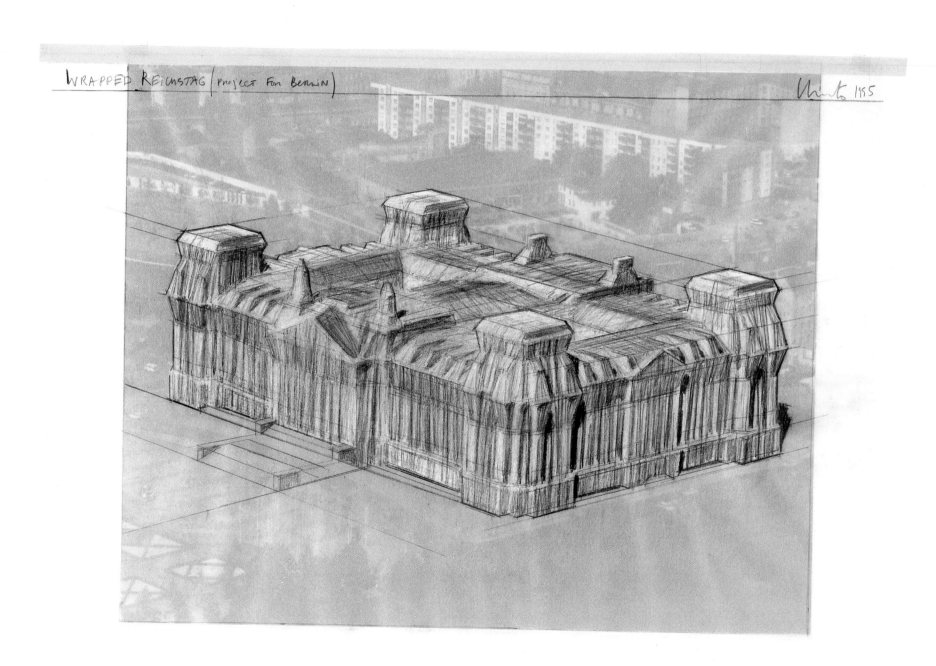

## Sewing in Three Factories

The job of sewing 109,400 square meters of fabric into 70 individually designed panels was given to two companies in eastern Germany, Spreewald Planen in Vetschau and Zeltaplan in Taucha. The work started in January 1995. By the end of February it became clear that the sewing would not be finished in time. Consequently, the material for ten of the panels was transferred to Canobbio S.p.A. in Castelnuovo Scrivia, Italy, where sewing commenced in early April.
Next spread: Some of the sewing was done in Canobbio's second plant in Serravalle Scrivia.

## Näharbeiten in drei Fabriken

Der Auftrag, die 109.400 Quadratmeter Stoff zu 70 individuell geschnittenen Paneelen zu nähen, wurde an zwei ostdeutsche Firmen vergeben, an die Spreewald Planen GmbH in Vetschau in Brandenburg und an die Zeltaplan GmbH in Taucha in Sachsen. Die Arbeiten begannen im Januar 1995. Gegen Ende Februar war abzusehen, daß die Näharbeiten nicht rechtzeitig abgeschlossen werden konnten. Deshalb wurde das Material für 10 Paneele zur italienischen Firma Canobbio S.p.A. in Castelnuovo Scrivia gebracht. Dort wurde Anfang April mit den Näharbeiten begonnen.
Folgende Doppelseite: Einige der Näharbeiten wurden im zweiten Werk der Canobbio S.p.A. in Serravalle Scrivia durchgeführt.

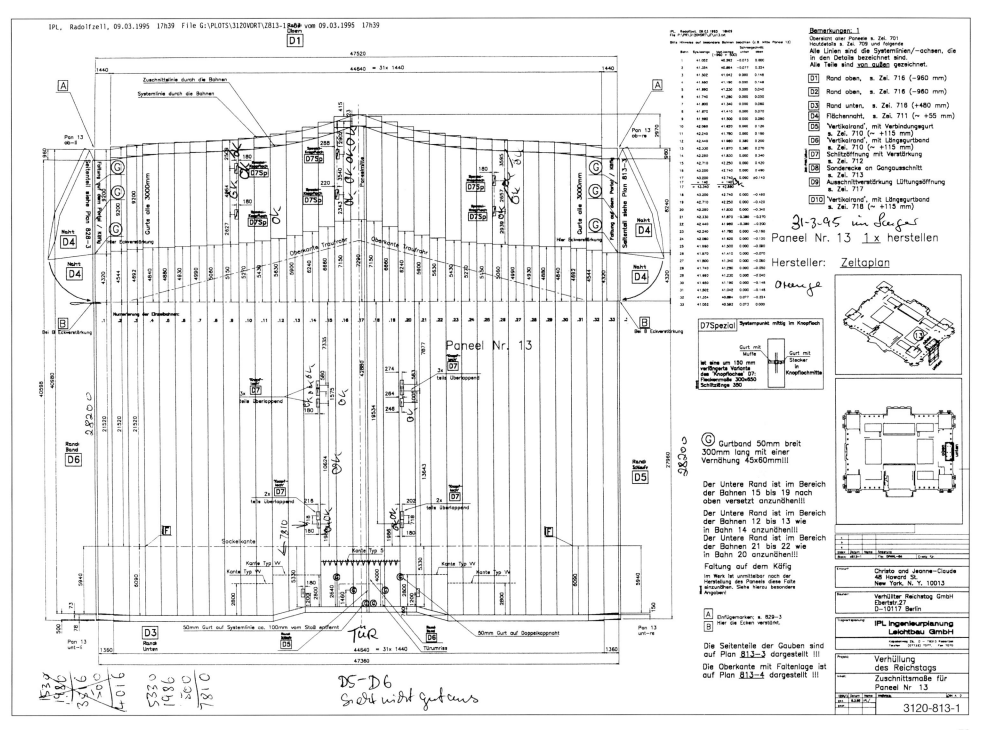

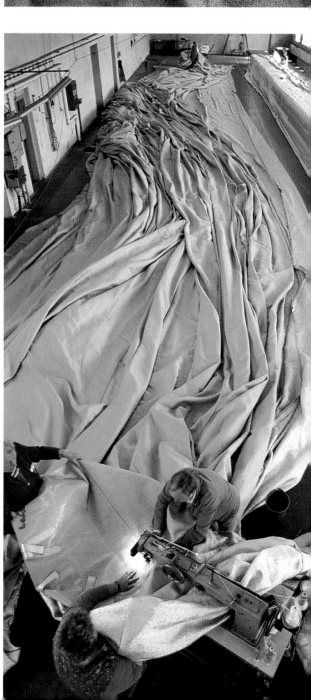

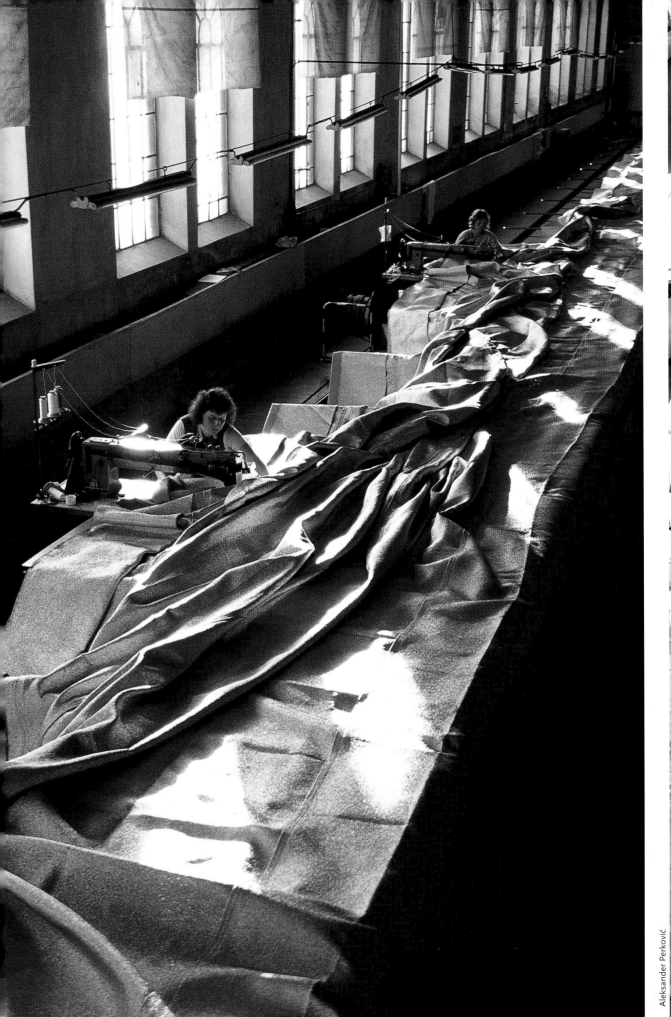
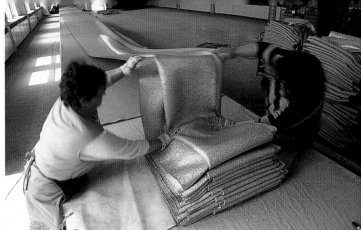
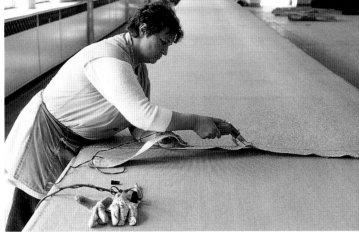
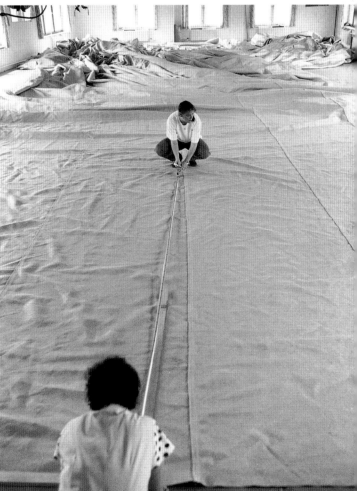

## Twisting in Bremen

Gleistein Tauwerk in Bremen manufactured 15,600 meters of blue rope for the project. The polypropylene yarn (left, top to bottom) was extruded, spooled and twisted until the desired thickness (3.2 cm) was attained. Rigger Olaf Wegmann (right, bottom) made all the splices, each tested for tensile strength (near right, top). Each length was tagged (below) for its precise location. Finally, all the tagged rope was assembled for shipment.

Sylvia Volz

## Seile aus Bremen

Von der Gleistein Tauwerk GmbH in Bremen wurden 15 600 Meter blaues Seil für das Projekt hergestellt. Das Polypropylengarn wurde extrudiert, gespult und gezwirnt, bis die gewünschte Stärke (3,2 cm) erreicht war. Der Takler Olaf Wegmann spleißte die Seile. Die Spleißen mußten einem Zugfestigkeitstest unterworfen werden. Jedes einzelne Seil wurde mit einem Schild versehen, auf dem seine spätere Position genau angegeben war. Zum Schluß wurden alle so markierten Seile für den Transport zusammengestellt.

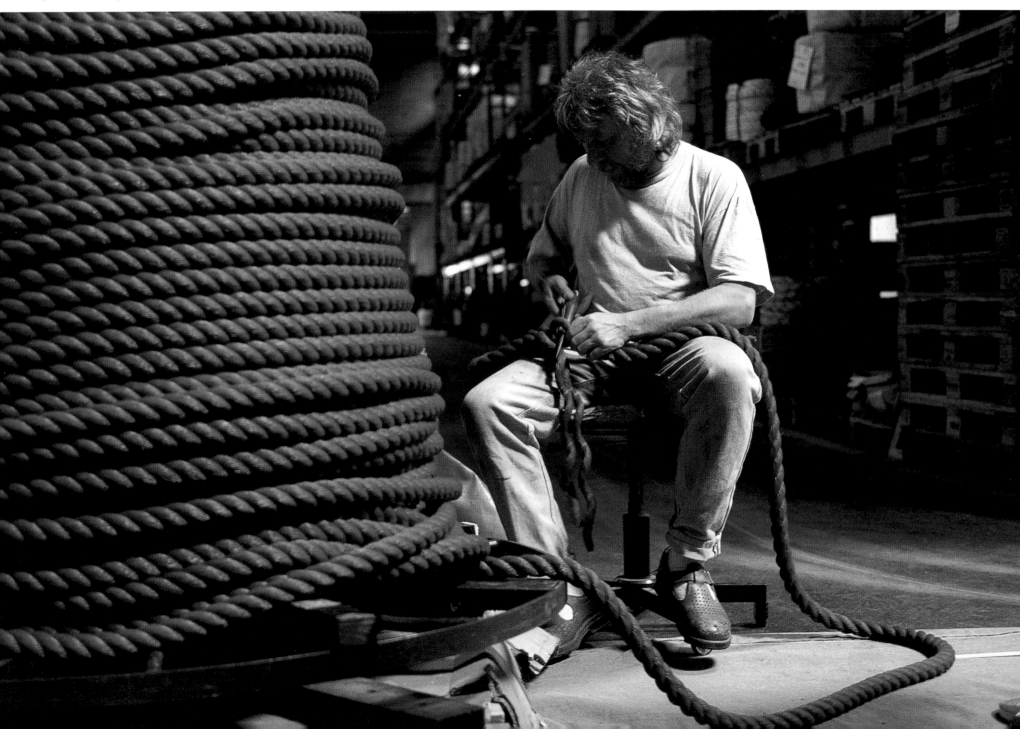

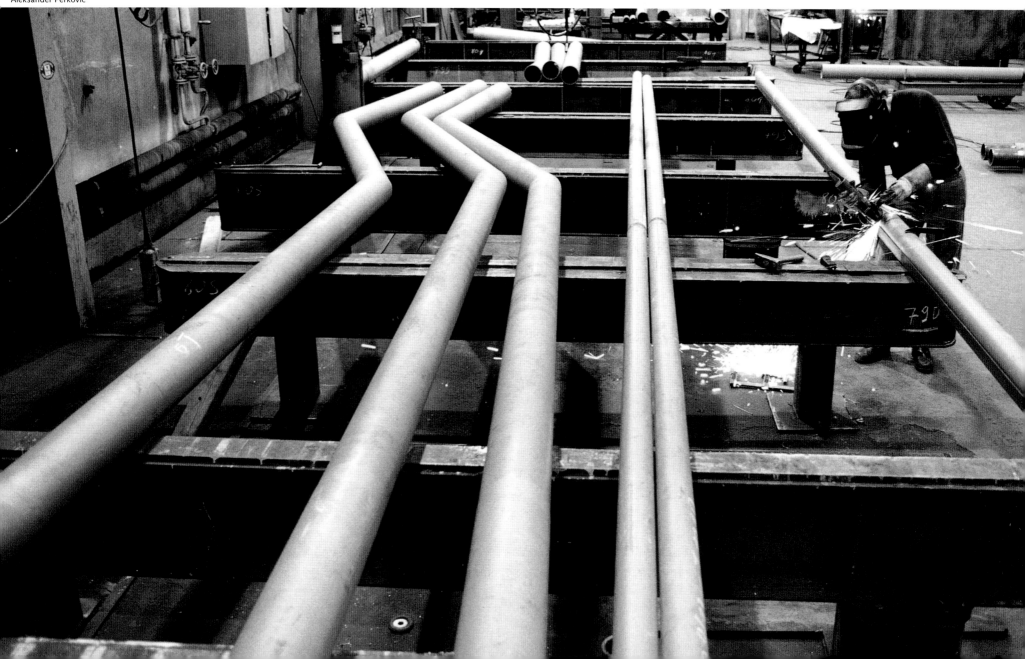

## Cages for the Parliament

The job of manufacturing 200 metric tons of steel structures, intended to alter the shape of the Reichstag's contours, was awarded to Stahlbau Zwickau, a company with workshops in both Zwickau and Chemnitz. IPL engineers designed all the structures, which had to conform to the conditions of the building permit. Stahlbau workers welded cages for the statues (far left, top) and ladder-like forms to enlarge the roofline (near left, top). Heavy steel pipes that would anchor the fabric to the roof were cut to size (left, bottom).

## Käfige für das Parlamentsgebäude

Mit der Herstellung der insgesamt 200 Tonnen wiegenden Stahlkonstruktionen, die die Aufgabe hatten, die Konturen des Reichstagsgebäudes zu akzentuieren, wurde die Stahlbau Zwickau GmbH beauftragt, deren Produktionsanlagen auf Zwickau und Chemnitz verteilt sind. Alle Stahlkonstruktionen waren den in der Baugenehmigung festgelegten Bedingungen gemäß von Ingenieuren der IPL entworfen worden. Die sächsischen Stahlarbeiter schweißten Käfige für die Statuen (oben links) und leiterartige Gebilde, die auf die Dachränder aufgesetzt wurden (oben rechts). Die schweren Stahlrohre, die das Gewebe mit dem Dach verankerten, wurden zurechtgeschnitten (unten).

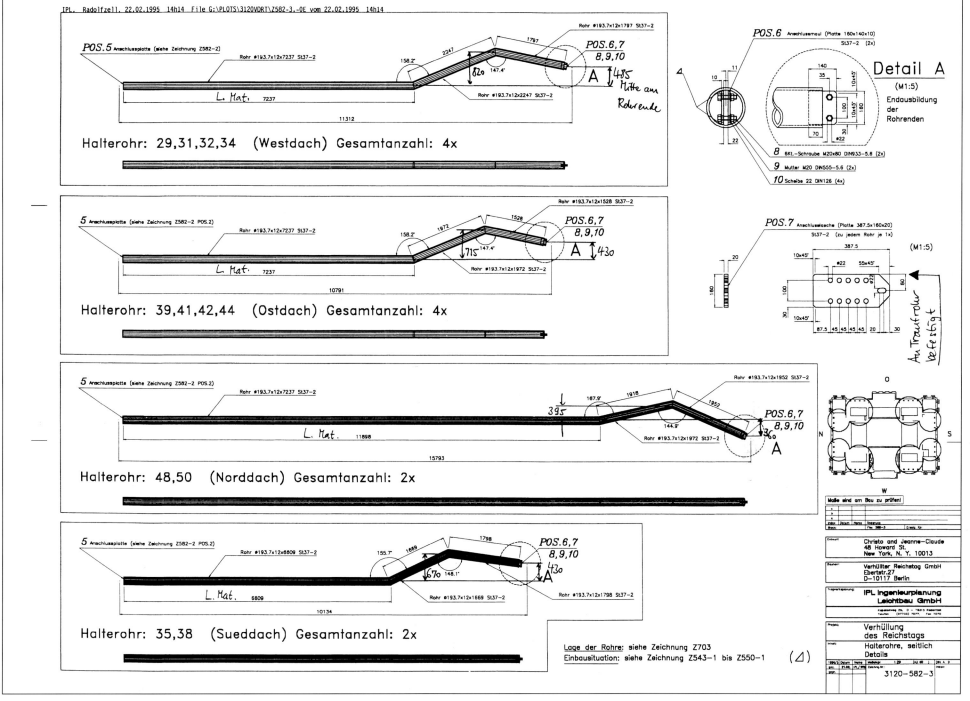

81

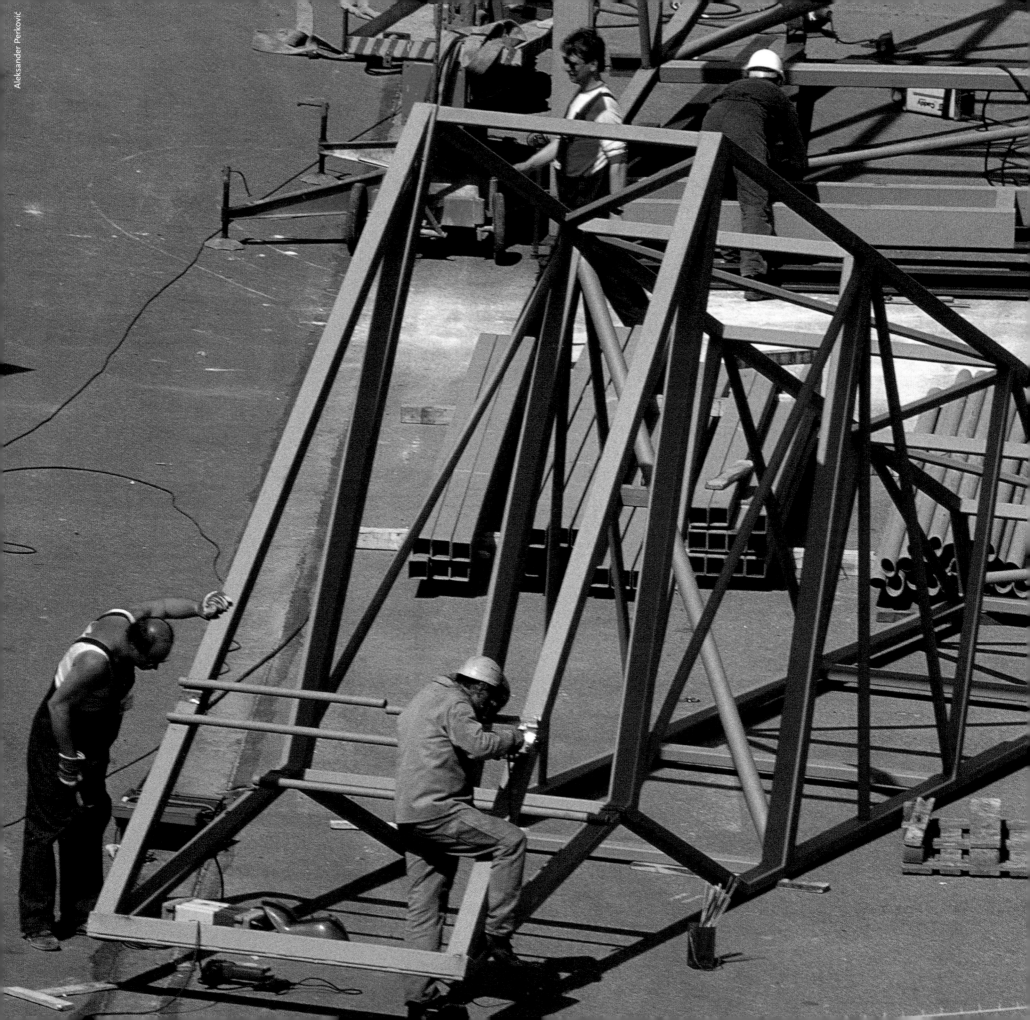

## A Field of Steel Grids

All the elements of the steel structures were delivered by truck to the Reichstag in early April 1995 and unloaded by crane. The cages for the urns were welded together on the site (opposite). Below, the west facade of the Reichstag is visible through the overlapped grids.

## Stahlgitter, soweit das Auge reicht

Alle Komponenten der Stahlkonstruktionen wurden Anfang April 1995 per Lastwagen zum Reichstag gebracht und dort mit einem Kran abgeladen. Die Käfige für die Urnen wurden an Ort und Stelle fertiggeschweißt (gegenüberliegende Seite). Unten: Durch die einander überschneidenden Gitter ist die Westfassade des Reichstags zu sehen.

Sylvia Volz

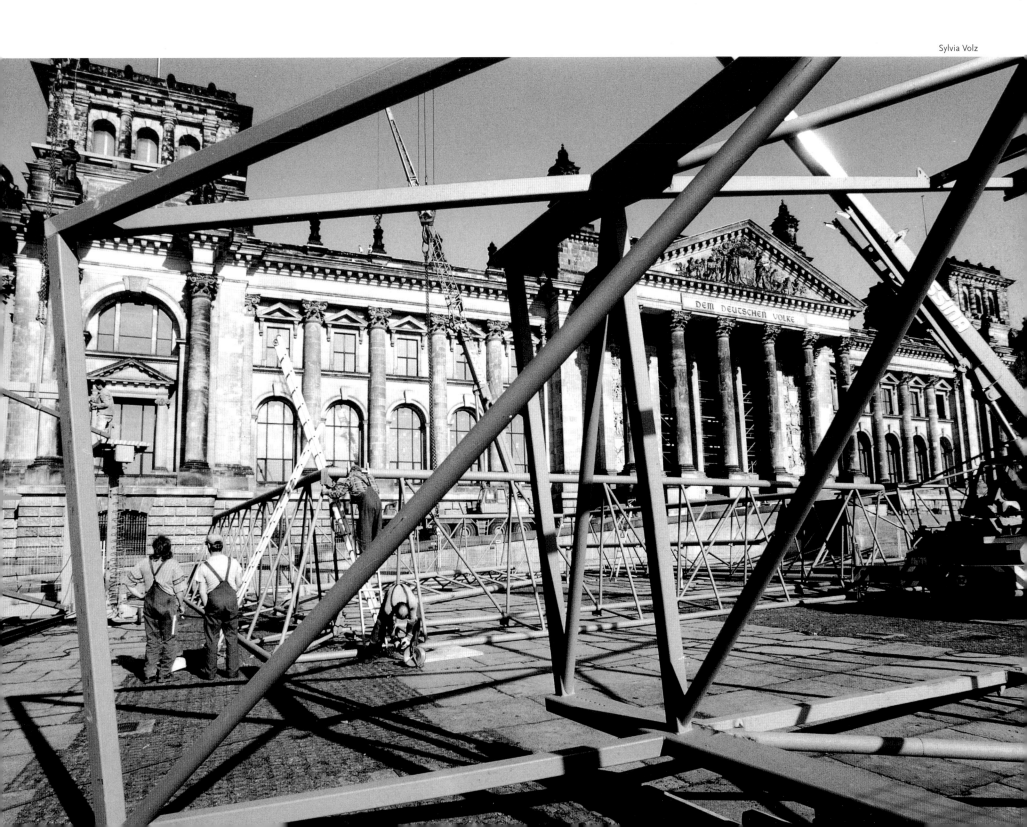

The crane operators and their rooftop partners exercised caution during the delivery of the large right-angled cornice covers, pairs of which crowned and enlarged each of the four towers. Each section had to be maneuvered with care to avoid unwanted swinging in the air. All were placed without any harm to the building.

Die Kranführer und ihre Kollegen auf dem Dach ließen alle Vorsicht walten, während sie die großen rechtwinkligen Simsabdeckungen in ihre Position brachten, die paarweise alle vier Türme krönten und erweiterten. Jedes Teil mußte umsichtig manövriert werden, ohne das Gebäude in Mitleidenschaft zu ziehen.

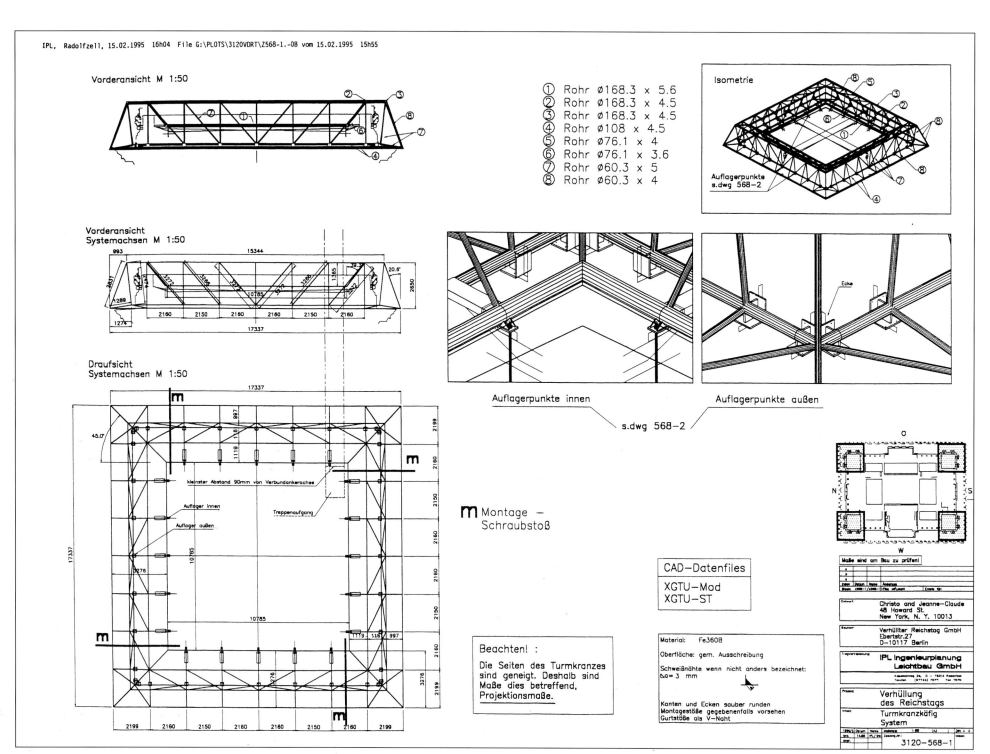

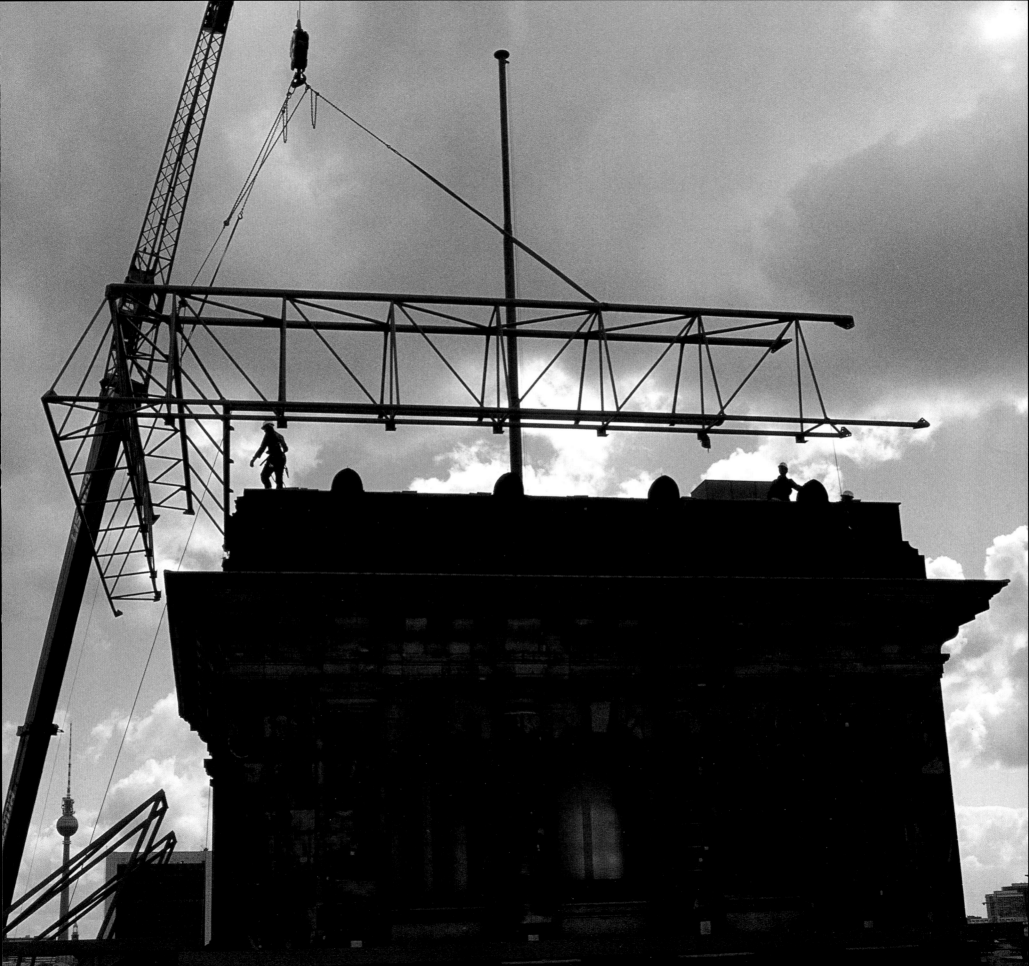

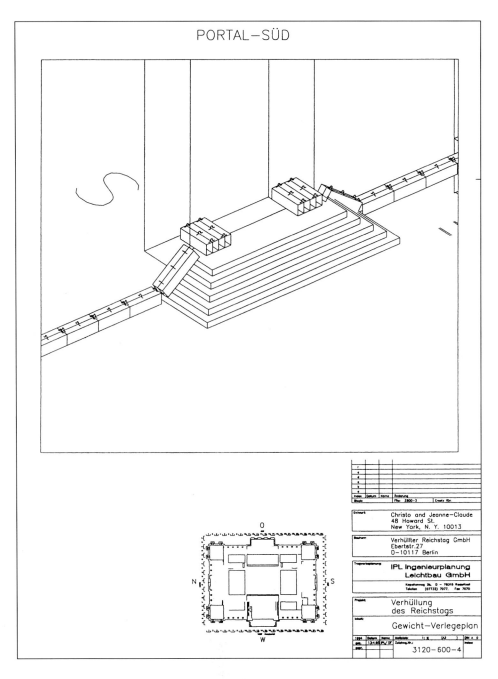

PORTAL-SÜD

Christo and Jeanne-Claude
48 Howard St.
New York, N. Y. 10013

Verhüllter Reichstag GmbH
Ebertstr.27
D-10117 Berlin

IPL Ingenieurplanung
Leichtbau GmbH

Verhüllung
des Reichstags

Gewicht-Verlegeplan

3120-600-4

Heavy blocks of steel (near right) – 477 of them – outfitted with metal loops through which pipes could be inserted, functioned as ground-level anchors for the fabric and the ropes. Additionally, heavy steel chains were distributed all around the perimeter of the building to hold down the fabric's undulating lower edge. All the steel weights were placed on wooden timbers (far right, top and bottom) to allow ropes to pass underneath.

Schwere Stahlblöcke (rechts) – insgesamt 477 – dienten auf dem Boden als Verankerungen für das Gewebe und die Seile. Sie waren mit Metallschleifen versehen, durch die Rohre geführt werden konnten. Darüber hinaus wurden schwere Stahlketten um das ganze Gebäude herum verteilt, um den welligen unteren Rand des Gewebes am Boden zu halten. Alle Stahlgewichte lagen auf Holzbalken auf (rechts, oben und unten), damit Seile unter ihnen hindurchgeführt werden konnten.

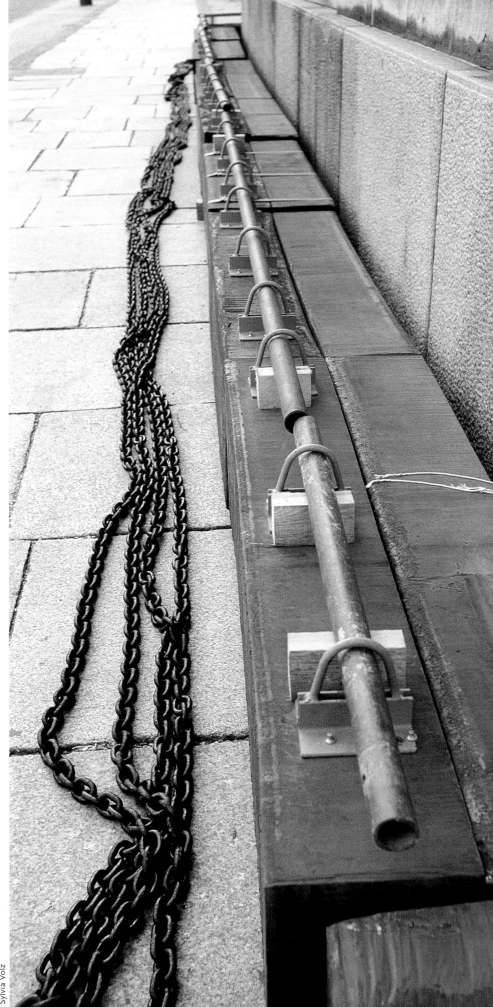

Sylvia Volz

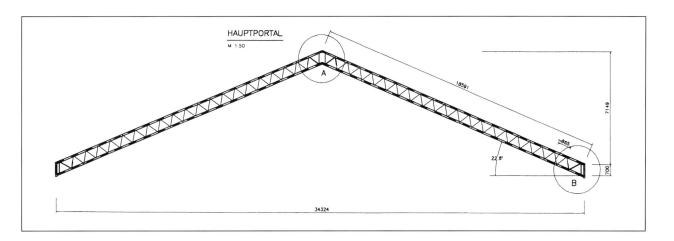

HAUPTPORTAL

M 1:50

A

B

18591

7149

≈865

22,5°

700

34324

Sylvia Volz

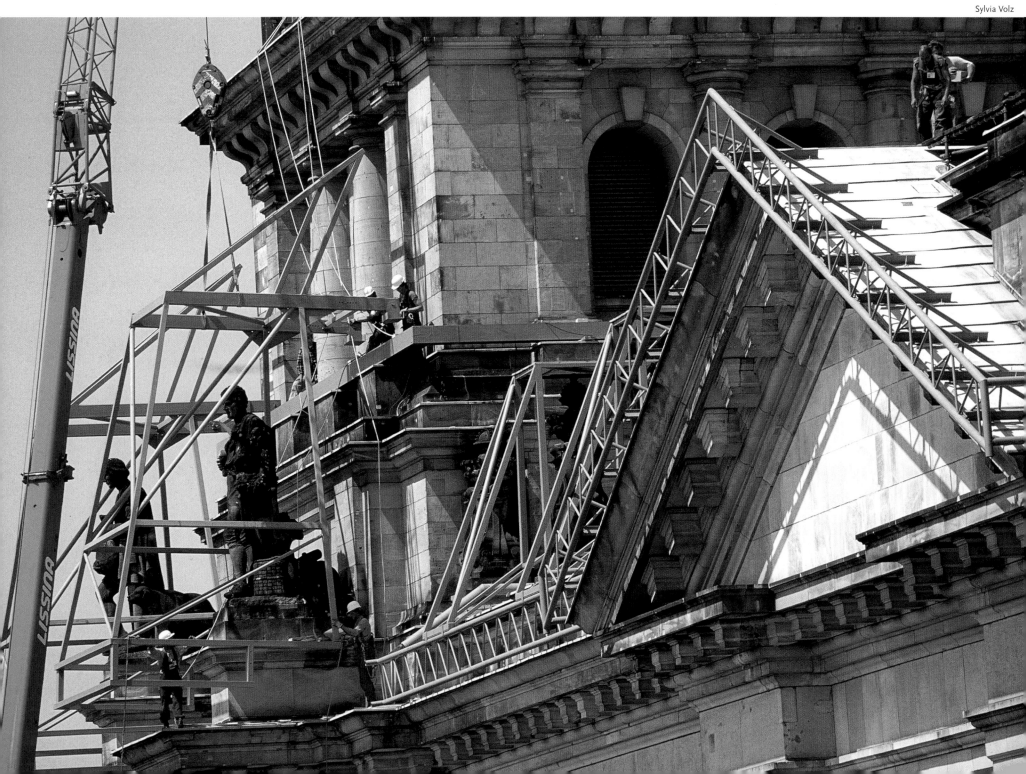

The 70 fabric panels were folded and rolled up in a warehouse near Berlin by members of the installation team. On June 16, 1995 the folded and rolled panels were transported to the Reichstag.

In einem Lager in der Nähe von Berlin wurden die 70 Stoffpaneele von Mitarbeitern des Montageteams zu großen Rollen zusammengelegt. Am 16. Juni 1995 wurden die gefalteten und gerollten Paneele zum Reichstag transportiert.

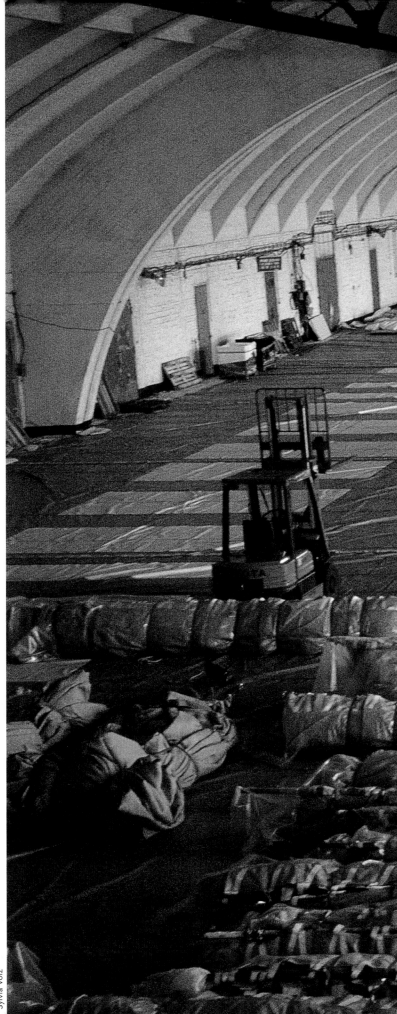

Sylvia Volz

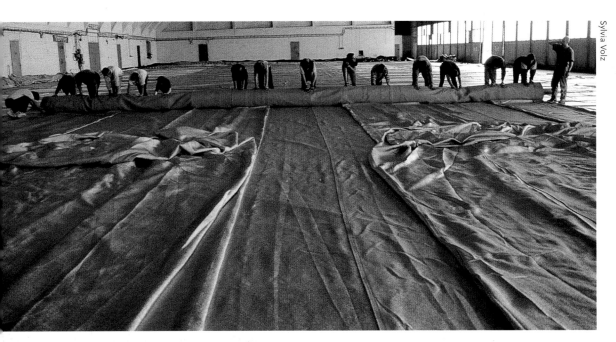

Sylvia Volz

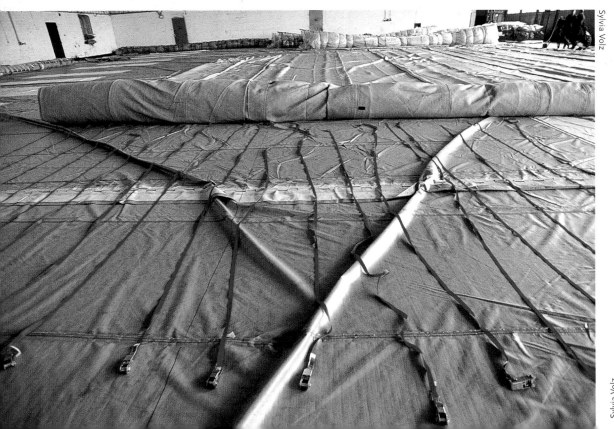

Sylvia Volz

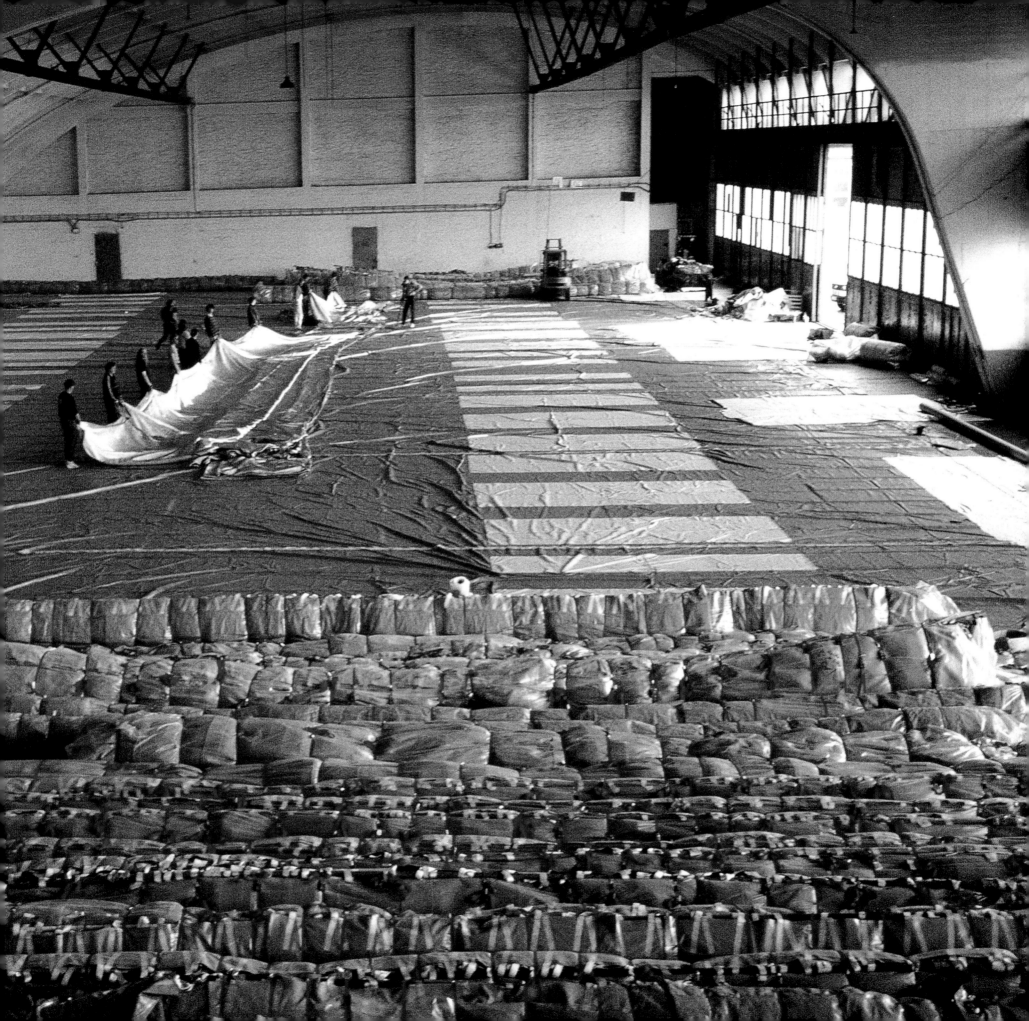

The staff at the Ebertstrasse headquarters (left, top) included (from the left) Vince Davenport, Wolfgang Volz, Jörg Tritthard, Sylvia Volz, Tilo Zaumseil, Hartmut Ayrle, Katrin Specker, Pamela Groos, Annette van Straelen, Siegward Hausmann, Renate Wolff, Werner Braunschädel, Anja Grünewald, Roland Specker and Julia Wirtz. Project directors Specker and Volz (left, center) constantly recalculated the expenses. Engineers Vince Davenport (left, bottom) and John Thomson (who had advised the Christos on all their projects since 1971) brought up procedural issues. Below, the team deliberated over Hartmut Ayrle's technical report on the positioning of the ropes. At bottom, professional climbers (seated, from the left) Robert Jatkowski, Henrik Modes, Frank Seltenheim and Ralf Haeger offered ideas on how to install the fabric.

Zu den Mitarbeitern in der Projektzentrale in der Ebertstraße (oben links) gehörten (von links nach rechts): Vince Davenport, Wolfgang Volz, Jörg Tritthard, Sylvia Volz, Tilo Zaumseil, Hartmut Ayrle, Katrin Specker, Pamela Groos, Annette van Straelen, Siegward Hausmann, Renate Wolff, Werner Braunschädel, Anja Grünewald, Roland Specker und Julia Wirtz. Die Projektleiter Roland Specker und Wolfgang Volz (links, Mitte) waren ständig mit immer neuen Kostenkalkulationen beschäftigt. Die Ingenieure Vince Davenport (unten links) und John Thomson (der die Christos seit 1971 bei allen ihren Projekten beraten hatte) brachten Ablaufüberlegungen vor. Rechts, Mitte: Das Team beriet über Hartmut Ayrles technischen Bericht über die Positionierung der Seile. Unten rechts: Die vier professionellen Kletterer Robert Jatkowski, Henrik Modes, Frank Seltenheim und Ralf Haeger (von links nach rechts) erläuterten ihre Ideen über die Entfaltung des Gewebes.

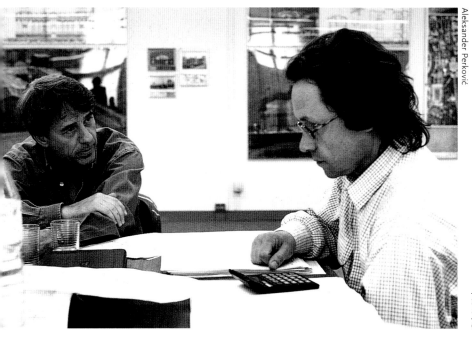

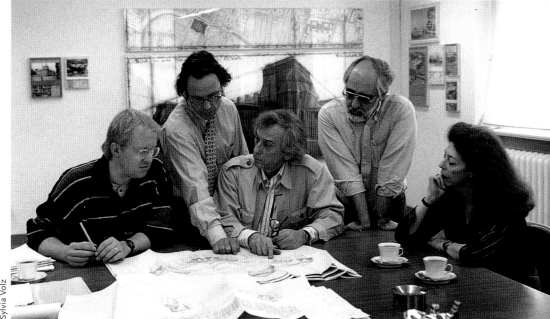

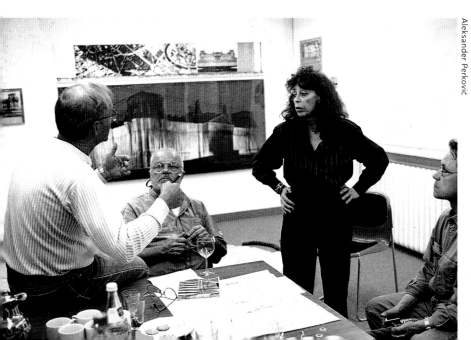

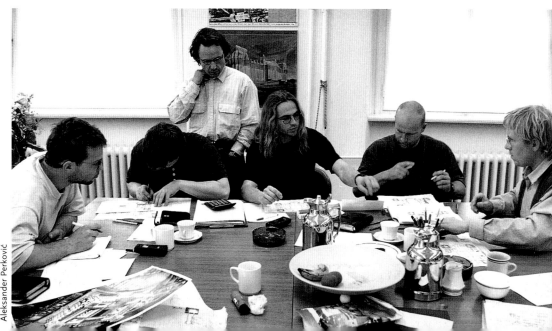

Vince Davenport (below, third from left) demonstrated his conception of the unrolling process to Volz, Ayrle, architect Dieter Mann (Büro Mann) and Jörg Tritthard (IPL). How to coordinate the installation of the steel structures was the topic of discussion among (bottom, from the left) Ayrle, Volz, chief climber Seltenheim, and Georg Plique and Gerhard Schilling, both of Stahlbau Zwickau.
At right (top), Christo calmly explained his needs to engineers John Thomson and Dimiter Zagoroff as John Kaldor, an old friend of the artists, looked on. Werner Braunschädel (right, center, seated) took charge of preparing and issuing photo passes, permitting workers to gain access to the Reichstag. In the computer and photo room (right, bottom), the *Wrapped Reichstag* was launched into cyberspace via the Internet.

Vince Davenport (links, Mitte, dritter von links) führte Wolfgang Volz, Hartmut Ayrle, Dieter Mann (Architektur-büro Mann) und Jörg Tritthard (IPL) seine Konzeption des Entfaltungsprozesses vor. Die Koordinierung der In-stallation der Stahlkonstruktionen war das Thema einer Diskussion zwischen (unten links, von links nach rechts): Ayrle, Volz, Chefkletterer Seltenheim, Georg Plique und Gerhard Schilling von der Stahlbau Zwickau GmbH. In aller Ruhe erläuterte Christo seine Vorstellungen den Ingenieuren John Thomson und Dimiter Zagoroff (oben rechts). Auch John Kaldor, ein enger Freund der Künstler, hörte aufmerksam zu. Werner Braunschädel (rechts, Mitte, sitzend) war für die Anfertigung und Ausstellung der Foto-Ausweise verantwortlich, die den Arbeitern den Zugang zum Reichstag erlaubten. Im Computer- und Fotoraum (unten rechts) wurde der *Verhüllte Reichstag* über das Internet ins Cyberspace katapultiert.

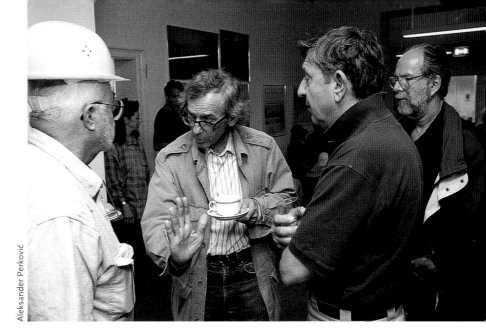

Aleksander Perković

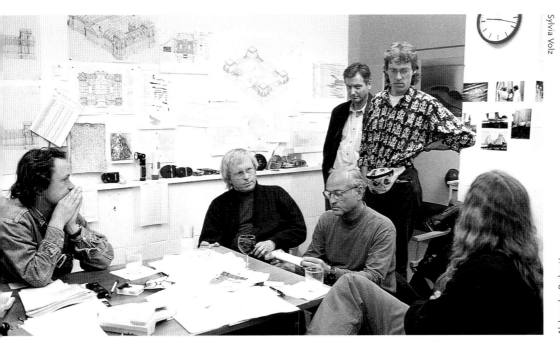

Sylvia Volz

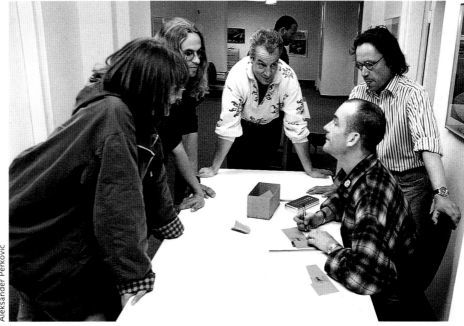

Aleksander Perković

Aleksander Perković

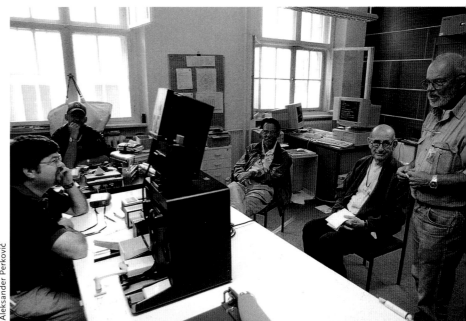

Aleksander Perković

Aleksander Perković

André Grossmann

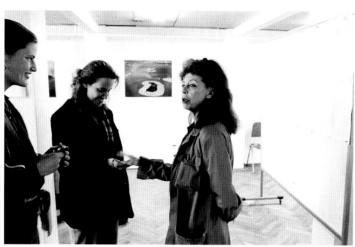
Aleksander Perković

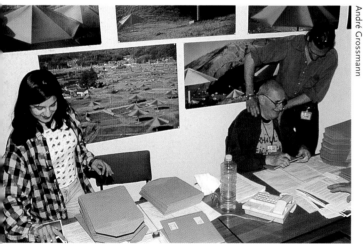
André Grossmann

Roland Baier

Calixte Stamp

Their shared June 13th birthdays found Jeanne-Claude in Berlin and Christo in New York. The Berlin office staff congratulated Jeanne-Claude in person, then lined up for the telephone (top) to relay their good wishes to Christo.

In the press office, Heidi Violand and Sophie Norinder (far left, second from top) worked the telephones. Anshula Kedar, Tom Golden and Christo's Bulgarian-born nephew, Vladimir Yavachev (far left, third from top), prepared press packets. Antje Müller-Schubert (far left, bottom), one of the two house doctors, kept in touch with La Charité hospital. Jeanne-Claude (near left, center) supervised the press office where Katrin Specker (right, bottom), daughter of the project director, ran daily operations.

Am 13. Juni – ihrem gemeinsamen Geburtstag – war Jeanne-Claude in Berlin und Christo in New York. Nachdem die Mitarbeiter im Berliner Büro Jeanne-Claude persönlich gratuliert hatten, standen sie am Telefon Schlange, um Christo ihre Glückwünsche auszusprechen (oben).

Im Pressebüro gaben Heidi Violand und Sophie Norinder (links, zweite Abb. von oben) telefonische Auskünfte. Anshula Kedar, Tom Golden und Christos aus Bulgarien stammender Neffe Vladimir Yavachev (links, dritte Abb. von oben) stellten Pressemappen zusammen. Antje Müller-Schubert (unten links), eine von zwei Teamärzten, blieb in ständiger Verbindung mit der Charité. Jeanne-Claude stand dem Pressebüro vor, wo auch Katrin Specker (unten rechts), die Tochter Roland Speckers, alle Hände voll zu tun hatte.

The monitors received their instructions and were issued T-shirts, caps and cloth bags. Roland Specker (below) assigned the captains to their respective positions around the building. Hundreds of young people applied for temporary positions as project monitors.

Die Monitore erhielten ihre Instruktionen und bekamen ihre T-Shirts, Kappen und Stofftaschen ausgehändigt. Roland Specker (unten) wies den Kapitänen ihre jeweiligen Standorte um das Gebäude herum zu. Hunderte junger Menschen hatten sich um die Jobs als Projekt-Monitore beworben.

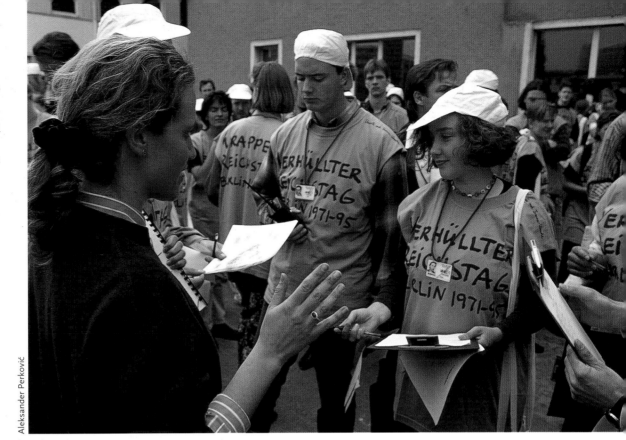

Aleksander Perković

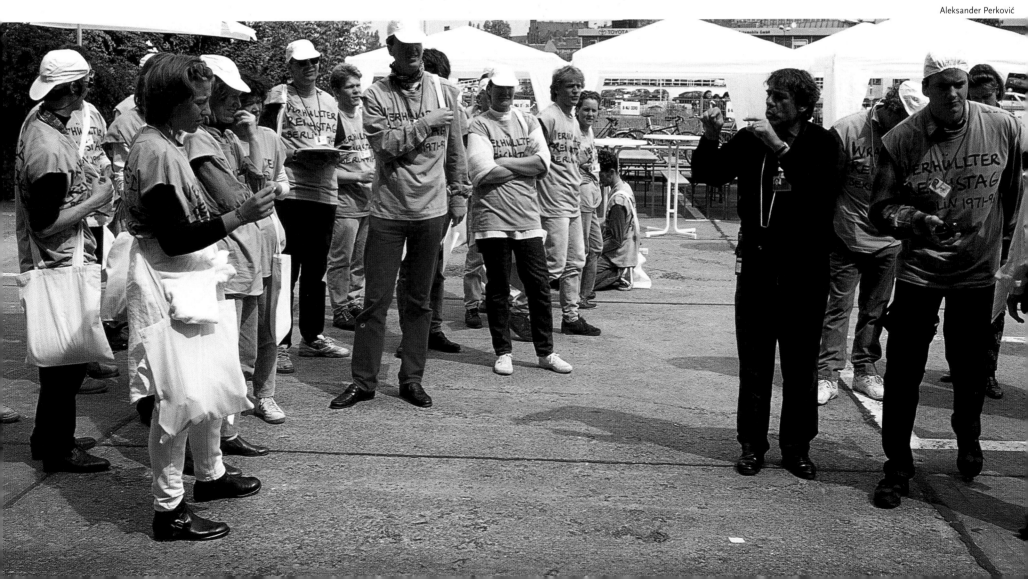

Aleksander Perković

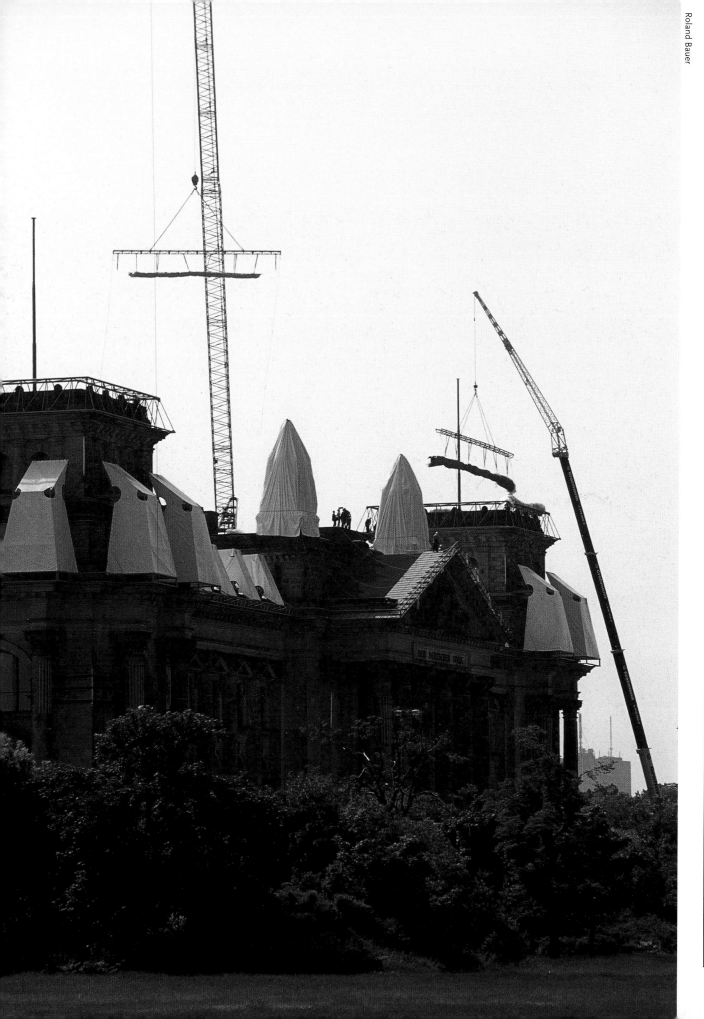

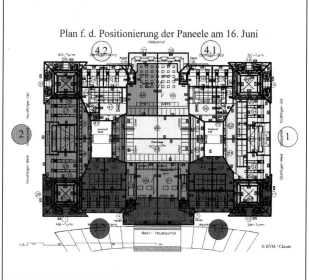

Plan f. d. Positionierung der Paneele am 16. Juni

© RVM / Christo

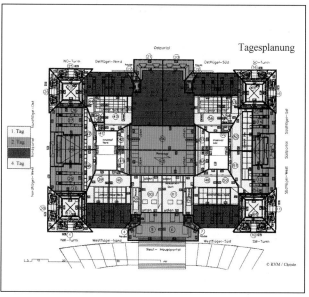

Tagesplanung

© RVM / Christo

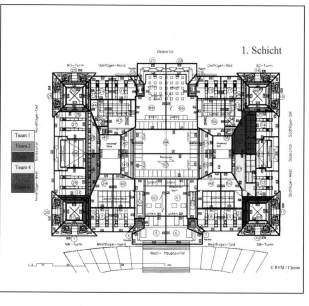

1. Schicht

© RVM / Christo

At the Reichstag site four cranes equipped with spreader bars lifted the rolled panels from the trucks (below) and hoisted them in their rigidly horizontal state to the roof of the Reichstag (opposite). Each of the 70 panels had to be delivered to its specific site on the roof and properly positioned (next spread) so it would unroll in the right direction.

Vor dem Reichstag angekommen, hoben vier mit Lasttraversen ausgerüstete Kräne die zusammengerollten Paneele von den Tiefladern (unten) und hievten sie unter Beibehaltung ihrer starr horizontalen Lage auf das Dach des Reichstags (gegenüberliegende Seite). Alle 70 Paneele mußten genau ausgerichtet auf ihre jeweils vorher bestimmte Dachposition gebracht werden (folgende Doppelseite), damit sie problemlos entrollt werden konnten.

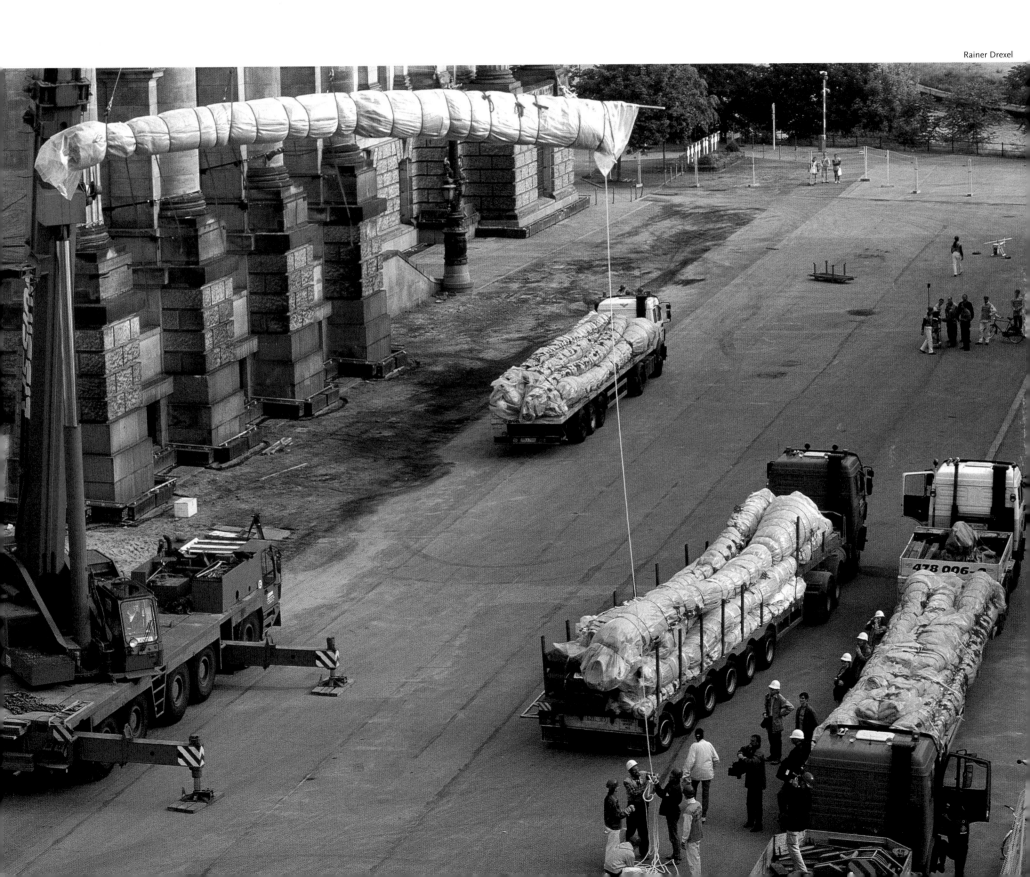

Rooftop crews assisted in the landing of each crane-delivered panel (opposite and below). As the weight of the rolls ranged between 500 and 2,500 kilograms, the crews wanted to be certain that each roll was precisely positioned so it would not have to be moved manually later.

Die Dachmannschaften halfen beim Abladen der Paneele. Da das Gewicht der Geweberollen zwischen 500 und 2.500 Kilogramm lag, mußten die Mannschaften sichergehen, daß alle Rollen genau richtig positioniert wurden, damit sie später nicht von Hand verschoben werden mußten.

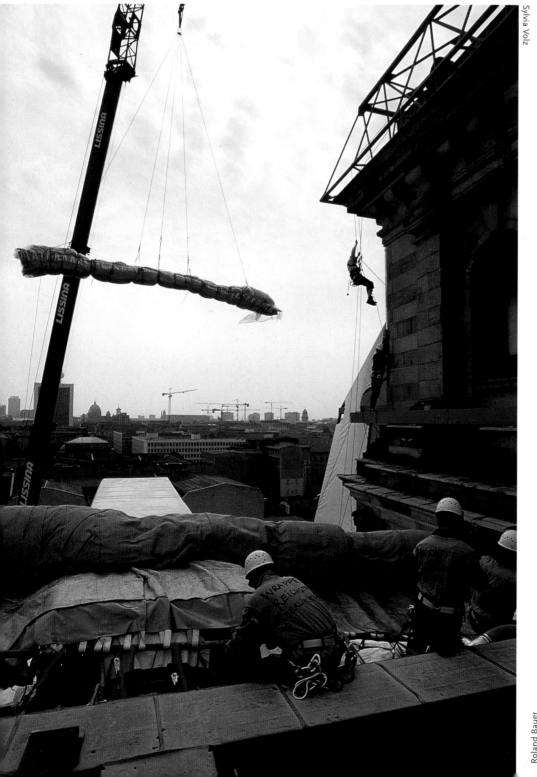

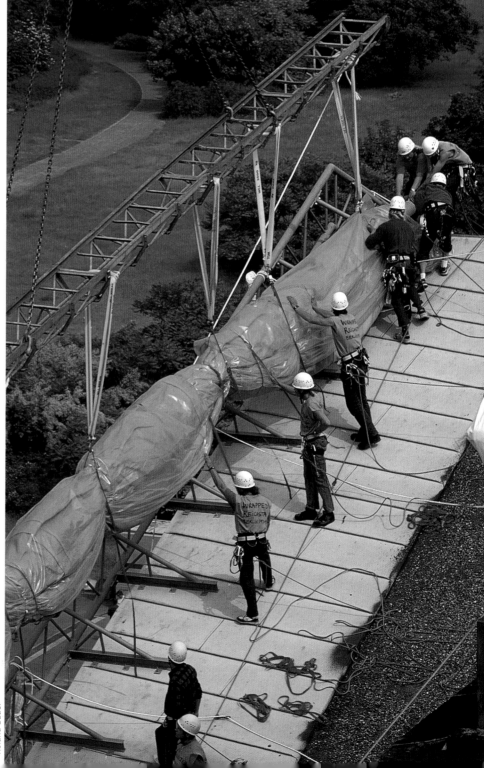

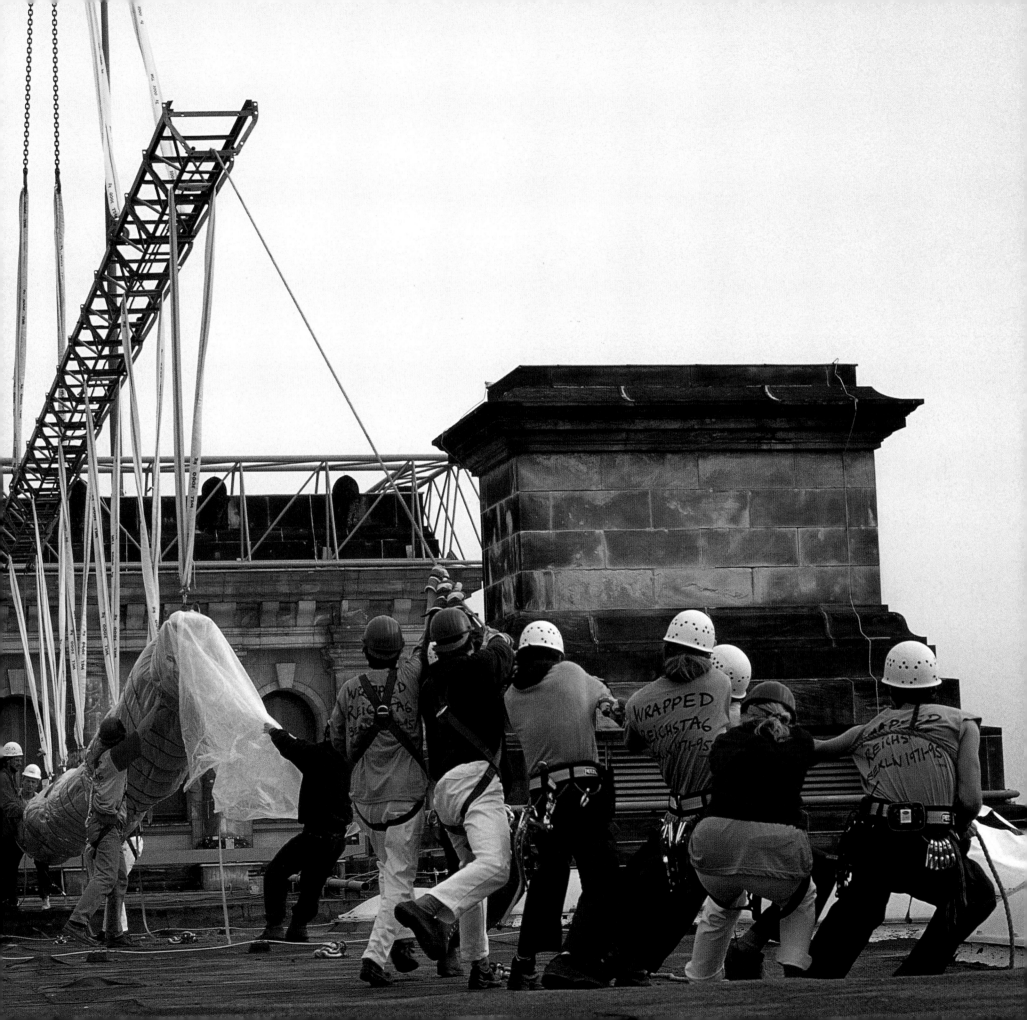

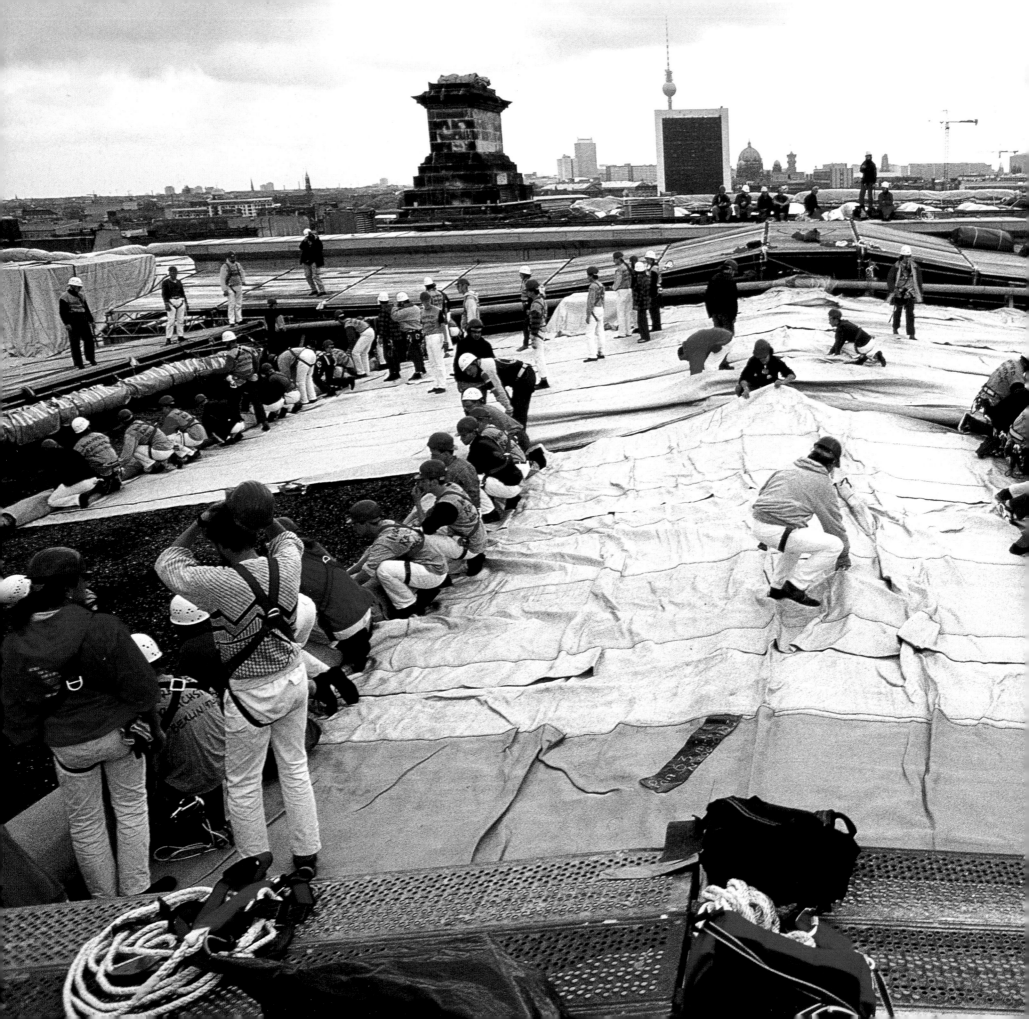

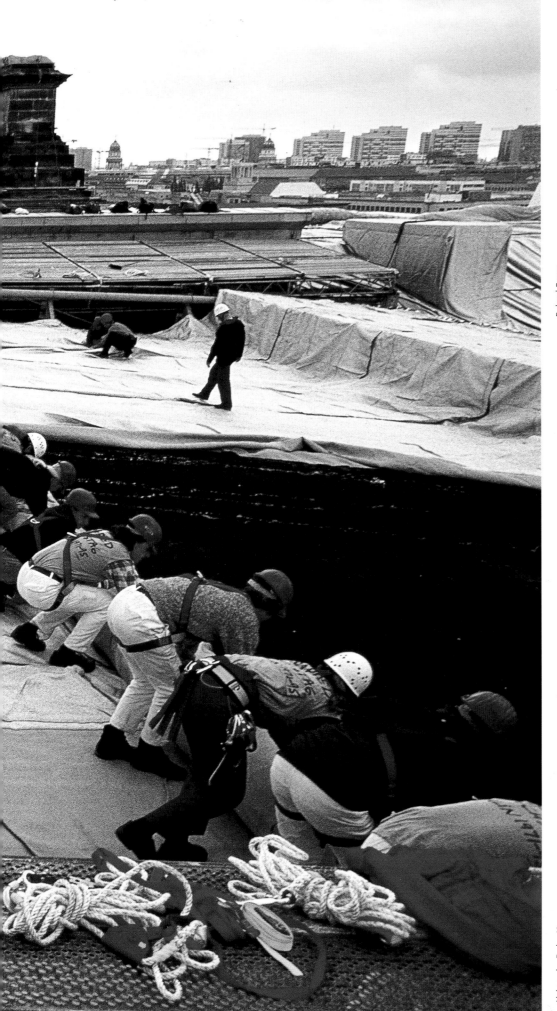

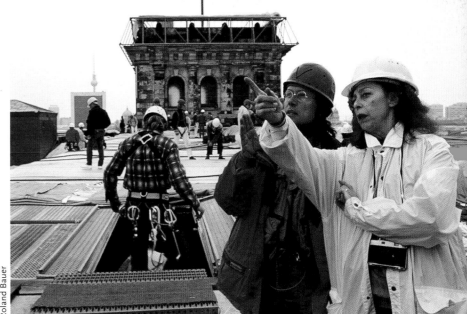

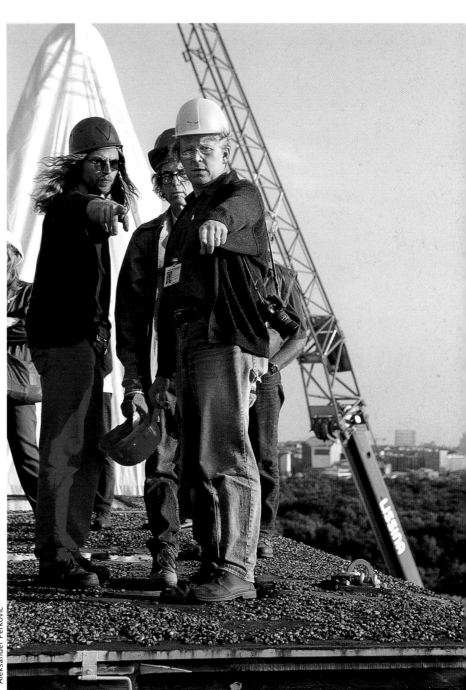

The roof crews attached the upper edges of the panels, each with its narrow pipe threaded through white loops, to larger holding pipes (below, left), anchored through the roof. Some of the holding pipes simultaneously supported panels for both the façade and one of the inner courtyards. The corrugated plastic tube, snaking through a web of belts (below, right), was an air duct used to inflate the air cushions.

Die Dachmannschaften befestigten die oberen Ränder der Paneele, die alle mit durch weiße Schlaufen geführten dünnen Rohren versehen waren, an größeren, auf dem Dach verankerten Halterohren (unten links). Einige dieser Halterohre sicherten sowohl Paneele für die Fassade als auch für einen Innenhof. Mit Hilfe des sich durch ein Netz aus Gurten schlängelnden Luftschlauches aus geriffeltem Kunststoff (unten rechts) wurden die Luftkissen aufgeblasen.

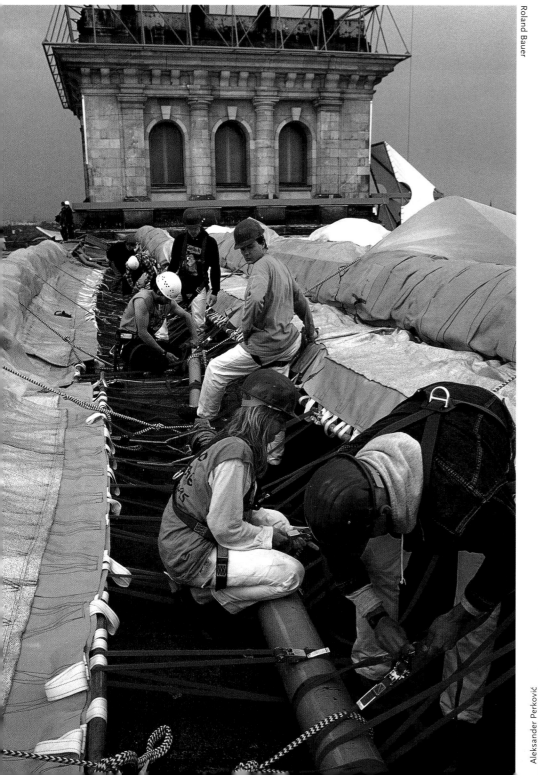

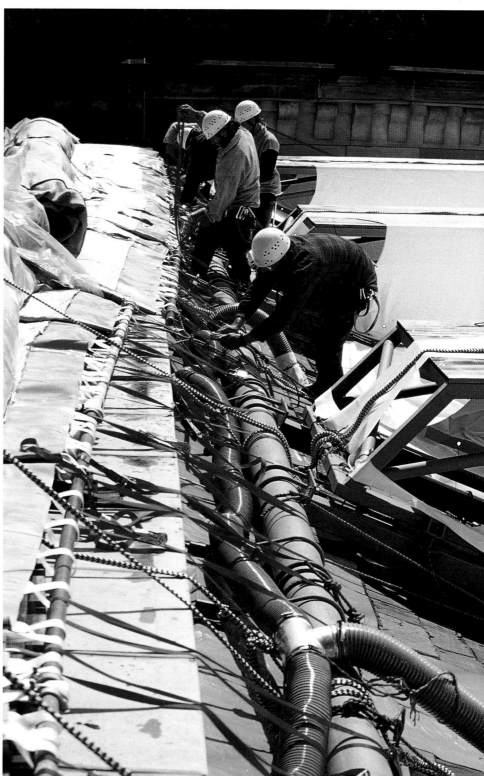

Roland Bauer

Aleksander Perković

The walls of the two inner courtyards were the first to be draped with fabric. A team of workers pushed the rolled fabric to the edge of one of the courtyards (below, left). As soon as a roll was manœuvred over the edge, the task of the roof crew was to guide its unfurling with white restraining ropes. Climbers accompanied the roll on its way down the wall. To everyone's relief the inner courtyards were wrapped without any problems.

Die Außenwände der beiden Innenhöfe wurden als erste mit Stoff verhüllt. Ein Arbeiterteam schob das zusammengerollte Gewebe an den Rand eines Innenhofs (unten links). Sobald eine Rolle an den Rand manövriert worden war, oblag es der Dachmannschaft, die Entfaltung der Rolle mit Hilfe weißer Rückhalteseile zu lenken. Kletterer begleiteten die Rolle auf ihrem Weg hinab. Zur großen Erleichterung aller verlief die Verhüllung der Innenhöfe ohne Probleme.

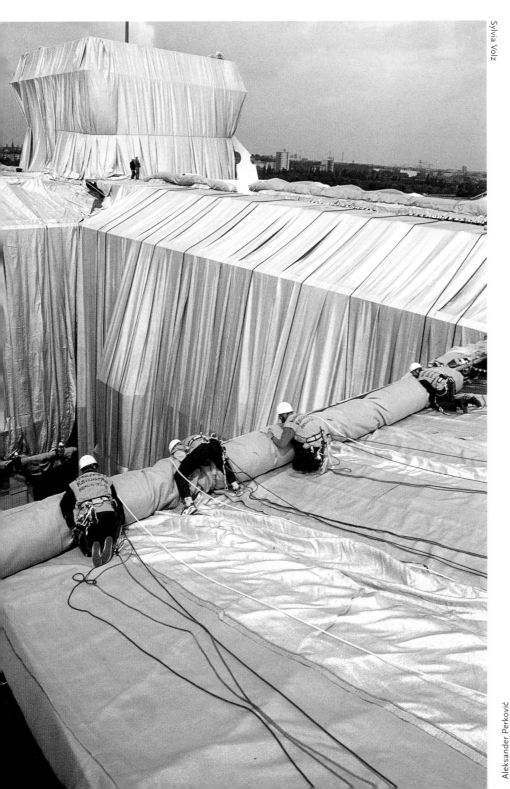

Aleksander Perković

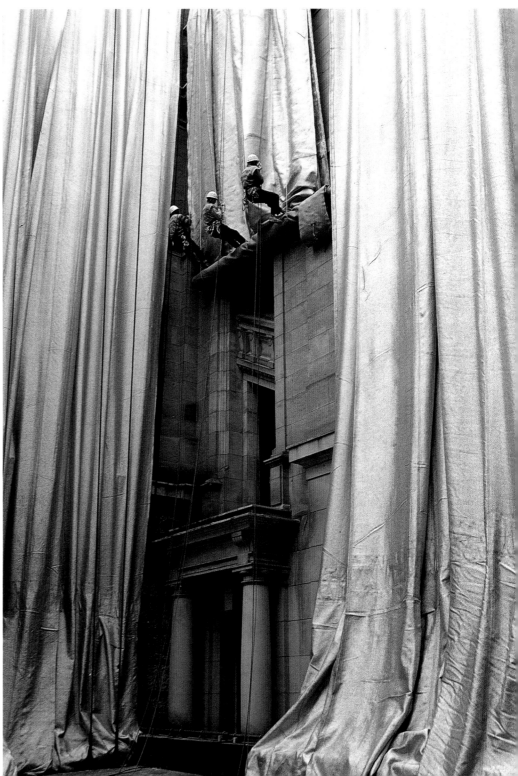

Sylvia Volz

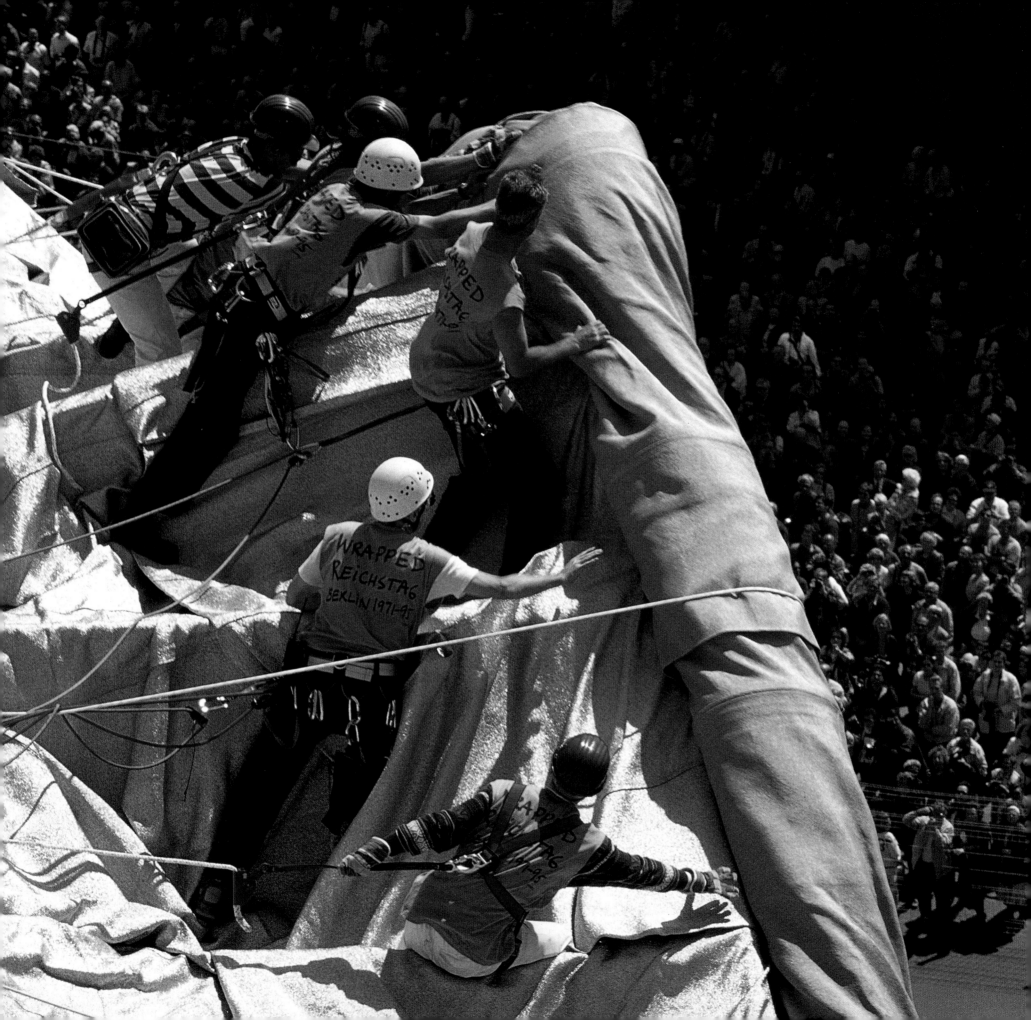

On June 18, 1995 at 5 a.m. the unfurling of the fabric began simultaneously on the four façades. Custom-made cushions placed between the cages supported the rolls of fabric, keeping them in a horizontal position and faciliating the unrolling. For safety reasons every panel was temporarily roped tight in case of sudden wind. The panels were connected by the climbers with sewn-in belts. This connection was then concealed by an overlapping strip of fabric which was clamped on.

Am 18. Juni 1995 um 5 Uhr morgens wurde damit begonnen, die ersten Paneele gleichzeitig an allen vier Fassaden herabzulassen. Bei diesem Vorgang erleichterten speziell dafür hergestellte aufblasbare Montagekissen zwischen den Käfigen das Abrollen. Jedes Paneel wurde zur Sicherheit in der obersten Seilebene mit einem provisorischen Seil zwischengesichert, um so Gefahr durch Windeinwirkung auszuschalten. Die Paneele wurden von den Gewerbekletterern mit eingenähten Gurten verbunden. Diese Verbindung überdeckte man schließlich mit einem überlappenden Streifen Gewebe, der danach festgeklammert wurde.

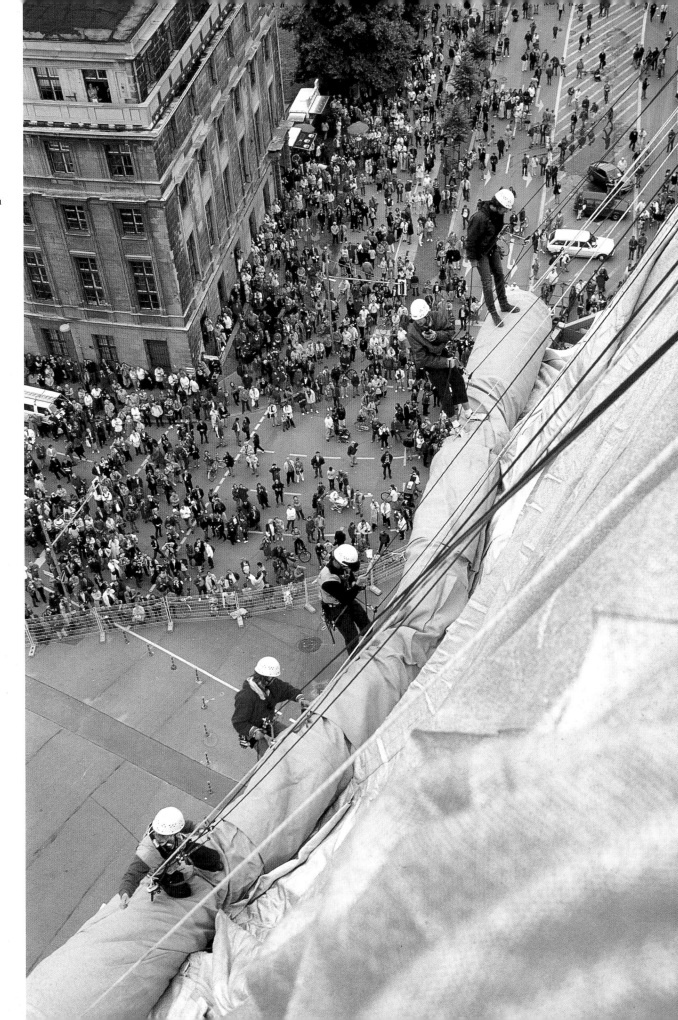

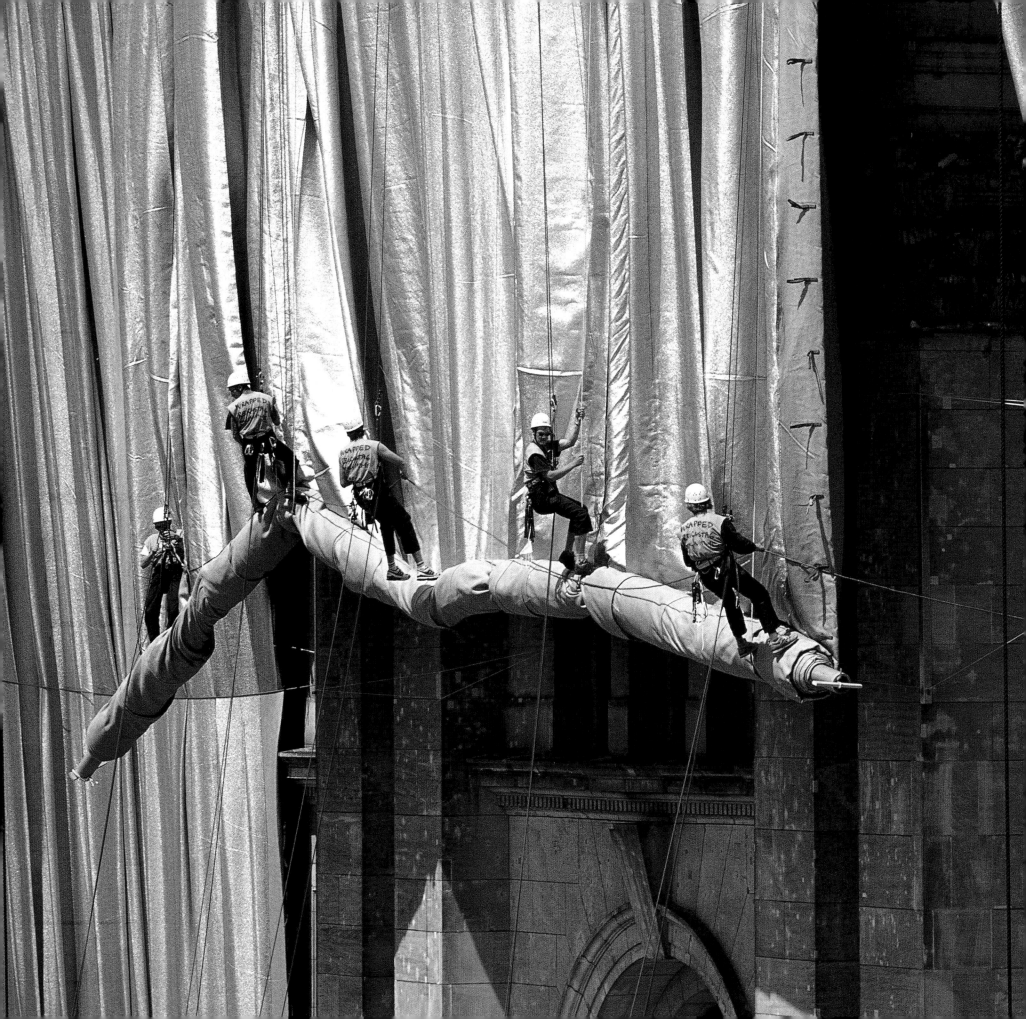

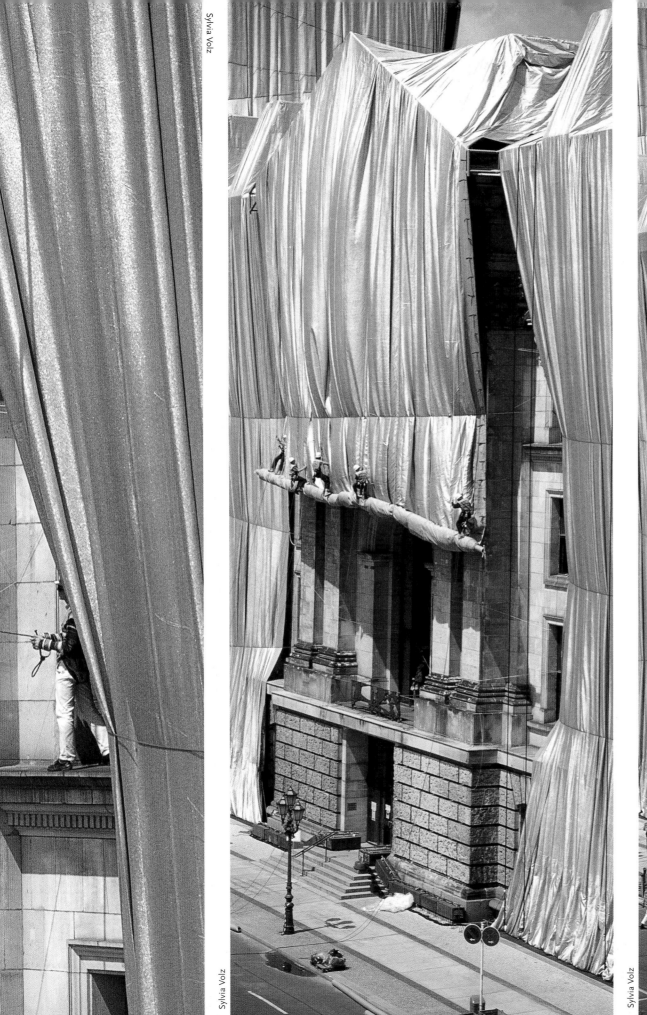
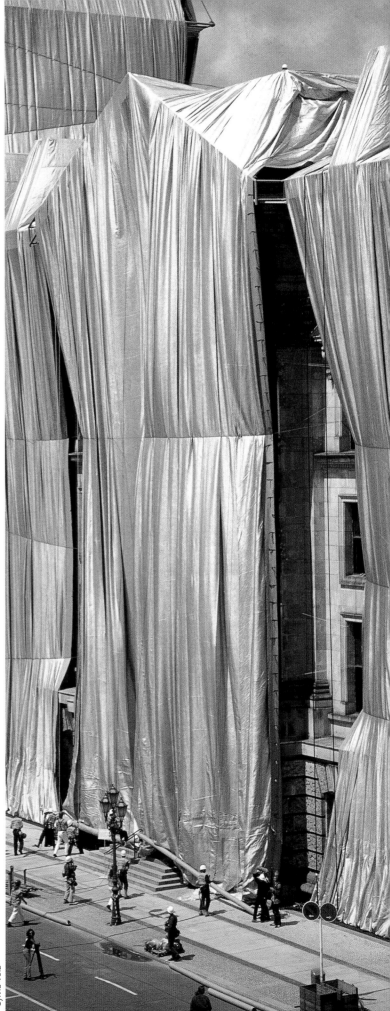

As soon as a section of the façade had been covered with fabric, the climbers affixed the grid of blue ropes. The vertical ropes were lowered from the roof; then the horizontal ropes were raised one by one and connected to the vertical ropes at the crossing points. Restraining ropes were guided through special slits in the fabric at most of these connections and secured to the anchoring system inside the building.

Immer, wenn ein Fassadenabschnitt mit Gewebe bedeckt war, wude von den Gewerbekletterern das blaue Seilnetz montiert. Die vertikalen Seile wurden von oben heruntergelassen; daraufhin wurden die horizontalen Seile einzeln hochgezogen und an den Schnittpunkten mit den vertikalen verbunden. An den meisten Knotenpunkten wurde dann ein Rückhalteseil durch das Gewebe geführt und mit den Haltepunkten innen im Gebäude verbunden.

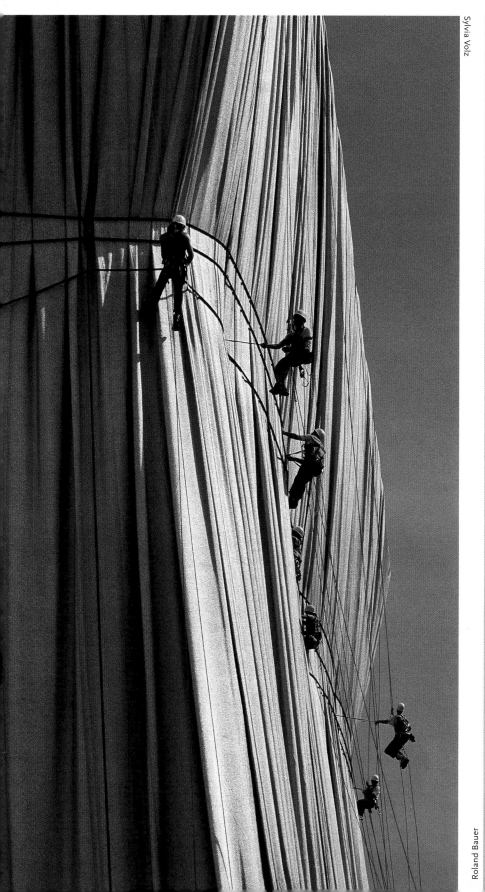

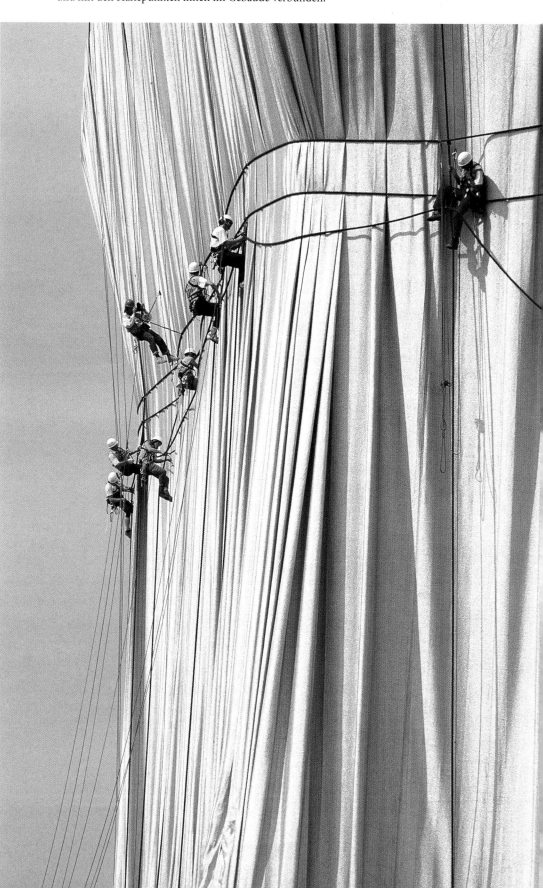

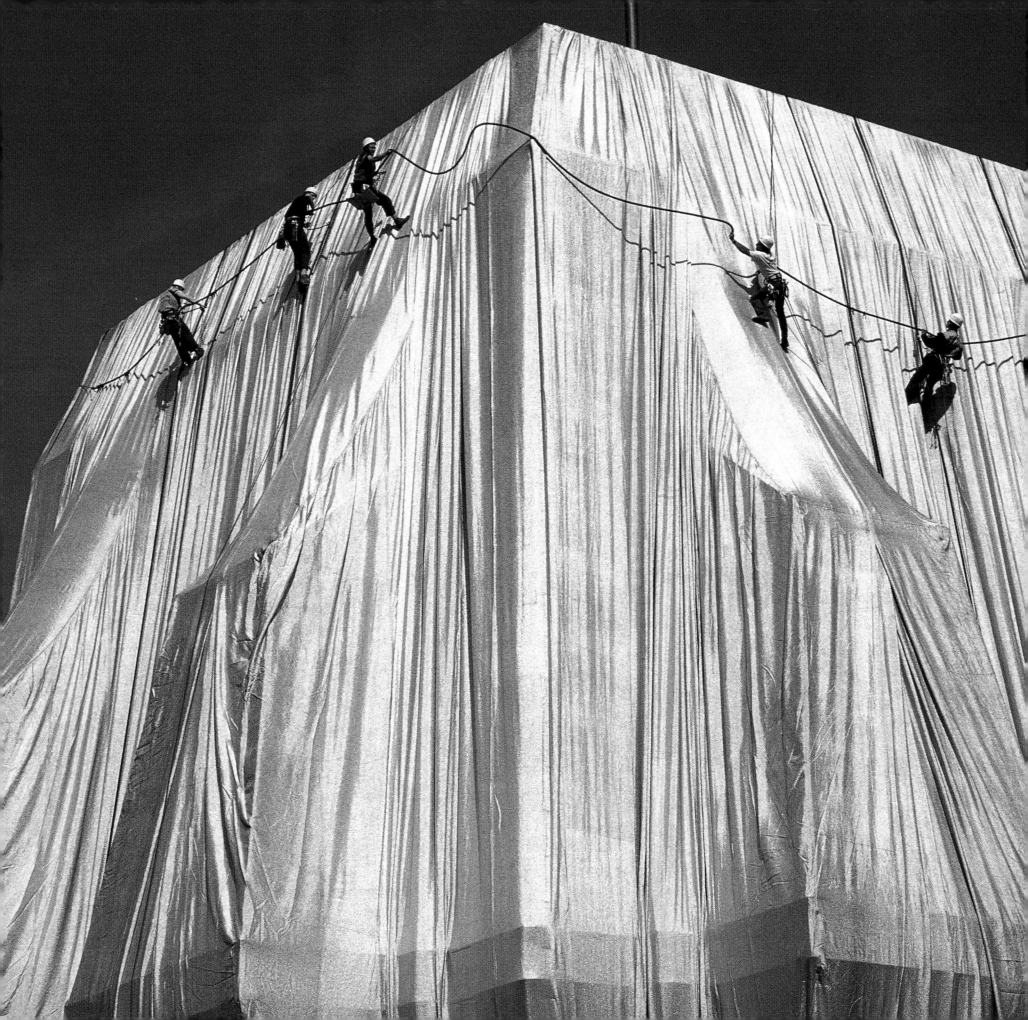

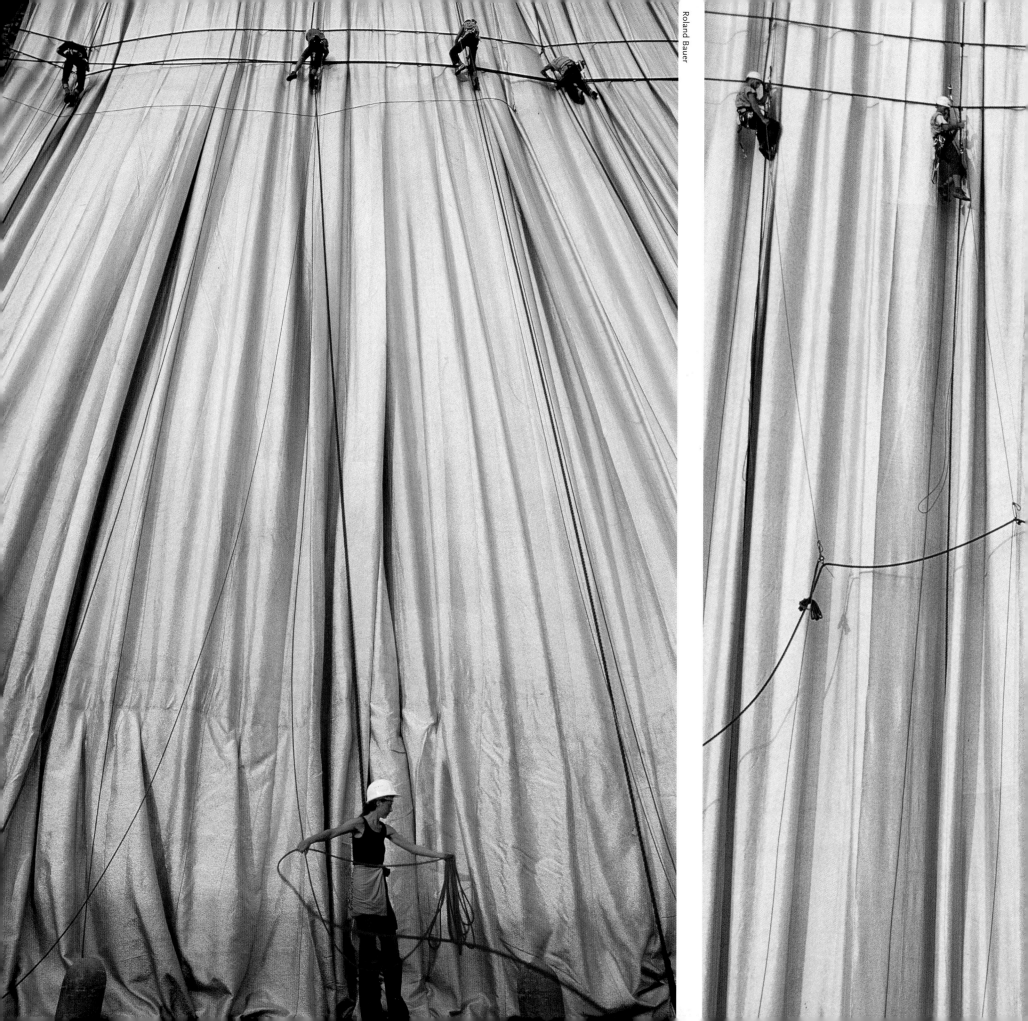

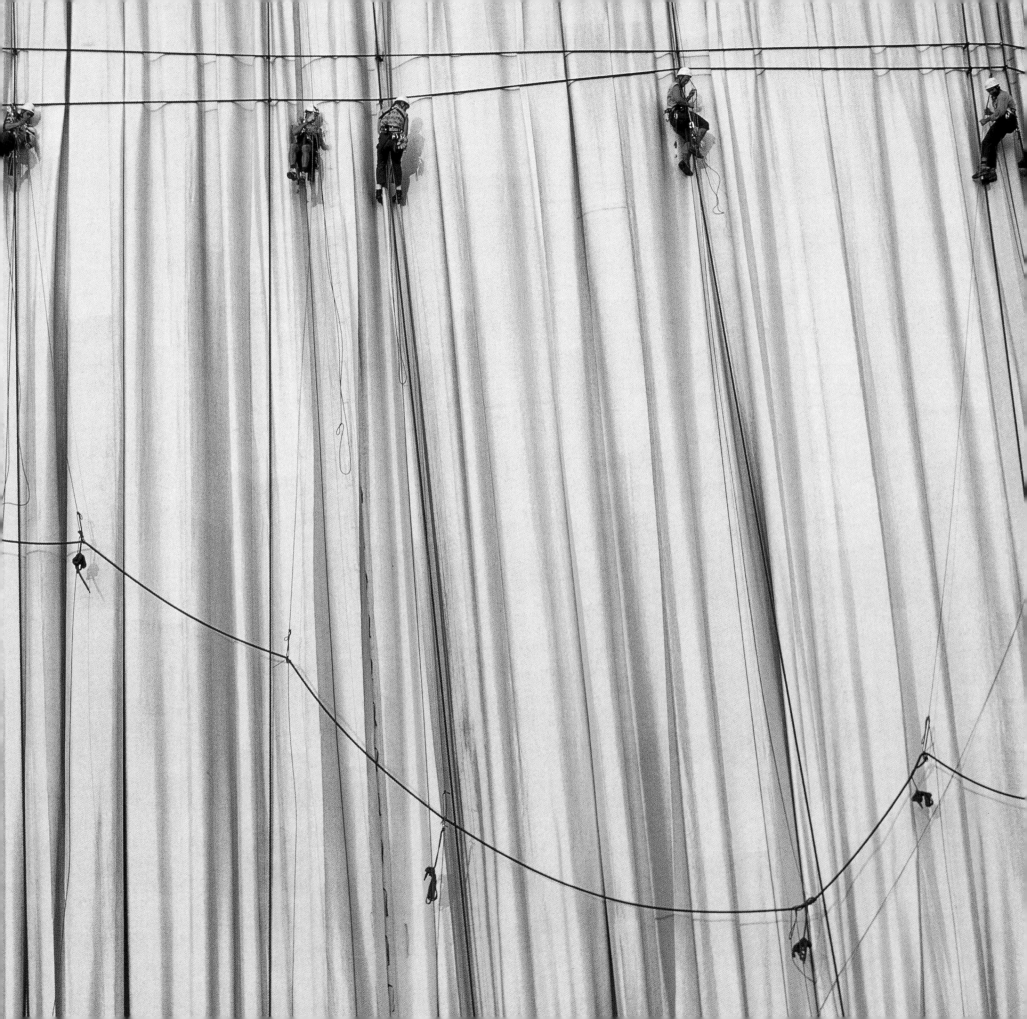

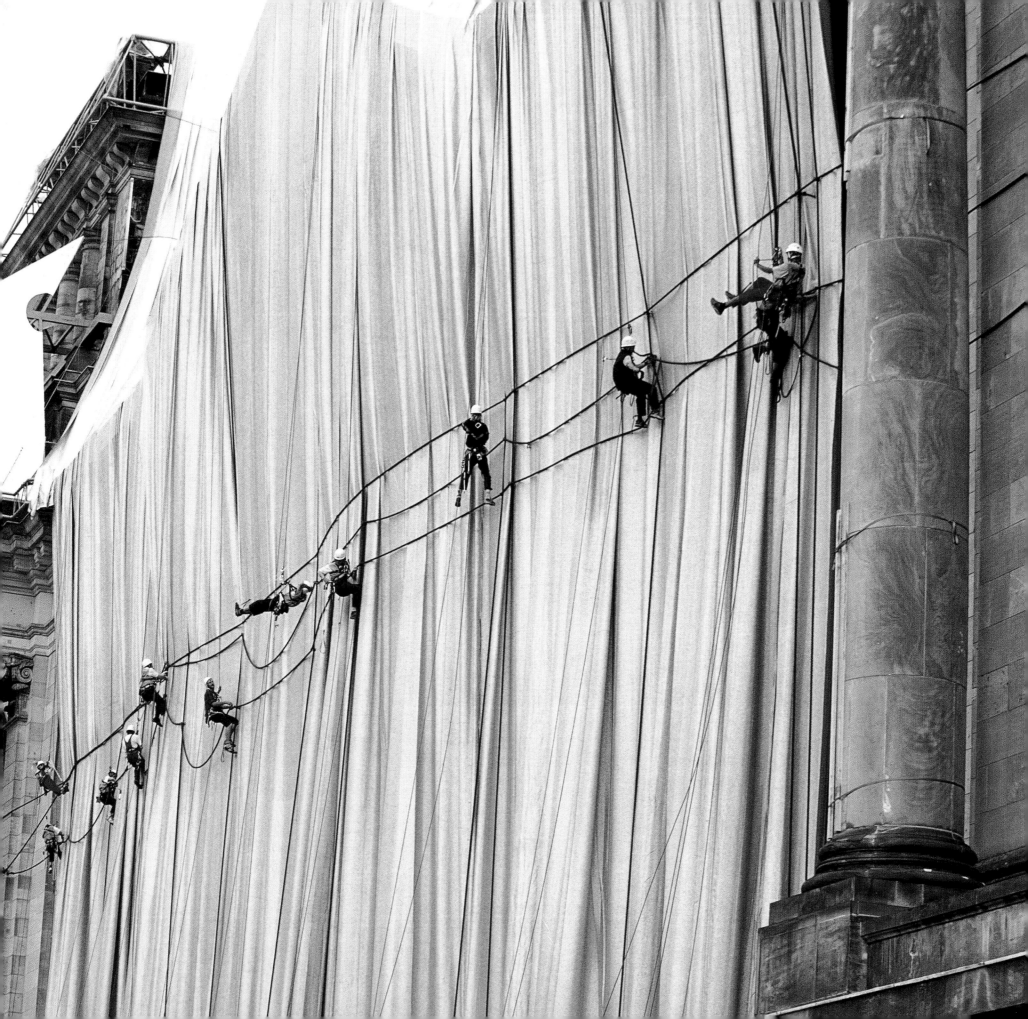

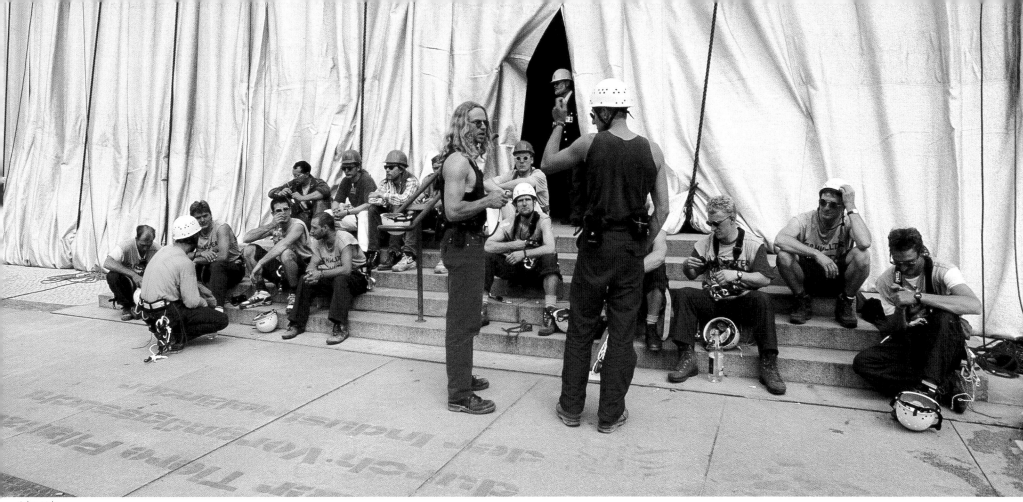

Sylvia Volz

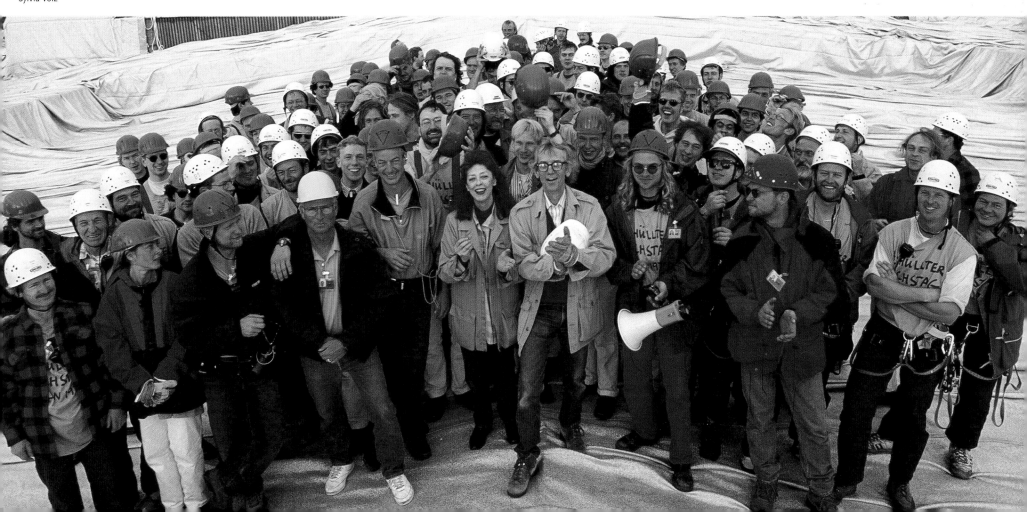

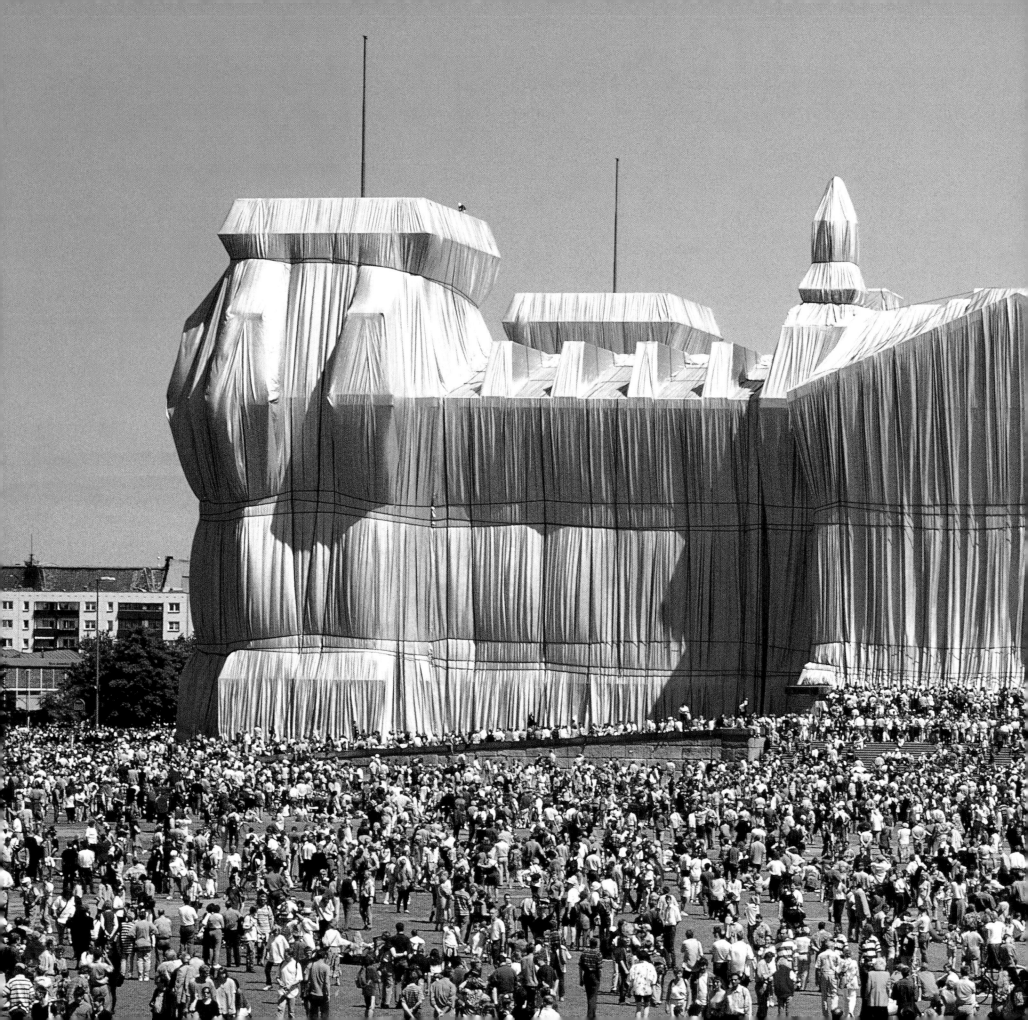

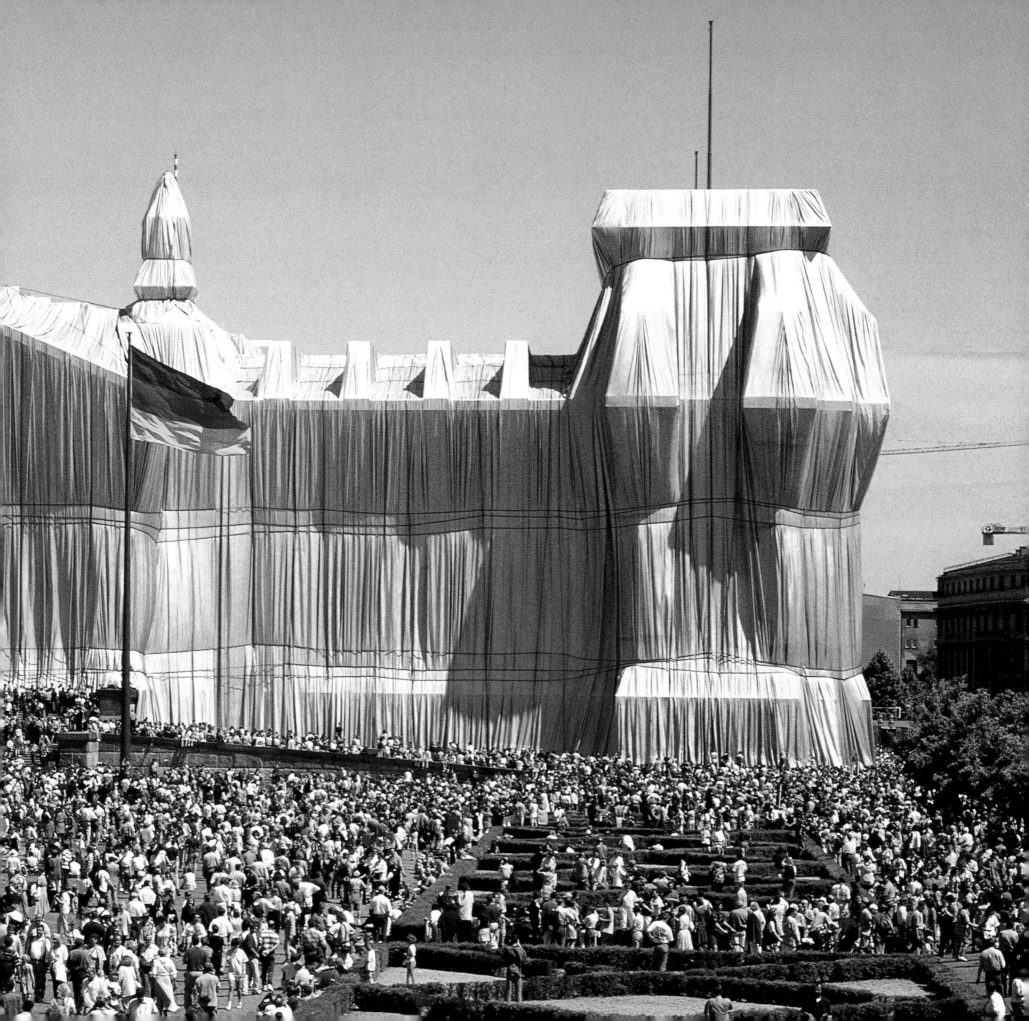

## The Spectacle of Natural Light

The aluminized fabric was exceptionally responsive to changing light, depending on the time of day (early morning, below), the brightness of the sky and the presence of clouds. The tone of the cloth ranged from shimmering pale silver to gloomiest gray.

Next spreads: The ever-shifting play of light and shadow across the folds offered a dramatic spectacle of its own.

## Das Schauspiel natürlichen Lichts

Das aluminisierte Gewebe reagierte intensiv auf das sich mit den Tageszeiten ändernde Licht (unten: am frühen Morgen), auf die Helligkeit des Himmels und auf vorbeiziehende Wolken. Der Farbton des Stoffes changierte von schimmerndem blassen Silber bis zum düstersten Grau.

Folgende Doppelseiten: Das ständig wechselnde Spiel von Licht und Schatten auf den Falten des Stoffes bot ein dramatisches Schauspiel ganz eigener Art.

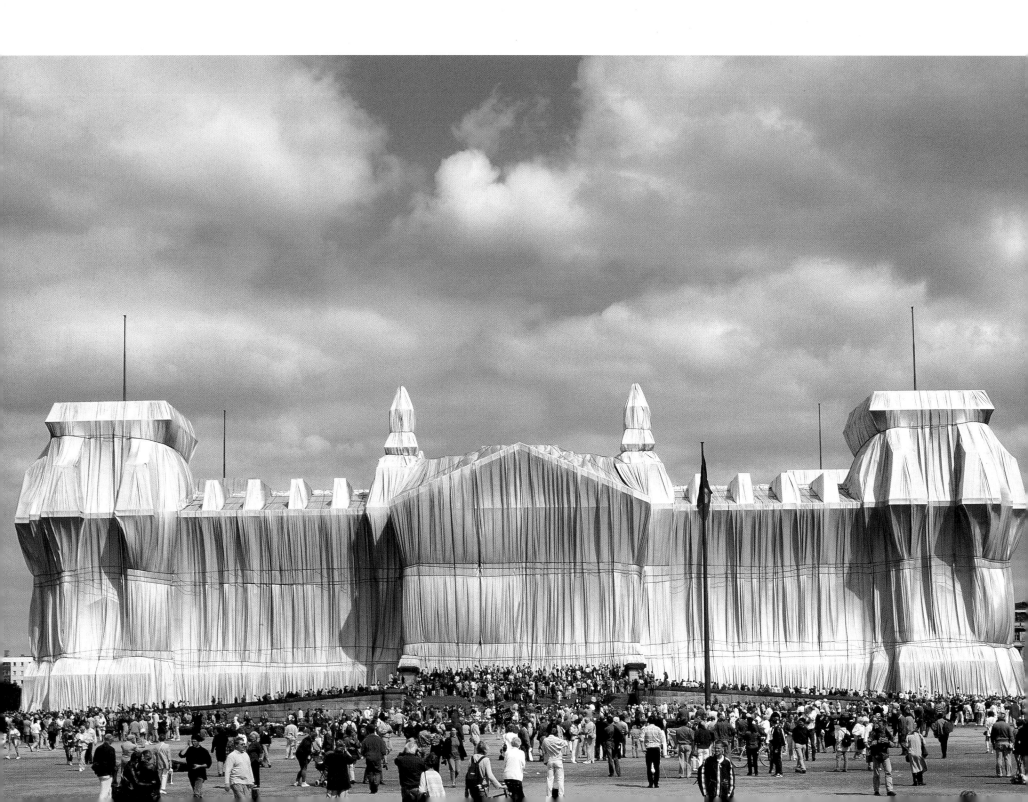

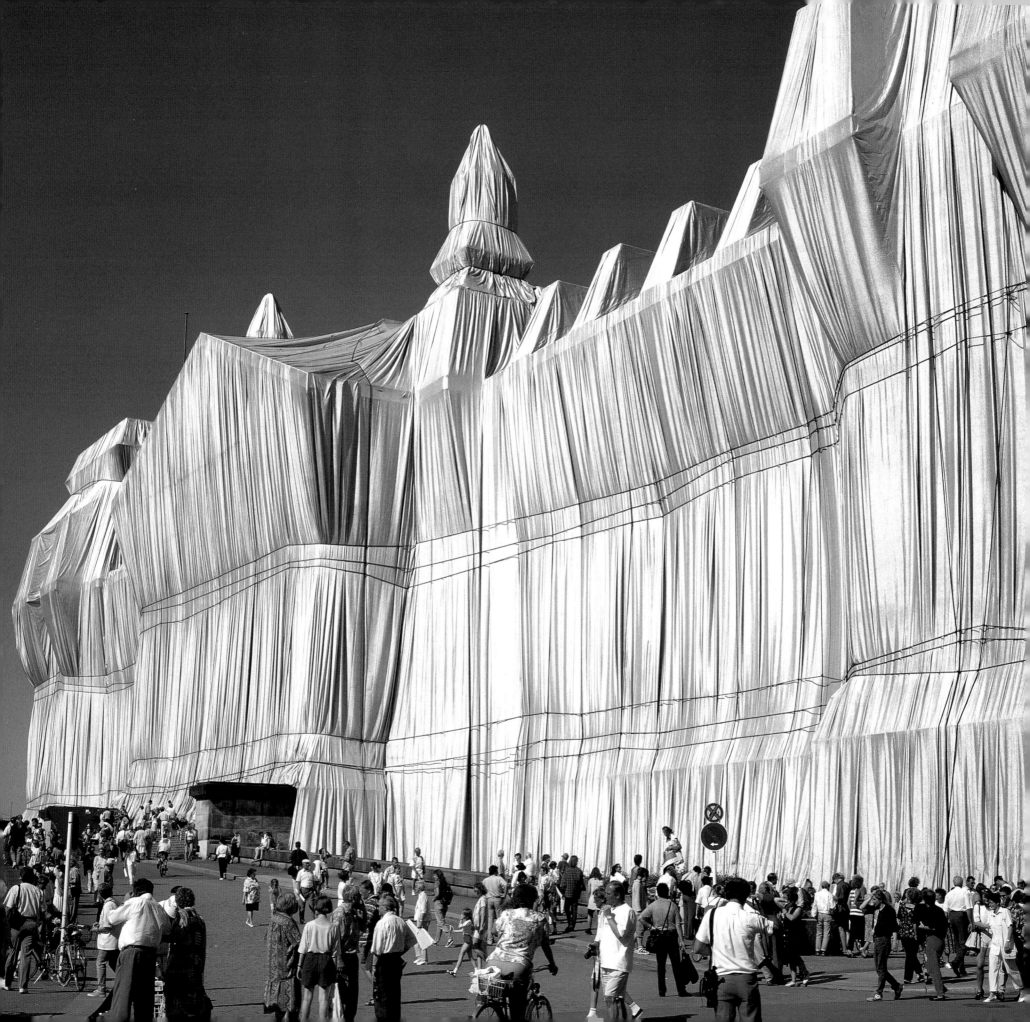

The west and south facades at noon

West- und Südfassade zur Mittagszeit

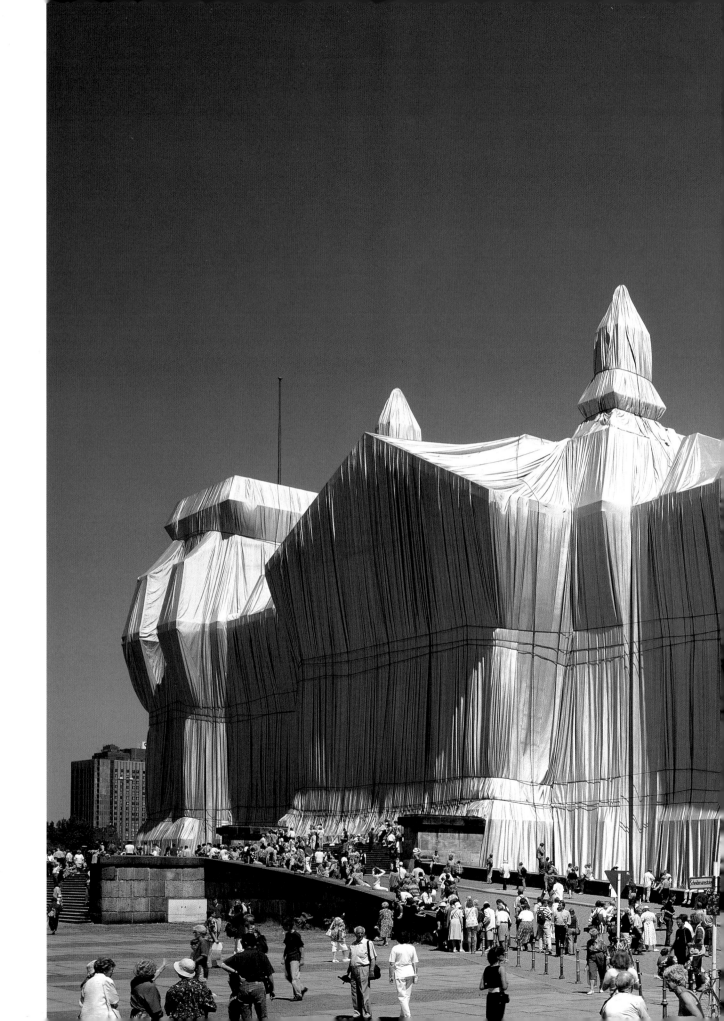

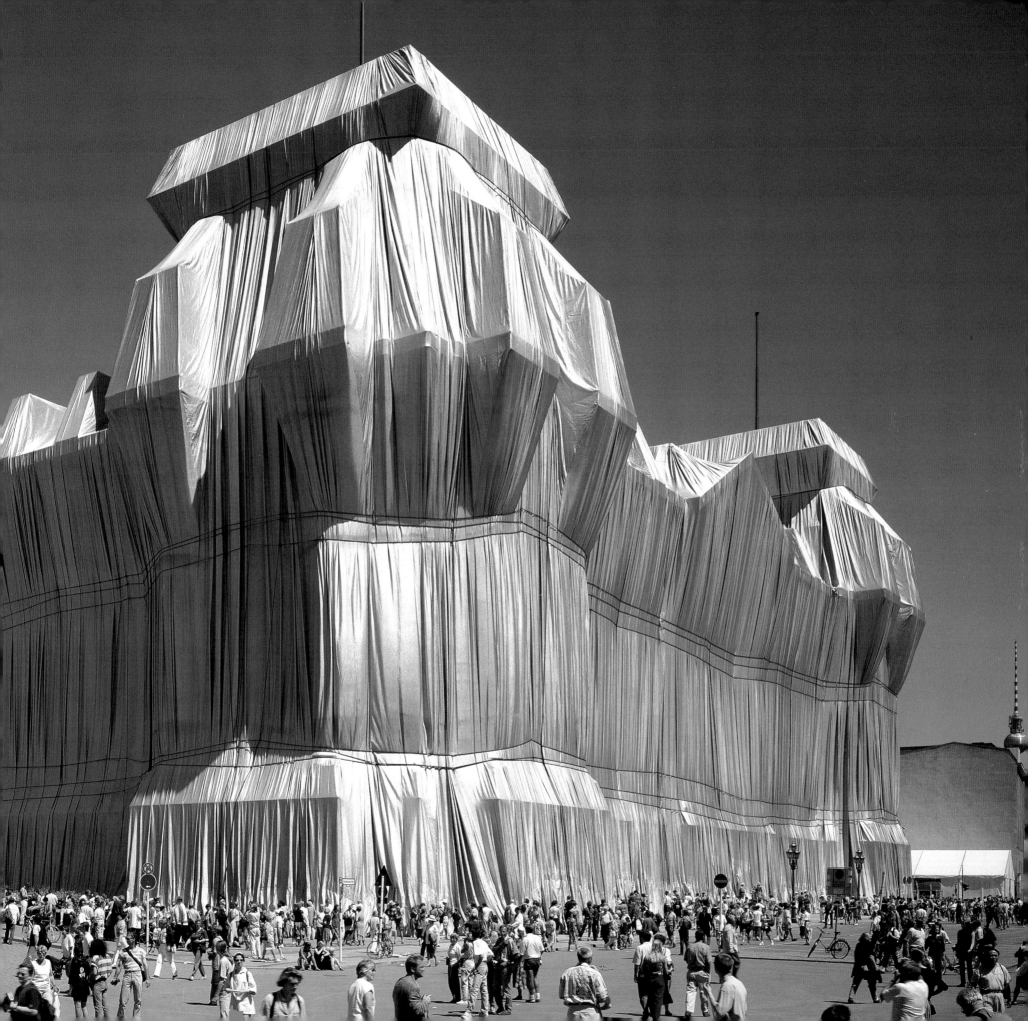

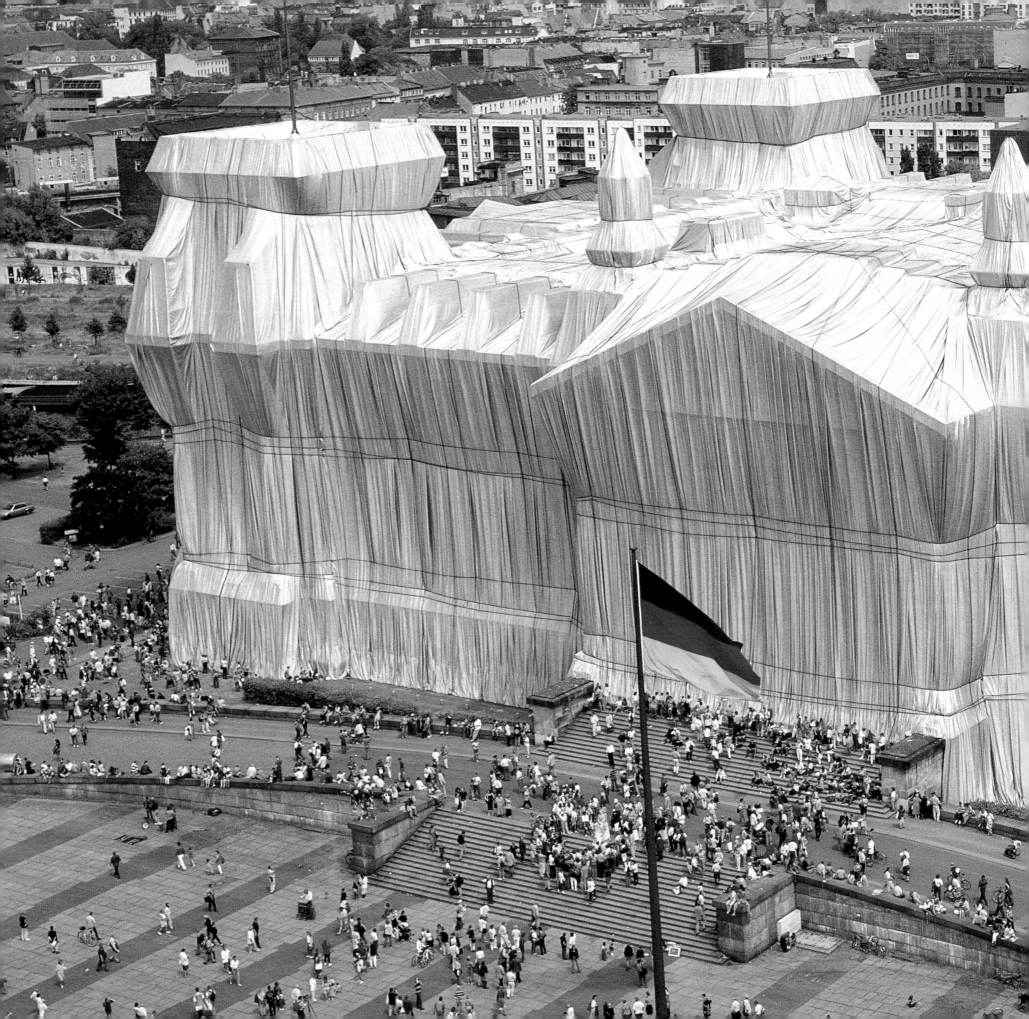

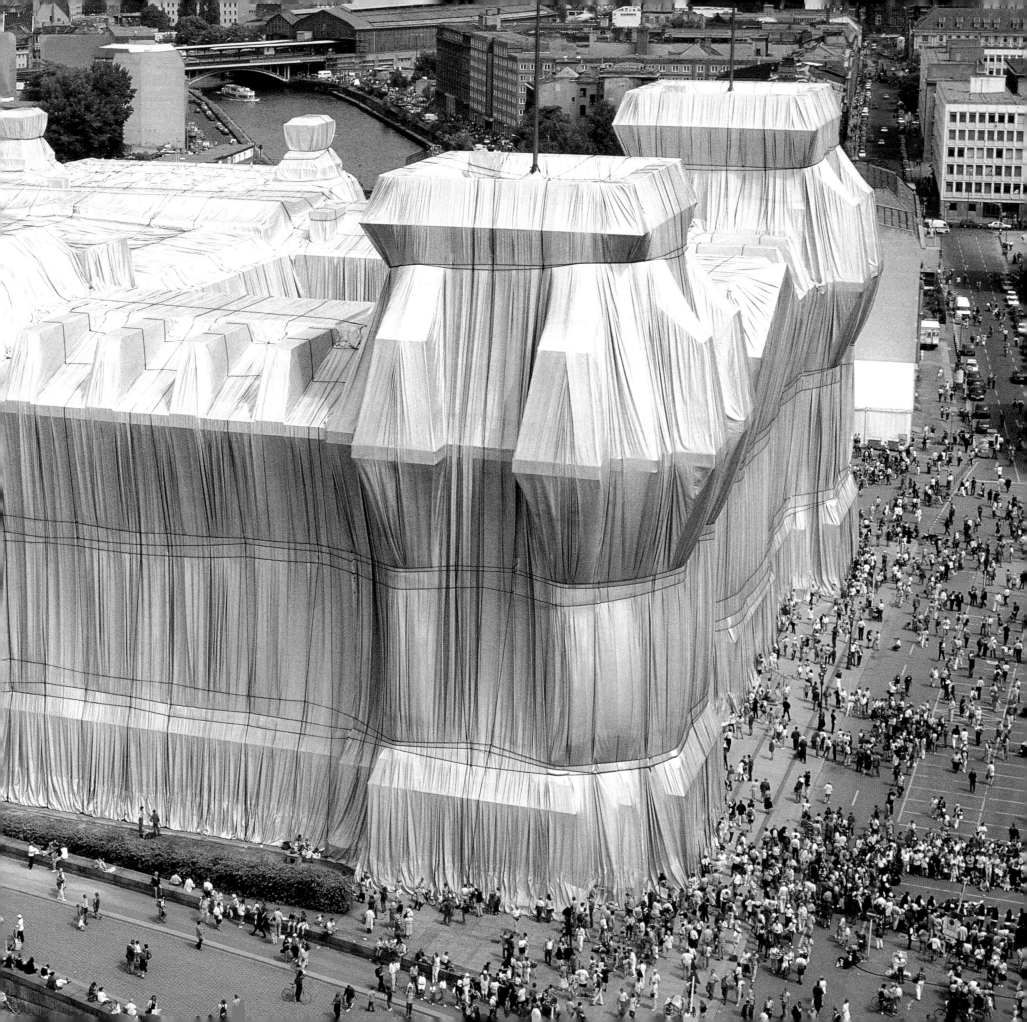

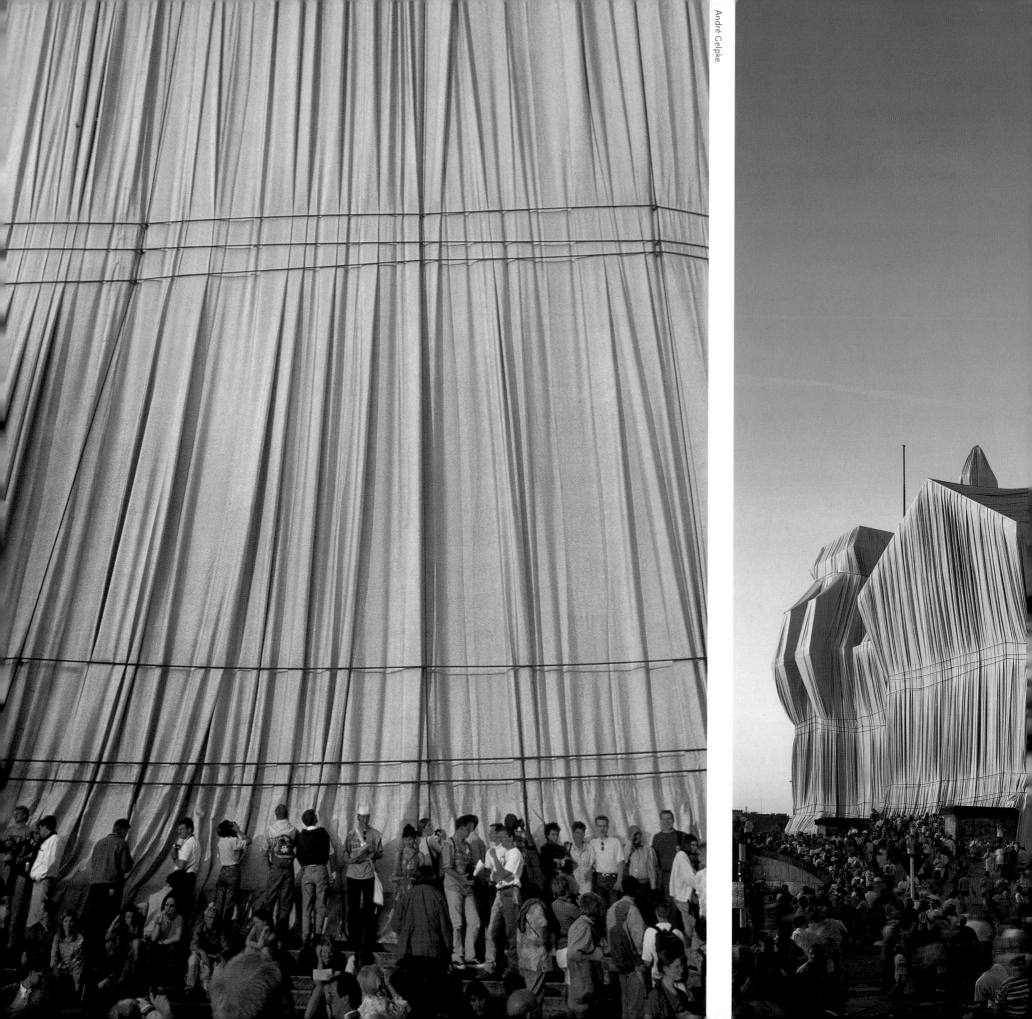

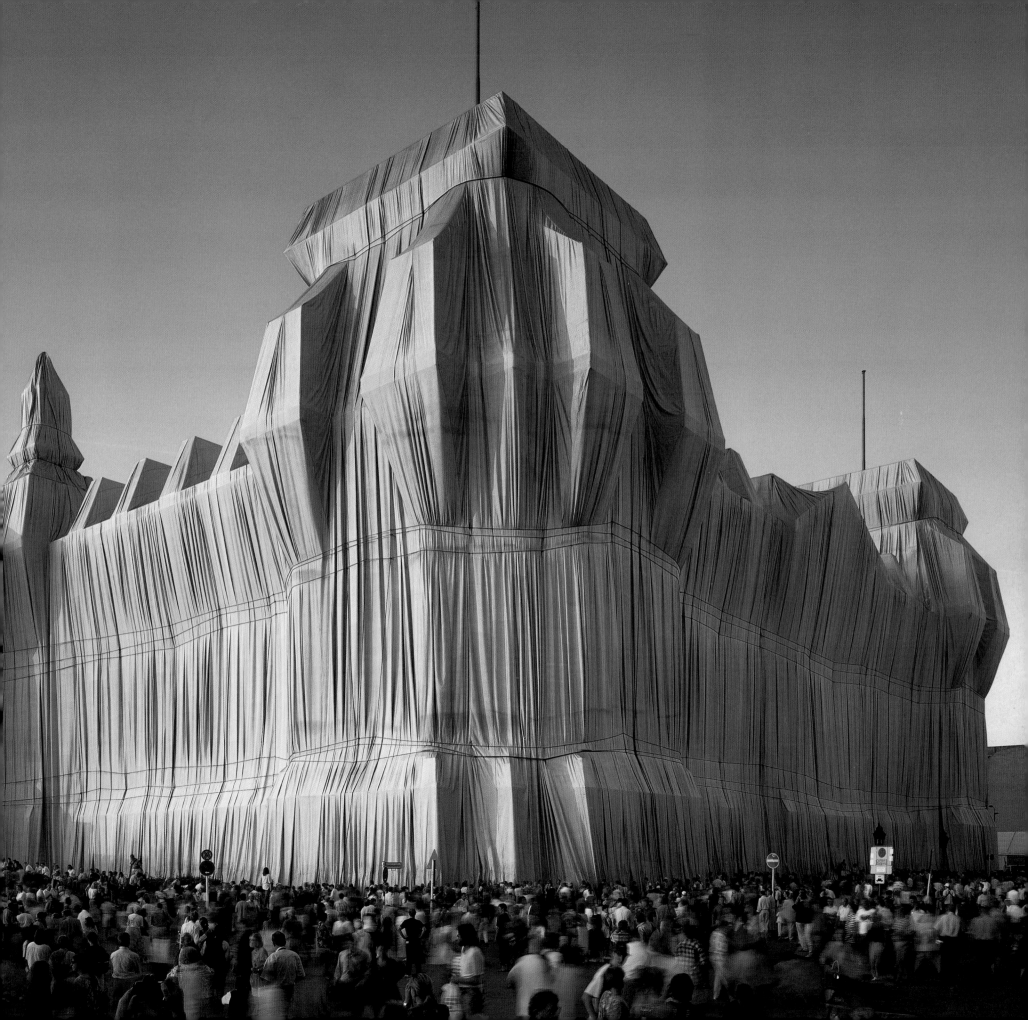

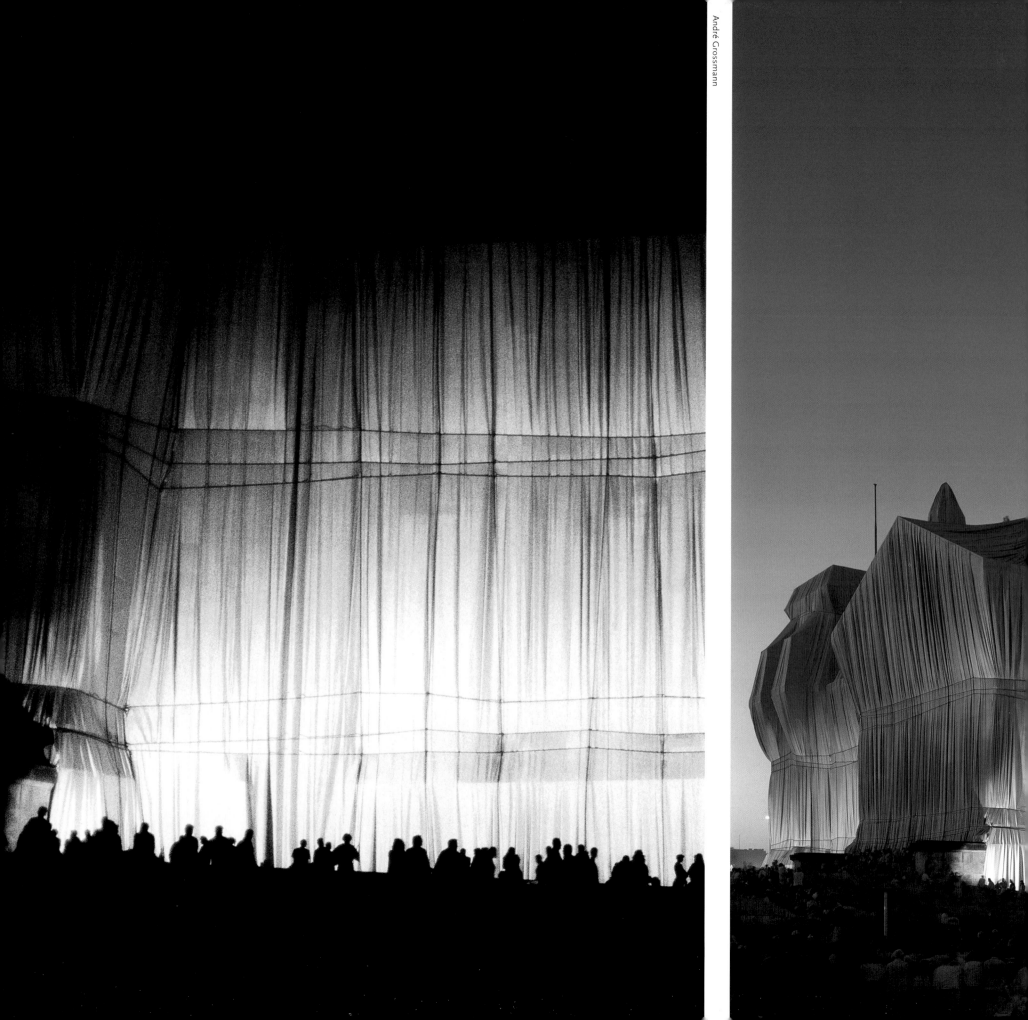

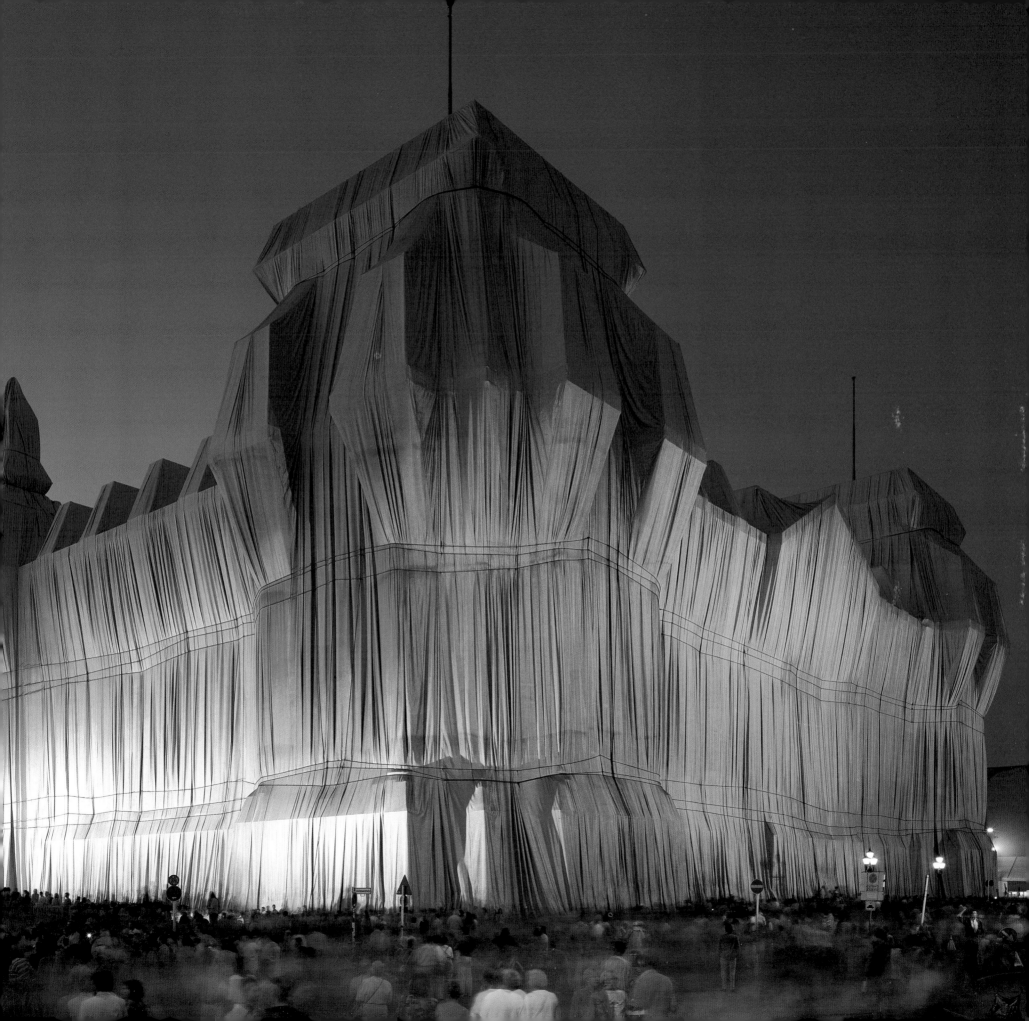

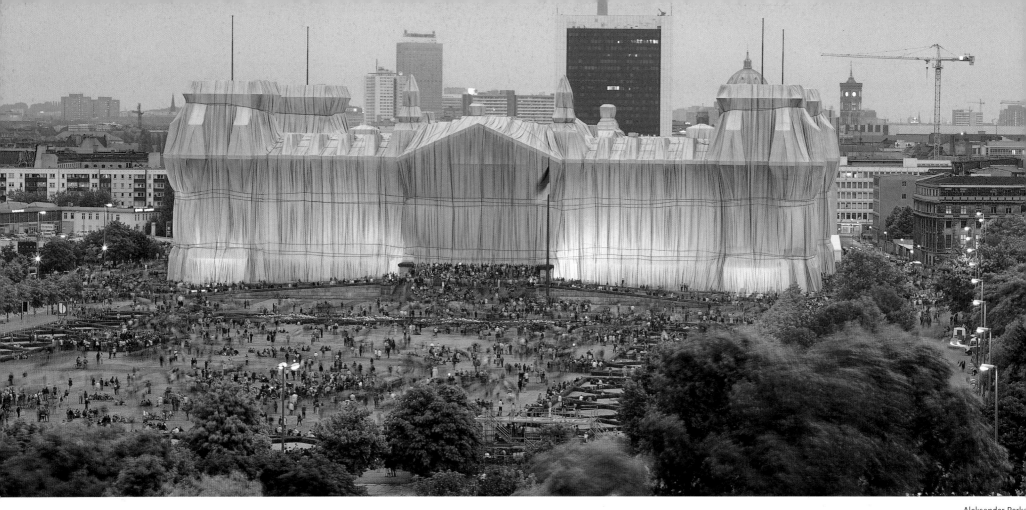

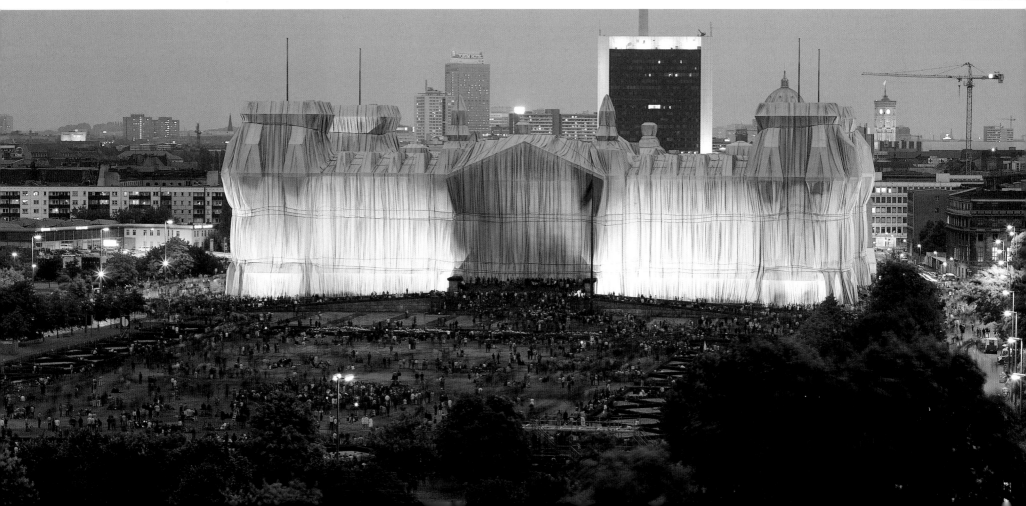

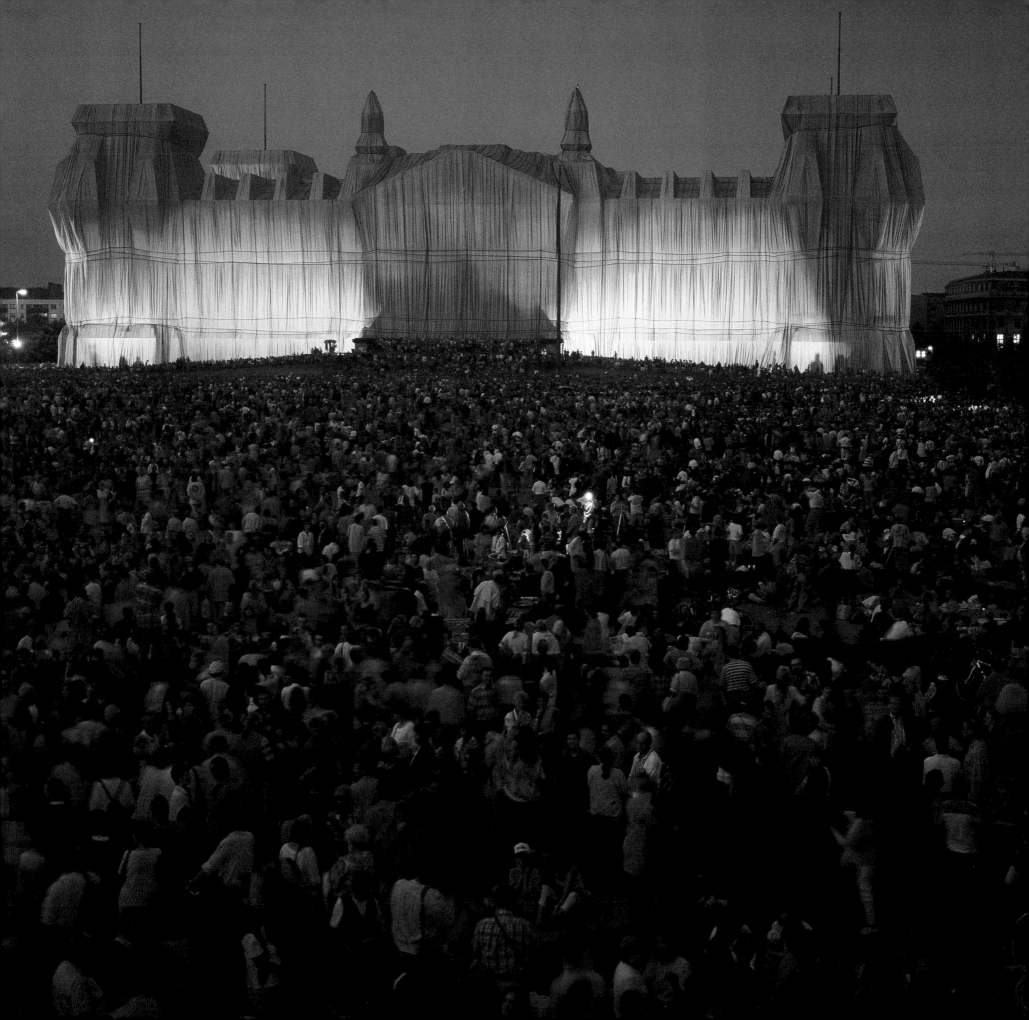

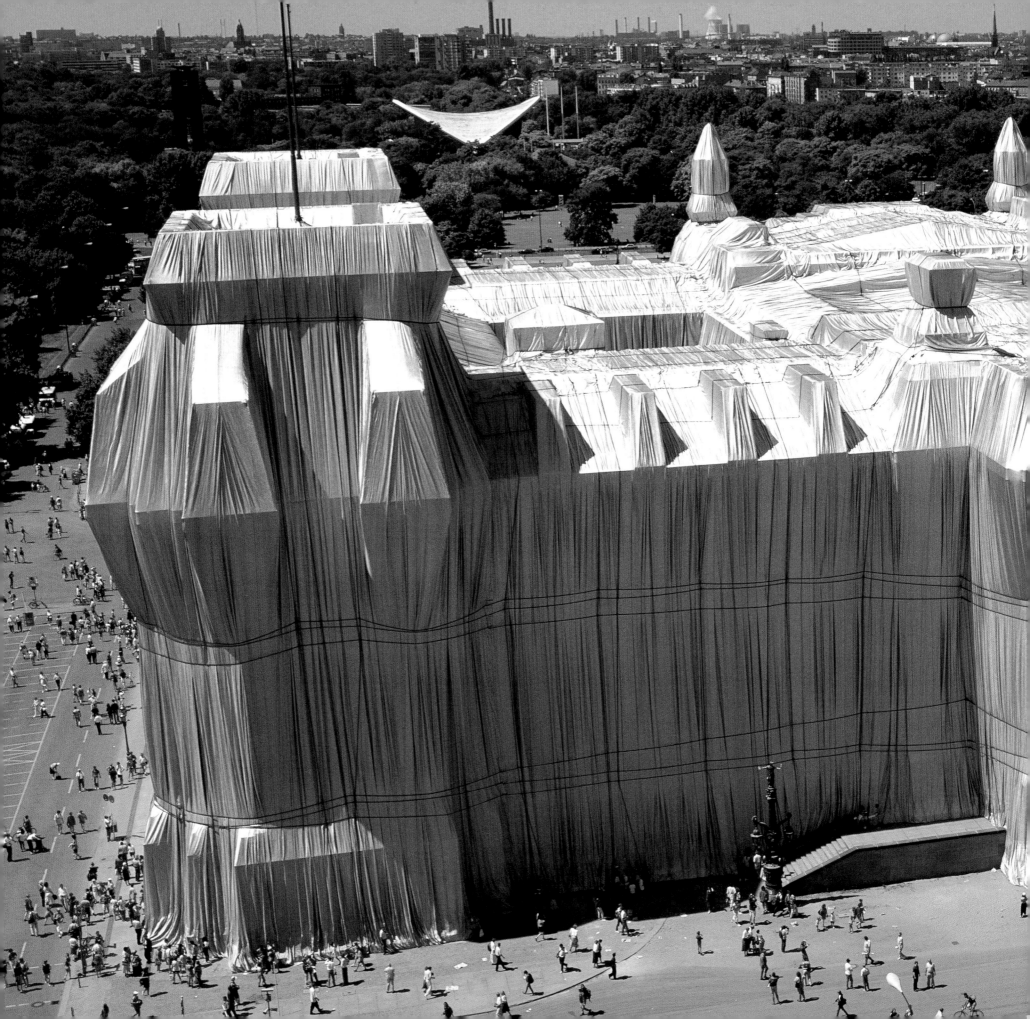

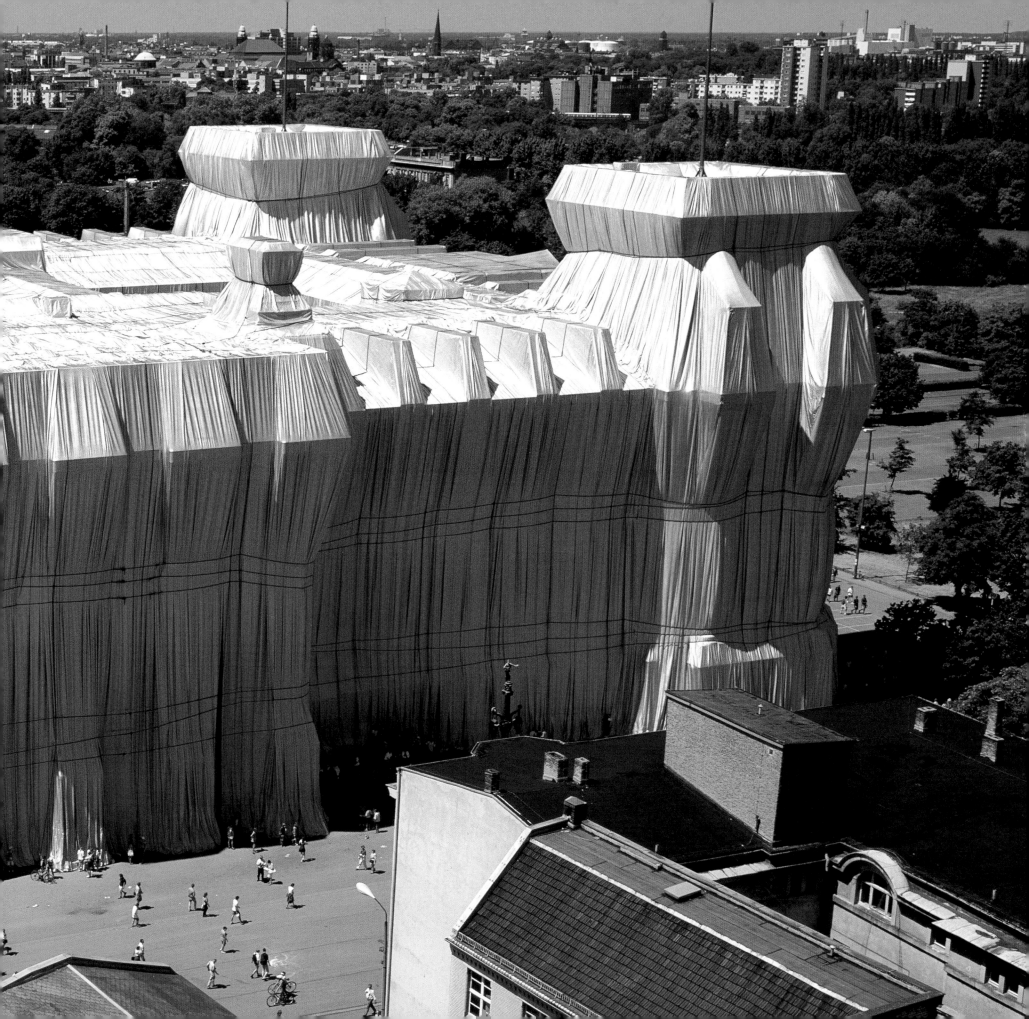

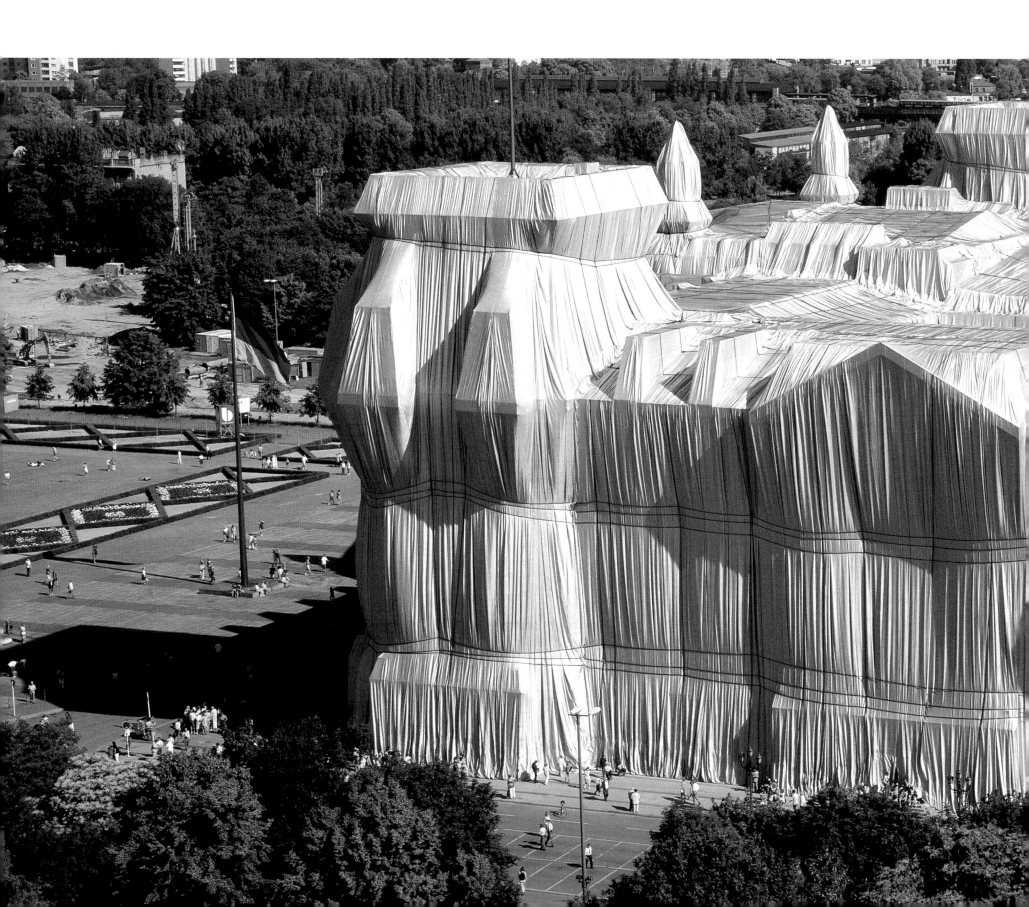

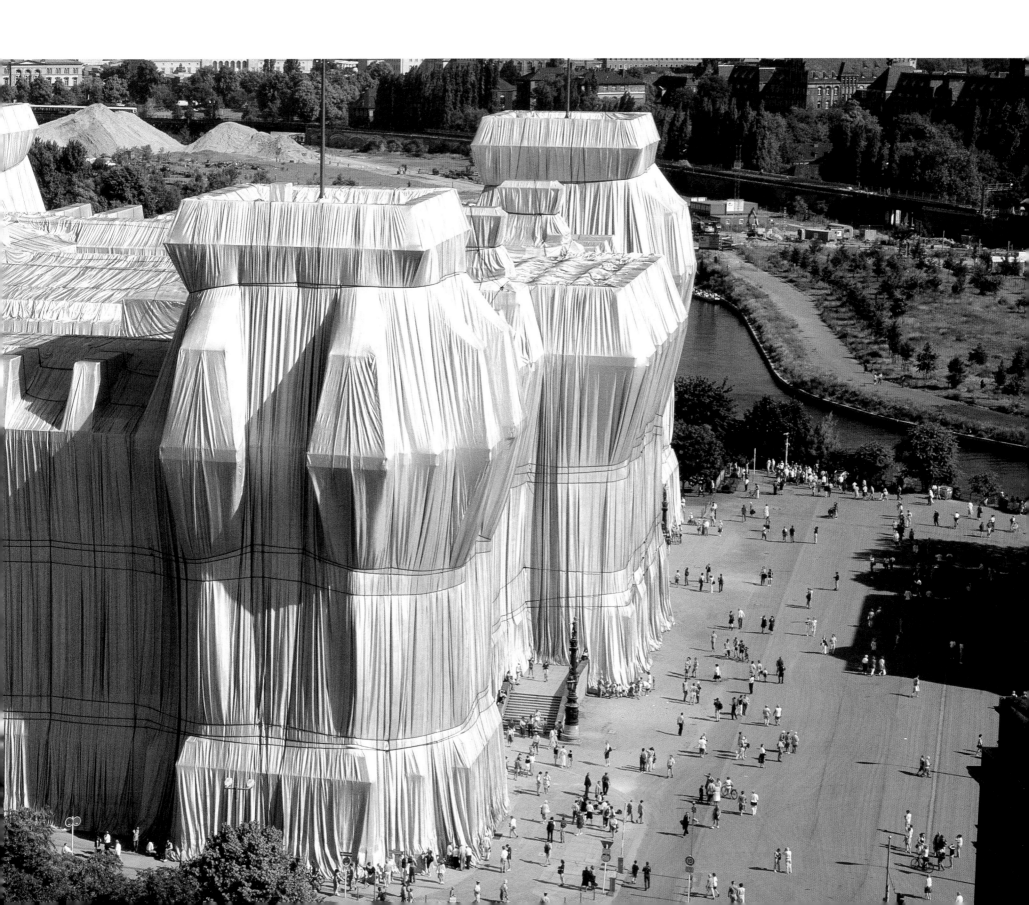

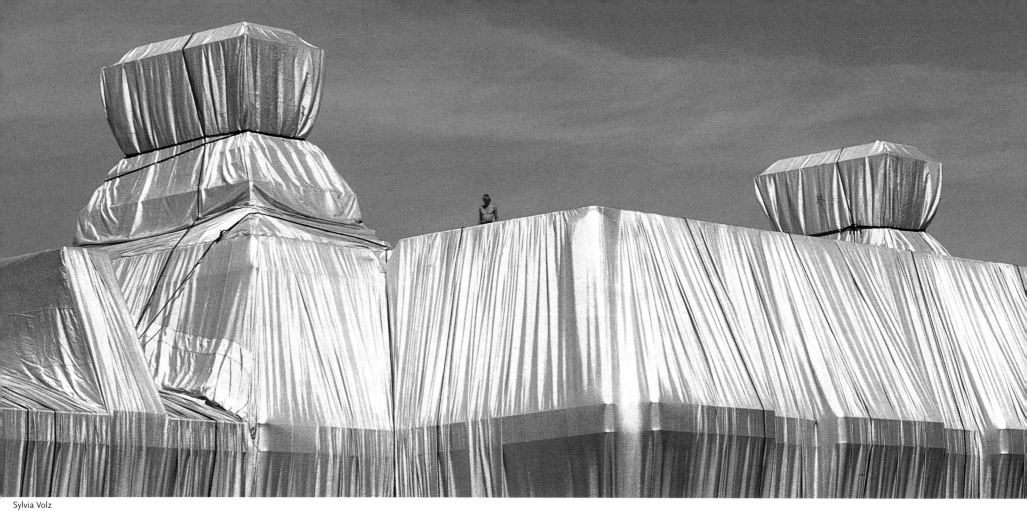

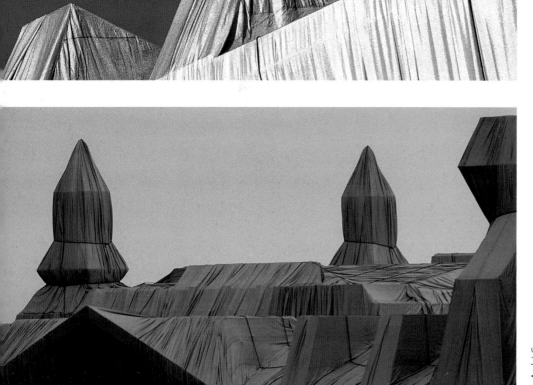

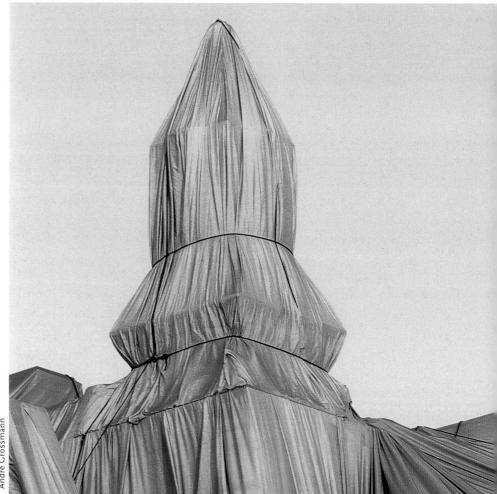

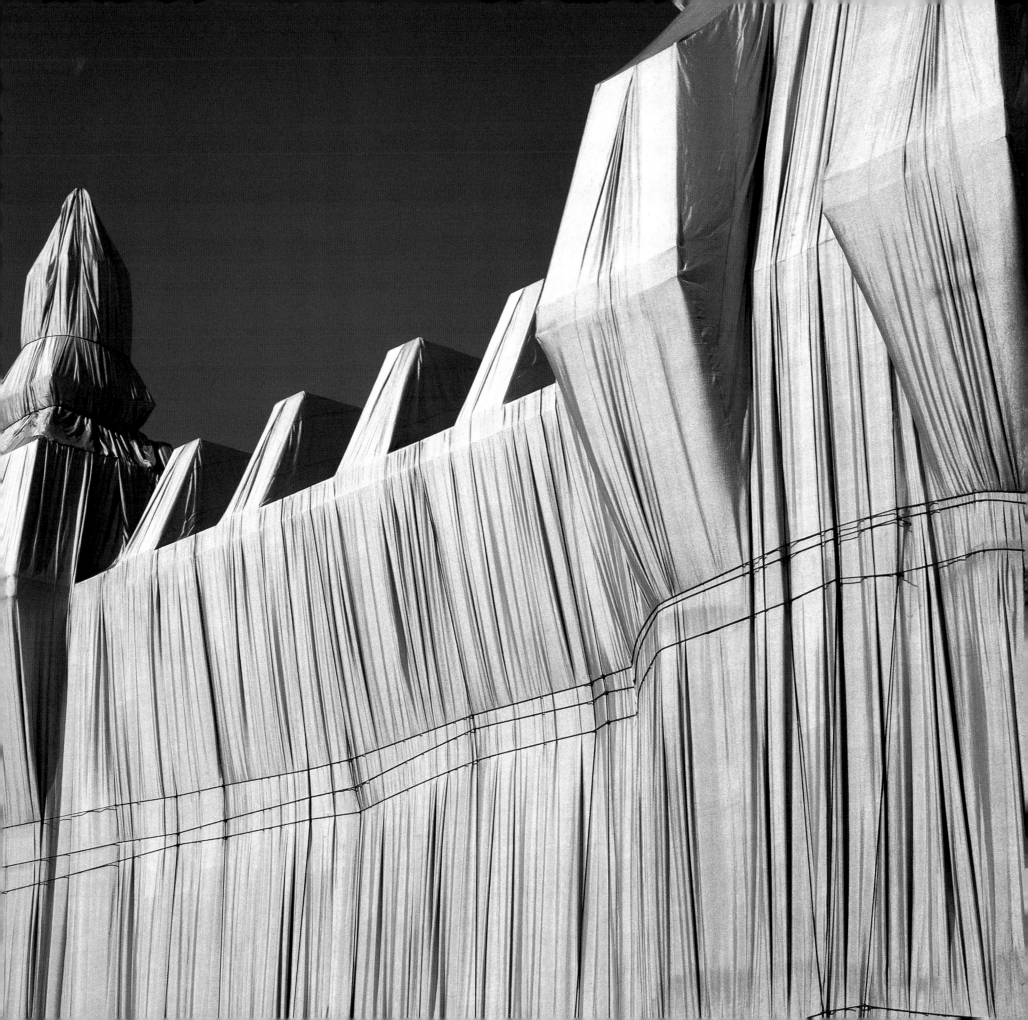

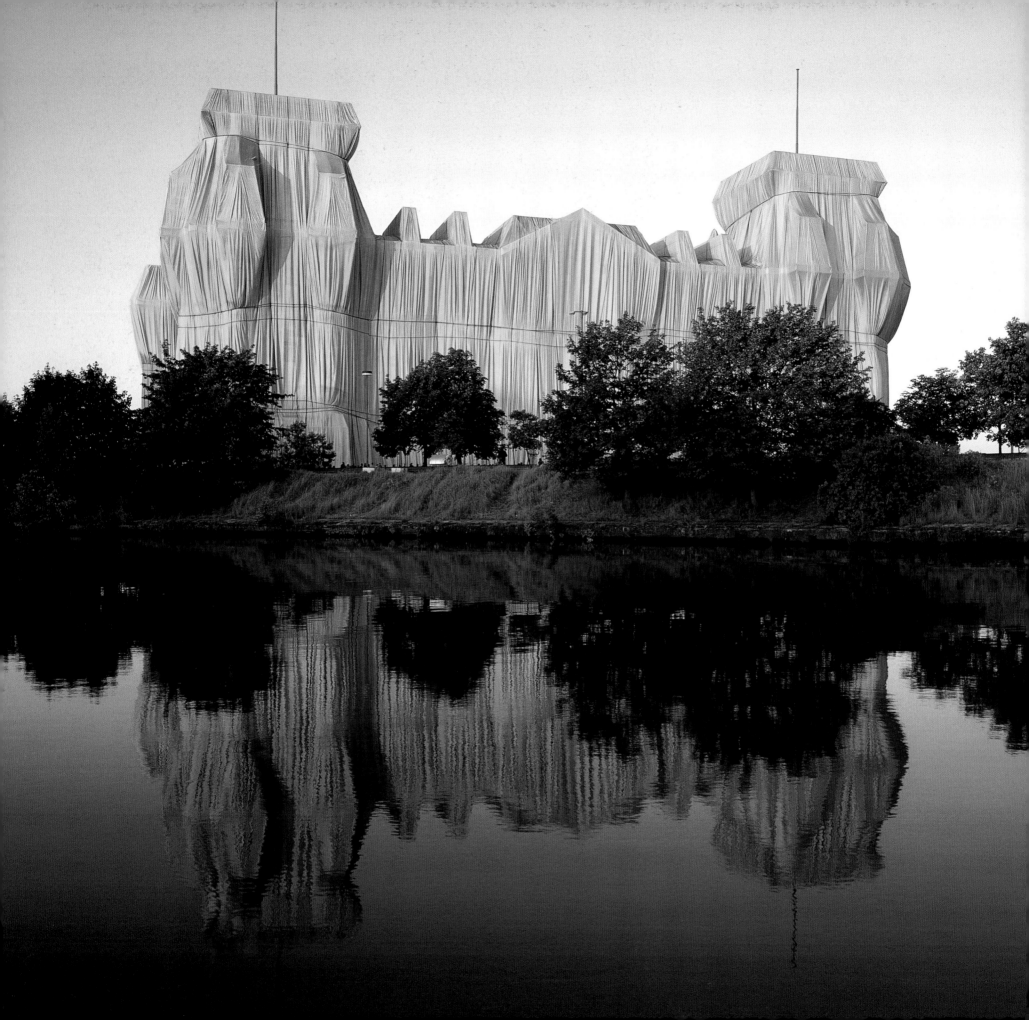

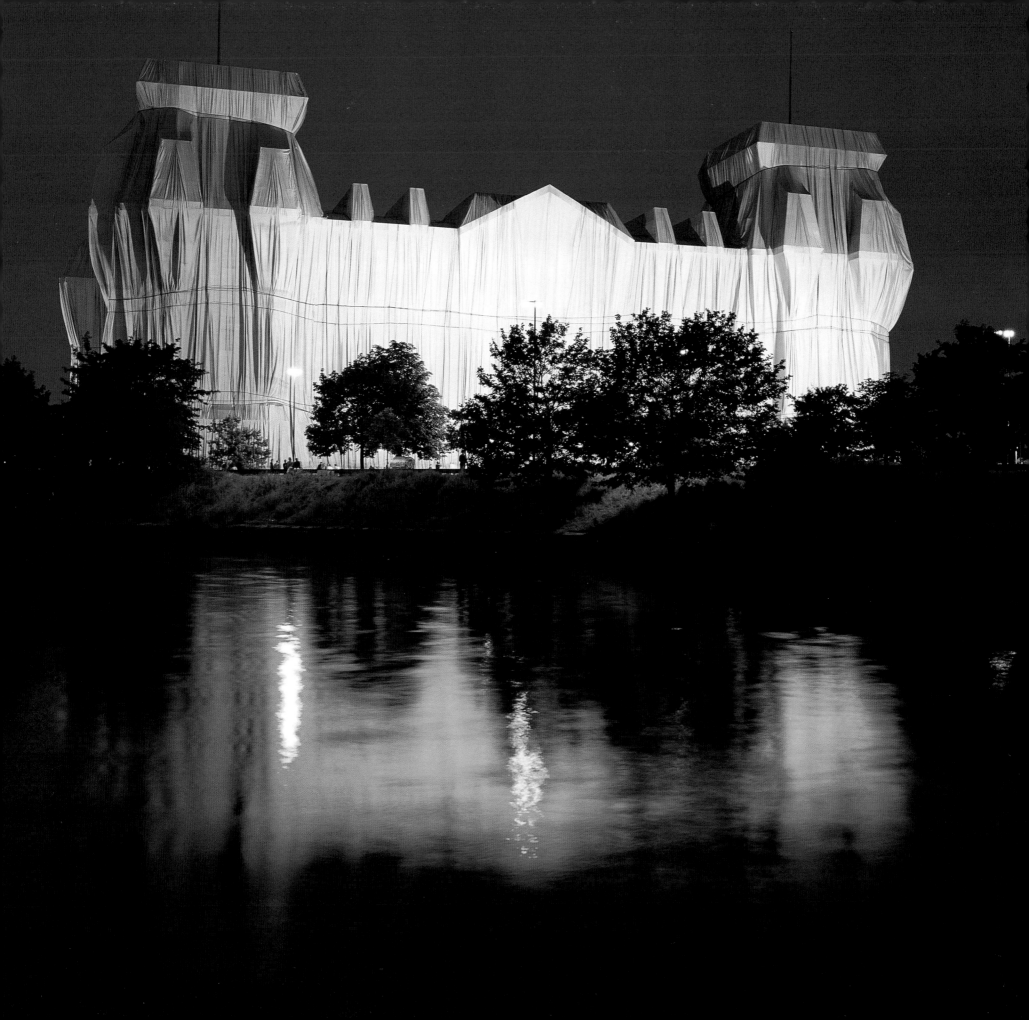

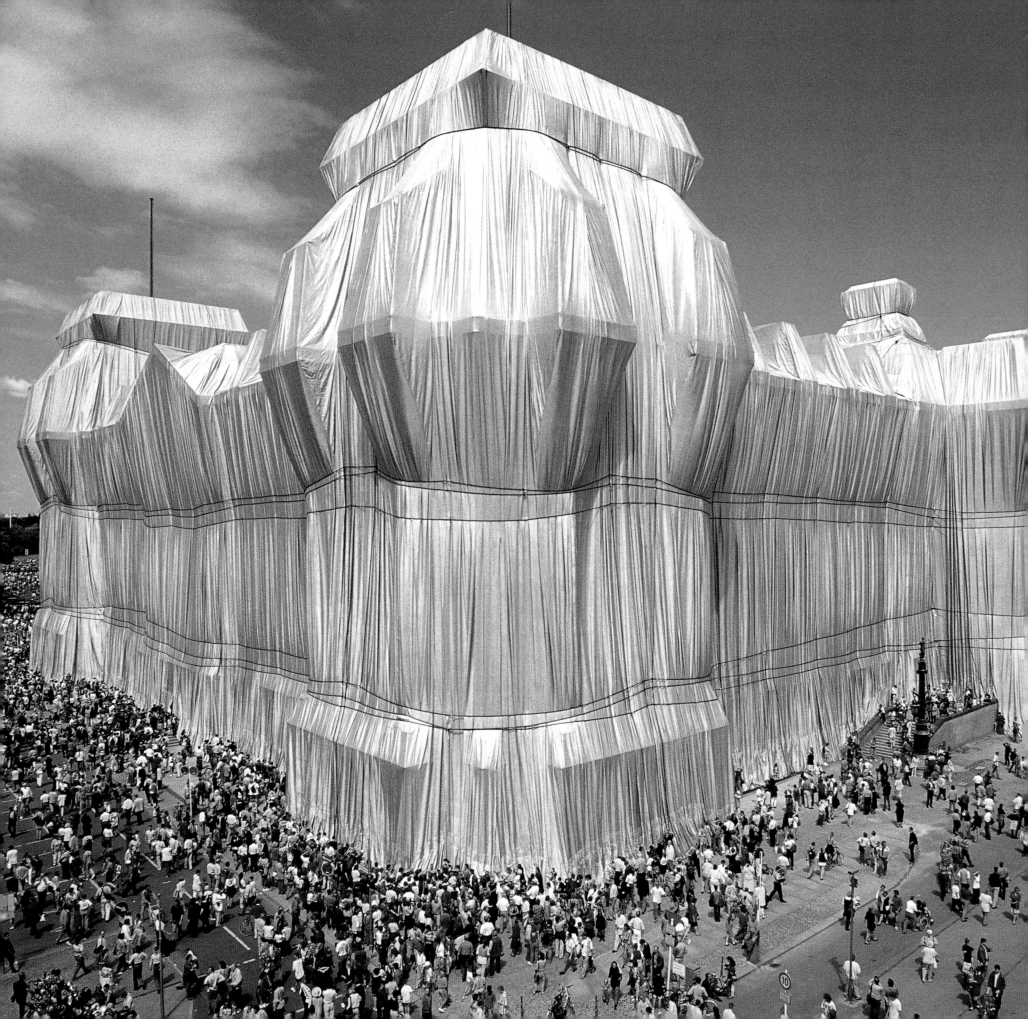

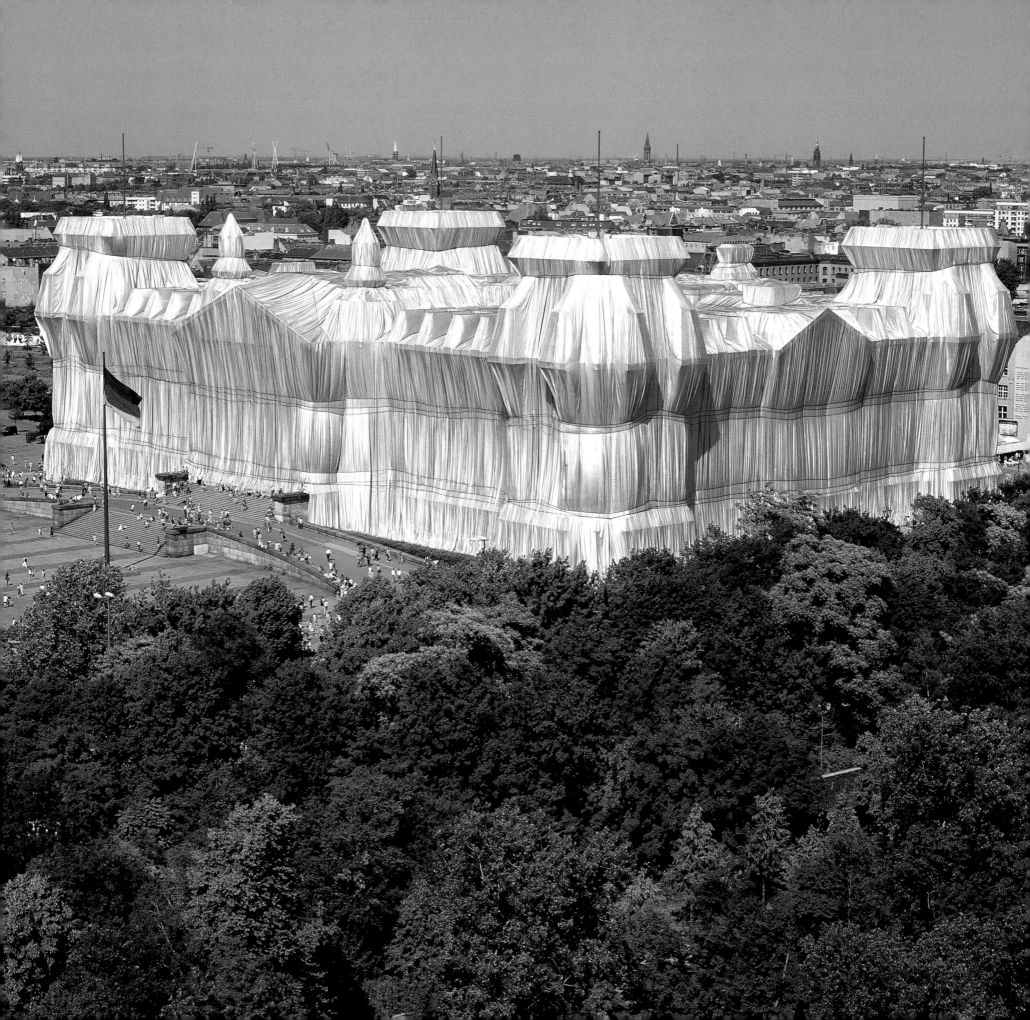

Street musicians, sidewalk artists and performance artists all made their presence known. The air was filled with the sound of clarinets, violins, guitars, accordions and drums.

Straßenmusikanten, Straßenkünstler und Performance-Künstler – sie alle waren unübersehbar. Die Luft war angefüllt mit dem Klang von Klarinetten, Geigen, Gitarren, Akkordeons und Trommeln.

Sylvia Volz

André Grossmann

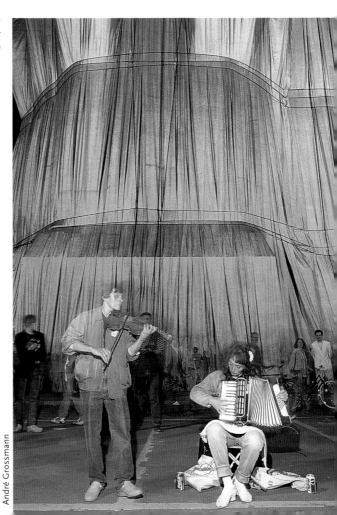

André Grossmann

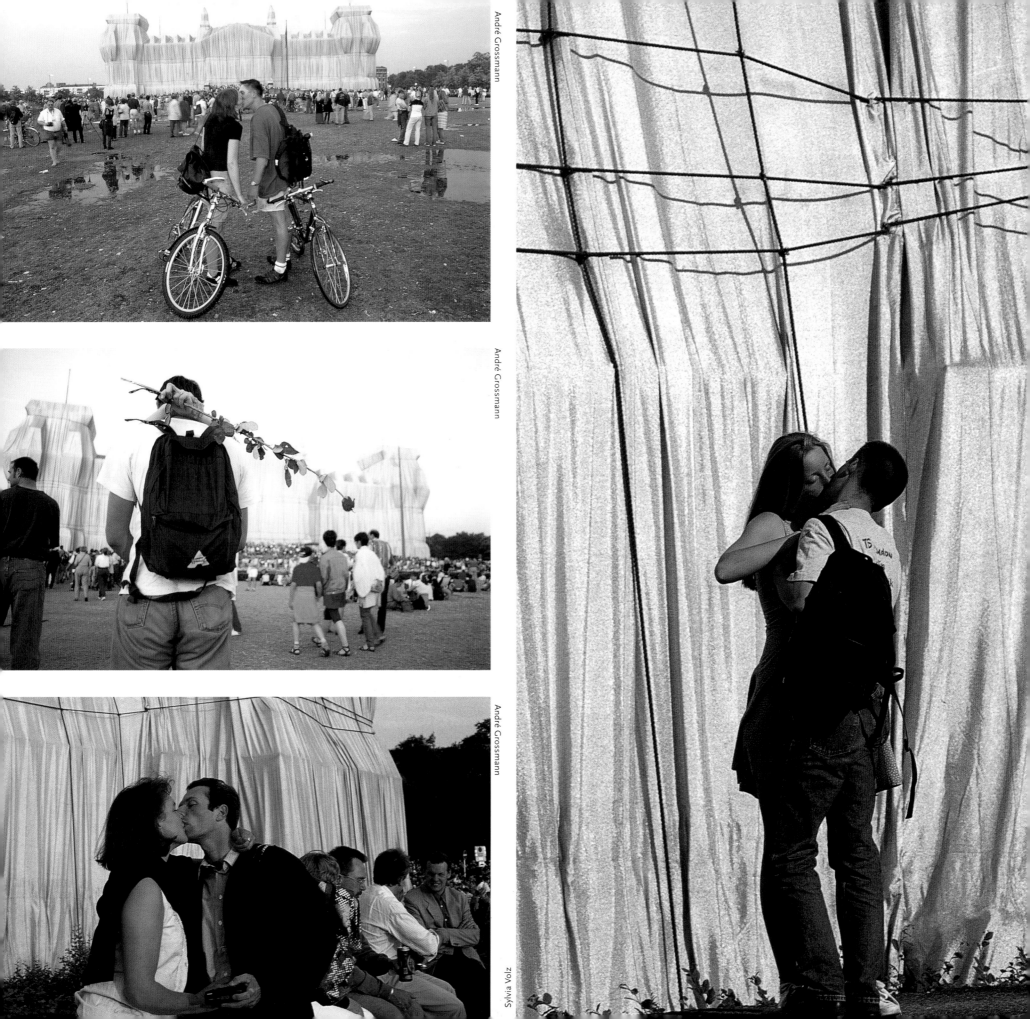

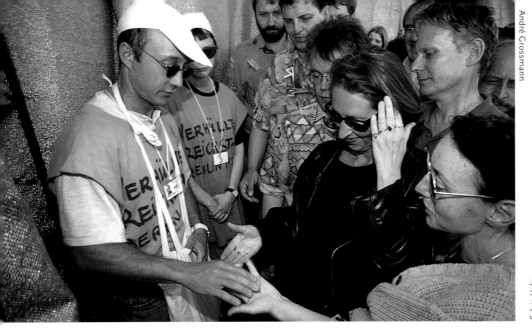

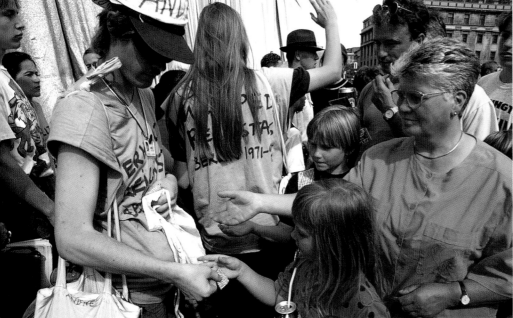

The monitors (left, top to bottom) presented visitors with more than one million free samples of the aluminized fabric, each 5 x 5 centimeters (below). Virtually all hands (far right) reached out for one.

Die Monitore (links, von oben nach unten) verteilten mehr als eine Million kostenlose, 5 x 5 Zentimeter große Muster des aluminisierten Gewebes an die Besucher (unten rechts). So gut wie alle Hände (gegenüberliegende Seite) streckten sich danach aus.

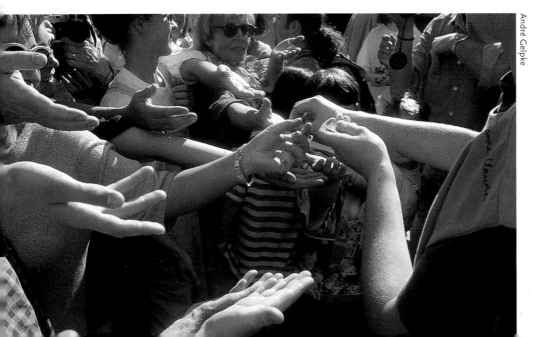

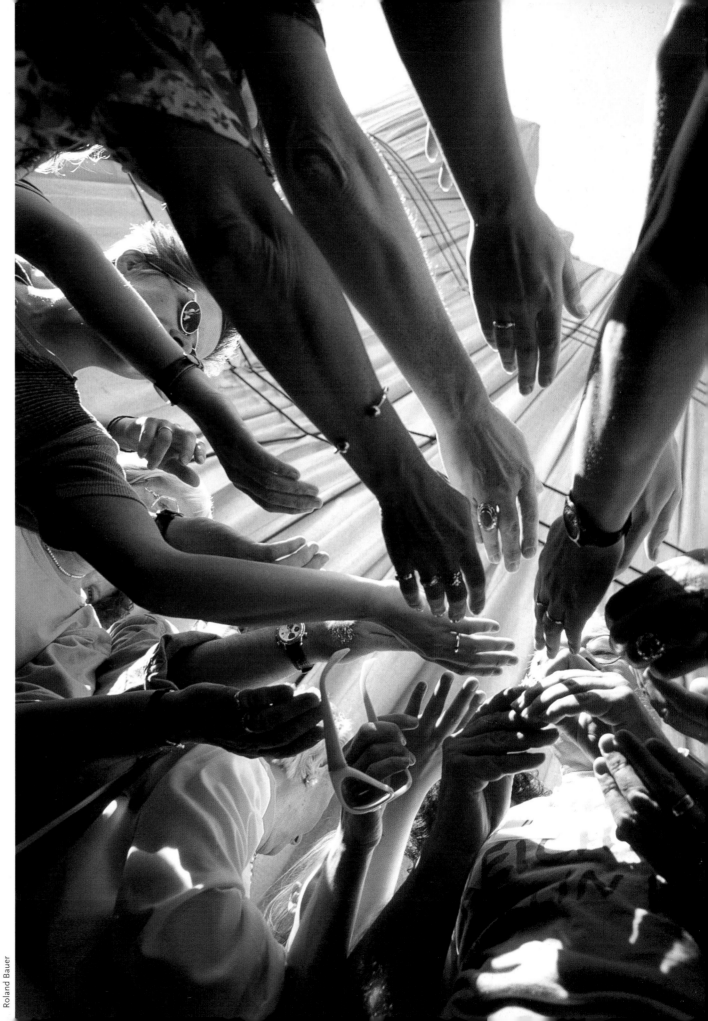

## CHRISTO UND JEANNE-CLAUDE: VERHÜLLTER REICHSTAG, BERLIN, 1971 - 1995

Nach langem Ringen, welches durch die Siebziger-, Achtziger- und Neunzigerjahre andauerte, wurde die Verhüllung des Reichstagsgebäudes am 24. Juni 1995 von einer Mannschaft bestehend aus 90 Gewerbekletterern und 120 Montagearbeitern vollendet. Der Reichstag bleibt für 14 Tage verhüllt, der Abbau beginnt am 7. Juli und alle Materialien werden recycelt.

Zehn Firmen in Deutschland begannen im September 1994 damit, all die verschiedenen Materialien nach dem Entwurf der Ingenieure herzustellen. Während der Monate April, Mai und Juni 1995 haben die Stahlmontagearbeiter die Stahlkonstruktionen für die Türme, das Dach, die Statuen und die Steinvasen installiert, die es dem in Falten gelegten Gewebe erlauben, wie ein Wasserfall vom Dach auf den Boden zu fallen.

100.000 Quadratmeter dickes Polypropylen-Gewebe mit einer aluminisierten Oberfläche und 15.600 Meter blaues Polypropylenseil mit einem Durchmesser von 3,2 cm wurden für die Verhüllung des Reichstags benutzt. Die Fassaden, die Türme und das Dach wurden mit 70 speziell dafür zugeschnittenen Gewebepaneelen bedeckt, die doppelte Menge der Oberfläche des Gebäudes.

Das Kunstwerk wird, wie alle anderen Projekte der Künstler ausschließlich aus eigenen Mitteln finanziert, durch den Verkauf der Vorstudien, Zeichnungen, Collagen, maßstabgerechte Modelle, frühere Arbeiten und Originallithographien. Die Künstler akzeptieren keinerlei Fördermittel aus öffentlicher oder privater Hand.

Der Verhüllte Reichstag steht nicht nur für die vierundzwanzigjährigen Bemühungen im Leben der Künstler, sondern auch für viele Jahre Teamarbeit der leitenden Mitglieder Michael S. Cullen, Wolfgang und Sylvia Volz und Roland Specker.

Am 25. Februar 1994 wurde im deutschen Bundestag in einer Plenarsitzung unter dem Vorsitz von Prof. Dr. Rita Süssmuth 70 Minuten lang über das Kunstwerk debattiert und danach namentlich darüber abgestimmt. Das Abstimmungsergebnis lautete: 292 dafür, 223 dagegen bei 9 Stimmenthaltungen.

Der Reichstag steht auf einem weithin offenen Gelände, das merkwürdige, ja gerade metaphysische Assoziationen erweckt. Das Gebäude ist einem ständigen Wandel und dauernden Erschütterungen unterworfen gewesen. Fertiggestellt im Jahre 1894, wurde es 1933 in Brand gesteckt, 1945 fast völlig zerstört und in den sechziger Jahren wieder aufgebaut. Doch immer blieb der Reichstag ein Symbol für die Demokratie.

Die ganze Kunstgeschichte hindurch haben Stoffe und Gewebe die Künstler fasziniert. Von den ältesten Zeugnissen der Bildenden Kunst bis hin zur Kunst der Gegenwart ist die Struktur von Stoffen - Faltenwürfe, Plissees, Draperien - ein bedeutender Bestandteil von Gemälden, Fresken, Reliefs und Skulpturen aus Holz, Stein und Bronze. Die Verhüllung des Reichstags mit Gewebebahnen folgt dieser klassischen Tradition. Stoffbahnen- wie die Kleidung oder die Haut - haben etwas Zartes und Empfindliches, sie verdeutlichen die einzigartige Qualität des Vergänglichen.
Für einen Zeitraum von zwei Wochen soll die verschwenderische Fülle von Tausenden von Quadratmetern des silbrig glänzenden, mit blauen Seilen vertäuten Gewebes einen üppigen Fluß vertikaler Falten ergeben, die die Bestandteile und Proportionen des imposanten Baues hervorheben und die wesentlichen Merkmale des Reichstagsgebäudes vor Augen führen werden.

## CHRISTO AND JEANNE-CLAUDE : WRAPPED REICHSTAG, BERLIN, 1971-95

After a struggle spanning through the Seventies, Eighties and Nineties, the wrapping of the *REICHSTAG* was completed on June 24th, 1995 by a work force of 90 professional climbers and 120 installation workers. The Reichstag remained wrapped for 14 days and all materials were recycled.

Ten companies in Germany started in September 1994 to manufacture all the various materials according to the specifications of the engineers. During the months of April, May and June 1995, iron workers installed the steel structures on the towers, the roof, the statues and the stone vases to allow the folds of fabric to cascade from the roof down to the ground.

100,000 square meters (1,076,000 square feet) of thick woven polypropylene fabric with an aluminum surface and 15,600 meters (51,181 feet) of blue polypropylene rope, diameter 3.2 cm. (1.1/4 "), were used for the wrapping of the Reichstag. The facades, the towers and the roof were covered by 70 tailor-made fabric panels, twice as much fabric as the surface of the building.

The work of art was entirely financed by the artists, as they have done for all their projects, through the sale of preparatory studies, drawings, collages, scale models as well as early works and original lithographs. The artists do not accept sponsorship of any kind.

The Wrapped Reichstag represents not only 24 years of efforts in the lives of the artists but also years of team work by its leading members Michael S. Cullen, Wolfgang and Sylvia Volz, and Roland Specker,

In Bonn, on February 25, 1994, at a plenary session, presided by Prof. Dr. Rita Süssmuth, the German Bundestag (parliament) debated for 70 minutes and voted on the work of art . The result of the roll call vote was: 292 in favor, 223 against and 9 abstentions.

The Reichstag stands up in an open, strangely metaphysical area,. The building has experienced its own continuous changes and perturbations: built in 1894, burnt in 1933, almost destroyed in 1945, it was restored in the sixties, but the Reichstag always remained the symbol of Democracy.

Throughout the history of art, the use of fabric has been a fascination for artists. From the most ancient times to the present, fabric, forming folds, pleats and draperies, is a significant part of paintings, frescoes, reliefs and sculptures made of wood, stone and bronze. The use of fabric on the Reichstag follows the classical tradition. Fabric, like clothing or skin, is fragile, it translates the unique quality of impermanence.

For a period of two weeks, the richness of the silvery fabric, shaped by the blue ropes, created a sumptuous flow of vertical folds highlighting the features and proportions of the imposing structure, revealing the essence of the Reichstag.

Roland Bauer

André Grossmann

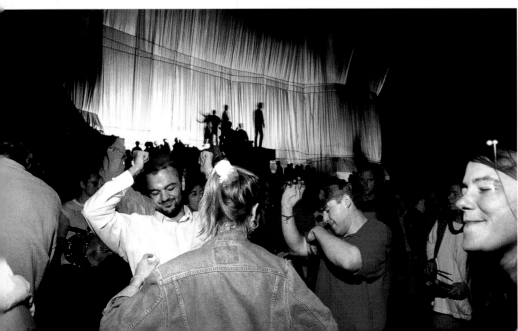

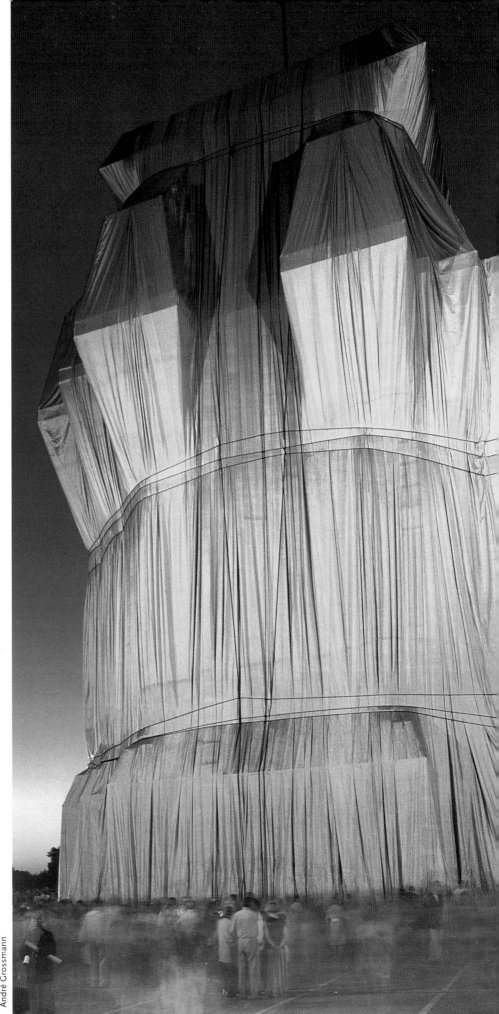

André Grossmann

Social life around the *Wrapped Reichstag* was uncommonly festive: People picnicked, played music, danced and just hung out peacefully.

Unter den Besuchern des *Verhüllten Reichtags* herrschte eine ungewöhnlich friedliche und festliche Atmosphäre: Die Leute picknickten, machten Musik, tanzten und schauten dem Treiben zu.

The standard nighttime illumination of the Reichstag, regularly provided by the city of Berlin, contributed to the dramatic transformation.

Die übliche nächtliche Beleuchtung des Reichstags trug das ihre zu der dramatischen Transformation des verhüllten Bauwerks bei.

sander Perković

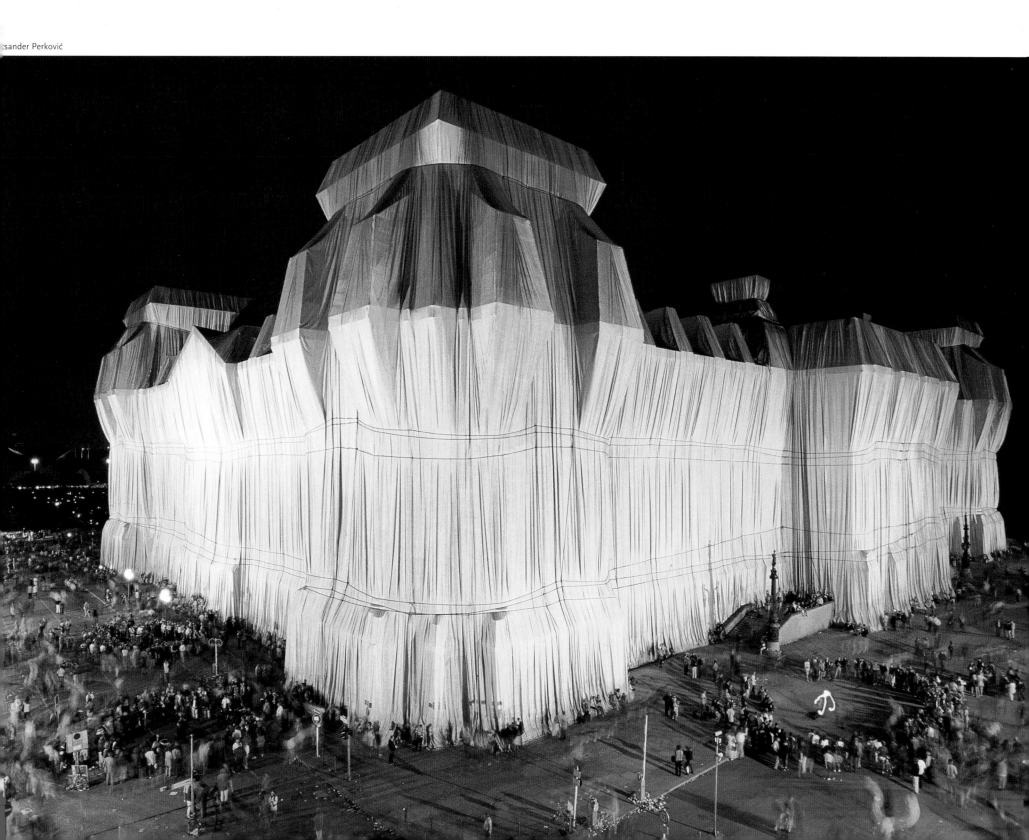

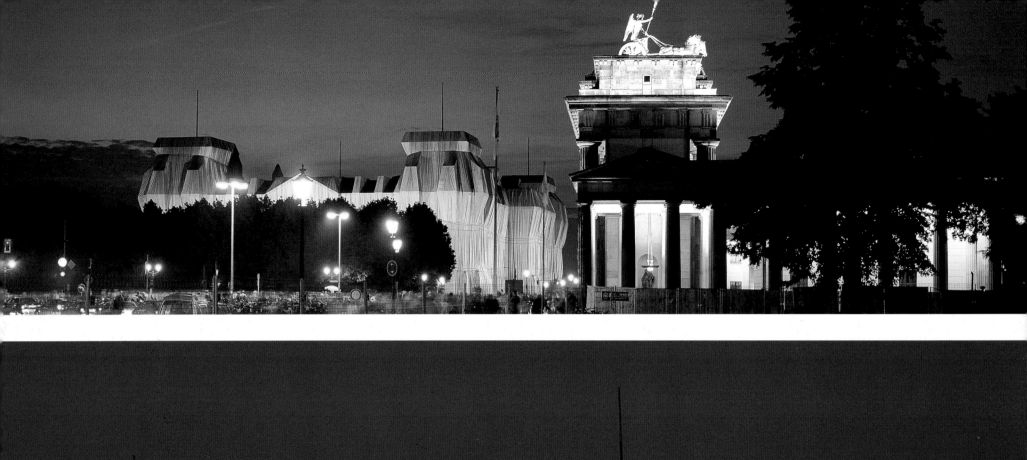

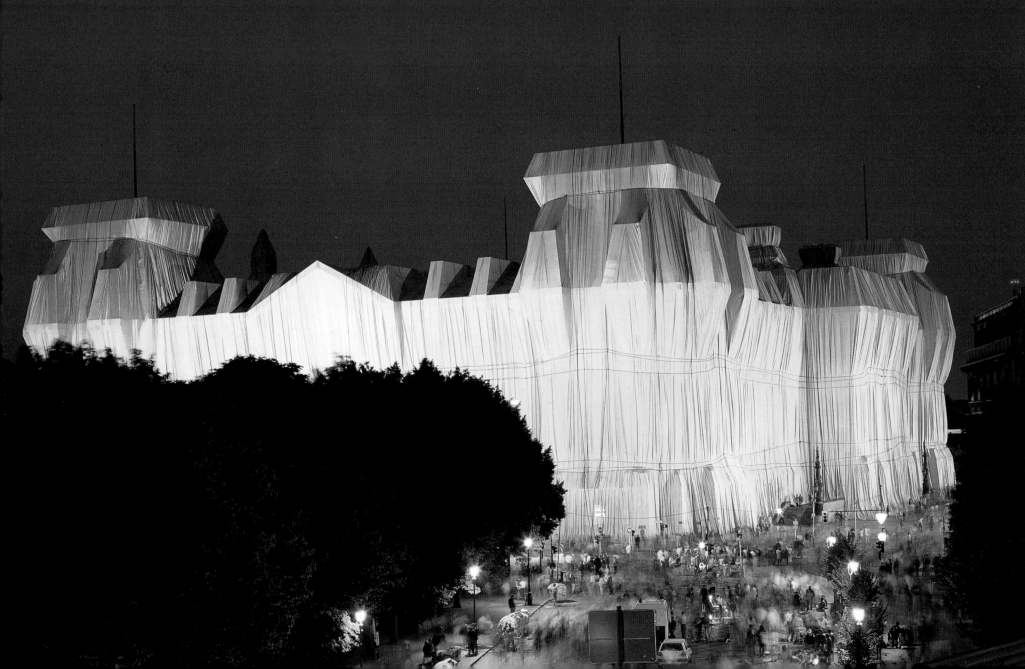

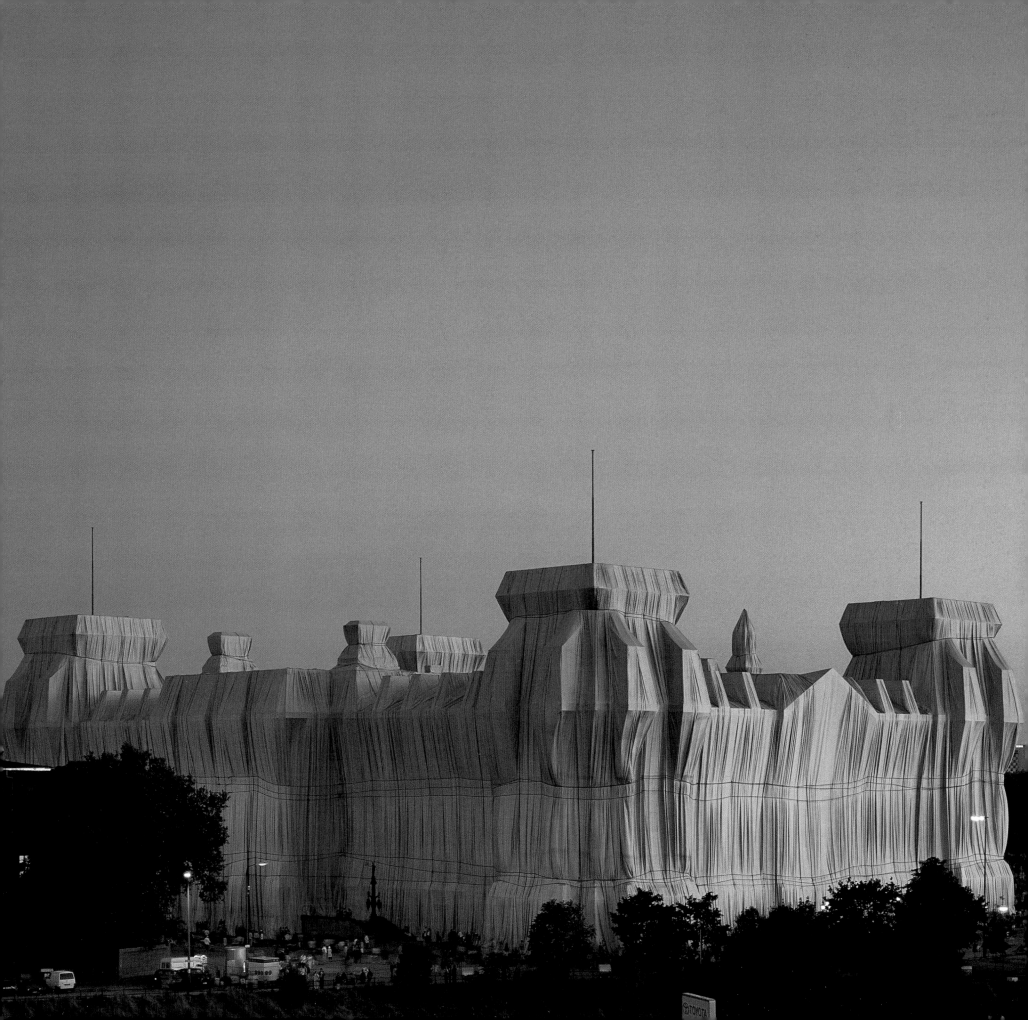

The Reichstag, viewed from the south (below), with the Branden-
burg Gate in the foreground. Unter den Linden, the city's most
historic avenue, leads to the Brandenburg Gate (opposite). The
Neoclassical structure with Doric columns was designed by Carl
Gotthard Langhans (1732–1808).

Next spread: The sculpture of Winged Victory driving a quadriga,
placed atop the Brandenburg Gate in 1794, is by Johann Gottfried
Schadow (1764–1850).

Der Reichstag, von Süden aus gesehen (unten), mit dem
Brandenburger Tor im Vordergrund. Unter den Linden, die hi-
storisch bedeutendste Allee der Stadt, führt zum Brandenburger
Tor (gegenüberliegende Seite). Der neoklassizistische
Bau mit dorischen Säulen wurde von Carl Gotthard Langhans
(1732–1808) entworfen.

Folgende Doppelseite: Johann Gottfried Schadow (1764–1850)
schuf die eine Quadriga lenkende geflügelte Siegesgöttin, die seit
1794 das Brandenburger Tor krönt.

Aleksander Perko

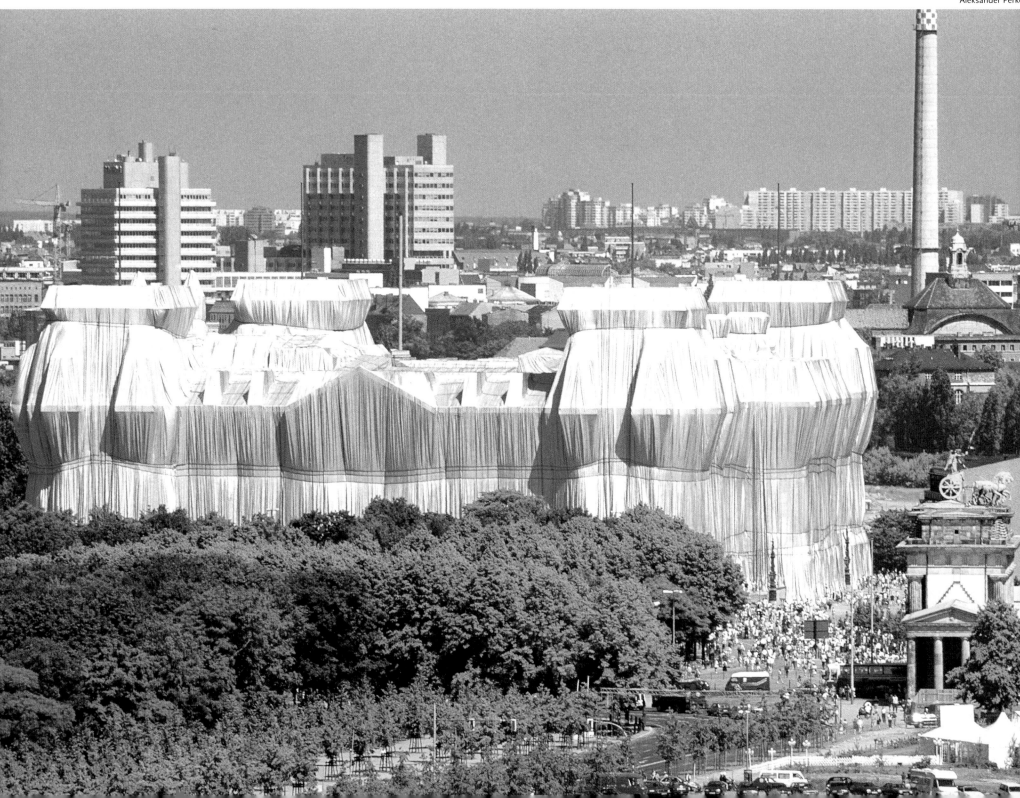

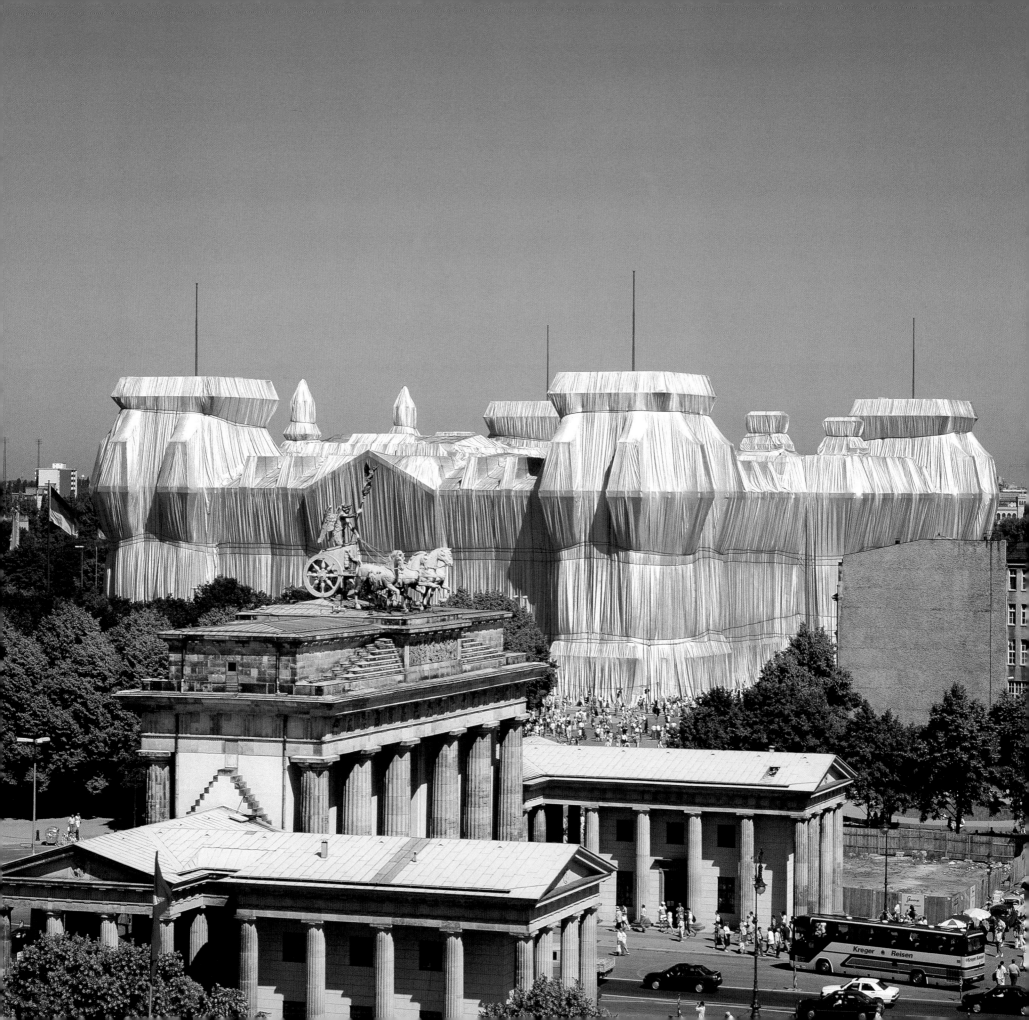

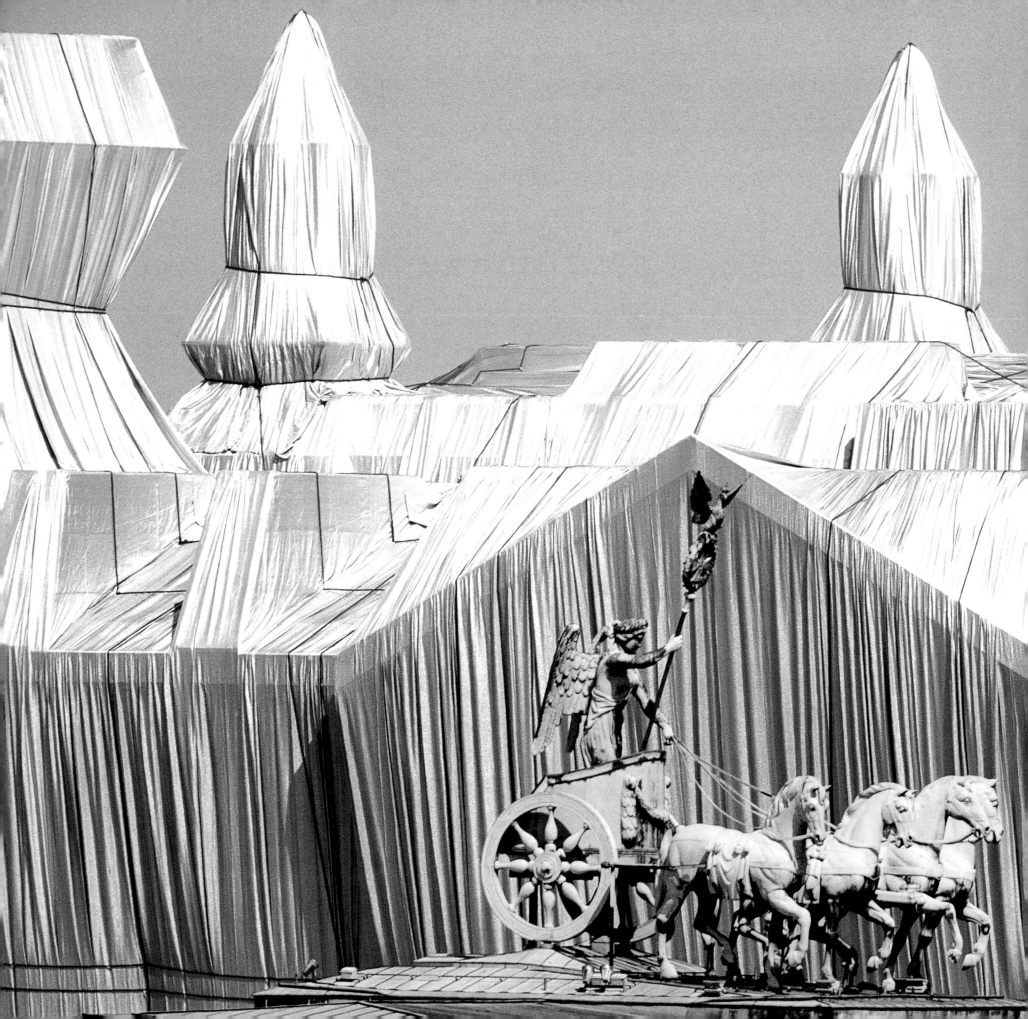

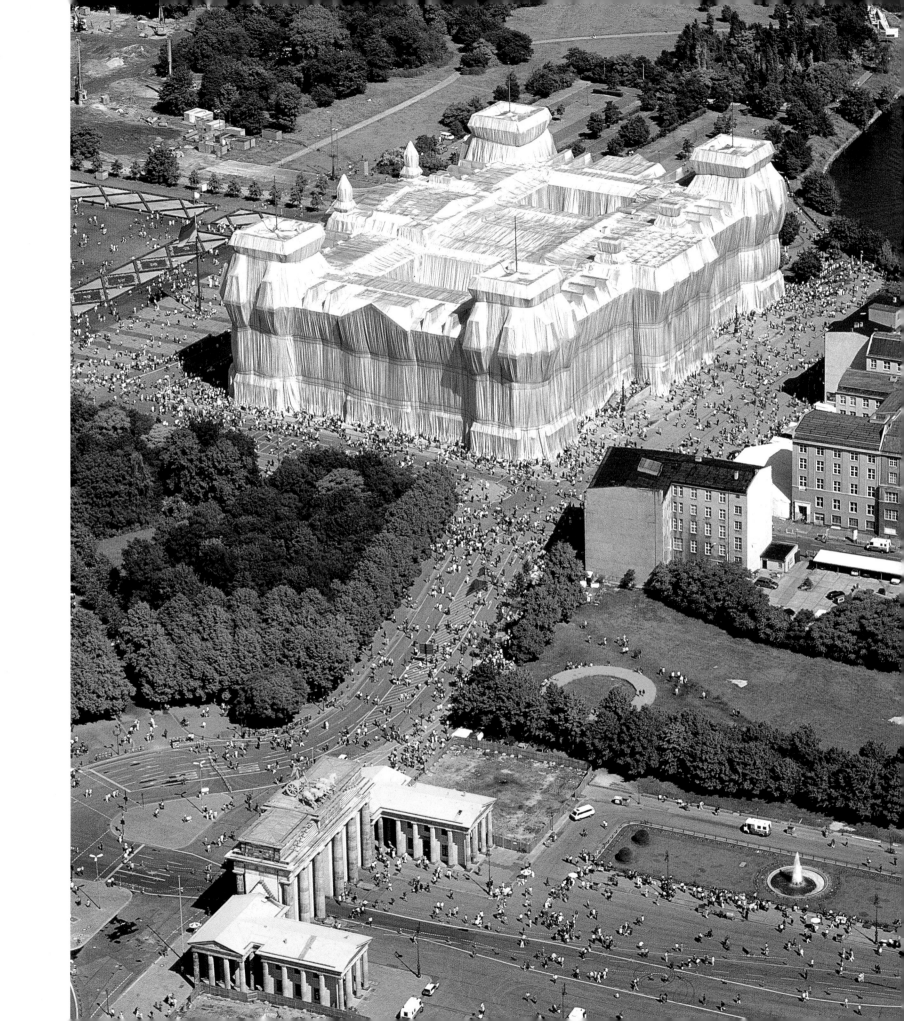

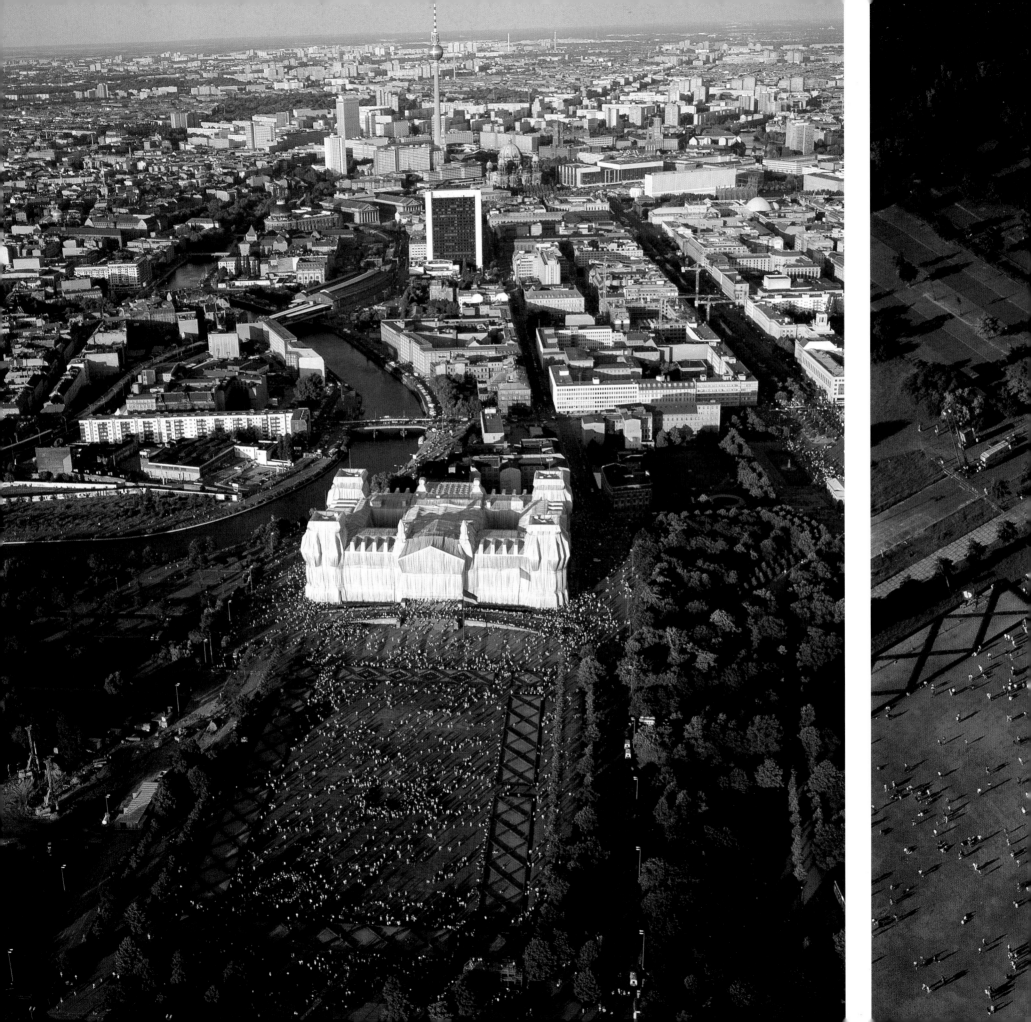

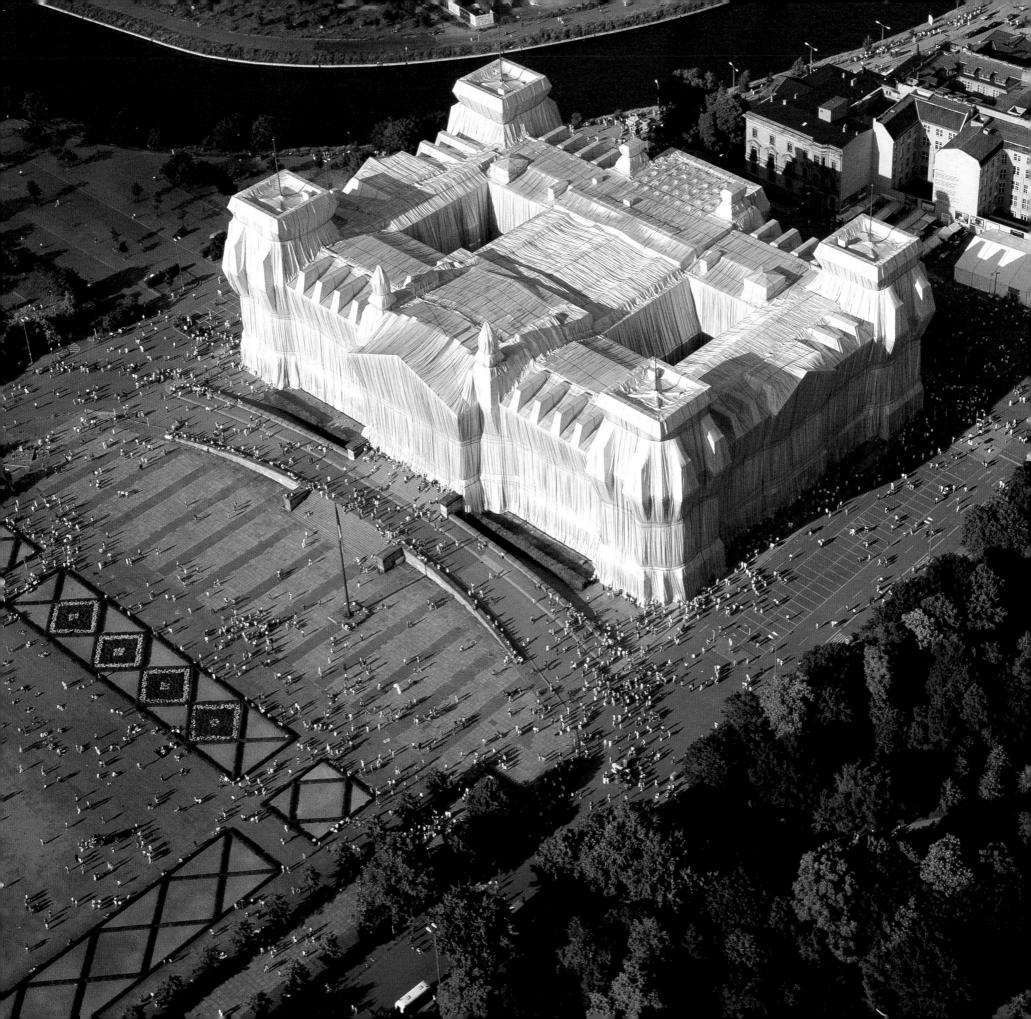

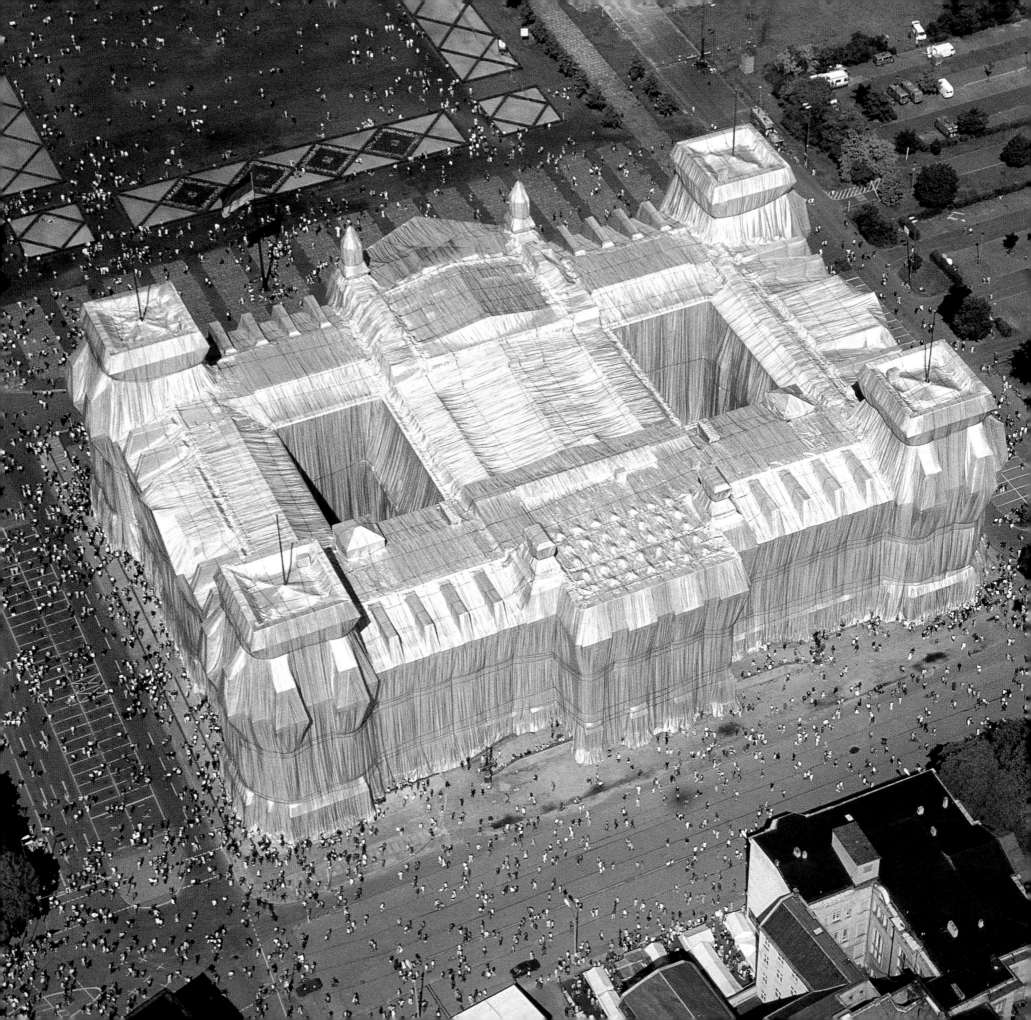

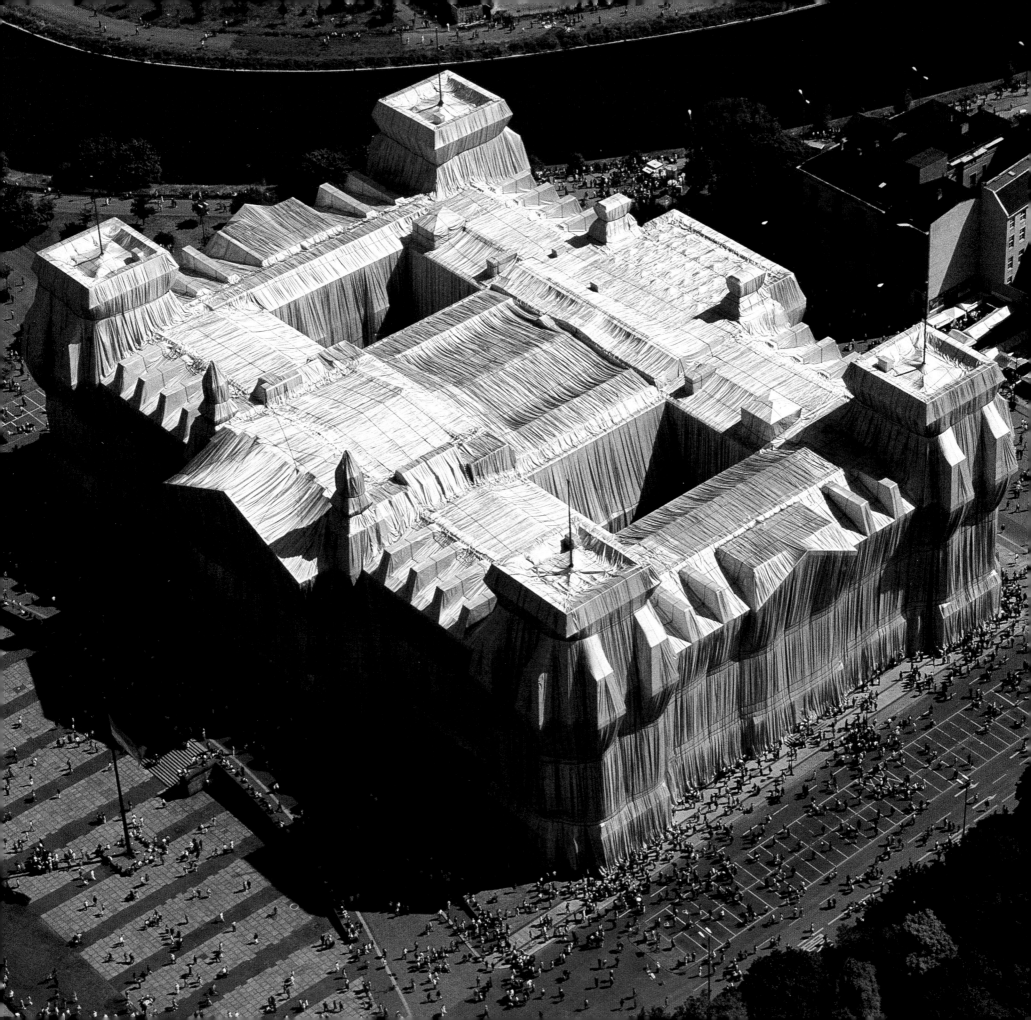

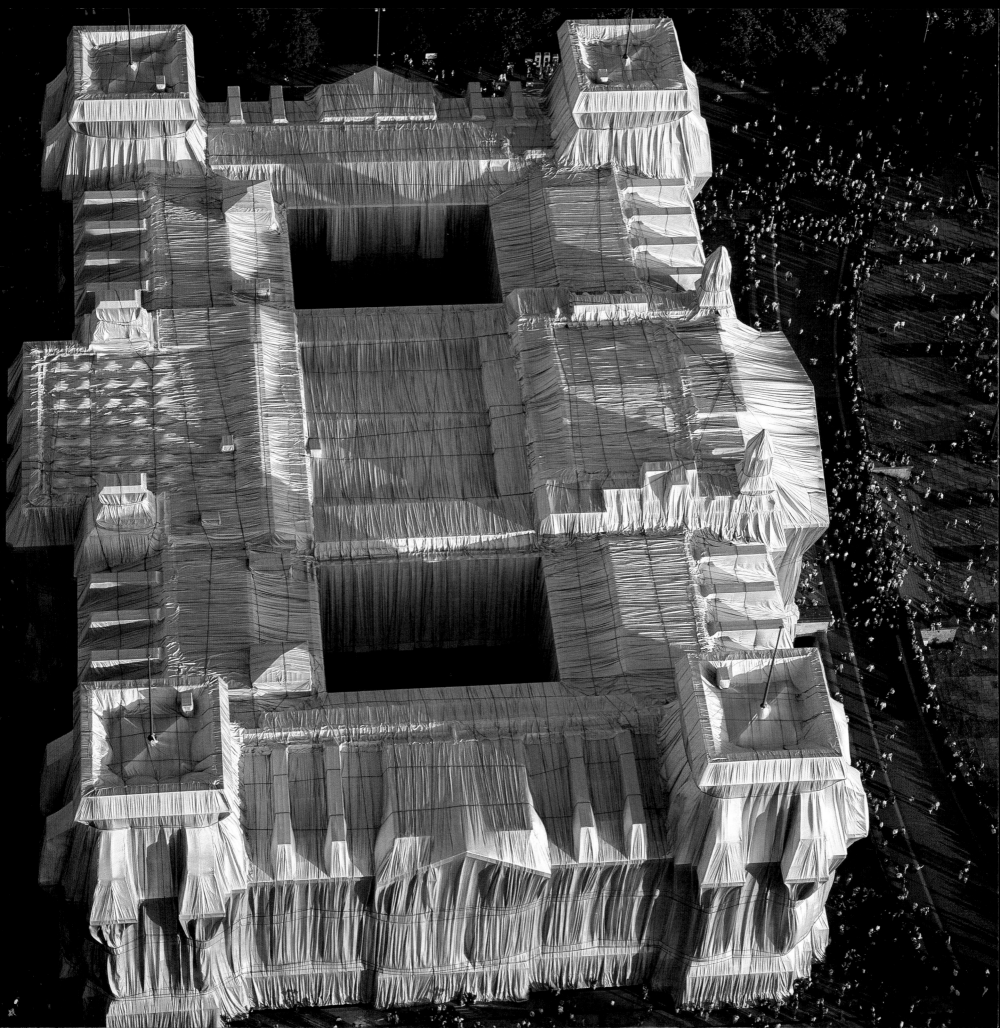

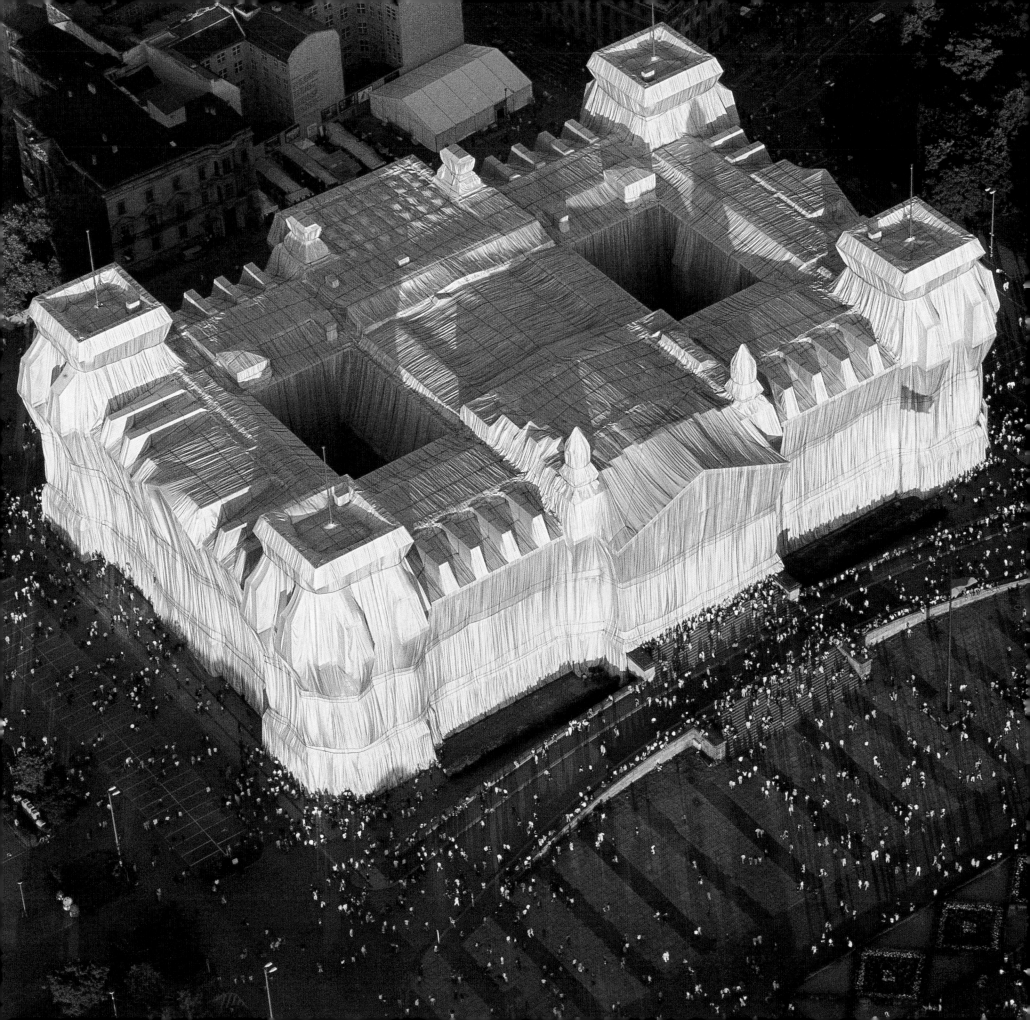

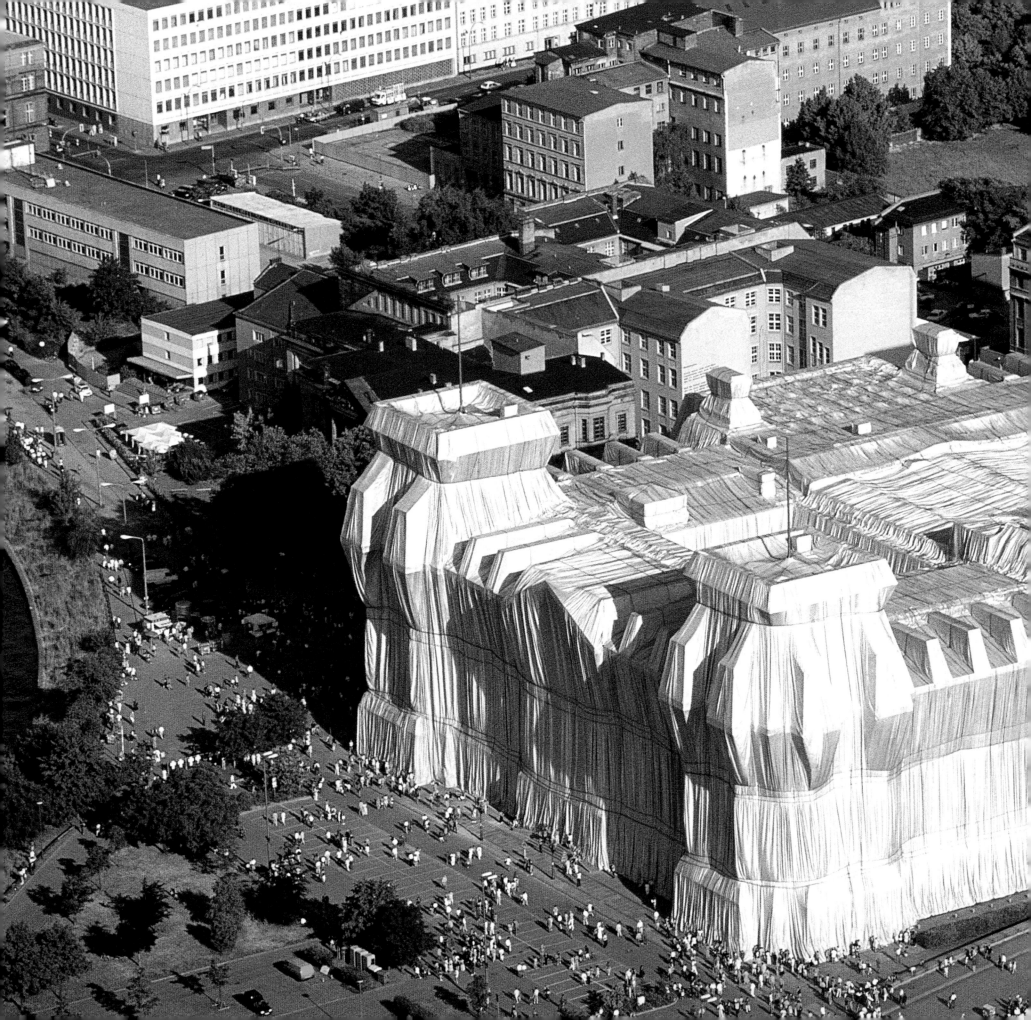

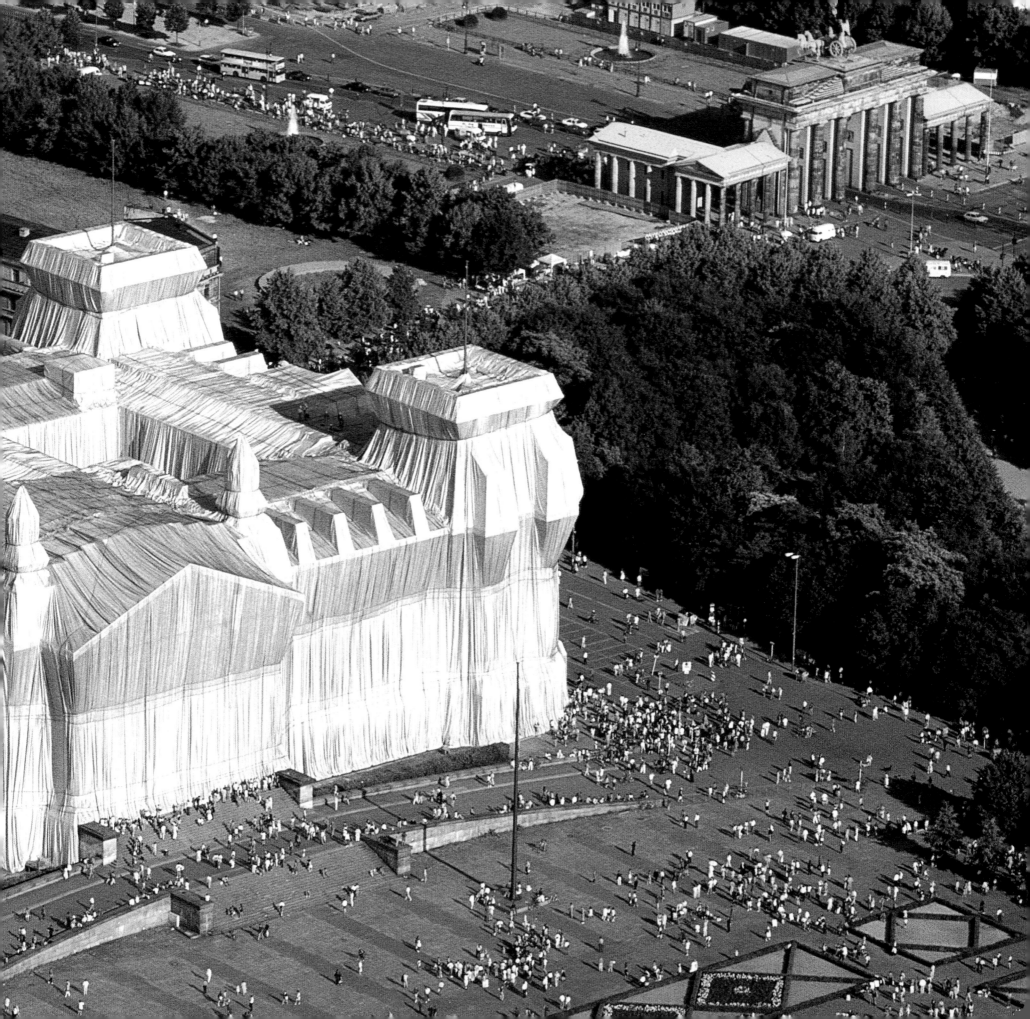